FREE AS GODS

CHARLES A. RILEY II

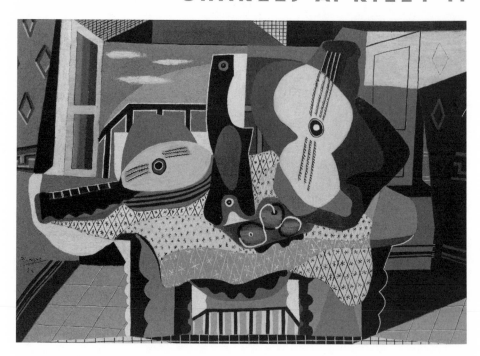

HOW THE
JAZZ AGE
REINVENTED
MODERNISM

FREE AS GODS

ForeEdge

ForeEdge

An imprint of University Press of New England

www.upne.com

© 2017 ForeEdge

Manufactured in the United States of America

Designed by Eric M. Brooks

Typeset in Arno by Passumpsic Publishing

For permission to reproduce any of the material in this book,
contact Permissions, University Press of New England, One Court
Street, Suite 250, Lebanon NH 03766; or visit www.upne.com

Library of Congress Cataloging-in-Publication Data

NAMES: Riley, Charles A., author.

TITLE: Free as gods: how the Jazz Age reinvented modernism /
Charles A. Riley II.

DESCRIPTION: Hanover: ForeEdge, An imprint of University Press of
New England, 2017. | Includes bibliographical references and index.

IDENTIFIERS: LCCN 2016049145 (print) | LCCN 2016050627 (ebook) |
ISBN 9781611688504 (cloth: alk. paper) | ISBN 9781512600551 (epub,
mobi & pdf)

SUBJECTS: LCSH: Arts, French — France — Paris — 20th century. |
Avant-garde (Aesthetics) — France — Paris — History — 20th century. |
Artists — Professional relationships — France — Paris — History — 20th
century. | Paris (France) — Intellectual life — 20th century.

CLASSIFICATION: LCC NX549. P2 R55 2017 (print) |
LCC NX549. P2 (ebook) | DDC 700.944/0904—dc23

LC record available at https://lccn.loc.gov/2016049145

5 4 3 2 1

With a profound
debt of loving gratitude
to the memory of
ISABEL COOPER RILEY.
Flying too high with
some guy in the sky was
her idea of something
to do.

CONTENTS

Preface ix

Introduction 1

Part 1 Freedom: Anything Goes 15

1 Enter the Ballets Russes 33

2 One of Those Fabulous Flights: Cole Porter 45

3 Stairway to Paradise: George Gershwin 51

4 Inevitable Paris Beckoned: John Dos Passos
and e. e. cummings 57

5 Dancing on Dynamite: Nancy Cunard 62

6 From Flappers to Philosophers: F. Scott Fitzgerald 71

7 New Amazements: Hart Crane 83

8 Weary Bluesman: Langston Hughes 93

9 Making It in the Paris Art World 100

Part 2 Order: Blessed Rage 111

10 Existential Octaves: Ernest Ansermet 113

11 Geometry and Gods, Side by Side: Le Corbusier 119

12 Connoisseur of Contrasts: Fernand Léger 132

13 Transfigurations of the Commonplace: Gerald Murphy 140

14 Prophet of Disorder: Oswald Spengler 161

Part 3 Truth: The Truest Sentence 165

15 The Truth in Painting: Pablo Picasso 174

16 Words in a Strange Language: Archibald MacLeish 194

17 The Malady of Language: Eugene Jolas 213

18 The Real Thing: Ernest Hemingway 221

Notes 237

Bibliography 249

Index 259

Color illustrations follow page 112

To be in the right place at the right time was the enviable knack of the astonishingly young geniuses of the Jazz Age. Paris in the twenties meant proximity to James Joyce, Pablo Picasso, Fernand Léger, Piet Mondrian, Gertrude Stein, Igor Stravinsky, and the international dramatis personae who had already shaped the course of modern art, music, and literature. History offers a handful of comparable moments when an onslaught of talent converges on one city, such as Periclean Athens, Augustan Rome, Tang dynasty Chang'an (now Xian, choking on its soot), Renaissance Florence and Amsterdam, Elizabethan London, imperial St. Petersburg, *fin de siècle* Vienna, and New York when the abstract expressionists roamed Greenwich Village. Even among these celebrated epochs, Paris between the world wars exerts a special attraction, especially for Americans who still can barely escape the "wish I'd been there" sense of how the stimuli of so many brilliant artists, writers, composers, and designers would produce such wondrous responses. The members of the generation whose lives and works were shaped by these encounters knew how lucky they were. Like participants in a particularly strong class at a university or a sports dynasty, F. Scott Fitzgerald and Ernest Hemingway, George Gershwin and Cole Porter, Langston Hughes and Archibald Motley, T. S. Eliot, Nancy Cunard and Hart Crane, and many others celebrated in these pages recognized that expatriate life competitively expanded their intellectual capital in ways that Harvard University, trench warfare, New Orleans speakeasies, or high society at New York's Plaza Hotel could not.

Even if the guest list and setting for the party seem familiar, this account of the way modernism progressed in the Jazz Age veers into new territory, diverging from the standard track from cubism to abstraction, for example. The age demanded fearless experimentation that outpaced the avant-garde elsewhere. It also craved the restoration of order after the chaos of the war years. The oscillation of these conflicting drives (for pleasure and discipline, freedom and order) adds an unexpected shading to the usual picture of twenties revelry. The rewriting of the history of modernism follows the School of Paris through breathtakingly

unexpected turns in painting, while the composers collectively known as Les Six were giving jazz the full orchestral sweep of Claude Debussy and Maurice Ravel. The polyglot complexity of Joyce's work in progress, later published as *Finnegans Wake*, was an ill-kept secret among insiders who took its incomprehensible linguistic mix as license to go further. Understanding the movements and countermovements requires a map of the connections among thinkers who were often working in media besides their own. Not all of them are as famous as the Fitzgeralds. I was blindsided in the best possible way by the important roles played by Eugene Jolas; Ernest Ansermet; George Antheil; Archibald MacLeish; and Nancy Cunard, whose long poem *Parallax* became one of the highlights of my literary research. I underestimated the significance of Jazz Age Paris to the careers of Eliot and Ezra Pound, whose dedication to composing music was, like Hemingway's art collecting or Le Corbusier's painting, among the many surprises in store when the hidden interests of the geniuses emerged. These expatriates were multitalented, curious, and brave. One biography after another relates the audacious wager that highly educated young men and women made to try out their ambitious ideas in Paris even if it meant deferring lucrative careers and defying family obligations (MacLeish as a lawyer; Gerald Murphy as the head of a luxury goods empire; John Dos Passos, Cunard, and Porter as heirs to fortunes).

I gratefully followed the lead of fresh new biographies and revelations about major figures — including Eliot, Pound, e. e. cummings, Cunard, Porter, and Gershwin — that gave me the all-important confidence in the vital historical assignment of connecting one figure with another, placing them in the same room for a party, building the sets for the ballet, or listening to Joyce delivering a fresh chapter. To read a poem or examine a painting in isolation from the cultural history is especially inadvisable because this was an era of collaboration more than of the individual genius toiling in seclusion. The transformative social scene that so delighted readers of *Vanity Fair* and the *New Yorker*, then as now the lifestyle magazines of the moment, led Hemingway, Fitzgerald, Crane, and others into sophisticated new territory. The decade-long run of triumphs that made the Ballets Russes the most important source of musical and design revolutions was completely a matter of

teamwork. Back in New York, behind the scenes in the editorial offices of Scribner's, Boni and Liveright, or the newly formed Random House or along Tin Pan Alley, sorting out who was where and when helps unpack the genesis of a long shelf of breakthrough volumes and recordings by Hughes, MacLeish, Eliot, Pound, cummings, Dos Passos, Crane, Gershwin, and Porter, among others. The authentically American sound of jazz conquered Paris and returned to the United States with European accents, much as Hughes's blues-inflected poetry included snippets of French and echoes of Charles Baudelaire. The creole of New Orleans, which eased entry into society and the bandstand community of Paris for such musicians as Sidney Bechet, offers a metaphor for the mixed cultural identities that often made Americanness the theme of the art (*An American in Paris*, the stories of Hemingway, and the paintings of Murphy). It also highlights the mixed modes, blending jazz and symphony, graphic design and painting, literature and journalism, and even dance and gymnastic exercises, that characterized their hybrid art.

The chronological scope of the book is roughly from the end of World War I to the Wall Street crash of 1929. Time and again the *annus mirabilis* of individual chapters in the book seemed to be 1923 (when Picasso painted *Woman in White* and Murphy and Porter created the ballet *Within the Quota*). That was the year my mother, Isabel Cooper Riley, was born, and this is the first of my books she will never read —although she shared the day-to-day thrill of the research, such as the discovery of Cunard's poetry in the Berg Collection of the New York Public Library, my walk home from the newly opened Whitney Museum after revisiting Murphy's *Cocktail*, and any number of other wildly exciting moments as the book progressed. Without her love of the arts in all forms, her exemplary taste, and the unwavering kindness of her support, my work would never have reached book form. Unaccustomed to her absence from my intellectual life, I found that the tight bonds to my sisters, Robin and Diane, became all the more precious, and their contributions to this book have been considerable. I leaned heavily as well on my gentle cousin, Stephen Horne, artist and thinker, wise counselor, and strong source of support when I was finishing a book about history's most exuberant era at a time of intense personal

grief. I am particularly indebted to the generous, firm, and unshakable support of my wife, Keming Liu, who has been at my side at every moment, from the most joyful to the most trying.

Phyllis Deutsch, the editor in chief of the University Press of New England (UPNE), has been the Maxwell Perkins behind one sound amendment after another, shaping and querying my pages into an argument she discerned before I did. This is our fourth book together, and my personal and professional debt (for she was a bulwark of wise comfort when I most needed it) is too vast for this brief paragraph. Sensitive, thorough, and scholarly in the best sense, the entire editorial team at UPNE has helped make this a better book at each stage of the process, and I extend my thanks as well to Susan A. Abel; Jeanne Ferris; and Kara L. Caputo, who handled all the permissions duties for the images and texts.

So many friends have been instrumental to my thinking on the Jazz Age that it is almost as though I have my own modest version of the Villa America set. Candy and Ken Caldwell, Laura Woo, Jerry and Barbara Schauffler, Dick and Linda Kahn, Sharon and Philip Francis, and Ellen Effron listened to early versions of some of these chapters in lectures and were on the trail with me in Provence as I pursued the perspectives of Paul Cézanne, an indispensable experience for understanding a section of Cunard's *Parallax*. Anthony Collins, John and Laura Donnelly, Richard Myers Brennan, Chester and Christy Murray, Pat Rogers, Andrew Botford, Rosina Rubin, Joanne Olian, Kate Deatly-Peluso of Babcock Gallery, Peter Peck, Lisa Hahn, Raoul and Bettina Witteveen, Shining Sung, and Asher and Michelle Edelman unfailingly encouraged me in my writing of this book. For two semesters I loved teaching an interdisciplinary seminar on the era, marching my undergraduates along Fifth Avenue past Scribner's offices, former speakeasies, and the Algonquin and Plaza Hotels as we revisited traces of Manhattan in the Jazz Age. For their cheerful energy and spontaneous insights in and out of the classroom, here is a tip of my old fedora to Christopher Zumtobel (founder of Thinkolio, an educational venture that gave me the opportunity to try many of the ideas in these pages out on a broader public), Vincent Brigante, Samuel Rubinstein, Bernard Agrest, Avi Atkin, Max Avrakh, Megan Chiu, Min Jee Choi, Julian Kipnis, Caitlin Larsen, Yana Manevich, Sarah Park, Stanislav Shamayev, Zoe Sobel,

Melina Athanassiou, and Kristi Zhang. Even as I write these heartfelt words of thanks, the echoes of the Jazz Age resound about me. Among the hottest tickets on Broadway are those to *An American in Paris* and *Shuffle Along*, Murphy's paintings are highlights of the Whitney Museum and Museum of Modern Art, Zelda Fitzgerald is the subject of a ten-episode television series, and movies and fashion shows return to the flapper look with migratory regularity. Cole Porter wrote the anthem of the age, which may have been just "one of those bells that now and then rings," but the echoes resound today as clearly as ever.

FREE AS GODS

INTRODUCTION

Wild, hot, roaring, and rhapsodic to the point of danger, jazz is rarely mistaken for a calm, cold medium of control. The stars of the Jazz Age are typically depicted as a gang of Dionysians — the Lost Generation, as Gertrude Stein insultingly called them — whose blithely decadent emblems are Zelda and Scott Fitzgerald, Ernest Hemingway, Cole and Linda Porter, Nancy Cunard, Tamara de Lempicka, Josephine Baker, e. e. cummings, Noël Coward, and Jean Cocteau, among so many other rascals. Even by time-honored bohemian standards, the prodigious carousing of these hell-raisers offers a *louche* dash of intrigue to historical novels, biographies, and movies that shamelessly exploit the antics of the era. A pocket history of the ballet and opera of the period by Richard Shead brusquely titled one chapter "Hedonism." The preface opens, "Were the 1920s as silly as all that?"[1]

The answer is no. Precise and serious art made by a generation scarcely lost that had spent the war years yearning to return to the studio, writing desk, or stage refutes the stereotype. The artists and writers convened in Paris, vital center of the creative adventures chronicled here, to rebuild themselves and the arts. They changed the history of modernism in substantive ways that most historians, focused on the rhapsody of liberation, have missed. The counterpoint between freewheeling jazz and Le Corbusier's call to order (*rappel à l'ordre*) is as important as it is incongruous. Aesthetic history swings on a pendulum between the tight contours of realism and impressionist and expressionist slinging of paint, the strictures of twelve-tone composition and the improvisations of blues, and the blunt monosyllables of Stein and Hemingway and the endless lyric sentences of Marcel Proust and James Joyce. In the Jazz Age, when "everybody was so young" (Sara Murphy's phrase, which was used as the title of Amanda Vaill's group portrait of the Murphy circle[2]) the balance tilts inevitably toward a sense of abandon induced by the legendary ecstasy of postwar prosperity. Many

more examples in this study spotlight figures identified with freedom than with order or truth, the third category that governs the division of this book. One reason for the extended consideration of freedom is that this seductive story of the loosening of bounds has its darker side, tallied in self-destruction (the suicide of Hart Crane and the decline of the Fitzgeralds, Nancy Cunard, as well as Bix Beiderbecke and so many other jazz greats) when the consequences of the ambitious rush toward masterpieces via excess follows the pattern of incandescent genius burning out early. It is precisely the tragic shadow looming over the age that outlines the insistent pursuit of truth, the third part of this study after freedom and order and a driving force in the fiction of Hemingway, a series of unpopular paintings by Pablo Picasso, heart-rending poems by Archibald MacLeish, and the crusading journalism of Eugene Jolas. Freedom and form were enlisted in a heroic effort to counter "that old lie"[3] of the war with a new truth that the age demanded.

The chronological scope of the book is precisely defined by familiar red-letter dates. It began when World War I ended on November 11, 1918 (at the eleventh hour of the eleventh day of the eleventh month), just over a year after the October Revolution in Russia. In 1919 Fascist parties in Italy and Germany gained seats in national elections, and in February 1920 the Nazionalsozialistische Deutsche Arbeiterpartei (the National Socialist German Workers Party, better known as the Nazi Party) was named. The United States went dry when the Eighteenth Amendment to the Constitution went into effect on January 17, 1920, and Prohibition began. On August 18 of that year women gained the vote in the United States. Charles Lindbergh landed the *Spirit of St. Louis* on May 21, 1927, after a 3,600-mile flight across the Atlantic. The epoch ended on October 24, 1929, when Wall Street crashed after its historic nine-year, over-leveraged bull run. In addition to these landmarks, there are certain essential cultural dates that define the era. George Gershwin was at the piano for the debut of *Rhapsody in Blue* at Aeolian Hall in midtown New York on February 12, 1924. On April 10, 1925, *The Great Gatsby* was published. Twelve days later, when the Exposition Internationale des Arts Décoratifs et Industriels Modernes (the world's fair at which art deco became famous) opened in Paris, Le Corbusier's Pavillon de l'Esprit Nouveau introduced a bold new sense of order. The

Ballets Russes de Monte Carlo presented George Balanchine's *Apollon Musagète* on April 27, 1928, and the impresario Sergei Diaghilev died in Venice on August 19, 1929, Coco Chanel having just been at his side.

Some assembly is required when a cultural history of this era is attempted, especially if we want to slip inside the intimate circles. Why did the audience shout "Boches" at Picasso and Erik Satie during the Ballets Russes premiere of their ballet, *Parade*? How was *Ulysses* along with other Jazz Age literature banned, and how did the writers skate around the law? Why did cubism end so abruptly? How did musicians incorporate jazz into their classical compositions? The chronologies tucked into appendices of museum catalogues or textbook surveys become invaluable sources. The hidden talents of major figures are the key to building a three-dimensional portrait of the artist, just as the web of support and competition in Paris is the sine qua non of so many works from the period. This was not a romantic-style era of the individual specialist toiling in seclusion. Fitzgerald, Hemingway, and Gershwin are the leading but not the only examples of Americans who experienced a public metamorphosis under the influence of the European intellectual scene.

The expatriate invasion of Paris in the twenties had distinguished antecedents. The Americans had been coming to the city since the time of Benjamin Franklin, Thomas Paine, and Thomas Jefferson. The next century brought James Fenimore Cooper, Harriet Beecher Stowe, Margaret Fuller, Nathaniel Hawthorne, Mark Twain (grumpily), Henry Wadsworth Longfellow, and Ralph Waldo Emerson. The generation of Edith Wharton, Henry Adams, Henry James, John Singer Sargent, Theodore Dreiser, Edward Steichen, and Isadora Duncan definitively shifted the mission to the passionate quest for an artistic life abroad rather than the pursuit of trade, diplomacy, or tourism.

Then, in 1903, came the Stein family. Michael and his wife, Sarah, became major patrons of Henri Matisse, even helping him open his own studio school. Michael's younger siblings, Leo, an amateur painter and professional connoisseur, and Gertrude, who had studied psychology under William James, shared a large apartment on the Rue de Fleurus. Its walls were soon crowded salon-style with major works by Paul Gauguin, Picasso, Georges Braque, Paul Cézanne, and Matisse. Leo and Gertrude established a vibrant version of the eighteenth-century

The "Hearst portrait" of Scott and Zelda Fitzgerald appeared in May 1923, just after Scott signed an option for his stories with the magazine publisher. Zelda jokingly called this her "Elizabeth Arden face."

salon or Stéphane Mallarmé's legendary Tuesday soirées. Many of their guests, the literary lights of the next generation, arrived in uniform. Malcolm Cowley, John Dos Passos, Hemingway, Julian Green, cummings, Harry Crosby, Dashiell Hammett, and Jean Cocteau were all volunteer ambulance drivers. James Thurber was a code clerk for the US Army, while MacLeish, Gerald Murphy, and Fitzgerald all served (not necessarily seeing action). After the armistice, Sherwood Anderson and Hemingway, his gifted protégé, began their residence in Paris as early as 1921, at about the time Cole Porter settled in at the Place Vendôme. In April 1924 Fitzgerald brought Zelda from Great Neck, New York, to France to finish *The Great Gatsby*, his elegy for the passing heyday of the Gold Coast of Long Island, while carousing on the Riviera. This is the story of how that book and so many other seminal works were shaped by the expatriate intellectual experience.

The Americans were lured to France in part by the exchange rate

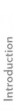

(then nineteen francs to the dollar) and the prospect of a supportive circle of friends both in Paris and on the Riviera. Murphy's sister, Esther, was one of the swinging Plaza Hotel crowd back in Manhattan. She helped many writers and artists snare the coveted invitations to the Villa America where Gerald and Sara held court in Antibes — about thirty miles east of St. Raphael, where the Fitzgeralds and Picasso stayed, and not far from the Porters' villa. Gerald spent the decade hard at work on meticulous large-scale still lifes under the watchful eye of Fernand Léger, who had a guest studio on the grounds, and Picasso, who brought his mother to the famed beach picnics at La Garoupe hosted by the Murphys. Powerful personal connections link the paintings, designs, performances, poems, plays, novels, and stories that grew from the near-daily contact young geniuses had with one other. In the twenties, most of these figures were only in their twenties, too. What has been obscured by the halo of their success is that many were audaciously trying artistic media with which they had little experience (writers and musicians were painting or collecting art, while artists were writing poetry or staging ballets) even as they ambitiously measured themselves against monumental figures such as Picasso, Joyce, Pound, Eliot, Piet Mondrian, Wassily Kandinsky, Sergei Prokofiev, and Stravinsky — all of whom were experimenting in Paris between the wars. Letters home were filled with sightings of these giants at restaurants, bookstores, and openings.

Writers in Paris could drink with impunity, but they could not escape censorship. The major case was Joyce's *Ulysses*, whose publication led to a decade-long fight against the US Comstock anti-obscenity law that finally ended in a federal appeals court in 1934 with a ruling in Joyce's favor.[4] The most effective way to curb the dissemination of the book was by enforcing postal regulations. Crane waited impatiently in the tower of his parents' home in Cleveland, Ohio, for a friend to smuggle him a copy of *Ulysses*. Many of the Joyce supporters who waged the battle ran afoul of similar forms of censorship. Dos Passos caved in to the objections of his editor at Doran to some of the bitterest passages in his postwar novel *Three Soldiers* (Dos Passos even allowed his editor to supply the transitional paragraphs where cuts were made). Hemingway, cummings, and Carl van Vechten dug in and fought timid publishers back in New York. They went to bat for one another, backing the

right of the author to use obscenities, sex, or politically volatile satire that took direct aim at the government for some of the stupid decisions made during the war. Porter's racy lyrics, including "Love for Sale," "Let's Do It," and the line about cocaine in "I Get No Kick from Champagne," came under fire from the radio stations from the moment recordings of the songs were released (by 1954, the line had been changed to "I get my perfume from Spain"). Coward fought the English lord chamberlain tooth and nail to preserve the gritty confrontation with drug abuse in *The Vortex*, his Jazz Age masterpiece with its terrifying view of the imperative of staying young to keep up with the fast crowd. "If we ban this, we shall have to ban Hamlet," Coward said to his understudy in the play, John Gielgud.[5]

The deeper I plunged into the social networks of Jazz Age Paris, the more convinced I became that an overlooked byway into a revised history of modernism had been opened up by unexpected moves made by familiar players (Picasso, Stravinsky, Stein, Joyce, Eliot, and Pound). Just after epoch-defining inventions such as cubism and stream of consciousness, they made hairpin turns toward neoclassicism or realism. In the conventional narrative, all roads led toward greater degrees of abstraction. This study argues that the form-shattering tendencies of modernist art, music, and literature were accompanied by a concomitant will to create form. The twenties witnessed not just a march toward abstraction through expressionism but also a resurgence of figural and still life painting, realism in fiction, and classical ballet on stage — led in many cases by the very artists who had pioneered abstraction (including Picasso and Stravinsky). This progressed to an abandonment of beauty itself, and form when necessary, in the pursuit of truth. Most histories of modernism emphasize the attack on form that prepared for its postmodern obliteration. This account revisits the exact conditions under which Picasso and Stravinsky departed from the movements they had started. It reassesses the place of realism, purism, long-form poetry, and a formalist theory of music that included jazz, building on the artists' own views of their historical moment. Documents reflect that they discussed these issues often enough during the era for us to track the precise moments when the relationship between the avant-garde and neoclassicism shifted.

Even the improvisational mandate of jazz itself — rupturing melody

in variations, busting the tyranny of the metronome with syncopation (playing off the beat, like the rubato used in playing Chopin)—returned from Europe tidied into scores for concerti, suites, and ballets. The experimental language challenged writers and artists who so often shared a bar tab with musicians in Montmartre, New York, Chicago, London, Berlin, or Chicago. Their literary and artistic response to jazz was immediate. What did Mondrian, Crane, Fitzgerald, and Léger listen to as they worked? Jazz was the soundtrack, holding out new compositional prospects for their own media. As his best-known painting attests, Mondrian favored boogie-woogie. Crane would induce feverish writing sprees with the repeated playing of Maurice Ravel's *Bolero* in alternation with blues sung by Bessie Smith. Fitzgerald and Gershwin are so closely identified that *Rhapsody in Blue* seems like the anthem of *The Great Gatsby*, especially on the movie screen. Hughes built prosody on the song forms of blues.

This blending of music and the arts is a reminder that the timeless diapason between collaboration and the artist working in solitude remains the real story of the era. The riotous crowd gave way to silence in which the soft sounds of brush on canvas or pen on hotel stationery or the staccato of a Royal typewriter were the only noise. On the one hand, Diaghilev would turn loose his A-list team of artists, musicians, and dancers with the motto: "We must be as free as gods."[6] On the other hand, veterans of the trenches such as Léger and Hemingway nursed an aching desire for solitary control after the experience of obeying orders on the front lines of battle. "Enough of games. We aspire to serious rigor," Le Corbusier declared in 1921.[7] Picasso told Tériade (Stratis Eleftheriades), his printmaker, "It was just at this period that we were passionately preoccupied with exactitude."[8] The austerity of Le Corbusier's monastic white villas and serene still lifes are unlikely emblems of the Jazz Age, but their place in this story is vital. Susan Ball frames the passion for order in these terms:

> On the surface the era was characterized by frivolity—the dance hall, the cocktail, the Charleston. Vichy celebrations which had begun in 1918 continued until the shock of the economic collapse at the end of the decade when people's eyes were finally opened to the imminent danger of yet another war. Intoxicated demonstrations of exultation issued from dance and

music halls. The "War to end all Wars" had been fought and won; there was cause for exultation. Yet the apparent frivolity of the Twenties masked a profound seriousness. Questions about the meaning of war, about the relationship between the individual and society, about the rationale behind war itself were avoided whenever possible. This sublimation and repression manifest themselves in the Jazz Age. Women dressed *à la garçonne* and men wearing Zouave trousers evaded the pending epiphany about their fundamentally existential existence, finding solace if not superficial meaning in frivolous fashion and furnishings, in cocktails and champagne, in jazz and the Charleston.[9]

While the twenties remains a favorite decade for glamour and revelry, its excesses have tarnished scholarly estimation of it. The reputations of Picasso and Stravinsky sagged because they spent much of the decade on neoclassical projects, such as the full-length ballets staged in some of the most elegant theaters in Paris, Rome, London, and Monte Carlo. Prominent critics sniff in disgust at this type of retro pastiche. The usual scholarly divisions stress the differences between Americans and Europeans and between formalists and expressionists, isolating art from literature and music. This is never a sound practice when minds and tastes are changing at such an accelerated pace and the boundaries among media are blurring. Some of the greatest writers, such as Hemingway and Stein, were also contemporary art insiders, just as Gershwin, Porter, cummings and Dos Passos were serious painters. Pound was writing an opera in the twenties, Le Corbusier was painting as well as designing buildings and laying out a revolutionary new magazine. Léger was making movies, and Picasso was designing sets for the theater.

What they read was a major part of what they created. Two immensely popular (and tenebrous) tomes landed with resonant thuds in the Jazz Age, becoming surprise bestsellers and garnering reverent reviews: Oswald Spengler's vatic *Decline of the West* and reissues of Thorstein Veblen's puritanical *Conspicuous Consumption*. As apposite as they could be to the blithe tales of flappers and millionaires that prevailed in the popular press, they were deeply influential additions to the libraries of such writers as Fitzgerald, Hemingway, MacLeish, Crane, and Coward. Their imprint can be discerned in the darker moments of

Hemingway's short fiction (notably "The Big, Two-Hearted River," "A Clean Well-Lighted Place," and "The Snows of Kilimanjaro") and in the sober perils of walking on the edge of the abyss in Fitzgerald's *Gatsby* or Crane's *The Bridge*. There is an aesthetic dimension to Veblen's insightful writing that may in part account for his standing among the intellectuals who convened in France during the Jazz Age, especially the circle gathered around Stein. Much as Le Corbusier's call to order and Spengler's historiographical schemata were aimed at organizing the inchoate phenomena of an epoch of accelerated change, Veblen's rebuke is built upon a widely applicable method of examining disparate materials that resembles the way a painter studies the objects for a still life or a reporter weighs material culled from various sources. He offers this set of directions:

> The ground on which a discrimination between facts is habitually made changes as the interest from which the facts are habitually viewed changes. Those features of the facts at hand are salient and substantial upon which the dominant interest of the time throws its light. Any given ground of distinction will seem insubstantial to anyone who habitually apprehends the facts in question from a different point of view and values them for a different purpose. The habit of distinguishing and classifying the various purposes and directions of activity prevails of necessity always and everywhere for it is indispensable in reading or working theory or science of life.[10]

Freedom, order, and truth offer three perspectives on a shifting target. There is no one formula for the Jazz Age aesthetic, which luxuriated in stylistic promiscuity. Like the history of art itself, which cycles through periods of tight and loose painting depending on the degree to which mimetic exactitude is valued, the period's visual taste ran the gamut from expressive and brushy curves to tightly formal linear compositions, and from figural to abstract. The orthogonal rigor and monochromatic planes of Picasso's large-scale still lifes joined the severely stripped-down geometry of Léger's mechanical nudes, Mondrian's neoplasticism and Le Corbusier's purism (both on canvas and in white concrete). These offer an angular contrast to the florid curves of the odalisques of Matisse, Amedeo Modigliani, André Derain, and Lempicka; the dense brushwork of Chaim Soutine; or the blonde arabesques of Aristide Maillol and Constantin Brancusi. While art deco

embellished surfaces with the writing exuberance of the Charleston, the international style of architecture pursued perfection in the stillness of a polished wall sealed in white Ripolin, the signature enamel coating of Le Corbusier's "machine for living."[11] The active Hemingway sentences with their weighty monosyllables and the bass ostinato of Stein are far from the fluvial poetry of the passive constructions in Proust, Joyce, Fitzgerald, Jolas, and Blaise Cendrars. In music the "bent" glissandos of jazzmen Sidney Bechet and Gershwin or the surging crescendos of Ravel, Darius Milhaud, George Antheil, and Francis Poulenc offered a lush alternative to the crystalline minimalism of Erik Satie, chamber music by Berg and Stravinsky, or Porter's miniatures. Looking ahead to the predominantly American art movements of our times, the enduring legacy of the loose and the tight gave rise to abstract expressionism and the clean lines of both pop and minimalism.

Rolling either backward or forward in history, one finds a similar alternation between a tight focus and the atmospheric dissolution of edge. It is most famous, of course, in the case of the impressionists, who succeeded such creators of immaculately photographic finishes as Jean-Auguste-Dominique Ingres, Georges-Henri Prud'homme, and William-Adolphe Bouguereau as well as the English pre-Raphaelites. In New York late in the forties, the abstract expressionists ran roughshod over the precisionists and their immaculate constructions. By contrast, Murphy, Le Corbusier, Léger, and Stuart Davis tightened painting, applying their architectural training to restore the cold, hard lines of machinery after the smoky cubist views of café tabletops. The standard art-historical track—as outlined in 1936 in a famous diagram (a shopping list, in effect) by Alfred Barr for the hanging of New York's Museum of Modern Art (MoMA)—progresses directly from the realism of the nineteenth century through the loosening of its representational grip in impressionism and postimpressionism to the destruction of the image in cubism that culminated in abstraction, either geometrical (Mondrian, Josef Albers, Frank Stella) or expressionist (Jackson Pollock, Willem de Kooning, Mark Rothko, and Barnett Newman). A few attempts to challenge this orthodoxy, including the revisionist histories of twenties and thirties art by Kenneth Silver and Kenneth Wayne and an admirable curatorial project at MoMA itself, led by Robert Storr under the alarming title "Modern Art Despite Modernism," have of-

fered reminders that the figure, landscape, and still life linger in the DNA of even the most abstract paintings. Many of the paintings considered in this study would pose a problem for museum curators who adhere to the textbook. Too realistic for the galleries where they would hang according to their dates, they are too schematic for surrealism or the Ashcan School. As in music, in painting the curveball of neoclassicism is befuddling because it breaks the wrong way at a crucial time, eluding the swing of the category maker and surprising even those on the side of the pitcher (Picasso, who invented cubism and then broke away from it).

This does not mean that the artists in this study did not play their part in the modernist progression. Their paradoxical contribution involves the way in which the bold contrast, fastidious surface, controlled color, and clean geometry are delivered. As with pop, which seemed to defy abstraction only to those who considered it easy because it was referential, the formal still lifes of Léger, Le Corbusier, Murphy, and Picasso drew ever closer to the ideal of what T. J. Clark calls "the truth in painting"[12] in a manner similar to the exploration of the monotone in music and poetry. The cold mood of reification meshed conveniently with Eliot's doctrine of the "objective correlative,"[13] a means of distancing the interior drama of the poem from the (inconveniently, in Eliot's case) underlying biographical circumstances in an "impersonal theory" of poetry: "Poetry is not a turning loose of emotion, but an escape from emotion; it is not the expression of personality, but an escape from personality."[14] The intellectual groundwork was laid for the truth — not just in writing, but in painting and music as well. In A Moveable Feast, Hemingway stated tersely: "All you have to do is write one true sentence. Write the truest sentence that you know."[15]

Clarity of vision and the strength of formal order were the desiderata in the aftermath of war. Selecting a single cover image for a dictionary of Jazz Age symbols would be difficult with so many icons at hand, from the Bugatti Royale to the crown of the Chrysler Building, the funnel of a Cunard liner, a bottle of Chanel No. 5, or a martini glass. One powerful leitmotif of the era is the lens. Le Corbusier, whose sartorial signature was an owlish pair of glasses with heavy black frames (still affected by some architects), was partial to telescopes and portholes after his first trip on an ocean liner. His architectural practice was

transformed by the acquisition of his first camera. In a letter from July 8, 1911, Le Corbusier wrote: "O the miracle of photography! Brave lens, what a precious extra eye."[16] Murphy's *Bibliothèque* features a meticulously rendered magnifying glass. No other element in Fitzgerald's fiction contends in semiotic weight with the yellow-framed spectacles surrounding T. J. Eckleburg's blue eyes, and Francis Cugat's famous cover for *The Great Gatsby* is dominated by the liquid gaze of a flapper's bedroom eyes, inside the irises of which naked figures lounge in champagne glasses. Stein's *Tender Buttons* collects a crystal and eyeglasses. Joyce's thick glasses, Diaghilev's monocle, the gun sights that Léger polished, and the field glasses he used to spot artillery targets are all ocular fixtures of the age. The most aggressive lenses are those of movie cameras, signs of a celebrity-mad era that even appear onstage in a jocund farce by the Ballets Russes. *Gatsby* was made into a movie by Famous Players–Lasky within a year of its publication, the film version of Hemingway's *A Farewell to Arms* starred Gary Cooper and Helen Hayes, and Thomas Mann's *Buddenbrooks* was a blockbuster. The snappy dialogue in Hemingway's and Fitzgerald's novels is screenplay-ready. The intersecting scenes of Dos Passos's *Manhattan Transfer* break and skip like a twenties silent picture, and recurring parodies of newsreels in *U.S.A.* are labeled "Camera Eye." Crane used jump-cut montages to speed the pace of his masterpiece, *The Bridge*. Mann found himself in tears by the end of a picture show, as he confessed to *Vanity Fair*: "It works like onions and garlic."[17]

When he encountered the films of D. W. Griffith, the technical coup Léger seized upon was the close-up, those colossal faces looming over the audience with disembodied severity. Cendrars, a friend of both Léger and Dos Passos, captured the early days of the film industry in his bizarre memoir, *Night in the Forest*: "The lens is ready to put the configuration, the constitution, the most intimate constellations of cells on display. . . . Why not capture the life of the mind in action, the chemical reactions of the brain, the silver bath of associated images, the over- or underexposure to an *idée-force* and the marvelous surfacing of that developing agent, the unconscious."[18] This chapter of Cendrars's memoir bursts from his professional experience on set watching the effect of the camera, and it sarcastically enumerates the lengths to which ambitious would-be actors would go to appear in a movie. He pinpoints the

shocking moment the objective lens catches up with the subject: "It is all so painless that, one fine day, a man bumps into himself at last and breaks down just knotting his necktie. A quick look in the mirror. What a revelation! What, is that me, that? Lights! Camera!"[19]

For another pair of lenses, consider the pilot's goggles worn by Charles Lindbergh, or the newsreel cameras trained on his every move. The journalist Waverley Root not only witnessed Lindy's arrival at Le Bourget airfield on May 21, 1927, but also secured an exclusive interview. What looked like a typical Jazz Age stunt, freedom at its most reckless, was actually testimony to the triumph of order. As Root observed:

> The press, which had started out by calling him the Flying Fool, had now shifted to Lucky Lindy. It was wrong both times, but as we watched him receive the accolades like a wide-eyed adolescent, we found it difficult to believe that he had achieved his exploit on purpose. He may have seemed helpless as he was guided through the unfamiliar political and social world, manipulated, apparently, by men more sophisticated, and more self-seeking, than himself; but in his own milieu he was complete master of his profession. His exploit was not the result of luck, it was the result of shrewd analysis of the factors making for failure or success, of unerring judgments in finding the best answers to the problems presented him, of courage in accepting the risk of applying those solutions and of minute preparation for his flight.[20]

From war to legendary parties to art driven by the passion for freedom, order, and truth, the Jazz Age was more than an interregnum. Modernism did not just leap from cubism and *Le Sacre du Printemps* to postmodernism. During the twenties a tightly connected group of writers and artists shaped aesthetics in their own surprising ways. Murphy later recalled: "There was a sort of unconscious discontent about life in America, but that wasn't all of it. Everybody who went, of the people we knew, were writing, or painting or composing, or interested in the arts, and they were young couples with children, so they all had, in a sense, settled down there. We were not tourists, not just people on a spree."[21]

PART I

FREEDOM
ANYTHING GOES

"Live it up to write it down"[1] was the systole and diastole of the Jazz Age, turning loose on the page, stage, or canvas the youthful excesses of a blissful circuit of parties without end in Montparnasse, on the Place Vendôme, or at the Côte d'Azur. The war was over, and the bubbles were endlessly rising in the champagne. At café tables dappled with spring sunshine, new arrivals fueled by espresso and Armagnac filled postcards with rapturous accounts of artistic breakthroughs that transgressed old boundaries of genres and taste. John Dos Passos marveled: "We were hardly out of uniform before we were hearing the music of Stravinsky, looking at the paintings of Picasso and Juan Gris, standing in line for opening nights of Diaghilev's Ballets Russes. *Ulysses* had just been printed by Shakespeare and Company. Performances like *Noces* and *Sacre du Printemps* or Cocteau's *Mariés de la Tour Eiffel* were giving us a fresh notion of what might go on the stage."[2] Ernest Hemingway's famous phrase was actually an aside to "a friend" that furnished the epigraph and title for his memoir: "If you are lucky enough to have lived in Paris as a young man, then wherever you go for the rest of your life, it stays with you, for Paris is a moveable feast."[3]

The alarming thrill of "dancing on dynamite" was Nancy Cunard's drug: "And Paris / Rolls up the monstrous carpet of its nights."[4] After his second day in town, Hart Crane filled a postcard from the Hôtel Jacob with a catalogue of excess: "Dinners, soirees, poets, erratic millionaires, painters, translations, lobsters, absinthe, music, promenades,

oysters, sherry, aspirin, pictures, Sapphic heiresses, editors, books, sailors, And How!"[5]

Everybody was there, breaking and remaking the rules—having been licensed by the musicians to take improvisation as the gold standard of originality. Free to be gay, straight, black, Jewish, bohemian, or aristocratic, they slipped into fluid roles that defied specialization. The greatest painters of the age (Pablo Picasso and Fernand Léger) spent as much time backstage at the ballet as in their studios, while the hottest hands in jazz (Cole Porter and George Gershwin) and writing (Dos Passos and cummings) were clutching paintbrushes. Americans brought more than the Charleston to the transatlantic avant-garde party. Syncopated expressionism danced with neoclassical formalism. The giddy mix of rebellious riffs and serious modernism is found in major works by F. Scott Fitzgerald and T. S. Eliot, Gershwin's tone poems and Igor Stravinsky's concerti, Léger's version of Charlie Chaplin's bowler and George Balanchine's Apollo. Eugene Jolas, the poet, journalist, and insider who connects so many of the figures in this book, recognized the essential "intercontinental" ingredient:

> It is difficult today to project oneself from the tenebrous era of the universe *concentrationnaire*, with its accompanying *esthétique* of epigones, to that period of felicity and effervescence in the nineteen twenties and thirties, when writers of the Anglo American literary colony in Paris competed with their French contemporaries in imagining new mental landscapes, in an atmosphere of complete intellectual liberty. We seem now to have been living in a golden age of logos. Many of us had taken refuge from the bleakness of the Volstead regime in the more friendly climate of Montparnasse and Montmartre, and we were hell-bent on discovering new continents of the mind as well. Daring experimentation with words, colors and sounds was the chief pre-occupation of an intercontinental avant-garde that extended across continents and did not pause until that day in 1929 when Wall Street "laid its historic egg."[6]

Jazz Age Paris had room enough for artists who chose an aesthetic of extreme order as well as those who needed to be, as Sergei Diaghilev decreed, "free as gods."[7] It had a special place for a wilder bunch who pushed liberty to its limits, abandoning their art to ecstasies that, when they were fortunate, exceeded anything they had ever accom-

plished back home. Malcolm Cowley claimed that Fitzgerald wrote *The Great Gatsby* well above his ability: "To satisfy his conscience he kept trying to write, not merely as well as he could, like an honest literary craftsman, but somehow better than he was able. There was more than one occasion when he actually surpassed himself—that is, when he so immersed himself in a subject that it carried him beyond his usual or natural capacities as demonstrated in the past."[8] These are the lost generation lessons in incandescent dissipation, the cautionary tales of "the beautiful and damned" (to cite the title of another work by Fitzgerald) whose talents burned out young. Dos Passos and cummings were so transported by their erotic and political passions that they flipped between fauve-style painting and exuberantly experimental writing, an alternating current of creativity with too many amps for one circuit. Gershwin offered glimpses of the potential of symphonic jazz with a rhapsody that he brazenly premiered in an unfinished state, but he died on a Los Angeles operating table at the age of thirty-eight, long before its possibilities could be realized. Crane finished his masterpiece *The Bridge* during Dionysian weekends at Crosby's château. Before it was published, Crosby shot himself and a girlfriend in a murder-suicide pact. And a few months later, Crane leaped from the stern of the ship returning him to New York and the responsibility of running the family candy company. The Jazz Age formula for projecting *joie de vivre* into art was not without its shadows.

It is called the Jazz Age for a reason. A working knowledge of the music that propelled the literature and art is vital to any cultural history of the period. The advent of ragtime, blues, and New Orleans–style jazz changed the basic elements of composition on both sides of the pond and both sides of the aisle dividing serious from popular. The scale is not the same, the rhythms are famously skewed from the comfortable quadruple and triple beats underlying classical sonatas or dance forms, and the physical fabric of the sounds is novel. Instruments invented for jazz bands were unlike the standard-issue strings, winds, brass, and especially percussion that had served composers and players perfectly well for six hundred years. The epitome of this innovation furnishes a favorite George Gershwin anecdote about the source of the street scene noises in *An American in Paris*. Gershwin shopped in the auto parts stores of the Grande Armée neighborhood for taxi

horns, squeezing the bulbs until he found just the right off-key honks and squawks. Although Gershwin's original horns have been lost by his heirs, a new critical edition of the piece suggests that the familiar tones (A, B, C, and D natural as they have been played for seventy years) may have been incorrectly inferred from a manuscript annotation, tidying the urban noise into a more conventional musical phrase. Expect to be surprised by the rougher sound of an A-flat, B-flat, a higher D, and a lower A when you hear the revised version. The ultimate note of authenticity especially in their untuned iteration, the blaring *bruit* of the hectic traffic circle at the Arc de Triomphe, was collaged into the tone poem, a mimetic coup as startling as the *trompe l'oeil* cigar box top in Gerald Murphy's *Cocktail*, Fernand Léger's blown-up illustration of a siphon lifted from a Campari newspaper advertisement, or the slogans for Ford and Edison captured by Hart Crane from billboards along the route of the Twentieth Century Limited as it sped out of New York's Grand Central Station into the US heartland.

In the musical history of the twenties, the taxi horns take their place beside the three whirling airplane propellers demanded in Darius Milhaud's score for *Création du Monde* (just big fans, which annoyed the hell out of the audience when turned toward the listeners) as well as the typewriters and blanks from a starter's pistol in Erik Satie's ballet *Parade*, the electric bells and sirens in the *Ballet Mécanique* by George Antheil (for which Léger made a film), and the Ford car horns in Frederick Converse's 1927 "Flivver Ten Million." From honky-tonk pianos slammed by forearms to the piercing soprano sax of Sidney Bechet and the mellow C melody sax of his band mate Frank Trumbauer onward to Dizzy Gillespie's bent trumpet and the electric guitar (invented by a Los Angeles jazzman in 1931), the physical culture of music was altered for and by jazz. The major aria in the most popular jazz opera ("I Got Plenty of Nuttin'" in Gershwin's *Porgy and Bess*) is accompanied by a banjo. Not even the human voice was immune to alteration, if you consider the shouting of the players in big bands such as Fletcher Henderson's and scat (supposedly invented by Louis Armstrong when the pages of his sheet music dropped to the floor during a recording session).

This sonic transformation can be experienced in a familiar way — under the fingers. Even a rank amateur can grasp the seismic shift in

music making by taking a seat at the piano, applying the right thumb to middle C, and starting to play the jazz scale. The first two notes are the same as the classical C major scale (C and D natural, both white keys), but by the third note in the jazz scale (an E-flat), the door is opened to another world of intervals, harmonies, modulations, and melodies. It all changes with the flatted third and seventh: the E and B of the major scale are diminished, slipping that telltale half-step down to the black keys known as blue notes.

Jazz on the page or in the studio and hot jazz in flux were the two poles of the music in practice. The former was an engine of business. The first major blues composer was W. C. Handy, a collector, adapter, and arranger of the postbellum folk spirituals of freedmen. His influential "Memphis Blues" (1912) and "St. Louis Blues" (1914) were best-selling sheet music scores, and they were recorded by singers including Ethel Waters, Sophie Tucker, Gilda Gray, and Ted Lewis. The first version of the Victrola was in thousands of homes by 1916, and three years later major radio stations in Detroit, Michigan (WWJ); Pittsburgh, Pennsylvania, (KDKA); and Newark, New Jersey, (WJZ) were operating. In 1926 NBC broadcast jazz programming, followed a year later by CBS. Powerhouse labels such as RCA Victor, Okeh, and Columbia were a force in the shaping of composition itself, since the timing and scoring of a piece (to ensure that the levels were balanced) were determined by the technology of the studio, the capacity of the long-playing disk, and the protocols of radio. While ragtime and the blues, its successor, originated in black culture, and the greatest singers and players were Joe "King" Oliver, Armstrong, Ma Rainey, Bessie Smith, and Florence Mills, by 1920 the trade was in the developmental hands of Tin Pan Alley and Broadway. Irving Berlin, Jerome Kern, Richard Rodgers and Lorenz Hart, George and Ira Gershwin, Hoagy Carmichael, Bing Crosby, and even Noël Coward (in "Russian Blues," 1923) took up the standard thirty-two bar form, incorporating flatted thirds and fifths in the service of melody. George Gershwin's mega-hit "Swanee" made its debut in 1919. By the beginning of the twenties jazz bands had rapidly outgrown the limited seating capacity of clubs in New Orleans and Harlem and were filling the major theaters of midtown New York and Chicago, where revues and musicals played to audiences of more than three thousand at a single performance. The all-black review *Shuffle*

Along opened on May 23, 1921, on West 63rd Street in New York in what used to be a lecture hall. Its run lasted 504 performances, thanks to star turns by Josephine Baker and Mills and hits such as "I'm Just Wild about Harry." Four years later, the show packed the huge Music Hall on the Champs-Élysées. In 1921, just a few blocks downtown from *Shuffle Along*, the Shubert brothers (Sam, Lee, and Jacob) opened the Jolson Theatre for their star Al Jolson and Fanny Brice, who introduced "My Man" in the Ziegfeld Follies. The song was translated from Mistinguett's showstopper, "Mon Homme," which she sang in New York for Florenz Ziegfeld's revue *Paris Qui Jazz* (1920), an early example of the two-way traffic between Manhattan and Paris.

Even if its defining characteristic in performance is improvisation, with box office money on the line, jazz composers could not afford to just wing it. Musicians and dancers in big bands or the vast choruses of the Follies need order as much as freedom. The composers left maps to their meanings in scores and analyses by John Hammond, Antheil, Ernest Ansermet, Paul Whiteman, Carl van Vechten, and others. The ideal hot jazz morphed so quickly that rival players would jot down riffs on their cuffs during late-night jam sessions to try out the next day. One of the cribbers was Maurice Ravel, brought by a flutist from the Chicago Symphony late one night to the Nest, a club at the famous corner of Calumet and Thirty-Fifth on the city's South Side, where jam sessions attracted competing virtuosi such as Oliver, Armstrong, Benny Goodman and Earl "Fatha" Hines. Amazed by the clarinet choruses of Jimmie Noone, he tried in vain to write down the runs. "Impossible!" Ravel said under his breath, before giving up to just listen.[9]

Steeped in imported jazz, exotic regional sounds, and avant-garde experimental music, the musical history of Paris from 1913 through 1929 was as vibrant as that of Vienna and Berlin, which belonged to Arnold Schoenberg, Alban Berg, and Anton Webern, the dour trio who stole more than their share of the modernist story. Ravel, Igor Stravinsky, and Milhaud traveled to New Orleans, Chicago, and Harlem to hear for themselves, puzzled and inspired by the liberating syncopation as well as the first major alteration of the scale since the introduction of equal temperament halfway through the 1700s. The watershed date for the jazz invasion of France is pinpointed as New Year's Day 1918, when the two thousand infantrymen of the all-black (except officers) Fifteenth

New York Regiment of the US National Guard (nicknamed the Harlem Hellfighters in honor of the action they had seen at the Marne and the Argonne) marched down the gangplank at Brest behind their famous band under the direction of Lieutenant James Reese Europe, the popular society dance bandleader who had introduced the fox-trot. They swung the "Marseillaise" in march time, and the soldiers danced their way along the streets. It took eight or ten bars for the onlookers to figure out the melody, but when they did they saluted and promptly went wild. The band played the Nantes opera house on Lincoln's birthday and then gave a massive outdoor concert before a crowd of 50,000, together with the Grenadier Guards, the Garde Républicaine, and the Royal Italian Band. The European band members were so baffled by the Hellfighters' sound that they asked to examine the instruments.

Jazz quickly invaded the rest of Europe. The Old Dixieland Jazz Band and Southern Syncopated Orchestra were the toast of London in June 1919, sharing a five-month run at the Royal Philharmonic Hall. Mabel Mercer, Hines, Duke Ellington, Mills, and Ada "Bricktop" Smith committed themselves to extended tours that often led to years of expatriate life. One of the first major talents to arrive in Paris was Sidney Bechet, the twenty-two-year-old star of the Southern Syncopated Orchestra. Born in New Orleans in 1897, he followed the jazz diaspora to Chicago and eventually New York before becoming the first black American marquee name in London and Paris. Nancy Cunard declared he was "as attractive as a panther, and rather like one — young with a beautiful, light-brown skin, rippling blue-black hair. He had innate courtesy and beautiful clothes."[10] Ansermet was a young conductor on tour with the Ballets Russes in London when, in 1919, he first heard the orchestra, led by the short-tempered and ambitious Will Marion Cook. Ansermet wrote a major essay comparing Bechet's "perfectly formed" solos to Bach:

Their form is gripping, abrupt, harsh, with a brusque and pitiless ending like that of Bach's Second Brandenburg Concerto. I wish to set down the name of this artist of genius; as for myself, I shall never forget it — it is Sidney Bechet. When one has tried so often to find in the past one of those figures to whom we owe the creation of our art as we know it today — those men of the 17th and 18th centuries, for example, who wrote the expressive

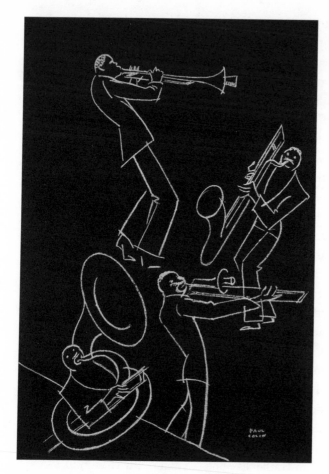

Sidney Bechet was featured in Paul Colin's portfolio of lithographs, *Le Tumulte Noir* (1929). It also included portraits of Josephine Baker, for whom Colin had been making poster designs since her arrival in Paris in 1925.

works of dance airs which cleared the way for Haydn and Mozart — what a moving thing it is to meet this black, fat boy with white teeth and narrow forehead, who is very glad one likes what he does, but can say nothing of his art, except that he follows his "own way" — and then one considers that perhaps his "own way" is the highway along which the whole world will sing tomorrow.[11]

There was a linguistic and cultural fit between Creole musicians such as Bechet and the French musical community. The teachers of many first-generation ragtime and jazz players had studied clarinet and oboe in Paris and played in the orchestra of the French Opera in New Orleans (which burned down in 1919). Achille Bacquet, for example, taught Bechet the soulful sound he then introduced to Paris.[12]

When Bechet recorded with Jelly Roll Morton (born Ferdinand Joseph La Menthe, another New Orleans Creole) and his Red Hot Peppers and with Armstrong and the Clarence Williams Blue Five, he used the piercing soprano sax, a spectacularly loud, straight version of the usually curved alto or baritone instrument. It made the decibel needle jump so much recording engineers greeted his arrival in the studio with, "Here comes trouble itself."[13]

When Baker quit the Revue Nègre in 1925, she and Bechet set off on a tour that included Brussels, Berlin, Athens, Istanbul, Cairo, Oslo, Madrid, Prague, and Rome, picking up local players (and ideas) along the way even as they spread the gospel of their music. They pioneered a hybrid of gutbucket blues, up-tempo dance music, and serious symphonic compositions, more adventurous than what the clubs of New York were presenting. The American instrumental giants of the age who connected with Europe were Bechet, his rival and sometime collaborator Armstrong, and the cornetist Bix Beiderbecke. Fans today can pose for photographs at the corner of Rue Bechet and Rue Armstrong in Noisy-le-Roi, France. Although Armstrong did not make his first European tour until 1931, his recordings were already in circulation there when he arrived. Beiderbecke died at age twenty-eight, after a recording career that lasted less than seven years. His fascination with modern French music became a part of his legacy. Armstrong once admitted, after listening to a Whiteman concert, that his "pretty notes go all through me."[14] When Beiderbecke's solos begin, the legato has the distinctive, pure accuracy that is also one basic characteristic of the tight edges of a Léger painting, the clean silhouette of a Le Corbusier building, or the crisp declarative sentences of Ernest Hemingway. The secret is clarity. Beiderbecke's musical tastes ran from the blues of Smith to compositions by Richard Wagner, Claude Debussy, Ravel, Schoenberg, Stravinsky, and Gustav Holst. Beiderbecke was the first to use whole-tone harmonies and the augmented scale, as well as altering the melodic line, which he played without vibrato, with ninths (another Debussy hallmark), elevenths, and thirteenths and with scales substituted for arpeggios.[15] On a New England tour with the Jean Goldkette Orchestra, Beiderbecke spent his downtime at a boarding house piano picking out the leitmotivs of Debussy and Ravel that he intended to build into his own atmospheric compositions, such as "In a Mist."

Asked by the adoring eighteen-year-old local cornet player, Max Kaminsky, whose job was driving him to the performances, why he would bother with classical European music, Beiderbecke said, "What's the difference? Music doesn't have to be the sort of thing that's put into brackets."[16]

When the stunning dissonances of jazz met the French style exemplified by the piano pieces of Debussy and Satie and the orchestral writing of the Russians, led by Stravinsky and Sergei Prokofiev (both in Paris in the twenties), the result was a bold new chromaticism different from the pan-tonality of the Viennese serialists. The distinguished jazz historian and trumpeter Richard Sudhalter pinpoints the connection in a tribute to the way Beiderbecke mastered an understated "correlated" phrasing played on the beat (most black musicians played off the beat):

> Its orientation, in common with those of Bechet and Armstrong, is melodic: recasting and de facto recomposition of a given melodic line through embellishment, vocalization, rearrangement and redistribution of phrase.... Such complexity was of course an innate feature of European formal music, in composers as diverse as Beethoven, Brahms, Wagner, and Schumann, and in such twentieth-century "moderns" as Stravinsky, Bartók, and Hindemith. The French Impressionists, for whom Beiderbecke evinced a special fondness, dealt in suggestion, in emotion implied as well as expressed. Painters explored responses suggested by the play of light on a subject rather than the subject itself. The poets Rimbaud, Verlaine, and Mallarmé used sounds of words to capture impressions and evoke feeling.[17]

Intellectuals at the intersection of jazz and classical music such as Nadia Boulanger, the virtuoso pianist and composer Federico Busoni, and Ansermet deflected the advanced musical thinking in unexpected directions. One of the oddest entrants on the scene was Ezra Pound, who arrived in Paris in early April 1921 not just to establish a beachhead for a new literary movement (he brought imagism from London, led the fight to publish James Joyce's *Ulysses*, and was finishing his own first thirty *Cantos*) but to compose and commission music as experimental as the writing and art with which he was surrounded. His pet term for the type of high-energy, interdisciplinary hub for cutting-edge creativity was "vortex." In a two-room apartment with a balcony in the

Hôtel du Pas-de-Calais, at 59 Rue des Saints-Pères, Pound set up the headquarters for a music and art laboratory where the members of his intellectual aristocracy convened, including Constantin Brancusi, Antheil, Jean Cocteau, Léger (who furnished material on trench warfare for *Canto 16*), Blaise Cendrars, e. e. cummings, Hemingway, Satie, Francis Poulenc, Milhaud, William Carlos Williams, and Wyndham Lewis. Another member, Olga Rudge, was a violinist who would soon become Pound's mistress and have his daughter, Mary. She took her turn along with Pound's wife, Dorothy, who gave birth to her son, Omar, in a Paris hospital (with Hemingway at her side). Cunard was in and out of the picture, luring Pound to hike the Provençal hills or spend drunken weekends in Rome and Sirmione. Under the siren's influence, he gave up Paris for the sunny Mediterranean.

Pound was indeed busy on many fronts during the Left Bank years, line-editing Joyce's *Ulysses*, T. S. Eliot's *The Waste Land*, William Butler Yeats's plays, and Hemingway's stories and curating exhibitions for Henri Gaudier-Brzeska, Brancusi, and Francis Picabia. Yet music preoccupied him starting in April 1921, when he composed *Le Testament*, a dark and jagged opera, part early Renaissance pastiche and part cutting-edge modern tone poem, based on the life and poetry of François Villon. It takes its place alongside *Parade, Within the Quota, Création du Monde,* and *Blue Monday* in the catalogue of neglected yet major stage works of the period. Pound's biographer David Moody bluntly states that despite a June 29, 1926, performance at the Salle Pleyel, no musicians of the time were capable of handling the demands of the score.[18] Both *Le Testament* and the *Cantos* rely on fragments, including the "fractional metrics" of *Le Testament* and the "micro-rhythms"[19] (these are Pound's terms) that made irregular measures during which the vocal line would be supported first by one group of instruments (flute, oboe, bassoon, and horn) and then, in a rapid shift, by another (cello and contrabass) in an effort to make the music serve the words. Pound had a fascinating idea about the wave action of a bass tone that created time intervals based on the duration of a note. Rhythm was based on pitch (the vibratory frequency of undertones and overtones).

One of the first professional musicians to understand this theory was Antheil, who was born in Trenton, New Jersey. He arrived in Paris in 1923 after a concert tour that offended much of Germany with its

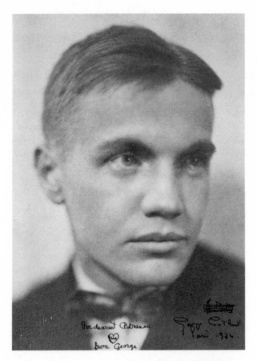

George Antheil lived in an apartment over the Shakespeare and Company bookstore. The sixteen player pianos required for his *Ballet Mécanique* made it, in his words, "the first piece of music that has been composed *out of* and *for* machines *on earth*."

dadaist antics. A former student (with Ansermet) of Ernest Bloch, Antheil titled his autobiography *Bad Boy of Music*.[20] He spent the twenties terrorizing European audiences as a wildly exuberant performer, renegade, agitator, and troublemaker. He composed not just the well-known *Ballet Mécanique* but also symphonies (including *Zingreska*, in 1921), string quartets, a piano concerto, violin and piano sonatas, the incidental music to a Cocteau production of *Oedipus* and ballets (including *Fighting the Waves*, in 1929). Pound ushered Antheil into the notorious salon of Natalie Barney, where the pianist's "tough guy" demeanor led a delighted Satie to bestow on him the nickname of "the Cagney of music."[21]

In the fall of 1923, Pound and Antheil were collaborating with Léger, Man Ray and Dudley Murphy on the "vorticist film-experiment"[22] *Ballet Mécanique*. They were also writing critical appreciations of one another's work. A glowing article (titled "Why a Poet Quit the Muses") by Antheil about Pound's music appeared in the Paris edition of the *Chicago Tribune* on September 14, 1924. Antheil dismissed the contention that Les Six (a group of French composers discussed below) were

postromantic, post-Debussy composers, placing Pound at the forefront of a "real music" that redefined conventions of tempo and pitch. His reference to the "glass of clear water" directly echoes Amédée Ozenfant as well as Pound's insistence on "clear prose" after the muddiness of Romanticism: "I assure you that the present period in fashionable Paris' excitement over the fashionable Six . . . and the rest of Satie and Co. is quite the height of 'Romanticism.' I offer you a glass of clear water in its stead, the consideration of this: the age of two dimensional music has passed forever. . . . With a simple gesture Pound gives us a real music."[23] Pound published "Antheil and the Treatise on Harmony," which music historians have favorably compared with similar works by Schoenberg and Heinrich Schenker. One of the crucial principles is the "open" system of consonance and dissonance: "A SOUND OF ANY PITCH, or ANY COMBINATION OF SUCH SOUNDS, MAY BE FOLLOWED BY A SOUND OF ANY OTHER PITCH, OR ANY OTHER COMBINATION OF SUCH SOUNDS, providing the time interval between them is properly gauged; and this is true for ANY SERIES OF SOUNDS, CHORDS OR ARPEGGIOS."[24] On July 7, Antheil and Rudge presented a private concert of American music at the Salle Pleyel that included Pound's *Fiddle Music* and Antheil's *Second Sonata for Violin and Piano*. Joyce, Hemingway, Sylvia Beach, and many other expatriate writers were there and afterward headed straight to the Dome café where they needed wine and cognac to soothe their nerves, after the beating taken by the piano under Antheil's "hammer-blows."[25]

Pound's cohorts were always keenly aware of their place in modernist history as it was being made. The connections among them produced results. In 1926, when Cunard started compiling her anthology *Negro*, she astutely chose Antheil to write the musicological chapter. His substantive essay on the pervasive alteration in "post Wagner" Paris brought about by jazz and African rhythms is valuable not just for its scholarly attention to the "method of Negro music" but as an insider's account of what the American invasion looked like from the perspective of a "serious" composer on the front lines. He divides the history of modern music in Paris into two phases: the first forty years, dominated by the Russians; and the current era, after the first jazz heard in Paris in 1918, which owed its freshest inventions to the American import. He reels off an impressive catalogue of artists touched by African sources,

from Pablo Picasso through Amedeo Modigliani, Brancusi, and Giorgio de Chirico. He points out the resemblance between Le Corbusier's white cube houses and North African desert architecture. He combines references to Alexander Pushkin, "the black Byron," and Louis Moreau Gottschalk, the first American composer to enjoy a reputation in Europe and a "mulatto." He chronicles the shock of black music in humorous terms: "Frightened at the gigantic black apparition, each European people scurried hurriedly towards their own racial music; the Latins became more Latin, and the Germans more German (and the Britons and white Americans of that time, having mixed French impressionism with Russian and German avant-gardism, became absolutely incomprehensible)."[26] Antheil proceeds through a litany of stereotypes (think rhythm) to a more technical definition that drills down into the sound:

> In general one might say that the African "sound" in music is usually a tightening-up of the musical force, an intensive concentration and compactness, and thinning-out of line, and brilliant and sudden rhythmical decisions more daring than those of any other people or race, a marked tendency towards the "black" on the pianoforte, and the inevitable eightnote on the strong beats throwing into an immediate quarter-note following, the latter with an accent (almost the Negro signature, for go where one will in Negro music, these two notes occur like the signature of Alexander the Great in the ancient world).[27]

New sounds demand a high level of musicianship. Like the École des Beaux-Arts, the Paris Conservatoire—under the direction of Gabriel Fauré at the beginning of the Jazz Age—was the base of classical training in Paris. Teachers who started at the Conservatoire, including Vincent d'Indy, created their own academies. D'Indy started the Schola Cantorum, housed in a Benedictine abbey, for the study of early Renaissance music from the time of Giovanni Palestrina. One of d'Indy's pupils in counterpoint and harmony was Cole Porter. The greatest lessons in modern composition were offered each Wednesday afternoon on the Rue Ballou, where "Mademoiselle"—the incomparable Boulanger—passed on the secrets of her teacher Fauré to generations of major minds. She started training with Bach's *Well-Tempered Clavier* and Gregorian plainchant. Three of the top American conservatories

were founded in the era (Eastman in 1921, Juilliard in 1923, and Curtis in 1924). The League of Composers was formed in New York in 1923, with the financial support of Addie Wolff Kahn, for concerts, publishing and recording deals, and resources, and it was a lifeline for Stravinsky, Schoenberg, Aaron Copland, Virgil Thomson, Walter Piston, and so many others. The League published *Modern Music,* the first musicological journal devoted to avant-garde composition, from February 1924 until its demise in 1946. Orchestras, operas, and ballet companies rebounded from wartime attrition to reach heights that are still the envy of the same companies, which struggle today with diminished attendance, greedy unions, and inept yet overpaid management. It was a golden age of modern opera and ballet. Although Stravinsky, Prokofiev, and Richard Strauss often conducted their own scores, Diaghilev maintained a lineup of conductors steeped in contemporary sounds. Pierre Monteux and Ansermet (the Pierre Boulez of his time) were called on to conduct works by Stravinsky, Satie, and Debussy. In London, Thomas Beecham, known for his Strauss readings, conducted his own arrangement of Handel's music. Roger Désormière was the chief interpreter of Les Six, including Satie and Georges Auric, and conducted Nicolas Nabokov's *Ode.* They competed for the Paris, Berlin, Vienna, and New York podiums with such titans as Carlos Kleiber, Otto Klemperer, Bruno Walter, and Wilhelm Furtwängler. Major orchestras, conductors, and opera and ballet companies risked new commissions with gusto. Klemperer in Berlin premiered Stravinsky's *Oedipus Rex,* Paul Hindemith's *Cardillac,* and Schoenberg's *Glückliche Hände.*

The dilemma for musicians straddling jazz and classical music was authenticity. Can a conservatory-trained musician convincingly swing? Can a jazzman write a ballet or concerto? If jazz was the brash, disruptive freshman on campus, neoclassicism was the dignified professor emeritus. Picasso returned to the upright style (literally, the posture straightens) of Jean-Auguste-Dominique Ingres for his portraits of his wife, Olga, and of Sara Murphy; Joyce invoked Homer; Crane alluded to Faust; Stravinsky and Prokofiev revisited the eighteenth-century Viennese and French sources of classicism; and George Balanchine and Leonid Massine retrieved their ballet steps from August Bournonville and the Mariinsky Theatre in the service of an audience as appreciative of balance and calm as they were of the off-kilter gyrations of such

flappers as Anita Page and Baker. In *Le Train Bleu,* a tennis champion and a golfer alternate via glissade between their base-line or first-tee swings and the arabesques and entrechats of the *danse d'école.* Serge Lifar and Massine were as expert at slipping in and out of the fox-trot or Charleston as the dancers were at changing from tutus to Chanel tennis outfits and bathing costumes. When it worked, the hybrid was spectacularly original and timeless. Some encounters were less fluid than others. There was, for example, the comical struggle to be cool that beset Hindemith when he tried jazz: "Basically an academic, he reacted dutifully and industriously to the prevailing cynical and satirical atmosphere of the 1920s, which he mirrored with Teutonic thoroughness. At this stage his music had the exuberance of youth, though it could not be said to have had its charm."[28] One of several superb essays in Cunard's anthology on the delicate issue of the assimilation of black culture, John Banting's piece on the "Dancing of Harlem" takes a swipe at the Ballets Russes: "It has been brazenly enough and, of course with much inaccuracy, representing it as an entirely 'night-life' quarter. . . . Fortunately it also escaped Diaghileff [*sic*] and chi-chi."[29] Die-hard adherents took exception to the efforts by Whiteman or Jack Hylton to "make a lady out of jazz."[30] Another essay in Cunard's book is "Hot Jazz," by the French critic Robert Goffin (translated by Samuel Beckett), who singles out Armstrong, Hines, and Coleman Hawkins as the true practitioners of hot jazz. The trouble with Whiteman is that he

industrialized jazz to such an extent that nothing remained but a weak dilution devoid of all real musical character. Melodic jazz has contributed nothing to music and will only be remembered for its unspeakable insipidness; whereas hot jazz is a creative principle which can scarcely fail to affect the music of the future in the most original and unexpected directions. Hot jazz has already exploded the automatism of musical composition as practiced before the war, when the composer wrote a melody, or a score, on the understanding that its realization should only vary in accordance with the interpretative ability of successive executants, who generally showed but little initiative in their reading of the work and could only express their own personality in their treatment of detail. It is obvious that the music of Beethoven and Debussy is played to-day exactly as it was when composed, and as it still will be a century hence. The most extraordinary achievement of

hot jazz has been the dissociation of interpretation from the "stenographical" execution of the work, resulting in a finished musical creation which is as much the work of the performer as of the composer. . . . The task of the performer is to realize, in whatever terms he sees fit, the possibilities of syncopation latent in the generally simple theme written by the composer.[31]

While the landmark debut of Gershwin's *Rhapsody in Blue* at Aeolian Hall in New York on February 12, 1924, remains the most famous swing-meets-serious concert of the Jazz Age, it was by no means the only moment of its kind. The symphonic appropriation of jazz led to major works, including John Alden Carpenter's early opera *Krazy Kat* (1922) and his ballet for Diaghilev, *Skyscrapers* (1925); Antheil's *Jazz Symphony* (1925); Robert Russell Bennet's *Charleston Rhapsody* (1926); and Copland's piano concerto, with its Charleston movement (1923). The catalogue of works that entered the permanent repertoire also includes Gershwin's *Porgy and Bess* (1935), *Four Saints* (1934) by Thomson and Gertrude Stein, Ellington's *Black and Tan Fantasy* (1929), Manuel de Falla's *Retablo* (1923), Arthur Honegger's *Amphion* (1929), and Kurt Weill's *Threepenny Opera* (1928) and *The Rise and Fall of the City of Mahagonny* (1930). An instant success was scored by Ernst Krenek's satire of the age, *Jonny Spielt Auf* (1929), a darkly amusing *Zeitoper* starring a black guitarist and a violin virtuoso as well as an impresario or manager. The jazz ballet and *Zeitoper* were neither exclusively American nor European but a dynamic coalition that reflected many transatlantic crossings. The most convincing serious creators were a new breed of theater pro, equally comfortable in high or low culture, backstage on Broadway or at the Opéra Garnier, and hitting Harlem clubs around midnight or the Salle Pleyel for Sunday afternoon recitals.

Never underplay, incidentally, the value of the arranger. The wily go-to group included Leopold Stokowski, Walter Damrosch, Percy Grainger, Ellington, and Don Redman (who played every instrument in Fletcher Henderson's orchestra). Whiteman's secret weapon was Ferde Grofé, better known as the composer of the *Grand Canyon Suite*. Like Whiteman, whom he met playing in John Tait's Café Band, Grofé was the son of a musician (a violist in the Los Angeles Philharmonic). During the five-week crunch leading to the debut of Gershwin's *Rhapsody*, he was the unsung hero in the back room of the apartment at

110th Street and Amsterdam Avenue. At an upright piano while "drinking Momma's delicious Russian tea,"[32] he and George and Ira Gershwin banged together the part scores just in time for Whiteman to give the downbeat that historic night. Tin Pan Alley graduates such as Irving Berlin, Victor Herbert, Kern, Richard Rodgers, Oscar Hammerstein, and of course Porter and George Gershwin reconceived the assignment of melodic lines, choral harmonies, and rhythmic figures. The accentuation of new instruments in the pit offered ways to rethink the black-and-white score in colors and with a magnitude of decibels that matched the most raucous massed forces of the megachoruses and Wagnerian orchestras in the Victorian era. Syncopation was an invitation to alter the stock or publisher's standard version of melody and chords. Big band leaders such as Whiteman (whose orchestra on the day the *Rhapsody* debuted numbered twenty-three) would work from trick arrangements made at the publisher's expense, taking the trumpet-clarinet-trombone combo of New Orleans or Kansas City and blowing it up into four-man sections, joining a four-man rhythm section for that ample, big-band sound. Gershwin's research in Paris, Porter's training at the Schola Cantorum, and the better part of Stravinsky's early tutelage under Modest Mussorgsky focused on orchestration. These tunesmiths, for whom melody was the natural idiom, focused their studies on expanding the vocabulary of their big-band sound, a challenge as important as the structural issues posed by counterpoint or the circle of fifths.

When jazz hit, the musicians of Paris were still digesting the unconventional harmonies of Debussy, like Franz Liszt an intrepid explorer of the piano's wilder shores — including the upper overtones and primary chords built on the ninth (one whole tone beyond an octave). The magical score for Debussy's only opera, *Pelléas et Mélisande*, became the vade mecum of advanced composition students under the guidance of Boulanger, while his revolutionary piano work *La Cathédrale Engloutie* (The sunken cathedral) was the virtuoso showpiece that epitomized the lush French sound. Add to this mixture the distinctive minor tonalities and buzzing operatic consonants of the Slavic composers, the bizarre chromaticism of glissandos, and the completely skewed rhythmic shift of syncopation, and you can see how the toolbox of the composers living in Paris during the twenties expanded.

ENTER THE BALLETS RUSSES

The other side of the modernist coin was the formidable network of Les Six and the Ballets Russes, who dominated the concert and ballet world, shamelessly lifting ideas from jazz. The central figure in the group of French composers was Satie, but he is not counted in the six: Georges Auric, Louis Durey, Honegger, Darius Milhaud, Poulenc, and Germaine Tailleferre. The prospect of landing one of Diaghilev's storied commissions (he was, after all, the genius behind the scandal of *Le Sacre du Printemps* in 1913, still the benchmark for theater riots) also attracted a brilliant group of Slavic composers, notably Stravinsky, Krenek, Prokofiev, Nicolas Nabokov (first cousin of the novelist Vladimir), and Dmitri Shostakovich—all of whom, like the Americans, were thrilled to find themselves suddenly fashionable. Jazz, the professional Russian sound, and Latin dances such as the tango (which reached its height of popularity in the twenties), were exotic commodities in what the historian Carol Oja calls the burgeoning "marketplace for Modernism."[1] A more glamorous measure of their popularity than numbers of records sold or amount radio air time their music received was the fabulous offer of a private concert or ballet mounted by aristocratic patrons such as the Countess de Noailles, the Princess Polignac (Winaretta Singer, heiress to the sewing machine fortune), the Count and Countess de Beaumont, the Clermont-Tonnerres, and Porter—whose Venetian Palazzo Rezzonico was the setting for a spectacular red-and-white ball in the summer of 1924. As the modern music historian Alex Ross noted in *The Rest Is Noise*:

> Paris in the twenties displayed a contradiction. On the one hand, it embraced all the fads of the roaring decade—music hall, American jazz, sport and leisure culture, machine noises, technologies of gramophone and radio, musical corollaries to Cubism, Futurism, Dadaism, Simultaneism and Surrealism. Yet beneath the ultramodern surface a nineteenth-century

support structure for artistic activity persisted. Composers still made their names in Paris salons, which survived the general postwar decline of European aristocracy, partly because so many wealthy old families had succeeded in marrying new money.[2]

Swanky soirées in Right Bank mansions and the stately châteaux in the hills of Monte Carlo hardly seem the occasions for revolutionary aesthetics, but private patronage is often the most auspicious guarantee of avant-garde freedom. Diaghilev, who had grown up with his family's house concerts featuring the world's preeminent soloists, cultivated the largesse of nobility who enjoyed the prospect of shaking up propriety. Sex helps. Ida Rubenstein in the role of Cleopatra, like Isadora Duncan, was unafraid to reveal legs and breasts at the Count de Beaumont's salon. Nijinsky was the first gay icon of the ballet stage. The costumes of the Ballets Russes redefined not just dance wear but fashion, partly through the up-to-the-minute look that Coco Chanel brought to the stage, but more dangerously with the introduction of the leotard for both men (in *L'Après-midi d'un faune*, the scandal of 1912) and women (the underdeveloped fourteen-year-old Alicia Markova wore a white unitard decorated by Henri Matisse in 1925 in the Paris performance of *Le Chant du Rossignol*, which had to be covered by a chiffon tunic and pants for London audiences). The first time the female corps was dressed only in leotards and tights was the opening of *Ode* in 1928, with costumes by the painter Pavel Tchelitchew. As the prima ballerina Alexandra Dionisevna Danilova recalled, "I think back on the leotards Tchelitchew gave us for *Ode* and laugh when I remember how naked we felt — so naked that we wore our dressing gowns over our costumes until the moment before the curtain went up."[3] Although still in toe shoes, the dancers were the conspicuous bearers of a message of liberation. They were abruptly invited to move off the beat, like the conservatory-trained musicians playing syncopated scores. Music and movement were sometimes at odds, an idea that has become part of modern dance, particularly in the work of Merce Cunningham, Twyla Tharp, and Pina Bausch. Set designs in the hands of Picasso, Braque, Matisse, and de Chirico veered into bold experiments in form and color that brought optical havoc to the traditional architecture of the romantic ballet stage (the perspectival view through woods or castle grounds to a distant horizon).

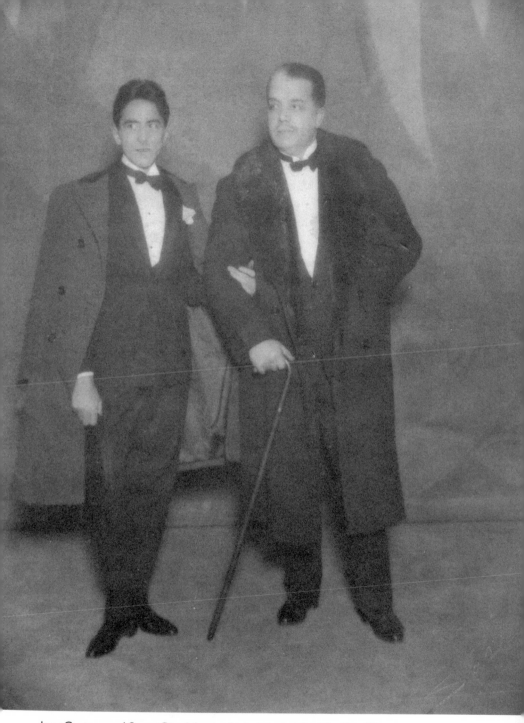

Jean Cocteau and Sergei Diaghilev on the opening night of *Le Train Bleu* in June 1924. Cocteau had written the libretto for the ballet, as he had for *Parade* seven years earlier.

Before he left Russia, Diaghilev had been founder and editor in chief of an important journal, *Mir iskusstva* (World of art). He was only twenty-six when he published a four-part manifesto under the title "Complicated Questions"—the first part of which, "Our Supposed Decline," addressed a sore point among Russians not just in 1898 (anticipating Oswald Spengler's *Decline of the West*). Diaghilev's prerevolutionary essay asserts: "There is nothing for us to decline from."[4] Lenin's New Economic Policy (NEP) of 1920 would create a louche class of "NEPmen" and flapper-style "NEPwomen" notorious for their drugged-out, drunken debauchery. Ever alert to the era's obsessively competitive question of what makes the "greatest generation," Diaghilev was disappointed in "pseudoclassicism," realism, symbolism, and romanticism: "We must be free as gods in order to become worthy of tasting this fruit of the tree of life. We must seek in beauty a great justification for our humanity, and in personality the highest manifestation of beauty."[5]

When the family fortune was lost in 1906, he headed to Paris, leveraging a scant two years' experience as an artistic advisor at the Mariinsky Theatre to become an impresario and international freelance art curator, organizing the Russian section of the Salon d'Automne in 1906, presenting concerts of Russian music in 1907, and in 1908 producing the Mussorgsky version of *Boris*, starring the great bass Fyodor Chaliapin (whom he had once accompanied in a recital). Successful seasons of opera and ballet starring the Mariinsky dancers and singers led to his formation of the Ballets Russes in 1909. It was based in Rome during World War I and then in Monte Carlo and Paris. The avant-garde repertoire was saved for Paris, the more traditional and lighter fare for Monte Carlo and tours to London, Rome, San Sebastián in Spain, and eventually North America. At the time of Diaghilev's untimely death in Venice in 1929, the Ballets Russes had had premieres in Paris, Monte Carlo, Berlin, London, New York, and San Sebastián but had never performed in Russia.

The most important date in the history of the company—arguably, in the history of modernism—is May 29, 1913, when an audience riot nearly halted the debut of *Le Sacre du Printemps* at the Théâtre des Champs-Élysées. A sophisticated public nursed on Diaghilev's edgy taste (including *Firebird*, *Daphnis et Chloé*, and *Narcisse*) was flummoxed by the strange and savage *Sacre*. The primitive scenario had

originated back in St. Petersburg, with Nicholas Roerich's suggestion for a ballet using the great sacrifice. The movement in the ballet was partly based on the rhythmic gymnastics of Émile Jaques-Dalcroze, who worked directly with Marie Rambert, Nijinsky's assistant. Stravinsky's pounding, irregular beat (a different tempo for each measure at one point) and spiky dissonances (cellos and horns biting into the timpani's base rhythm in deafening tutti) were too raw even for ears accustomed to his earlier work or the ballet scores of Prokofiev. Robert Craft, Stravinsky's amanuensis, revealed in the 1980s the secret relationship between the music and the choreography by examining the composer's penciled dance accents which go against the printed orchestral accents: "The music imitates the dancers' jump, and a *hoquetus* is set in motion between them."[6] Nijinsky's frenetic, barely controlled leaps abruptly ceded the stage to the flat-footed, ultra-fast stomping of the corps, their fists balled and wrists crossed like bound prizefighters. While audience partisans shouted insults that interrupted the quiet passage before the rush to the coda, the virgin's head drooped to her right shoulder and her arms hung limply at her sides. The circling corps hopped around her in a cross between a Dionysian revel and a war dance, Eros and Thanatos conjoined. Then she jumped and bowed herself to death in a convulsive climax. The curtain was greeted by stunned silence followed by a battle of boos and bravos. For decades after, members of the smart set, including Stein, claimed to have been there even if they had not been. The Ballets Russes performed the work only seven more times (four more performances had been scheduled in Paris, none of which turned out to be as exciting as the opening night, and three in London) before dropping it from the repertoire. When Le Corbusier completed Sarah Stein's villa in the summer of 1928, his décor included not just paintings by Matisse but a player piano that looped on a transcription of *Le Sacre du Printemps.*

Unlike the American expatriates in Paris, the Russians in the city were exiles, some of them recently acquainted with what it was like literally to be a starving artist. The highlight of a tour of St. Petersburg dancers heading to Berlin in 1924, when Georgy Melitonovich Balanchivadze (soon to be renamed George Balanchine, at Diaghilev's insistence) escaped from Russia, was the memorable buffet the first night on board the ship. Stravinsky, son of a famous opera singer from St. Petersburg,

left Russia for good when he was thirty. The multitalented dream team assembled by Diaghilev also included Natalia Goncharova and Mikhail Larionov, a husband-and-wife duo of cubo-futurists who arrived in Paris in 1914. They turned loose a bold palette of golds and reds that replaced the elegant art deco and art nouveau idiom of Léon Bakst and Alexandre Benois, whose pastel palette and swooping lines were the hallmark of their sets and costumes for the company until 1915.

The program of enlisting the major stars of the avant-garde took another stride forward in 1917 when Picasso agreed to be the cocreator of *Parade*, a one-act *ballet réaliste* based on a story by Cocteau set to a jazz-inflected score by Satie. Only twenty-six at the time, Cocteau had been part of Diaghilev's company since 1909. He hatched the plan for the new ballet with Satie at a soirée in Paris on October 18, 1915, hosted by Valentine Gross. A week later, Cocteau dropped a stack of rough ideas for the ballet at the composer's door. After a few weeks, Satie chose the sketch for the "parade" of a hapless carnival act trying to drum up an audience at the entrance to their booth. Cocteau had been unsuccessfully angling for years to have his portrait painted, or at least drawn, by Picasso. He showed up at the door of Picasso's studio on the Rue Schoelcher with an introduction from the composer Edgar Varèse and wearing a harlequin costume under his tunic. Picasso did not invite him to model but somehow kept the costume. After the death of Eva Gouel in December, Picasso did paint a darkly introspective *Harlequin*, but art historians are divided between calling it a portrait of Cocteau and a disguised self-portrait. Cocteau had infected Picasso with the "red and gold disease" (love of the theater) that was made all the more feverish by the encouragement of Gertrude Stein and the Chilean silver heiress Eugenia Errázuriz, a millionaire a decade older than Picasso who was crazy about him. She was already a backer of the Ballets Russes, paying Stravinsky a monthly allowance of a thousand francs. Her patronage of the avant-garde also extended to hiring Le Corbusier to design her villa at Viña del Mar, in Chile.

The future of art, music, and dance history was at a crossroads. Picasso was leaving cubism behind for neoclassicism. Satie was bridging honky-tonk and stride piano with the layered atmospherics of Debussy, Poulenc, and Fauré. Diaghilev gave Picasso and Satie, now suburban neighbors, five months before rehearsals began in Rome with Mas-

sine. At day's end the composer and artist would walk each other home toward Satie's modest place at Arcueil and Picasso's comfortable villa at Montrouge, a couple of metro stops from their old Montparnasse haunts. They conspired to tone down Cocteau's unreal and outrageous effects: an offstage voice shouting gibberish through a megaphone, the drowning of the American girl on the *Titanic*, the Chinese magician becoming a torturer. Cocteau wanted to shock with a grotesquerie "comme un accident organisé qui dure" (like an organized accident that lasts).[7]

When the company with its impressive corps of sixty dancers convened in Rome for rehearsals in February 1917, Picasso was thrilled to have a hands-on role. He was in love with Olga Khokhlova, a ballerina — and, supposedly the daughter of a Russian noble — whom he married the next year. He painted the dancers' makeup and details on their costumes as they waited in the wings for their entrances. In the evenings he worked on the décor using models of the set in his temporary studio in the Via Margutta, overlooking the Villa Medici. He made firmly delineated sketches for the curtain as well as a number of finished drawings of the dancers in the style of Ingres, some of them based on publicity photographs, with Khokhlova front and center. Like Edgar Degas, Picasso enjoyed drawing dancers offstage. A group of them flirting and enjoying themselves at lunch one day offered the Renoiresque curtain motif.

When the troupe left for Naples and Florence, Picasso returned to Paris to supervise the crew at the huge studios on the Buttes-Chaumont, where the curtain was painted and the sets were built. Working with a huge brush on the flats and drop curtains may have been a bourgeois crime in the eyes of the committed cubists, but it became a badge of honor among such expatriates as Gerald and Sara Murphy, cummings and John Dos Passos. Because they painted the huge drop cloths on the floor of the studio with giant brushes as well as squeegee-like tools, they learned a whole vocabulary of design that would have an impact on their easel painting, enlarging gestures and emboldening palettes much as advertising would alter the diction of Crane and F. Scott Fitzgerald.

During the debut of *Parade* at the Théâtre du Châtelet on May 18 there was another near-riot, in part because the audience, only four years after the *Sacre* debacle, was apprehensive at the turn world events had been

taking. The advancing German army was pounding the French line less than two hundred miles from Paris, while the Russian revolution was in its fourth month. Satie's music pushed the limits of taste, lurching from dreamy string passages to boisterous anthems based on jazz riffs — among the earliest ragtime heard in Europe. During the overture Picasso sent three bizarre figures to the apron of the stage. They were towering, top-hatted creatures, one wearing a cubist costume that used the Manhattan skyline for silhouettes and smoking a yard-long blue pipe. These living sculptures shouted a nonsense chorus ("Tilanic toctoc tic tadelboc tadeltac mic") in a dadaist version of carnival barkers drawing patrons to a show. That was the cue for a hyperkinetic Chinese magician, played by Massine, to produce "the American Girl" in her sailor suit. Her movements oscillated between classical arabesques and *fouettés en tournant* and jazz shimmies with knee-knocking acrobatics. Satie filled the score with intrusive sound effects, including a typewriter's tapping and faint bell that asserted its puzzling presence under the strings and winds. The thirty-four-year-old Ansermet was conducting, under orders to keep the music going no matter what happened out front. A blank fired from a pistol in the percussion section straightened the backs of the box-seat holders, such as the Counts and Countesses Beaumont, Chevigné, and Greffuhle, who were further assailed by whistles, a siren, a blaring klaxon, the cracking of a bullwhip and the whirring of a dynamo. Dissenters in the audience started making their disgruntled noises by the third of eight episodes: "Go back to Berlin! Shirkers! Draft dodgers! Foreign scum!"[8] The Russians and the Spanish "kubists" were easy targets for xenophobes. Cocteau was already on edge, paranoid about the disputes with Satie and Picasso over last-minute cuts made behind his back. When he started to cry in panic in the wings, the artist gave him "une bonne paire de gifles" (a good pair of slaps in the face), right in front of André Gide. The papers the next day, from *Le Gaulois* to *Le Temps*, were brutal. One reviewer tagged Picasso, Cocteau, and Satie as "les trois Boches" (seemingly unaware that Diaghilev donated the box office take to aid refugees from the eastern provinces of France). Satie unsuccessfully sued for libel and landed in jail for eight days. Four years after *Sacre*, Diaghilev had another *succès de scandale* to his credit.

Something special had occurred that set the stage for the Jazz Age's most significant advances in art and thought. Picasso had escaped from

what he had seen as the cul-de-sac of cubism into his own brand of theatrically inspired realism. Cocteau experimented with dadaism, while Satie found in jazz the way into a new sound. Picasso's supporters recognized that the curtain had come down on cubism. Cocteau called the turn of events "la chute des angles" (the fall of the angles — a punning reference to the fall of the angels).[9] The Ballets Russes had waltzed Picasso away from Montparnasse. Rome and Naples, Michelangelo and the Farnese marbles, and Flavian portrait busts and Pompeian frescos lured the genius to neoclassicism. The Apollonian calm succeeded the Dionysian revels, now ended.

It sounds blasphemous, in this history of the avant-garde during the twenties, to applaud the retrogressions of Stravinsky, Picasso, Cocteau, and Balanchine with his Mariinsky technique. Modernism has its orthodoxies, including the determined march to abstraction in painting or serialism in music and the linguistic play of *Tender Buttons* or *Finnegans Wake*. Picasso, Stravinsky, Balanchine, and others had the audacity to break with the tradition of the new that they themselves had pioneered. David Vaughan notes in a valuable essay on the "classicism" preserved by Nijinsky and Balanchine: "The Ballets Russes was among the most important artistic manifestations of the twentieth century, and what it finally proved is that modernism in ballet can only be fully cogent when it goes hand in hand with classicism."[10] The same company that created *Sacre*, *Parade*, and *Le Train Bleu* also presented *Apollon Musagète*. The mythic method of the deep past is at the core of *Ulysses*, *The Waste Land*, Archibald MacLeish's return to *Hamlet*, Crane's "For the Marriage of Faustus and Helen," and Stravinsky's *Apollon Musagète*. It guided Eliot's essay "Tradition and the Individual Talent" (published in 1919 and an acknowledged influence on MacLeish, Crane, and many other writers). As Picasso's biographer John Richardson astutely observed regarding the reopening of the Louvre in 1919 after the war, the occasion led to a reevaluation, in an article by André Lhote on the classical canon: "Picasso is likely to have agreed with it. As someone who saw himself reworking the masters of the past in his own idiom, he was all too ready to return to the Louvre eager to convert, as Lhote put it 'the classic theme into the furniture of our pictures'; he needed to study how the masters of French classicism had reacted to the classicism of the ancient world, the better to reinvent the style in his own work."[11]

When Balanchine and Stravinsky created *Apollon Musagète* in 1928, the nostalgia for the classical ballet's purest form in czarist St. Petersburg was heightened because the Bolsheviks had insisted, eight years earlier, that every reference to the leading company be rephrased as the "ex-Mariinsky" (officially, the State Academic Theater of Opera and Ballet, also known as the GATOB or Ak). The precursor to *Apollon Musagète* was an experimental work created in the spring of 1922 when the dance master Fyodor Lopukhov gathered a volunteer group of eighteen young dancers (nine pairs of boys and girls, including Balanchine's "lost muse" Lidia Ivanova, or Lidochka) to create a plotless ballet he called *Velichie mirozdaniya* (The grandeur of the universe), known now as the *TanzSymphonie*. Elizabeth Kendall's controversial *Balanchine and the Lost Muse* affirms the importance of the twenties to Balanchine. The first of his famous muses was Lidochka, a gifted ballerina who was meant to escape Russia with Balanchine on tour in 1924 but who died (possibly murdered by government agents) in a ghastly boat accident on the eve of their departure. In student projects he choreographed for Lidochka, Balanchine tested the abstract, Greek style of ballet in the era dominated by the Russian choreographer Michel Fokine, who had already begun the reform movement away from mime and Russian romanticism. Kendall writes: "At the very least, *Tanz-Symphonie* gave its participants, especially Balandchivadze, a switch in perspective they might not have encountered without it. Balanchine's later ballets turn on this belief that energy patterns can trump narrative in a dance construction."[12]

The dance masterpiece of the Jazz Age was first called *Apollon Musagète*, a two-scene work with a score by Stravinsky, who conducted at the premiere on June 12, 1928, at the Théâtre Sarah-Bernhardt in Paris. Serge Lifar was the first Apollo, dancing with Alice Nikitina (Terpsichore), Lubov Tchernicheva (Calliope), Felia Doubrovska (Polyhymnia), and Sophie Orlova (Leto). In 1929, Chanel designed new costumes. *Apollon Musagète* holds a special place alongside Picasso's *Woman in White*, Joyce's *Ulysses*, and Le Corbusier's Villa Stein, all transcendent examples of neoclassicism. The choreographer and composer chafed at the limits set on them by having only five dancers and a string ensemble, yet *le chant soutenu des cordes* (the sustained song of the strings) ensured structural and sonic integrity. The ballet can be de-

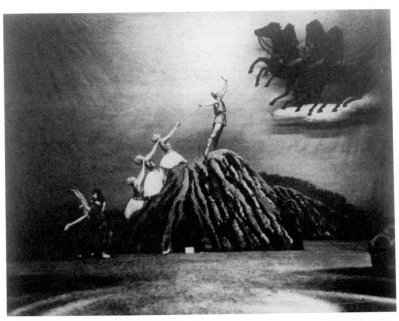

On the opening night of George Balanchine's original *Apollo*, Serge Lifar starred with Alice Nikitina, Lubov Tchernicheva, Felia Doubrovska, and Sophie Orlova. The costumes were by André Bauchant, but Coco Chanel designed new ones for the production the next year.

scribed as an eighteenth-century French translation of the Greek myth, anachronistically invoking the ordered past in an idiom that would have been acceptable as an entr'acte for a play by Jean Racine presented at Versailles (or to the czar). Balanchine recalled his initial response to the score: "In its discipline and restraint, in its sustained oneness of tone and feeling the score was a revelation. It seemed to tell me that I could dare not to use everything, that I, too, could eliminate.... I began to see how I could clarify, by limiting, by reducing what seemed to be multiple possibilities to the one that is inevitable."[13]

The boy-god Apollo discovers his creative powers in three encounters with the muses, whose grouped silhouettes assemble in rhythmic patterns like the marriage of contours in a Le Corbusier still life. Apollo dances with each in turn, but the most deeply engaging duet is saved for Terpsichore (dance), whom he separates from the other two with a princely yet firm gesture. The three muses weave a pattern of adoration around him and lead him to Parnassus in a colossally moving ending.

The stately processional rises and rises steadily to the accompaniment of an ascending four-note phrase marked out over a four-note ostinato. In the *tableau vivant* on which the curtain descends, the extended legs of the three muses balance the reaching hands of the god. As the biographer Bernard Taper has recorded, the work had a special place in Balanchine's *oeuvre*:

> "I consider *Apollo* the turning point of my life," he has said. Here, for the first time, he struck the unmistakable Balanchine note. At the height of the Jazz Age, he turned to classicism — or, rather, he evolved a new classicism, which serenely embodied the classical virtues of clarity and grandeur and yet in spirit and in style of movement was more up to date and adventurous than the run of ultramodern ballets. With *Apollo* — "a work of capital importance in the arts of the twentieth century," it has been called — Balanchine started out on what was to be one of the major lines of development in his career.[14]

ONE OF THOSE FABULOUS FLIGHTS

Cole Porter

Not all Jazz Age opening nights were as wild as that of *Parade* or as auspicious as that of *Apollon Musagète*. "My one effort to be respectable must remain in limbo," Cole Porter told a biographer in 1965, referring to his experimental ballet *Within the Quota* (the title alludes to the ever-fierce debate over immigration). Theater and popular-music history have made Porter into a debonair yet monumental emblem of the wit and elegance of the epoch. He offered Hollywood the ideal formula for the hit musical, using tricks that had worked on audiences at Yale University undergraduate revels called "smokers," in Paris music halls, and Broadway theaters. Porter's apotheosis on stage and screen would have had an alternative ending if *Within the Quota* had played differently. A recently rediscovered score for a café-concert revue, together with a close examination of this neglected ballet, reveals a serious young artist in Paris with ambitions as an orchestral composer and painter (a watercolor that Porter painted on the Lido in Venice is better than a mere Sunday painter's exercise). *La Revue des Ambassadeurs* was a "lost" show that opened in the Ambassadeurs club in 1928 with George Gershwin at the piano accompanying his sister, Frances; Clifton Webb; and Morton Downey, under the baton of bandleader Fred Waring. Peter Filichia, a musical theater historian, was quoted in a *New York Times* article about the unearthing of the lost orchestral pages notes: "Back in 1928, Cole Porter was nothing. He was lucky he got the job. This turned out to be a significant stepping stone in the history of Cole Porter. He might not have had a career if this had not come along."[1] Cast member Amy Burton offered an even more intriguing comment: "I felt we were sitting on something important, like an early Mozart opera. Nobody knew about it here. It struck me as very French, what he wrote."[2] Focus on that hint about the French accent. It elevates Porter's Paris writing from Amer-

ican export ware (in much the same way as *Ulysses* is hardly an Irish novel) to an experimental hybrid.

Porter had been in France almost a decade by the time the revue was staged. Rich (one room of his apartment on the Rue Monsieur was done in platinum), famous, and funny, he was nonetheless in a period of intense self-scrutiny. Along with George Gershwin and Irving Berlin, he had been positioned to integrate jazz with the ballet orchestra five years earlier, when he wrote the score for *Within the Quota*. There is an awkward backstory to this neglected chapter in his career. His wife Linda, rich from the million-dollar settlement she had won in her divorce from her first husband, had angled unsuccessfully for a Diaghilev commission (she could have underwritten a production). She tried to lure Stravinsky into becoming Cole's private tutor in composition, but on the advice of Gerald and Sara Murphy Stravinsky turned her down. At this point Léger and Gerald Murphy made a proposition. The rich Swedish nobleman Rolf de Maré had created a Paris-based rival to the Ballets Russes, the Ballets Suédois, as a vehicle for his boyfriend Jean Borlin, with the goal of turning him into the Swedish version of Massine (choreographer and principal dancer). The lavish productions had costumes by Jeanne Lanvin; a hundred-piece orchestra; and major scores by Darius Milhaud, Honegger, Ravel, and Debussy as well as sets by Picabia, Pierre Bonnard, and Léger built by the boss of the Paris Opera scenic unit, working as a freelancer. De Maré planned an American tour for the winter of 1923–24 and had already commissioned Léger, Milhaud, and Cendrars to create *La Création du Monde*, for which he wanted a comic, all-American-themed curtain raiser. The publicist for the American tour was Edmund Wilson, literary critic and mentor to Fitzgerald since their Princeton days.

Cole and Linda Porter and Gerald and Sara Murphy convened in a Venetian *palazzo*, the Casa Papadopoli on the Grand Canal, in August 1923 for a three-week creative binge. The Murphys had just spent July in a hangar-like studio in suburban Belleville, painting the replacement curtains and flats for the Ballets Russes; they had used a grisaille design that is strongly echoed in the huge black-and-white set for *Within the Quota*. In Venice, Gerald wrote the libretto, while Sara drew watercolors for the costumes as well as the cover for the program, which showed a Swede in a blue bell-bottomed suit holding a cloth bundle and small

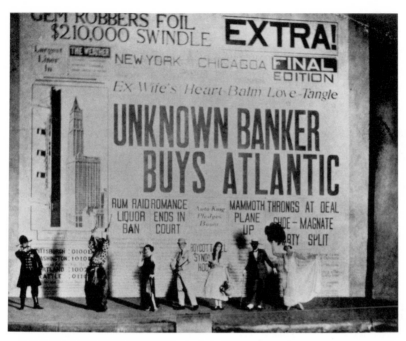

The mock front page of Gerald Murphy's curtain for Cole Porter's *Within the Quota* anticipated the use of headlines in the film version of Gershwin's *An American in Paris* as well as paintings by Stuart Davis, novels by John Dos Passos, and the poetry of Hart Crane.

valise and standing in front of a jumble of familiar buildings (you can glimpse the Mark Cross building between his legs; his right hand intersects the eighth and ninth floors of New York's Flatiron Building, while a pair of smokestacks rises behind it). If Porter's score hews closely to Stravinsky and Milhaud, then Murphy's scenario bears a family resemblance to Cocteau's episodic parodies *Le Boeuf sur le Toit* and *Parade*. Dos Passos, a member of the Murphys' intimate circle, was writing *Manhattan Transfer* in France that year using headlines that Amanda Vaill, the group's biographer, relates to Gerald Murphy's curtain, but Dos Passos's Irish immigrant ends a suicide. In contrast, Murphy's libretto is upbeat:

> A millionairess, bedecked with immense strings of pearls, ensnares him; but a reformer frightens her away. Then a Colored Gentleman appears and does a vaudeville dance. He is driven away by a "dry-agent" who immediately

thereupon takes a nip from his private flask and disappears, to the immigrant's increasing astonishment. The Jazz Baby, who dances a shimmy in an enticing manner, is also quickly torn from him. A magnificent cowboy and a sheriff appear, bringing in the element of Western melodrama. At last the European is greeted and kissed by "America's Sweetheart" and while this scene is being immortalized by a movie camera, the dancing of the couples present sweeps all troubles away.[3]

Decoding the vignette according to the intimate circle on the beach at Antibes that summer, the millionairess combines Sara (with her double length string of pearls) and her sister, Hoytie (Vaill points out the resemblance to Hoytie in Sara's drawing, "a study of American women entering the Ritz"), cross-pollinated with Linda Porter.[4] The Jazz Baby is likely based on Zelda Fitzgerald, while Sidney Bechet might be the model for the Colored Gentleman. It is charming to picture Hemingway or Rudolf Valentino, both frequent visitors to the Murphys' Villa America, as the magnetically masculine cowboy. Vaill offers a logical interpretation: "*Within the Quota* was about how the image becomes the real attraction. For an artist who wanted to 'represent' real objects as abstractions, the progression was obvious. . . . They're all manifestations of the kind of patriarchal disapproval that had dogged Gerald in his youth and that, in part, had driven him from America. In the end the European overcomes that disapproval because he becomes a star. Perhaps Gerald hoped for the same thing."[5]

Porter's score is a sophisticated tour of current ideas, from Stravinsky's *Noces* and *Pulcinella* through the sweeping gestures of Les Six crossed with the ragtime antics of a movie theater accompanist (Porter's job in Indiana when he was a child, from which he was fired for improvising too cheekily). The Stravinsky influence is particularly audible in the opening measures, an off-kilter fox-trot with dissonances where chords based on thirds and fifths usually reside. Richard Strauss also put this device to use in the waltz parody in *Der Rosenkavalier*. In a brief interlude, pensive and almost twelve-tone in its chromaticism, the European leaves the millionairess and makes his way further into Manhattan. This leads to a slower, thornier version of a dance with heavy downbeats that arpeggiate oddly into blue notes up and down the keyboard. The accents fall, as they do in Stravinsky and Schoenberg, on the

least appealing of the dissonant chords. Suddenly Porter is sweeping us into a crescendo at a tempo that, like the machine-propelled racing passages in Milhaud, reaches an alarming rate and then screeches to a halt. The pensive interlude returns, and then we are in a jazz vamp, like the walking theme in Gershwin's *American in Paris* (but five years before it). The bouncing left hand partners with a flashing, Debussy-worthy set of phrases, a glissando recurs (another favorite Gershwin trick), and we swing at last in the syncopated and sassy riffs of the Colored Gentleman's dance.

A bass note interjects, as though holding up a finger, and a variant on the classic club scenario takes hold when the stride pianist lays down a steady beat, breaking it occasionally with a four-note ornament but basically maintaining a metronomic growling ostinato above which increasingly more complex figures are traced. We are deep in the minor key (no score survives, but Richard Rodney Bennett takes this in E-flat in his two-piano version), and even in that chromatic territory what makes the opening part of this section all the more avant-garde is the number of wrong notes — flats under flats and adjacent keys mashed as in the violent slamming of keyboards with Antheil's forearms. The faster treble figures begin pulling at the bass, creating another accelerando, while the melodic phrases break up into shards of two and three chords.

Suddenly after a few bars, the volume slips down into pianissimo, and the pianist noodles a bit on a single note that returns, like Gershwin's echoing A-flat in the opening section of *Rhapsody in Blue*. Then we have the comic interlude of toy piano music (a possible allusion to Debussy's "Children's Corner") and falling arpeggios that soften the edges. The carnival atmosphere returns with long runs to make us smile–it's America's Sweetheart working the crowd, shimmying to lure the European into her sybaritic entourage. Porter manages to infuse even her saccharine melody with an undercurrent of haste, with Philip Glass–like repeated figures in the bass to hustle us along to the edge of a pause.

A soaring overture worthy of Giacomo Puccini opens the next section, in which a two-chord figure, like the ticking of a clock, is answered by dissonant chords and leads into grander, more Lisztian forays into chromaticism and dissonance. This part leaves Stravinsky behind to build a climax more typical of Leoš Janáček or Sergei Rachmaninoff— an ambitious attempt at reaching, with six-stage ascending passages, an

orchestral effect more often associated with classical music than with jazz. Even the traveling music that comes out of this, which anticipates the linking music of Copland and Grofé in their suites, is not as jazzy as it is a version of the similar walking theme of Mussorgsky's *Pictures at an Exhibition*. An ascending scale is repeated in the minor, and for eight measures we are suddenly in cocktail mode, Porter at the Ritz bar wooing the couple in the corner. Then with a snap of the fingers, he's back into the walking theme as his Swede turns another corner and the mood darkens. Loading his palette with heavier tones, thumping the bass and then overlaying a haunting version of that climbing six-chord treble figure, he ventures into the atmosphere of Debussy's *Pelléas et Mélisande*. Porter alternates between the American style of soft jazz piano and the moodier European orchestral idiom. Then an ominous two-chord figure starts growling in the bass, and we are suddenly driving to what seems like a coda, rippling glissandi moving upward to a banging version of the dance that offers a Stravinsky-style test of the dancers' speed and stamina. In a surprise retreat, the lyrical jazz recurs, a romantic passage in a sunny, American idiom that transplants us to Broadway until a couple of off notes are interjected, and within two measures we are returning to cubism that swings. This is where we feel that Porter might have missed his calling. Only about twenty minutes long, *Within the Quota* twists its way through a convincing dialogue of jazz and serious ideas, displaying melodic gifts as well as an admirable analytic mind that was willing to interrupt his own facility.

The ascending figure at the end, reaching like the arms in Balanchine's *Apollon Musagète*, lifts *Within the Quota* from parody and experiment to something more moving and integrated. Whenever Porter shifts into the minor and picks out those single-finger melodies over disturbingly attractive chord progressions, there is a feeling of confidence in the serious composer for orchestra, trying out the massed and contrapuntal techniques of d'Indy instead of relying on song formats and call-and-response jazz protocol. This is an ensemble, not a vehicle for soloists like so much of Gershwin or jam sessions. Porter sweeps the whole into a final Broadway-style anthem, an applause machine to which critics responded in both Paris and New York. Despite his sense that the work had been a failure, Porter had built a bridge from Tin Pan Alley to Paris.

STAIRWAY TO PARADISE

George Gershwin

The musical paradigm for the expatriate experience in Paris is George Gershwin's symphonic accomplishment. He first visited the city at the tail end of a hurried London gig in April 1923. Most of his more famous and productive trips were also in April (in 1925; 1926; and, triumphantly, 1928, to complete his suite *An American in Paris*). His progress as a songwriter turned orchestral composer exactly parallels, year by year, the literary rise of Fitzgerald, whose short stories and features were weekly cover candidates for the *Saturday Evening Post* before he started *The Great Gatsby*. Gershwin made his name in 1919 with the hit "Swanee" for Al Jolson, which led to five straight years of rave reviews of his showstoppers for the annual George White *Scandals*. For 1922, the year that Fitzgerald chose for the historical basis of his masterpiece, the hit may as well have been the novel's theme song: "I'll Build a Stairway to Paradise."

The fascinating rhythm of Gershwin's career bounces between light and serious. When the midtown society crowd began going to Harlem to cap their evenings out on the town, Gershwin and Whiteman saw an opportunity to pitch a one-act jazz opera based on black themes, a risqué interlude for the *Scandals* of 1922. It represented Gershwin's first effort in an idiom he would pioneer: concert-level jazz. *Blue Monday* played on opening night at the Globe Theater and was summarily dropped from the program — Whiteman conceded its tragic ending did not accord with the upbeat mood of the revue. Like Porter's *Within the Quota*, this self-contained *Zeitoper* was the composer's first serious large-scale work, with a prelude, recitatives, and three blues songs — including a lullaby and orchestral passages that point the way to *Porgy and Bess* (especially the storm scene and the aria "Summertime").

Just two years later, Whiteman made Gershwin the star of the career-defining (for both bandleader and soloist) "Experiment in Music."

Gershwin left Paris in 1926 with a sketch for a piece he called "Very Parisienne" and returned two years later to finish *An American in Paris*.

Understanding the thrill in 1924 of what it meant to import jazz from club to concert hall is vital to the appreciation of not just Gershwin's place in modernist music history, but also of the roles of Porter, Berlin, Kern, and Ellington as well as their champions Ansermet, Damrosch, Whiteman, and the publisher Max Dreyfus. Knocking out a hit a year imposed constraints, as the demise of *Blue Monday* demonstrated. European audiences and encounters with classical composers offered a chance for liberation.

The prequel to the *Rhapsody in Blue* experiment was instigated by Carl van Vechten. The man about town from Iowa was the leading advocate of American music in his capacity as critic and reporter for the *Chicago American, New York Times* (he was the paper's Paris correspondent in 1908), *Smart Set*, and *Vanity Fair*. His goal was to include jazz on the concert stage, starting with a recital program that combined lieder and blues. The concert that he organized in New York for November 1923 featured the Paris-based, Canadian-born classical singer Eva Gauthier in a program of "Ancient and Modern Music for Voice."[1] Vincenzo Bellini, Giovanni Perucchini, and Henry Purcell were the ancients. Béla Bartók, Hindemith, Arnold Schoenberg, Arthur Bliss, Darius Milhaud,

and Delage Hennessy were the serious moderns, and Jerome Kern, Irving Berlin, Walter Donaldson, and Gershwin were the popular moderns. Gershwin himself accompanied Gauthier for his pieces. On November 1, 1923, at Aeolian Hall, "I'll Build a Stairway to Paradise" and his five other jazz numbers were warmly received. Singer and pianist were recalled to the stage for three encores, including Gershwin's "Do It Again" — sung twice. The reviews were so positive that Gauthier reprised the program several times on tour in the United States and Canada. The ice had been broken.

Just three months later — on the afternoon of Tuesday, February 12 — in the same hall, the stage was set for the "Experiment in Music." The program was too ambitious, with more than twenty numbers. The audience began to shuffle toward the exits after the "Chansonette" of Rudolf Friml, two-thirds of the way through the lengthy proceedings. Held for last, Gershwin appeared in his morning coat and gray pants, his shiny black hair combed back, and saved the day. That was when *Rhapsody in Blue* was first heard — literally. The so-called final score had been copied out in parts on February 4, titled by Ira Gershwin, and distributed on February 12 to the orchestra, which had already been rehearsing fragments at lunchtime at the nightclub Palais Royal for a couple of weeks. The conductor's copy included blank bars for the piano line in the middle movement, ending with the outrageously cavalier instruction: "Wait for nod."

There are many recommended recordings of the *Rhapsody*, the most authoritative being a piano roll made by George Gershwin a year after the concert that is in effect a four-hand version. The lost roll for the orchestral part was among the last of the 140 that Gershwin made during his career, starting when he was only seventeen. There are magnificently different interpretations by Earl Wild, André Previn, Leonard Bernstein, André Watts, Garrick Ohlsson, and even James Levine, among more than two hundred other strong readings and recordings, but you will never hear the *Rhapsody* as it was experienced that day. In the best jazz tradition, only those who were there knew what Gershwin did with the "outrageous cadenza," as Olin Downes called it in his review the next day in the *New York Times*,[2] or the glissando (later the specialty of Benny Goodman) as played by Ross Gorman, who bent the seventeen notes of the upward run from F to F, instead of tonguing

them individually. Gershwin had written the notes out (that is how a pianist has to play it) but the "wail" or "siren" of the Gorman glissando became the distinctive opening impression starting in rehearsal, when the liberty of the jam session made its way into what is now a classic of twentieth-century music. The audience at the concert included a contingent of eminences such as Damrosch; the conductor Leopold Godowsky; the violin virtuoso Fritz Kreisler; Stokowski; Rachmaninoff; and the opera singers Mary Garden, Jeanne Gordon, Frances Alda, Amelita Galli-Curci, and Alma Gluck.

The Gauthier recital and the "Experiment" crossed over to the European music establishment. Many prominent figures from conservatories, orchestras, and opera and ballet companies in Germany, Austria, France, and England lectured at the newly established Juilliard School, where Gershwin's friend Ernest Hutcheson was president. A series of encounters between Gershwin and some of these luminaries had unexpected outcomes. In January 1925, Hoytie Wiborg, who lacked the tact as hostess of her sister, Sara Murphy, hosted a party and insisted that Gershwin and Stravinsky sit together at a special, mechanized piano-organ. She wanted the men to play a four-hand improvisation, but both were reluctant to entertain Fred and Adele Astaire, Chaliapin, several Vanderbilts, and — thank goodness — John Hays Hammond Jr., whose company made electric organs and pianos. When he saw how uncomfortable Gershwin and Stravinsky were, he discreetly flicked the switch and turned off the instrument's amplifier so the keyboard emitted no sound. Later he turned it back on, and Gershwin played through the *Rhapsody* as well as some selections, performed by the Astaires, from *Lady Be Good!*

Then it was time for Gershwin to go abroad for two months to pursue orchestral projects. He had a major commission from Damrosch for the *Concerto in F*, a sketch for a tone poem for symphony orchestra titled *Black Belt*, and a group of twenty-four piano preludes (the number is canonic — it was used by Johann Sebastian Bach and Frédéric Chopin). In Paris in 1926, Robert and Mabel Schirmer put him together with Antheil, who attempted with a single piano to give Gershwin an idea of the *Ballet Mécanique*. Gershwin met Ravel, living link to the grand tradition of Debussy and a supporter of the avant-garde (at the premier of *Sacre* he shouted "Genius!" during curtain calls[3]), in New York

in January 1928, courtesy of Gauthier. After playing the *Rhapsody* and several songs, Gershwin asked to study with Ravel, who demurred but offered a letter of introduction to Boulanger, then the leading teacher of modern composers. Three months later, Ira and George Gershwin settled into the Hôtel Majestic in Paris, where they would stay until June as George worked on the *American in Paris* score. One of his first stops, with Mabel Schirmer as translator, was Boulanger's atelier, where she turned him down firmly — because she said "there was nothing she could teach him," according to Ira.[4]

That was the famous Paris stay when George Gershwin starred with his sister in Porter's *Revue des Ambassadeurs* and finished *An American in Paris*, the next-generation tone poem, adding the blues section. It was the only orchestral piece he ever wrote without either a commission or a piano part. That was also the year when Gershwin and Alban Berg became friends in Vienna. After listening to a reading of Berg's string quartets at the home of Rudolf Kolisch (Schoenberg's brother-in-law), Gershwin played through some of his hits and a section of *Rhapsody in Blue* but stopped because he felt self-consciously commercial. "Music is music, Mr. Gershwin," Berg assured him. Gershwin's baggage included an autographed passage from Berg's *Lyric Suite*, a pocket score of the Berg quartet, and eight volumes of Debussy's piano works.

This touching rapprochement between serious and jazzy frames the sad reality of Gershwin's early death and the fact that we will never know what more he might have done as he "negotiated" (to borrow Wynton Marsalis's term) between the two.[5] Both Gershwin and Porter could turn out a novelty song or interject a smile-inducing trombone slide. Both created large-scale works in traditional forms — opera and ballet — before settling into the seasonal rhythm of their Broadway and Hollywood successes. Porter got the urge to compose major orchestral works out of his system at an early stage, but Gershwin returned often — from *Blue Monday* to the *Rhapsody*, the *Concerto in F, American in Paris*, and *Porgy and Bess*. For the 1929 film version of *American in Paris*, the dream sequence and six-minute "Manhattan rhapsody" (known as the "second rhapsody" — there was not time in his brief life for a third), staged by Vincent Minelli and Gene Kelly, came dangerously close to Porter's *Within the Quota*. Both used newspaper collages, traveling motifs, and episodic structure. Porter's ballet is about a young Swede's

adventures in Manhattan, while Gershwin's tails a young American from confusion to romance. This time, Porter was seven years ahead of Gershwin. Gershwin's biographers are careful to note his departure date from Paris—April 28, months before *Within the Quota* was on the boards. Note how the sophisticated Porter abandoned his orchestral projects after one ballet to focus on musicals, while the lower-middle-class piano showman persisted in writing history's greatest serious jazz in addition to hits. Mass popularity and a good laugh condition expectations whenever the great comics of the era are mentioned, such as Dorothy Parker, Ring Lardner, Damon Runyon, Coward, Robert Benchley, and Philip Barry. Gershwin reconceived the relationships among text, melody, rhythm, and dramaturgy. He could demonstrate a traveling step to the Astaires (he was that able a dancer) and write the soaring andante to the *Rhapsody*. As Schoenberg recognized, he had the savoir faire of a hoofer and the talent to spin indestructible melodic lines over irresistible dance rhythms.

INEVITABLE PARIS BECKONED
John Dos Passos and e. e. cummings

John Dos Passos and e. e. cummings were freshly minted Harvard graduates who burned a trail through the twenties, often playing wingman not just to each other but to their close friend Ernest Hemingway. Dos Passos and cummings had been inseparable since their college days, and their closely entwined lives balanced painting and writing. The manic energy in their work rose from deep within their shared experience on the front lines during World War I. Both even did jail time as dissenters. They first reached France in 1917, as ambulance drivers who did not want to miss the action but did not want to fight, either. Their deep revulsion at what they witnessed was captured in three raw novels published at the start of the decade — cummings's *The Enormous Room* and Dos Passos's *One Man's Initiation: 1917* and *The Three Soldiers*. Even before the scandalous arrival of these pointedly pacifist books, the authors had gained notoriety for cummings's imprisonment for his withering comments about the top brass in letters home from the front. Dos Passos, who campaigned for cummings's release, once confessed to his friend's family that he also should have gone to jail (he was arrested in Boston years later, during a protest on behalf of Nicola Sacco and Bartolomeo Vanzetti).

John Roderigo Madison was the illegitimate son of Lucy Addison Sprigg Madison and John Randolph Dos Passos, whose name he took in his college years. Born in a Chicago hotel room, he lived in Brussels and London with his mother and, after graduating from Choate a year early and a six-month European tour, arrived at Harvard. He was more colorful, sophisticated, and linguistically proficient than most of his classmates (his nickname was Frenchy). Seated alphabetically in lectures, Edward Estlin Cummings, S. Foster Damon (who became a famous William Blake scholar) and Dos Passos struck up a friendship and lived in Thayer Hall. They joined forces to create the Poetry

Society and went to see the Ballets Russes on its first American tour, the Armory Show in Boston 1913, and often to the cummings home in Cambridge for dinner (Estlin's father, a former Harvard philosophy professor, was the minister at the conservative South Congregational Church of Boston). Just as John Peale Bishop was F. Scott Fitzgerald's literary tutor when they were undergraduates, Damon and Scofield Thayer (whose wife cummings would steal years later) prepped Dos Passos and cummings on the impressionists, Paul Cézanne, the cubists, Marcel Duchamp, and the fauves. One look at the molten colors in the paintings of Dos Passos and cummings confirms the thunderous impact of the fauve palette. During the 1915 Harvard commencement at which cummings received his degree magna cum laude he read an essay on "The New Art," connecting modernist literature and painting. Few in the audience were amused.

The two friends joined other Harvard graduates as volunteers with the Norton-Harjes ambulance unit (Section Sanitaire [États-]Unis 60, under the aegis of the Red Cross), sailing to France in June 1917. By August, the unit was at the front near Verdun, and in January 1918 Dos Passos was evacuating the wounded in Bassano, Italy, where he first met Hemingway, also driving a Red Cross ambulance. All three writers had traumatic war experiences that furnished them with literary capital. Cummings quickly found a publisher for *The Enormous Room*, but thirteen publishers rejected Dos Passos's *Three Soldiers* before George H. Doran accepted it. The book appeared after heavy editing in the fall of 1921, a year before *One Man's Initiation* (about the Spanish Civil War) appeared with the same publisher. Dos Passos capitulated completely to demands that he delete the most flammable passages, even inviting his editor to fill in transitions where cuts were made. Cummings was less compliant when Boni and Liveright butchered *The Enormous Room*. Two years later, Hemingway asked Dos Passos to intervene at the proof stage with Boni and Liveright as they were editing his collection of stories, *In Our Time*. Hemingway and cummings were thrilled to play cat and mouse with censors. These were precisely the years when James Joyce's *Ulysses* was not just banned but hunted down from bookstore to bookstore in New York by prosecutors with the district attorney's office and officials of the Customs Bureau and Post Office. It took the efforts of so-called bookleggers to bring copies into the country. As

with the naughty lyrics of Cole Porter and the eroticism of early films, the fight for free speech in literature was a main current of Jazz Age aesthetics, bridging civil rights and the arts at a time when the laws were in flux.

Hemingway and Eugene Jolas were not the only journalists in this circle. Dos Passos filed articles for *Vanity Fair* on expatriate life, drawing on the escapades of his circle of artistically ambitious Harvard buddies that included Thayer, Stuart Mitchell, Slater Brown, John Howard Lawson, and Gilbert Seldes. He wrote about taking tea with Ezra Pound in his studio and an evening with Archibald and Ada MacLeish in Saint-Cloud. He interviewed Pablo Picasso, Jean Cocteau, Louis Aragon, Michael Larionov, and others. He and cummings were also painting up a storm. Dos Passos beat cummings to the punch in having his first one-man exhibition early in 1923, alongside the work of Adelaide Lawson and the sculptor Reuben Nakian at the Whitney Studio Club on West Fourth Street. There is in these works by Dos Passos plenty of Edvard Munch, more than a dash of the orange and purple favored by André Derain and Maurice de Vlaminck, and an added dollop of expressionism that hints at an acquaintance with Amedeo Modigliani, Egon Schiele, and Max Beckmann.

The fiction and the painting share a political dimension. Dos Passos's city views and paintings of Coney Island excursions throb with the infatuation he felt for the little guy on the margin — the hero of *Manhattan Transfer*, the novel he was working on in the spring of 1923. During that spring and summer in Paris, Dos Passos and Gerald and Sara Murphy were often together, working on the Ballets Russes sets for *Les Noces*. Dos Passos, a painter for the first *Revue Nègre* set, was involved as well in the preparations for *Within the Quota*, like *Manhattan Transfer* the tale of an innocent arriving in Manhattan told using tabloid-style typography and punchy prose. Along with Dorothy Parker and Philip Barry, Dos Passos was a Murphy insider for decades and loyal friend of the family — and the only writer in the group who did not turn on them in print (as Hemingway and Fitzgerald would).

American writers in Paris followed a range of styles, from the silken lyricism of Fitzgerald to the blunt directness of Hemingway and Sherwood Anderson and the archly inaccessible imitators of the breathtaking excesses of Joyce and Marcel Proust. Dos Passos experimented with

all three models. The committed Joycean is evident in the jump-cut scenes and the paragraph-long prose poems at the head of the chapters of *Manhattan Transfer*, published by Harper and Brothers in 1925. The syncopated prose of the trilogy titled *U.S.A.*, which Harcourt Brace published in 1930, is even more of a virtuoso performance. He used the fast cut of cinematic montage, the rhythms of advertising, and other low sources (he had a great ear for street scenes) to commit to paper the episteme of an artist's urban perspective. Like Fitzgerald the year before he started *The Great Gatsby*, Dos Passos and cummings even tried their hand at plays. In 1925, Dos Passos's *The Moon Is a Gong* (later retitled *The Garbage Man*) was presented at Harvard. It bore an understandable resemblance to the archetypal characterizations and picaresque structure of Porter and Gerald Murphy's *Within the Quota*. In a similar vein, a year later cummings created *Him*, a sexually charged surrealist play laced with vaudeville turns that ran for twenty-seven performances at the Provincetown Playhouse in Greenwich Village, to dreadful reviews.

The journalist and the painter often contend for supremacy in Dos Passos's writing. When the painter wins, the visual power of the writing is formidable, as in the italicized descriptive paragraphs in *Manhattan Transfer*, the jazziest of his novels. At the beginning of the chapter "Metropolis," for example, he offers a prescient vision of the city of curtain-wall skyscrapers as planned not just by the staid Le Corbusier but by the starchitects along the High Line and the superscraper condominium towers rising along 57th Street: "There were Babylon and Nineveh; they were built of brick. Athens was gold marble columns. Rome was held up on broad arches of rubble. In Constantinople the minarets flame like great candles round the Golden Horn. . . . Steel, glass, tile, concrete will be the materials of the skyscrapers. Crammed on the narrow island the millionwindowedbuildings will jut glittering, pyramid on pyramid like the white cloudhead above a thunderstorm."[1]

As Dos Passos fashioned his lyric style, cummings was turning out an amazing four volumes of the most freely jazz-inflected, rule-shattering poetry of the age, even as he painted prodigiously. In December 1922 he shipped home fifty-nine watercolors, mainly landscapes in a style that he admitted was an imitation of Cézanne's. In the bolder oil paintings, voluptuous nudes snake through arabesques in a fauve palette

of pure passion, abounding in lavenders, sunny oranges, and molten reds, pulsing with the heat of early Henri Matisse or Alexei Jawlensky. Cummings's landscapes, which reflect his knowledge of the Collioure paintings of Georges Braque and Derain, reverberate with high-volume golds and greens slathered on the canvas by a confident brush that never hesitates. The greatest of cummings's Jazz Age volumes is the early collection *Tulips and Chimneys* (1923), which won the Dial award. The opening lines are worthy of an artist who has set up his easel before Notre Dame, avidly assessing the form and color of the cathedral spire "sprouting gently" through the darkness of an unusually mild January sunset (the moon has already appeared). Even the textures of an oil painting are felt in his description of how the cathedral "leans its dreamy spine against thick sunset."[2]

At the risk of ruining the eroticism of a typical cummings love poem, I sense the presence of a Cézanne-like artist (the invisible spectator as voyeur?) along the cliffs of the Cap d'Antibes overlooking the Mediterranean, its tone "bluer / than we had imagined."[3] He captures a glimpse of a white-walled villa (in my imagination, the Villa America or Picasso's Vigie) snared in the trees "like pieces of a kite." The reference to a "fat colour" invokes one of the studio rules for painting in oils: fat over thin, meaning that each superimposed layer of paint must have more oil in the medium than the one beneath so it will not crack or flake. Stroke on stroke, cummings summons the sea, yachts, palm trees, villa and a pair of lovers who find a secluded spot for a climax comparable to the *Liebestod* from *Tristan und Isolde*: "everywhere you your kisses your flesh mind."[4]

5

DANCING ON DYNAMITE
Nancy Cunard

The flapper roll call from Josephine Baker to Zelda Fitzgerald and all the bold-faced names in between includes Diana Cooper, Tallulah Bankhead, Pola Negri, Dorothy Parker, Edna St. Vincent Millay, Djuna Barnes, and Kay Boyle. A favorite name on that list of fast women is Nancy Cunard. Heiress to a shipping fortune, champion (and lover) of black Americans, hard-drinking sybarite relentlessly on the move to be wherever the party was, the fashion-forward Cunard was a meal ticket for gossip columnists. They chronicled every defiant bout she had with her hypocritical mother, Lady Maud Cunard (the rich American who married a shipping magnate had been naughty too in her day). With her arms encased in African bracelets, long skinny legs flashing from under abbreviated Chanel hemlines, and kohl-rimmed eyes, Nancy Cunard dared Man Ray, Cecil Beaton, and other photographers to tame the predatory pheromones she exuded even as a teenage member of London's "Corrupt Coterie." Biographers batten on her dalliances with black jazz musicians and high-profile literary figures (no less than three Nobel prizewinners), a roster of lovers that included Evelyn Waugh, Michael Arlen, Louis Aragon, Tristan Tzara, Pablo Neruda, T. S. Eliot, Ezra Pound, Samuel Beckett (*peut-être*), and Wyndham Lewis. She inspired portraits by Oskar Kokoschka and Constantin Brancusi, among others, and was the basis for characters in the work of Eliot (in a section eventually cut by Pound from *The Waste Land*), Pound (part of the *Cantos* is addressed to her), Beckett (who mentions her by name in *Waiting for Godot*), Aldous Huxley, Pablo Neruda, and Ernest Hemingway (Lady Brett in *The Sun Also Rises*). The most direct portrait of her is Michael Arlen's *The Green Hat*, which literary historians have denigrated as lightweight since it appeared. The London it depicts is dated specifically to 1922, and the book's plot and characterizations bear direct similarities to another novel set in that year, *The*

Nancy Cunard was thirty when Man Ray made this portrait of her in Paris wearing her signature African ivory bracelets.

Great Gatsby. The opening portrait in *The Green Hat* is delivered in that breathless mode Scott Fitzgerald reserved for his heroines:

> The light that plunged through my half-open sitting-room door fought a great fight with the shadow of her green hat and lit her face mysteriously. She was fair. As they would say it in the England of long ago — she was fair. And she was grave, so grave. That is a sad lady, I thought. To be fair, to be sad . . . why, was she intelligent, too? And white she was, very white, and her painted mouth was purple in the dim light, and her eyes, which seemed set very wide apart, were cool, impersonal, sensible, and they were blazing blue. Even in that light they were blazing blue, like two spoonfuls of the Mediterranean in the early morning of a brilliant day. The sirens had eyes like that, without a doubt, when they sang of better dreams. But no siren, she! That was a sad lady, most grave. And always her hair would be dancing a tawny, formal dance about the small white cheeks.[1]

Today Cunard is admired for her role as a civil rights advocate. During the twenties she commissioned the essays on black American, Caribbean, and African life that, together with her own impassioned contributions, comprised *Negro*, an encyclopedic anthology (nearly nine hundred pages in length and generously illustrated). Her tone in the summary essay on the Scottsboro trial, one of several essays she wrote, is furious. She adopts the Harlem Renaissance practice of calling whites "offay." The volume, published in London by Wishart in 1934 with a press run of a thousand copies, included contributions by Langston Hughes, Louis Armstrong, Norman Douglas, Theodore Dreiser, W. E. B. Du Bois, Zora Neale Hurston, William Plomer, Arthur Schomburg, and William Carlos Williams, among many others. Cunard had proven her editorial skill as the founder of the Hours Press in 1925. It resembled a Continental version of Leonard and Virginia Woolf's Hogarth Press, which published *The Waste Land* in 1922 and *Parallax*, a book-length poem by Cunard, in 1929.

The ambitious *Parallax* is a revelation, taking its place alongside *The Hamlet of A. MacLeish* and Hart Crane's "For the Marriage of Faustus and Helen" and *The Bridge*, which appeared just a year after *Parallax*. It is, above all, a technically adept and dramatically engaging reaction to Eliot's *The Waste Land*. Reviewers immediately compared the two. Since she was as passionately fond of *Prufrock* as she was of its author, finding the echoes of Eliot in her poetry hardly qualifies as literary detective work. Cunard offers one more example of how the long form progressed rapidly during the Jazz Age from the dramatic monologues of Robert Browning or relentlessly positive catalogues of human grandeur in Walt Whitman. Their tendency toward narrative persists in the substructures of *The Waste Land* and *The Bridge*, both based on quest romance, or *The Hamlet of A. MacLeish*, which uses Shakespeare's play. Yet the through line of a plot is only a chassis on which the unity of the work is constructed. Although not as fragmented as Pound's *Cantos* or as abstract as Gertrude Stein's *Tender Buttons*, *Parallax* takes a significant step in the direction of fast-cut bricolage building toward a Wagnerian crescendo, the hallmark of Crane's *The Bridge*, to which it bears a close resemblance. It is more overtly autobiographical than the cautious and "impersonal" Eliot, closer to Archibald MacLeish in the incorporation of her own life, which would stir the morbid curios-

ity of readers intrigued by her wild ways and infamous fights with her family. It has a number of period touches, such as the invocation of Arthur Rimbaud in urban nocturnes and this snippet from the beginning — "each candle wasting at both ends" — which reminds me of Millay, Cunard's hard-living Greenwich Village alter ego.[2] There is a brisk rhythm to parts of *Parallax*, as quotable as the "Shakespeherian Rag" passage in Eliot's *The Waste Land* ("It's so elegant / So intelligent")[3] the percussive train sequence in Crane's *The Bridge*, the cascading cadences of William Carlos Williams's *Paterson*, or the rattling momentum of the express train in the *Prose Trans-Sibérien* of Blaise Cendrars. Like them, Cunard omits the extra connective material and gallops from noun to noun:

Brain

Train

Of conscious passion

Music

Absolution, sweet abnegation

Of choice.[4]

The attraction of Eliot's "impersonal theory of poetry" would be understandable for a celebrity as rabidly pursued as Cunard (when she woke up in a Harlem townhouse after a late night in the clubs, the front stoop was lined with a gantlet of tabloid journalists). As the poem veers into bitter observations on wealth and hypocrisy ("serious patriarchal banks"[5]), it is impossible not to think of the author's strained relations with her family. The deflection of autobiography requires a dramatist's skill at concocting voices, as in the *Waste Land*. One critic has offered a brilliant reading of the philosophical depths of Cunard's poetry: "Unlike Eliot's personae, however, Cunard's figures illustrated the inability to maintain a moral and spiritual value system due to the relative nature of individual perception and reality itself. In this, she anticipated the metaphysical-ontological relativism that marked much of the twentieth century's turn from traditional values to a plural secularism. Her intellectual clarity, unique concrete images, and occasionally passionate confessions distinguish *Parallax* as her greatest poem."[6]

The decadent travels recounted in the poem reflect the adventures of the peripatetic Cunard. In 1922 alone she visited Iris Tree in Menton in

February, moved on to Monte Carlo in March and to Fontainebleau in April, and returned to England for the summer. She went to the beach at Deauville in August, spent September in Spain, and in October was in Venice with the rich and charismatic Robert McAlmon, Wyndham Lewis, and Osbert and Sacheverel Sitwell. This restless pace continued through walking tours of Provence and Italy with Pound and urban binges in London, Paris, New York, and Rome. Nestled in this fluvial travelogue is the abrupt notice of a relationship severed, tucked into parentheses:

— Then I was in a train in pale clear country
By Genoa at night where the old palatial banks
Rise out of vanquished swamps,
Redundant —
And in San Gimignano's towers where Dante once . . .
And in the plains with the mountains' veil
Before me and the waterless rivers of stones —
Siena-brown with Christ's head on gold,
Pinturicchio's trees on the hill
In the nostalgic damps, when the maremma's underworld
Creeps through at evening.
Defunct Arezzo, Pisa the forgotten —
And in Florence, Banozzo
With his embroidered princely cavalcades,
And Signorelli, the austere passion.
Look: Christ hangs on a sombre mound, Magdalen dramatic
Proclaims the tortured god. The rest have gone
To a far hill. Very dark it is, soon it will thunder
From that last rim of amaranthine sky.
Life broods at the cross's foot,
Lizard and campion, star-weeds like Parnassus grass,
And plaited strawberry leaves;
The lizard inspects a skull,
You can foretell the worm between the bones.

(I am alone. Read from this letter
That I have left you and do not intend to return.)

Then I was walking in the mountains,
And drunk in Cortona, furiously,
With the black wine rough and sour from a Tuscan hill,
Drunk and silent between the dwarves and the cripples
And the military in their intricate capes
Signed with the Italian star.
Eleven shuddered in a fly-blown clock —
Oh frustrations, discrepancies,
I had you to myself then.[7]

As tempting as it is to trace the intimate details in this passage — I suppose she is addressing Pound — the title warns against the perils of biographical interpretation. The double vision of parallax is Cunard's version of Eliot's impersonality. It means the simultaneous coexistence of two points of view that, in terms of optics and geometry, yields a prismatic succession of stereoscopic views, such as the mesmerizing effect of looking down through the rows of a vineyard as you pass by on a bicycle. The vines angle off right and left to divergent vanishing points, splitting the sensation of space in time, a cubist illusion both disorienting and pleasant. What were the sources of Cunard's advanced aesthetics? She had superb tutors, including George Moore (her mother's boyfriend), Eliot (who had formal training in epistemology), Pound with his linguistics, and Beckett with his empiricism (his tutor at Trinity, Arthur Aston Luce, was a leading authority on George Berkeley, René Descartes, and Henri Bergson). Using similar themes of divided perception and its representation, Ludwig Wittgenstein, Ernest Ansermet, and MacLeish foregrounded the unreliability of art that hinges on the transience of sensation and the limits of a singular point of view.

Parallax is temporal and spatial, like the Proustian doubling of the present moment with memory, Fitzgerald's "borne back ceaselessly into the past,"[8] or Cézanne's shimmering, translucent planes of leaf and sky. Cunard identifies the "passing and re-passing / By the twin affirmations of never and for-ever / In doubt, in shame, in silence."[9] The knowing echo of the last line of William Butler Yeats's "Sailing to Byzantium" ("what is past, or passing, or to come"[10]) makes sense via Moore, who collaborated with Yeats. There are forthright expressions of the pain of

amours gone awry and alcohol-fueled, all-night revels ending in a cold city dawn similar to Crane's favorite hour. Fleeting youth is linked to the dismal toll of Cunard's romantic life in lines that echo Porter's controversial "Love for Sale":

> Sorrow, my sister —
> Yet who accepts
> At once her tragic hand?
> … Whose beauty pulls
> The will to fragments —
> Young beauty in raffish mood,
> Love to be sold,
> Lily and pleasant rose,
> Street lily, alley rose
> For all Love-to be-sold, who will not buy?[11]

Her knowledge of art history must also be factored into an appreciation of the philosophy in the poem. My favorite section is a wistful visit to Cézanne's Aix-en-Provence, tracing a pilgrimage to his run-down studio as well as the places where he painted *en plein air*. The route has been followed by Pound (with Cunard), cummings, Hemingway, Beckett, Rainer Maria Rilke, Martin Heidegger, Stein, and even Allen Ginsberg. Cézanne's inclusion in a poem titled *Parallax* is a brilliant commentary on the meaning of his doubts regarding the adequacy of paint as a medium. This watershed moment in twentieth-century thought and art is the basis for a central text in phenomenology, Maurice Merleau-Ponty's superb 1945 essay "Cézanne's Doubt." Beckett stressed the same uncertainty: "He [Cézanne] had a sense of his own incommensurability not only with life of such a different order as landscape but even with the life of his own order, even with the life operative in himself."[12] Beckett and the upper-class Cunard, visiting Aix together, were struck by the prosperous Cézanne mansion ("the life of his own order" refers to the life of his father, a self-made banker). For Rilke, who hovered in the studios of both Rodin and Cézanne, the connection is clear in the ninth *Duino* elegy, with the figure of Cézanne descending from another sortie to Mont Sainte-Victoire that ended in defeat: "For the wanderer doesn't bring from the mountain slope a handful of earth to the valley, untellable earth, but only some word he has won, a pure word, the yel-

low and blue gentian."[13] The *Duino Elegies* was published in 1922, that magic year when the *Waste Land* and *Ulysses* also appeared. Heidegger, better known for an essay on Vincent van Gogh, found "a path revealed here, which leads to a belonging-together of poetry and thought."[14] Cunard uses shifting, mobile points of view like Cézanne's flickering brushwork, the modernist starting point for the blurred questioning of form in cubism. Stein owned dozens of the 954 paintings, 654 watercolors, and 1,400 drawings of Cézanne, all of them essentially études. More than two hundred times he determinedly approached the motif of Mont Sainte-Victoire from multiple vantages without ever conquering it. As Stein wrote, "in this way Cézanne nearly did nearly did and nearly did."[15] Doubt is the keynote. Cunard alludes in a single passage to the "beauty" of the paintings, endlessly "re-shaped"[16] but unfinished, similar to Beckett's "Try again. Fail again. Fail better."[17] The Hamlet-like uncertainty is sensed in Beckett's stammering dialogue and the fluttering fingers of Alberto Giacometti (his collaborator on a 1961 production of *Waiting for Godot*) that pared away plaster from the maquettes for sculptures of standing women whose reality he could barely grasp. Cézanne himself wrote: "All that we see dissipates and disappears, does it not? Nature is always the same, but nothing remains of what we see of it. Our art must convey the sense of permanence."[18] After so many essays, the final balance on the picture plane he insisted on (holding together near, middle, and far distances on a flat surface) eluded him. That technical challenge of pictorial space and the epistemological impossibility of "knowing" the mountain via the senses make Cézanne the perfect artist for the irreconcilable realities of *Parallax*.

For Cunard, an unimpressed waiter's gruff verdict on the maestro's legendary impatience takes its place alongside the fate of faded beauty "sold." The heart-rending truth is that soon after his death Cézanne's abandoned studio, for rent when Cunard visited, became decrepit even as collectors and dealers (to this day) profit by auctioning his work on the market. A last-ditch effort by the American art historian John Rewald restored it as a museum when the municipality of Aix took no interest. Cunard finds in this travesty of neglect a parable of art's impermanence rather than monumentality (note the way the "thread of the same story" in the passage cited below plays on "threat"). Cézanne's unrequited love for Aix is captured in a comment he made in 1902 to Jules

Borly, a visitor: "I was born here; I'll die here. . . . I live in my hometown, and I rediscover the past in the faces of people my age. Most of all, I like the expressions of people who have grown old without drastically changing their habits, who just go along with the laws of time. . . . See that old café owner under the spindle tree? What style he has!"[19] It may have been "the master's town" but he is a dim presence:

> In Aix, what's remembered of Cézanne?
> A house to let (with studio) in a garden.
> Meanwhile, "help yourself to these ripe figs, profitez . . .
> And if it doesn't suit, we, Agence Sextus,
> Will find another just as good."
> The years are sewn together with thread of the same story;
> Beauty picked in a field, shaped, re-created,
> Sold and despatched to distant Municipality —
> But in the master's town
> Merely an old waiter, crossly,
> "Of course I knew him, he was a dull silent fellow,
> Dead now."[20]

The history of modernist poetry was written as it unfolded by critics as self-conscious as Eliot and Pound and Jazz Age witnesses such as Jolas, Edmund Wilson, Carl van Vechten, and Malcolm Cowley. They had a blind spot for Cunard's place in the canon even as they included lesser poets. Like hanging the work of Fernand Léger and Murphy side by side, to read *Parallax* with *The Waste Land* is to understand what can be lost in the shuffle when preconceptions rule.

FROM FLAPPERS TO PHILOSOPHERS

6

F. Scott Fitzgerald

In simple terms, there would be no *Great Gatsby* without F. Scott Fitzgerald's visit to France. Revisiting that masterpiece, the summit not just of his career but, some would contend, of American literature, in the context of Sara and Gerald Murphy's vortex of young geniuses restores the vivid colors of the original, faded due to overexposure in pallid movie adaptations and banal misreadings that bask in the ultraviolet radiance of Gatsby's wealth. Fastening the gaze on the glitter of materialism ignores the shadows in which the deeper meanings are inscribed. In just a few months among the stars of modernism in Paris and Antibes, Fitzgerald was transformed from a promising yet provincial writer of stories for the American heartland to a major international novelist.

Either John Dos Passos or John Ogden introduced Scott and Zelda Fitzgerald to the Murphys in May 1924, just two weeks into their second trip to France (they had been in Paris less than a week in 1921, when Zelda was pregnant). They had already met Gerald's sister, Esther, in New York the year before. Dos Passos knew the Fitzgeralds needed a steady pair of friends among the American expatriates, and the Murphys (an Irish Catholic husband out of Yale University with a stylish but wise wife) were the perfect candidates. Gerald was eight years older than Scott, Sara was thirteen years older than Zelda, and the Murphys had three children while Scottie was the Fitzgeralds' only child. Scott and Dos Passos playfully called Gerald "Dow Dow" that summer at the Hôtel du Cap at Antibes when the Villa America was under renovation. A vivid account of those halcyon days is offered by the Sorbonne's André Le Vot, who interviewed European eyewitness sources for his biography of Scott Fitzgerald. He summarizes the experience in these terms: "To Fitzgerald, who knew little of the America of the rich except the vulgar and ostentatious parties he attended in New York and

Long Island, the Murphys clearly represented the sole justification of a society based on money ... it was the Fitzgeralds' imaginativeness and spontaneity that won the Murphys' friendship, not the novelist's fame; they were accepted because of their personal qualities, and they were temporarily excluded on several occasions when those qualities deteriorated."[1] The Fitzgeralds gained access to advanced art and thought that surpassed the world they knew on Long Island and in the Manhattan of the Plaza Hotel, private clubs, and speakeasies. Scott wrote: "A fourth man had come to dictate my relations with other people when these relations were successful: how to do, what to say. How to make people at least momentarily happy." The next sentence admits a certain consternation at this savoir faire, in a voice almost identical to Nick's in *Gatsby*: "This always confused me and made me want to go out and get drunk, but this man had seen the game, analyzed it and beaten it, and his word was good enough for me."[2] Gerald Murphy's competence and honesty offer a contrast to the mendacious braggart Gatsby and the melodramatic Fitzgerald. Sara Murphy's painting may play a role in one of the lingering mysteries of *Gatsby* lore. A recurring problem for early readers, including Maxwell Perkins, was the blurred central figure of Gatsby. At Antibes, Zelda made a series of drawings (now lost) of Gatsby, just as Sara, that same spring, had done the watercolor designs for the characters in *Within the Quota*.

Unlike Hemingway, who deftly navigated the contemporary art world with an informed eye, the Fitzgeralds were novices in that area. Scott's spotty Princeton transcript is underwhelming in the area of the visual arts. When he should have been studying art history at Princeton (his only course in the subject was ancient art, and he managed only a B–), he was writing songs for the Triangle Club's *Safety First* revue, including a witty sendup of the futurists and cubists at the Armory Show in 1913. The lyrics for "Is It Art?" exude a whiff of the Midwestern philistine looking askance at the avant-garde, facetiously comparing "a complex cubist dimple" to the relatively more "simple" *Mona Lisa* and concluding that there is no "Safety First" in the game of artistic judgment.[3]

What baffles me is how Fitzgerald, in Paris and Antibes at all the right moments, missed the opportunity to show off his newly acquired inside knowledge of the contemporary art world. Did the smell of oil

paint in Gerald Murphy's studio have no effect? He knew the artists, so where is the Picasso or Léger that should be hanging over Gatsby's fireplace? We do not even see a still life of a cocktail tray with an amusing backstory about a rich American painter living in Paris. The Murphy biographer Calvin Tomkins infers that Fitzgerald missed the art boat: "Neither Scott nor Zelda seemed to have the slightest interest in the art, the music, the ballet, or even the literature of the period. . . . He never showed any curiosity about Murphy's painting, which he appeared to consider a mere diversion."[4]

Henry James might have included a John Singer Sargent or Mary Cassatt, Tom Wolfe would have hung a louche Max Beckman self-portrait in black tie, a sly allusion to the awkward German origins of Gatsby, or a naughty Tamara de Lempicka society portrait from the era. Duchamp's *Nude Descending the Staircase*, the cause célèbre of the Armory Show, would sort well with the timely music. Scott Fitzgerald eschews these choices. The aphrodisiac toys are confined to the yellow Rolls-Royce, the custom-made shirts, the "Adam study," the "Merton College Library," and "Marie Antoinette music-rooms and Restoration salons."[5] There is not one hint of what hangs on the walls other than silk. Astonishingly, the only reference to an artist in the novel is in the last chapter, where Fitzgerald describes the "fantastic" memory of West Egg as a "night scene by El Greco."[6]

The Murphys escorted Fitzgerald to the perilous edge of modernism's cliff. Looking into the depths of *Finnegans Wake*, the cacophony of the music of Pound and Antheil, cubism, and surrealism, he stepped back from the brink to a more cautious style. There are two viable explanations for this retrograde choice. Proud to be the highest-paid short-story writer of his generation, obsessive about royalties, boastful about the deals cut with studios for film rights, Fitzgerald was shameless in his avarice. As Crane was finding out the hard way, cutting-edge modernism was a hard sell, even with the munificent support of Cunard, Sylvia Beach, Harriet Monroe, and other saintly patrons of the little magazines. The spendthrift Fitzgeralds and Harold Ober, their long-suffering agent, realized that abstraction and expressionism were territories better ceded to Dos Passos or cummings.

Scott Fitzgerald may also have followed the aesthetic of the company he kept. This was the summer of Picasso's *Woman in White*, the Ballets

Russes debut of the neoclassical *Cimarosiana,* Le Corbusier's call to order and other neoclassical landmarks. It was also the moment when Léger and Darius Milhaud were at work on *La Création du Monde.* Critics have overlooked the reference to this ballet with its jagged music in the first party scene of the novel—the faintly disguised reference to a "Jazz History of the World" by Vladimir Tostoff. In one draft of the novel, a passage (cut late) attempts to put the music on paper: "It started out with a weird spinning sound, mostly from the cornets. Then there would be a series of interruptive notes which colored everything that came after them, until before you knew it they became the theme and new discords were opposed outside. But just as you'd get used to the new discord one of the old themes would drop back in, this time as a discord, until you'd get a weird sense that it was a preposterous cycle, after all. Long after the piece was over it went on and on in my head—whenever I think of that summer I can hear it yet."[7]

This focus on the European accent will disturb ardent champions of *The Great Gatsby* as the archetypal American narrative arc described by Theodore Dreiser and Sherwood Anderson through Arthur Miller, the rising trajectory from hardscrabble origins to wealth ending tragically. Despite the local verisimilitude—as a lifelong resident of the "East Egg" of Long Island and midtown Manhattan who crosses the 59th Street Bridge weekly, I can vouch for his pinpoint accuracy—I suggest a more Continental view of how Fitzgerald raised *Gatsby* above the level of *This Side of Paradise* and his stories (especially "The Rich Boy," a 17,000-word, New York–based novella). Consider the expanded intellectual range of Joyce, Beckett, Eliot, Stein, cummings, Hemingway, Crane, and Dos Passos under the same conditions. Paris and Antibes offered a broader horizon than the view from Dublin, St. Louis, San Francisco, Chicago, Boston, or Cleveland.

Gatsby is journalistically based on a specific moment and place: the summer of 1922 on the "Gold Coast" of Long Island and a well-worn path along what is now Northern Boulevard across the 59th Street Bridge to midtown Manhattan. In her paean to the novel, Maureen Corrigan extolls the freshness of this snapshot: "One of the many breathtaking achievements of *The Great Gatsby* is that it thoroughly engages its time without being a one-dimensional political novel."[8] Timeliness had always been Fitzgerald's modus operandi, a secret to his stateside

celebrity as the voice of his generation, the sort of currency (think Tom Wolfe in the 1970s, Jay McInerney in the 1980s, and David Foster Wallace in the 1990s) that rapidly transmits the speech and phenomena of the moment into hot type. Grace of an awakened historical consciousness, by the end of the summer of 1924 Fitzgerald had made the transition from flappers to philosophers. Two sources are important: Oswald Spengler's *The Decline of the West* and Thorstein Veblen's *Theory of the Leisure Class.* In the first chapter of *Gatsby*, Tom Buchanan refers to Spengler's book along with other jeremiads of the time, lecturing his wife and her friends on the crisis of the West's decline. Yet Tom is a boor, the loudmouth Wall Street master of the universe who domineers over suburban dining tables to this day with archconservative rants derived from cursory readings of the latest bestsellers skimmed during gin-soaked commutes on the Long Island Railroad. He conflates Spengler with more odious screeds such as the bestseller of 1920, Lothrop Stoddard's *The Rising Tide of Color: The Threat against White World Supremacy,* the brisk sales of which filled the Scribner coffers so they could take a flier on a young Princetonian's first novel the same year (the house had also published *The Rise of the Colored Empires* and *The Passing of the Great Race* the year before, both bestsellers on eugenics).

Fitzgerald coldly gives Tom just enough rope, the proverbial little learning, to hang himself. Nick is a Yale littérateur snidely regarding two philistines, one a Yale football player and the other a poseur with a nebulous claim to an Oxford degree. When Perkins enthusiastically commented on the revised manuscript in November 1924, he singled out this stratagem of splitting the characters and narrator, cannily adding the reader: "You adopted exactly the right method of telling it, that of employing a narrator who is more of a spectator than an actor: this puts the reader upon a point of observation on a higher level than that on which the characters stand and at a distance that gives perspective."[9] The tricky question is where Fitzgerald fits into this hierarchy. The rapid changes wrought in Fitzgerald by his months in France opened a gap between him and his narrator, who is already above the hero and Tom. The novel can be read as a valediction to his younger self, the portrait of two Midwesterners (Gatsby and Nick) whose point of view is limited by their provincial experience. Fitzgerald occupies the catbird seat, regarding the ecstasy of seductive suburban parties from the

cynical perspective of a worldly twenty-six-year-old whose daily object of study is a gentleman (Gerald Murphy) who "had seen the game, analyzed it and beaten it."[10] The opening words of the novel, "In my younger and more vulnerable years,"[11] announce the wisdom of one who has moved on. Gatsby is placed on one level of ignorance laced with lies; the Yale-educated Nick on the next step up the scale; and Fitzgerald, the one who has met the greatest artists and writers in Paris, on a higher level still, loath to confer the distinction of an art collection on his hero. Only a year before he finished *Gatsby*, Fitzgerald had been much closer to the intellectual level of Nick.

France offered the perspective he had been missing when he was alone in that room over a garage in Great Neck starting to write *Gatsby*. "I would take the Long Island atmosphere that I had familiarly breathed and materialize it beneath unfamiliar skies," he wrote in the memoir "Ten Years in the Advertising Business."[12] He intuitively faced the fact that in *Gatsby* he was turning out all the lights on his own party. By comparison with the hard-news journalists Jolas, Hemingway, Dos Passos, and MacLeish, Fitzgerald scarcely seems a paragon of truth telling. One of the shameless whoppers he and Zelda dined out on was that her affair with the pilot Édouard Jozan led to a duel and even suicide (Jozan died in 1952). Fitzgerald's most famous character is a legendary fake, down to the florid signature "in a majestic hand" on his invitations, whose "elaborate formality of speech just missed being absurd."[13] The telltale name change from Gatz to Gatsby is part of a mendacious streak ("Somebody told me they thought he killed a man once"[14]) that offers intrigue and a smug sense of superiority. Truth is outlined in the novel as the negative space left by the foreground figures of falsehood. Tom ineptly erases the tracks of his infidelity. Jordan cheats in a country club golf tournament (moving her ball). Nick presents himself on the first page as a confessor for the "secret griefs of wild, unknown men" quickly able to assess when their stories "are usually plagiaristic and marred by obvious suppressions."[15] Gatsby's mansion is the "factual imitation of some Hotel de Ville in Normandy, with a tower on one side, spanking new under a thin beard of raw ivy."[16] The ridiculously baronial hall completed in 1923 for Harry F. Guggenheim on Sands Point, which Fitzgerald visited just before he left the neighborhood, serves today as an over-the-top location for twenties-era movies and television shows.

After living in France, Fitzgerald deems the "white palaces of fashionable East Egg" to be "inessential."[17] The "white palaces" allude to the farewell speech of Shakespeare's Prospero in *The Tempest*, whose "insubstantial pageant faded" leads to the epiphany: "We are such stuff as dreams are made on." When the phone rings in the first chapter, Myrtle calling Tom at home, everything "vanished into air."[18]

My favorite demonstration of separating the faux from the genuine is the library scene in chapter 3. Gatsby's mansion is so replete with ostentatious trompe l'oeil imitations of European interiors that it is only logical to assume the books in the library would be for show. Perilously close to his own failings, having faked his way through Princeton, Fitzgerald uses the soused "owl-eyed man" in the library to assure us the books are "absolutely real—have pages and everything." Then he makes a reference to the legendary theater impresario David Belasco, who knew how to dress a stage to effect. The kicker in the scene, however, is an intimation of Gatsby's downfall: "He snatched the book from me and replaced it hastily on its shelf, muttering that if one brick was removed the whole library was liable to collapse."[19]

Of all the improvements Fitzgerald made in *Gatsby*, the most impressive intellectual idea is the use of double vision to simultaneously consider present and past through one moment. In a manner comparable to Cunard's *Parallax*, in turn related to the theoretical physics of Albert Einstein and Niels Bohr, the conflation of past and present is the futile goal of Gatsby (rendered in one wrenching paragraph), stoked by the "colossal vitality of illusion" that he had stored "in his ghostly heart" the Keatsian way in which Daisy's "voice was a deathless song."[20]

Fitzgerald toyed with this double consciousness in the stories, especially when it involved the pursuit of more than one woman by a single man. It reaches more sophisticated depth in *Gatsby*. The brevity of the summer season on Long Island is collapsed in a shocking twist: "It was when curiosity about Gatsby was at its highest that the lights in his house failed to go on one Saturday night—and as obscurely as it had begun, his career as Trimalchio was over."[21] The reference is to a character in the *Satyricon* of Petronius. As late as December 1924, *Trimalchio* was the proposed title for the book, but Ring Lardner and Perkins shot it down because potential readers would be deterred by their inability to pronounce it. A page later we are offered an unusual glimpse into

Daisy's inner feelings: "So the whole caravansary had fallen in like a card house at the disapproval in her eyes."[22] Fitzgerald was a connoisseur of this type of rapid catastrophe, less a denouement from an ecstatic height than a crash. "Holocaust"[23] is the chilling synonym he interjects in the penultimate chapter, when Gatsby's murder follows Myrtle's death ("holocaust" is also in William Carlos Williams's 1923 volume *Spring and All* as well as the "Ave Maria" section of Crane's *The Bridge*).[24]

The paradigmatic instance of double vision is alcohol induced. When Nick and Tom join the low-class sisters Myrtle and Catherine in the love nest on 158th Street just west of Central Park, the second and last time Nick was drunk in his life, the whiskey bottle has been going around, they have sent out for sandwiches, Gatsby's name has been mentioned, and there is still more than an hour to go before Tom strikes Myrtle, breaking her nose. Weary and a little disgusted by the banal chatter, Nick wants to go outside for air but cannot manage to escape: "Yet high over the city our line of yellow windows must have contributed their share of human secrecy to the casual watcher in the darkening streets, and I was him too, looking up and wondering. I was within and without, simultaneously enchanted and repelled by the inexhaustible variety of life."[25]

Parallax depends on an angled vision that is mobile and on a floating sense of time. Written at the height of the Jazz Age, *Gatsby* is disturbingly elegiac. Just as a photograph is an elegy for the moment just past, this archly mimetic glimpse through the hedgerows at a tycoon's party in the summer of 1922 is already conscious of the terminal decay, the passing "caravansary" in all its "hilarity" (the word recurs three times in the first three chapters[26]). The double consciousness of the present and its evanescence is one of the strengths of Fitzgerald's "The Rich Boy" and *This Side of Paradise*, whose heroes glance ahead to the next flapper with each first kiss. Blame the war, or dissipation, addiction, and disappointment (that one area in which Stein's insult about the Lost Generation found its mark). Nick makes this self-pitying and jaded remark to Jordan in their farewell scene: "I'm thirty. I'm five years too old to lie to myself and call it honor."[27]

Nick takes down the paternal Tom Buchanan, using the always awful recognition that a former varsity football star peaks in life at twenty-one. The model for this is the real-life story of Hobey Baker, well known to

the audience for "All the Sad Young Men." Fitzgerald had already given
him his cameo appearance as Allenby in *This Side of Paradise*. Baker
was a bona fide national figure, the superstar of the football team (Fitz-
gerald watched him, helmetless, kick a forty-three-yard field goal to tie
Yale 3–3 in a famous game in 1914) and the greatest hockey player in
Princeton history, drawing standing-room-only crowds of thousands to
Madison Square Garden when he played for the St. Nicholas Hockey
Club. He briefly worked in finance before becoming a fighter pilot in the
elite Lafayette Escadrille. When World War I was over, defying super-
stitious rituals, he announced he would take one more flight, in a plane
that had not had sufficient maintenance. It crashed, and Baker died at
age twenty-six. The important difference between *This Side of Paradise*
and *Gatsby* reflects Fitzgerald's personal progress. Where Baker was the
model for a demigod in the early work, in *Gatsby* he has become a "hulk-
ing" has-been: "Her husband, among various physical accomplishments
had been one of the most powerful ends that ever played football at New
Haven — a national figure in a way, one of those men who reach such
an acute limited excellence at twenty-one that everything afterward sa-
vors of anticlimax."[28] The postscript to this damning comment turns to
"drift," an important verb in the book: "I had no sight into Daisy's heart,
but I felt that Tom would drift on forever seeking, a little wistfully, for
the dramatic turbulence of some irrecoverable football game."[29]

The fun-house reflection of Gatsby mirrors his five-year obsession
with Daisy. He insists crazily: "'Can't repeat the past? He cried incredu-
lously. 'Why of course you can!'"[30] The time references track from the
loudly ticking alarm clock on Jimmy Gatz's bedside table to Gatsby's
wordless retreat in Daisy's presence: "he was running down like an
overwound clock."[31] In the rendezvous scene, Gatsby checks his watch
relentlessly and is ready to leave two minutes before Daisy arrives at
the appointed hour of four o'clock. Then the mantelpiece clock defeats
them, "tilting dangerously" and beginning to plunge before Gatsby
catches it. Nick projects the destruction caused by this awkwardness:
"I think we all believed for a moment that it had smashed in pieces on
the floor."[32]

Then as now, there is a season of parties in the Hamptons, cut off
on Labor Day when the crowd decamps for the city. In the aftermath,
Gatsby's untended grass is too long, there are leaves in the pool, and

the neighboring houses are shuttered for the winter. In the pool parlor on 43rd Street where Nick confronts Wolfsheim, the gangster abruptly declares, "It's all over now."[33] The "blue smoke of brittle leaves" is in the air when Nick packs up his little house on West Egg, and Jordan's hair has turned "the color of an autumn leaf."[34] Gatsby's mansion has descended to "that huge incoherent failure of a house,"[35] and Fitzgerald is about to write the epitaph for the Jazz Age before it is even half over. Instead, he offers a register shift. At one moment, Nick is noticing with disgust the obscure graffito scrawled with a brick on the white steps of the mansion, and he tries to erase it with his shoe. From that vulgar low point, Fitzgerald builds a crescendo of lyricism that is so exquisitely paced, so eloquently phrased and soundly constructed, that it occupies a special place not just in the novel (we must discern the difference in style from the other high point, the visionary invocation of Manhattan from the bridge) but also in the history of American literature. My own beloved teacher, Alfred Kazin, was no fan of Fitzgerald. "His senses always opened outward to the world, swam in it as self-contentedly as the new rich, and understood it sagely and the world was full of Long Island Sundays," Kazin wrote in exasperation.[36] He reluctantly admitted to me, then a recent Princeton graduate, that he considered the final sentence of *Gatsby* to be the greatest single sentence written by an American. To reach it, the passage advances in three movements. Fitzgerald offers a Whistlerian nocturne that changes into a vision of a mythic, prehistoric paradise, a moonlit scene in which "the inessential houses began to melt away." Nick pictures the green paradise of the unspoiled island as it appeared to a Dutch explorer, "face to face for the last time in history with something commensurate to his capacity for wonder."[37]

Fitzgerald unabashedly repeats "wonder" in the next paragraph, returning us to the summer of 1922 even as he manages to hold the wheel through the turns of the next three paragraphs (the draft he took with him ends with the paragraphs in which he broods on the unknown world). From present to Edenic past to the most difficult transition, the pivot to the future, his prose maintains traction:

> Gatsby believed in the green light, the orgiastic future that year by year recedes before us. It eluded us then, but that's no matter — tomorrow we will run faster, stretch out our arms farther. . . . And one fine morning —

So we beat on, boats against the current, borne back ceaselessly into the past.[38]

For the Fitzgeralds, the champagne went flat abruptly. It was not the Wall Street crash that precipitated their collapse, but Zelda's mental illness. After grabbing the steering wheel on a dangerous turn when they were returning to Paris from Aix, Zelda was committed to a clinic in Malmaison, Switzerland, on April 23, 1930. "Paris had grown suffocating," Scott wrote in exasperation.[39] Matthew Bruccoli offered, midway through his sympathetic biography of Fitzgerald, an insight into what went wrong: "As the Twenties lurched or sprinted forward, Fitzgerald's warning notes became clear. Yet the preacher was unable to heed his own sermons. He could only send out messages from within the hysteria. The moralist had to be a participant. By 1929 Fitzgerald knew that he had lost something. Not his genius, not his capacity to feel intensely, not even his capacity for work. He had lost his belief that 'life was something you dominated if you were any good.'"[40]

The bitterness of the exodus from France via a Swiss mental clinic was soon compounded by betrayal. Perhaps because Murphy was an upstanding patrician, or because his endless generosity and forgiveness amassed a debt of gratitude, he was rewarded by the calumny of Fitzgerald's *Tender Is the Night*. Nine years in the making, the "novel of deterioration"[41] turned the tables on the Murphys, to whom it was dedicated. Their portrait is cruelly disfigured by dipsomania, infidelity, and insanity more closely resembling the Fitzgeralds' domestic shambles than the paradise of the Villa America. The year the novel was published (1934), Zelda, having already made manic attempts to become a classical ballerina and writer, tried her luck in the art market. During her solo show of thirteen paintings and fifteen drawings at Cary Ross's gallery and the Algonquin Hotel in New York from March 20 to April 30, 1934, the only buyer was Dorothy Parker, who took home *The Cornet Player* (now lost). The epigraph for the catalogue was: "Parfois la folie est la sagesse" (Sometimes madness is wisdom). Scott Fitzgerald's novel of revenge was especially malicious, as it was published not long after the death of both Murphy boys within six months of each other — eleven-year-old Patrick had been diagnosed with tuberculosis, but it was devastating when his fifteen-year-old brother, Baoth, died first,

of meningitis while at boarding school. Hemingway, whose later memoir *Moveable Feast* was also unkind to the Murphys, pulled no punches in a verdict on Fitzgerald's cowardly exploitation: "Goddamn it you took liberties with people's pasts and futures that produced not people but damned marvelously faked case histories. . . . You could write a fine book about Gerald and Sara for instance if you knew enough about them and they would not have any feeling, except passing, if it were true."[42]

NEW AMAZEMENTS

Hart Crane

When the literary lights of the Jazz Age are invoked, the glamorous, ocean-liner set comes readily to mind (F. Scott and Zelda Fitzgerald, Ernest Hemingway, John Dos Passos, e. e. cummings, Robert Benchley, Dorothy Parker, Noël Coward, Cole Porter, and George Gershwin) along with their stern predecessors James Joyce, T. S. Eliot, Gertrude Stein, and Sherwood Anderson. Few would invite the troublesome Hart Crane to this party. He was an uglier drunk than Fitzgerald, and his work is hellishly opaque. Eager to protect his Whitmanesque ecstasies from what he deemed the negative mood of Eliot, Crane was the epic celebrant of the moment, translating it in jazz symphonies that blend the "orgiastic"[1] *Gatsby* with the Joycean linguistic excesses of his dear friend and champion Eugene Jolas.

Crane was twenty-nine when he finally made it to Paris. The scion of a Cleveland candy baron (his father invented the Life Saver), he was courted by the ill-fated Harry Crosby (an heir to the J. P. Morgan fortune), Walker Evans, William Carlos Williams, Marsden Hartley, Alfred Stieglitz, and Anderson. It was a bittersweet adventure similar to Fitzgerald's in that he brought with him the manuscript for his masterpiece, *The Bridge*, finally published in 1930 — just months after the death of its guardian angel, the publisher and patron Crosby. A prodigy whose first appearance in print came when he was only eighteen, Crane replied to the taunting invitations of his Montparnasse-based American friends with letters about holding court in salons discussing music, art, literature, and the mystical philosophy of P. D. Ouspensky in a tower at his mother's shabby genteel home in Cleveland. "Apollinaire lived in Paris. I live in Cleveland, Ohio," he remarked to Matthew Josephson, who had started a literary review, *Secession*, based in France.[2] He spent the Jazz Age in Cleveland and in New York at a copywriter's desk at the J. Walter Thompson advertising agency (beginning in May 1923,

not long after Fitzgerald was first on the clock at the rival Barron Collier agency). Like Hemingway, Crane never attended university (he told his father he was going to New York to study at Columbia University, and to land a reporting job at *Fortune* through Archibald MacLeish, he shamelessly pretended to be a graduate of Case Western Reserve University), but he was a superb writer of literary criticism. In his "General Aims and Theories," a brief but essential essay from 1925, Crane explains the "grafting process" that melds tradition and the shock of the new: "It is a terrific problem that faces the poet today—a world that is so in transition from a decayed culture toward a reorganization of human evaluations that there are few common terms, general denominators of speech that are solid enough or that ring with any vibration or spiritual conviction. . . . Its evocation will not be toward decoration or amusement, but rather toward a state of consciousness, an 'innocence' (Blake) or absolute beauty."[3]

Crane's most entertaining Jazz Age–style poem is "For the Marriage of Faustus and Helen," published in 1923 in *Secession* after some delay and radical editing. Its scenario is right out of a Fitzgerald short story or Dos Passos's *Manhattan Transfer*. On a rooftop bar in Greenwich Village one summer night, a jazz band with a hot cornet player serenades a beauty, our Helen, based on a woman Crane glimpsed one day on a streetcar. By turns urbane and harsh, it looks ahead to other series (including *Voyages* and *The Bridge*), combining "something terribly fierce and yet gentle."[4] The money culture of the age (exemplified by his father's boasts of the millions he made and offering a parallel with the way wealth was on the conscience of Nancy Cunard in *Parallax*) dominates the opening stanzas, which extract heroic drama from such mundane items as office memoranda, baseball statistics, and stock prices.

The poet encounters his Helen on the streetcar after enduring the embarrassment of finding himself short of either a nickel for the fare or a transfer. Although the poem begins at dawn (many of Crane poems —notably, sections of *The Bridge*—progress from dawn to dawn) the most vivid depiction of Helen is at the Charleston party on the roof, distinguished by the brisker tempo of shorter lines ("Glee shifts from foot to foot"[5]). Crane's wild nights in New York careened "from roof to roof," supplying the authentic sensation ("naively—yet intrepidly") of reeling momentum led by the driving accelerando of a torrid cor-

net solo to "new soothings, new amazements." The denouement has the ring of autobiographical accuracy: "And you may fall downstairs with me / With perfect grace and equanimity."[6]

Where Fitzgerald had Gerald and Sara Murphy, Crane had Harry and Caresse Crosby (sybaritic friends of the much tamer Murphys). The map of the two writers' travels is strikingly similar, starting in the Midwest, migrating to New York where they were advertising copywriters, and then moving to Long Island (Fitzgerald on the Gold Coast; Crane further out, at Brookhaven), Hollywood, Paris, and the Côte d'Azur. Fitzgerald drafted *Gatsby* in close proximity to the Plaza Hotel and the 59th Street Bridge, then revised it in Antibes. Crane nearly finished *The Bridge* looking at his subject through the window of the now-famous apartment at 110 Columbia Heights and then had the creative jolt he needed to finish in 1929 ("the most decisive year of my life"[7]) in the château of the Crosbys and in Collioure, just along the Côte d'Azur from Antibes. The narrative arcs of these two tales of lost innocence align with their rhapsodies on Manhattan; their nocturnal reveries and dawn epiphanies; and their powerful evocations of prehistoric New York in counterpoint with the most up-to-date references to the wealth, cheap thrills, postwar frailties, and destructive desires of the Jazz Age. The critic David Bromwich also notes that in Crane, who owed his own intellectual debt to Spengler, "there is something akin to Scott Fitzgerald in the chaos of squandered energies that gradually engulfed him."[8]

As for Hemingway and Crane, an unforgettable web of coincidences dramatizes how tightly interwoven were the two lives. Both eventual suicides, they were born on the same day of the same year to overprotective mothers named Grace in prominent upper-middle-class households in the Midwest. Neither went to college, and both served as teenage apprentice journalists with unquenchable literary aspirations fanned by the same mentor, Anderson. Crane was in midtown watching the May Day 1918 parade down Fifth Avenue, to the blaring strains of "Over There," when Hemingway went by. They shared a number of friends — including Dos Passos, cummings, Slater Brown, and Williams — as well as a fearless publishing house, Boni and Liveright. Toward the end of their lives, both Crane and Hemingway would find refuge in Cuba.

Crane the literary autodidact made his pilgrimage to Paris the culmination of his long-term passion for symbolist and modernist literature in French. He channeled Jules Laforgue through Eliot, Ezra Pound, and the translator Arthur Symons. After returning to New York in 1930, Crane wanted to maintain the momentum via a Guggenheim fellowship. The "Plan of Study" section of his application reads: "I am interested in characteristics of European culture, classical and romantic, with especial reference to contrasting elements implicit in the emergent features of a distinctive American poetic consciousness. My one previous visit to Europe, though brief, proved creatively stimulating in this regard, as certain aspects of my long poem, *The Bridge*, may suggest. Modern and medieval French literature and philosophy interest me particularly. I should like the opportunity for a methodical pursuit of these studies in conjunction with my creative projects."[9]

On January 6, 1929, he was greeted in Paris by Jolas, who had been planning to publish Crane's poetry in *transition* since early 1927. Jolas declared that "after Crane, America has no poets."[10] Crane's work was included in the first issue of *transition* (alongside items by MacLeish, Stein, and Joyce) as well as many others to follow, during which he tried out in public the private process of conceiving and executing an epic poem as, section by section, *The Bridge* was published. In the way that he had escorted Joyce's *Finnegans Wake* to its first audience, Jolas accompanied the excerpts from Crane's poem with adulatory essays by himself, Kay Boyle, Williams, and others, which explained that Crane was trying to "absorb the rhythms of the indigenous Afro-American and Indian traditions, and find skyscrapers of the fourth dimension he dreams of."[11] As Dougald McMillan points out in his superb blow-by-blow history of the magazine, including the month that Crane spent planning its sixteenth issue, the mutual admiration linking Crane and Jolas was based on "the restoration of 'the word' as the medium of truth."[12]

Events moved too fast for Crane, a vulnerable literary lion cub set loose in Paris. Jolas connected him with Harry Crosby, the founder of the Black Sun Press. According to Crosby's diary for January 19, 1929, the plan to publish *The Bridge*—completed at his estate, Le Moulin, in Ermenonville—was in place just two weeks after Crane arrived in France. During the daily "teas" (cocktail parties at which Crane was

inevitably tipsy), they planned the format for the volume, including a print of the Joseph Stella painting of Brooklyn Bridge. Crosby was enthralled: "Hart Crane for luncheon and a long talk on poets and sailors he is of the Sea as I am of the Sun."[13] One Tuesday Crane paid his respects to Stein. His notebooks and drafts in hand, Crane took Crosby up on his offer of a rustic sanctuary at Le Moulin, with its Gatsby-esque fêtes (complete with a form of polo played with golf clubs on donkeys), where he wrote the "Cape Hatteras" section, the fourth of eight sections of the epic poem. His writing thrived in the tower room, where he had installed all the best furniture in the place overlooking "a forest like that in *Pelléas et Mélisande*, with a roaring fire burning all day long in the fireplace and old peasant servants to bring me red, red wine."[14] Trusting souls, the Crosbys left the bibulous Crane alone for the week in their château when they returned to Paris. Harry exuberantly praised each draft and promised a lavish limited edition of two hundred copies on heavy stock. The parties at Ermenonville continued into April, with enough Cutty Sark on hand during weekdays to keep Crane's writing fueled. In late April he headed to the ravishingly beautiful seaside town of Collioure on the Côte d'Azur and on to Marseille, where he spent some time with Marsden Hartley and read *The Hamlet of A. MacLeish*. This, not coincidentally, is when he decided—having also read Samuel Taylor Coleridge's *The Rime of the Ancient Mariner* earlier in the trip—to use a marginal gloss for *The Bridge*. From Marseille Crane explored Paul Cézanne's landscape ("you see him everywhere here"[15]) in the footsteps of Pound and Cunard. The material he garnered immediately found its way into the poem, such as the reference to the "songs that gypsies dealt us at Marseille."[16] The Crosbys were gently applying pressure on Crane to produce a final draft in September, in time for a December publication date.

Then came the notorious July night at the Café Select in Paris when Crane, with fifty centimes in his pocket and a stack of empty saucers on his table, could not pay his bill. Other Americans offered to settle his tab, but the manager refused their cash. Crane took on the waiters, then assailed a squad of gendarmes with chairs and bottles. He was flung into a cell at the notorious La Santé jail, where he was beaten with a rubber hose. After a week, he had his hearing, and cummings, Crosby, and other influential people from the *Nouvelle Revue Française* were

Joseph Stella's *Study of the Brooklyn Bridge* (1922) was one of many versions. Hart Crane was so inspired by the "divine" approach to the subject that he commissioned Stella to write an essay for *transition* and to illustrate the Black Sun Press edition of *The Bridge*.

able to spring him. Just before Crane's thirtieth birthday, Crosby gave him a fifth of Cutty Sark to last him the first few nights on the homeward passage to New York.

Crane returned with the nearly complete manuscript for his masterpiece, *The Bridge*. In France, he summoned the Keatsian powers he needed, as in the rhapsodic ode that became the proem "To Brooklyn Bridge," with its unapologetically lyric references to the "dip and pivot" of the gulls at dawn "shedding white rings of tumult" as the span crosses the "chained bay waters" toward the Statue of Liberty.[17]

The parallels between *The Bridge* and Fitzgerald's *Gatsby* extend beyond the circumstances of their creation. Fitzgerald launched his apostrophe to the city from the 59th Street Bridge in the fourth chapter of *Gatsby*, after the car has passed through the Dantesque Valley of the Ashes (Crane's poem has its corresponding inferno, "The Tunnel"). The ecstatic passage reads: "Over the great bridge, with the sunlight through the girders making a constant flicker upon the moving cars,

with the city rising up across the river in white heaps and sugar lumps all built with a wish out of non-olfactory money. The city seen from the Queensboro Bridge is always the city seen for the first time, in its wild first promise of all the mystery and the beauty in the world."[18]

Here is a corresponding description from an essay on the Brooklyn Bridge by Stella, whose painting was the frontispiece of the deluxe edition of *The Bridge*. Crane brought this essay to Jolas for publication with his epic poem:

> Seen for the first time, as a weird metallic Apparition under a metallic sky, out of proportion with the winged lightness of its arch, traced for the conjunction of WORLDS, supported by the massive dark towers dominating the surrounding tumult of the surging skyscrapers with their gothic majesty sealed in the purity of their arches, the cables, like divine messages from above, transmitted to the vibrating coils, cutting and dividing into innumerable musical spaces the nude immensity of the sky, it impressed me as the shrine containing all the efforts of the new civilization of AMERICA — the eloquent meeting point of all forces arising in a superb assertion of their powers, in APOTHEOSIS.[19]

Sometimes a gesture is all you need to begin to understand a work of art. The truest emotion displayed by Gatsby is outwardly expressed in the raised arms of that unforgettable visionary embrace of a redemptive future, when he "stretched out his arms toward the dark water in a curious way."[20] In an article about the glorious Mediterranean written as he finished *Gatsby*, Fitzgerald observed: "When your eyes first fall upon the Mediterranean you know at once why it was here that man first stood erect and stretched out his arms toward the sun."[21] The same raised arms recur with regularity in Crane's poetry. They are seen in the "hands extend and thresh the height" that conclude "For the Marriage of Faustus and Helen."[22] They are in the proem to *The Bridge*: "night lifted in thine arms." Trace that verb "lift" through the epic and you find it at the close of "Quaker Hill," "The Tunnel," and in the elegy to Crosby, "The Cloud Juggler." The gesture is most beautifully captured in the love poem "Voyages III" when the ocean "lifts, also, reliquary hands."[23] The rhapsody of desire and supplication strikes me as worthy of a Martha Graham solo or the arresting final tableau of George Balanchine's *Apollon Musagète*. Crane was a great admirer of William

Blake, whose illuminated books are crowded with figures, some tiny, of children or adults making an unmistakably similar gesture. So do the white arms of the shrouded figure that emerges from the luffing spinnaker in Marsden Hartley's gloomy *Eight Bells/Folly* (1932), a disturbing elegy he painted in memory of Crane (the eight bells and the huge red sun signal high noon, when Crane jumped to his death). Hartley, who had accompanied Crane on his revels both in New York and in France, wrote three essays about Crane. A later American artist, Jasper Johns, made the extended arms the principal motif of a group of paintings, drawings, and prints dedicated to Crane. Johns's *Diver* and *Periscope* are two major paintings that tighten the terpsichorean ecstasy of the outstretched arms into plank-like boards, like the rendering of words in blocked out stencil forms. The motif is Johns's elegiac reminder that neither Fitzgerald nor Crane should ever have fully trusted in the saving embrace into which they flung their heroes.

At the beginning of "The River," in one of the most sensually thrilling passages in the poem, we are aboard the Twentieth Century Limited out of Grand Central Station "whistling down the tracks"[24] westward. Billboards flash by too fast to be read completely, and the up-tempo effect is one of the jazziest passages in the work. It's a hit-and-run scene with the graphic punch of Fitzgerald's eyes of T. J. Eckleburg; of Blaise Cendrars's train odyssey on the Trans-Siberian Railway; and the billboard-inspired paintings of Fernand Léger, Murphy, and Stuart Davis. Crane beats out a "breathtaking" tattoo of passing patent names from Tintex to Japalac, Certin-teed Overalls, Ford and Edison (whizzing by so fast they become "Thomas a Ediford").[25] The last part of the train we see is the red eye of the taillight disappearing into the darkness.

The next train is the subway in a section that offers the aural response to the visual virtuosity of this section. It is also the darkest, most pessimistic part of the poem, a descent through the turnstile and down the stairs into the tunnels of "hades in the brain," the express subway that "yawns the quickest promise home."[26] Like his gimlet eye for roadside signs, Crane's keen ear tunes in and out of broken conversations in the din. The voices span the city's mix of classes, nationalities (a Genoese cleaning lady takes her star turn, reminding me of Dos Passos, especially *Manhattan Transfer*). The realism is intensified by the details. Crane catches the snippets you hear today in the system. "IS THIS

FOURTEENTH?"[27] refers to the Union Square station on the Broadway line, still one of the busiest stops in the system, along with Times Square and Columbus Circle.

With Cunard and Langston Hughes, Crane was one of the most adroit translators of jazz into poetry. The steady, high-decibel backbeat of the trains brings to mind a backstage gem from the world of contemporary music. Gershwin revealed to a biographer that the epiphany that led to completing his *Rhapsody in Blue* came during a train ride from New York to Boston. Even the language is similar to Crane's poem: "It was on the train, with its steely rhythms, its rattle-ty bang, that is so often so stimulating to a composer — I frequently hear music in the very heart of the noise. . . . And there I suddenly heard — and even saw on paper — the complete construction of the Rhapsody from beginning to end."[28] Gershwin, Fitzgerald, and Crane were all riding the same express nonstop to greatness and recognition by age thirty, followed by disaster.

Literary research is a quiet pleasure that occasionally brings a heart-stopping moment. At the hallowed Berg Collection of the New York Public Library, I treated myself to an encounter with the poetry of MacLeish in typescript and the luxuriously bound first editions of Cunard's *Parallax* and *The Bridge*. Opening the handsome blue leather cover of the presentation copy of the Horace Liveright edition of Crane's epic, I paused at the inscription. Dedications from Jazz Age writers are rife with incestuous links among friends, editors, wives, muses, patrons, critics, playwrights, and movie and Broadway producers. This was the most distressing inscription I ever read:

> To Caresse Crosby —
> with love and gratitude
> and in Harry's memory —
> always
> Hart Crane
> Brooklyn, '30

The awful story of the double suicide is well known. Thanks to world events, the scene had shifted from the château in Ermenonville to Manhattan in the fall of 1929. Just the day before the market crashed (Monday, October 28), reducing the Morgan fortune by several digits, Crane

sent a telegram to Harry and Caresse begging them to "DEFER PUBLI-
CATION. LOVE — HART"[29] In his frenzy to complete the work, Crane
had been on another tremendous spree. This was the period when he
maintained a gallon tank of bootleg corn whiskey, which cost him only
six dollars to refill, in his Brooklyn apartment. On December 7, he in-
vited the friends who had seen him through the writing of the epic,
at that stage in proofs, to his apartment. The guests included William
Carlos Williams and his wife Flossie; e. e. and Anne cummings; Mal-
colm and Peggy Cowley; and Walker Evans, whose brooding, slightly
blurred photograph of *The Bridge* appears as the frontispiece. They
were also sending off the Crosbys, due to sail back to Europe on the
thirteenth. Crane's party broke up near dawn, but only with the prom-
ise to reconvene a couple of days later at the Caviar Restaurant in mid-
town before a night at the theater.

The second dinner was hosted by the Crosbys. Caresse and Harry's
mother were on time, but Harry was a no-show. The party moved on
to the Lyceum Theater, where Leslie Howard was appearing in *Berke-
ley Square*, but Crane and others were anxious about Harry. So Harry
Mortimer volunteered to check in at the studio uptown at West 67th
Street. Crane told the theater usher to summon him if an urgent phone
call came to the box office. Sure enough, the flashlight of the usher ap-
peared in the aisle at his row. Harry had been found dead in bed, fully
clothed, with nineteen-year-old Josephine Ratch dead beside him.
Both had gunshot wounds to their temples made by his 0.25 caliber Bel-
gian pistol, found in his hand. The coroner ruled that both deaths were
suicides. When Caresse, Crane, and the others arrived at the Hôtel des
Artistes they had to make their way through a crowd of rubberneckers,
press, and police. Caresse and Harry's mother sailed on the thirteenth
as planned after a rushed funeral, and Crane, shaken, returned to the
galleys of his book.

I could not help noticing, as I studied the inscription, a fleck of ink
between "with" and "love," another between "love" and "and" and a
third between "and" and "gratitude." These telltale spots where the tip
of Crane's fountain pen paused lightly on the paper disappear in the
next line, along which the even flow of Crane's cursive adds, "and in
Harry's memory." Less than three years later, Crane plunged into the
Atlantic from the stern of the homeward-bound *Omerica*.

WEARY BLUESMAN

Langston Hughes

8

By decade's end, many of the century's greatest literary careers had been launched by the materials and movements that, like decent croissants and excellent wine, could be found only in France. Manuscripts postmarked Paris became one debut volume of poetry or fiction after another published in New York and London. Expatriates found their voices through communion with rivals and friends in a diaspora that spoke French with a soupçon of Midwest, New England, or Harlem accents. Langston Hughes maintained an uneasy equilibrium between edge and beauty, advocacy and seduction, while his sense of identity swung between Americanness and global citizenship (with the accent on Africa), blackness and the ambivalence of his mixed-race background. For seven months at the peak of the Jazz Age he lived in Ernest Hemingway's Montmartre, but Hughes was not a *flâneur*—he was a *plongeur* (dishwasher), in the kitchen of a club called the Grand Duc. His autobiography opens with a Conradesque gesture of liberation during the departure of a freighter on June 13, 1923, the very day he impetuously signed on as crew. As the ship left port and rounded Sandy Hook, New Jersey, Hughes jettisoned the books from his freshman year at Columbia University (he earned his bachelor's degree at Lincoln University, years later): "Melodramatic maybe, it seems to me now. But then it was like throwing a million bricks out of my heart when I threw the books into the water. I leaned over the rail of the S.S. Malone and threw the books as far as I could out into the sea — all the books I had had at Columbia, and all the books I had lately bought to read."[1] He was bound for Senegal, the Gold Coast, Nigeria, and the Congo, his first international journey. All his trips returned to Harlem. His second voyage on the next freighter that hired him, the *Mckeesport*, left Hoboken, New Jersey, on February 5, 1924, for Rotterdam, the Netherlands, where the twenty-two-year-old took $20 in wages and jumped ship to

Langston Hughes was only twenty when he arrived in Paris with seven dollars in his pocket, after jumping ship. Only two years later, his debut volume *The Weary Blues* was published.

fulfill a dream. He boarded the train to Paris. Hughes was distressingly aware that he had left one renaissance for another when he temporarily traded Harlem, at its musical and literary height, for Paris. He sought a synthesis of strengths that would advance the gritty lyricism he inherited from Claude McKay, Paul Laurence Dunbar, Countee Cullen, Sterling Brown, Thomas Fortune Fletcher, Carrie Williams Clifford, and Walter Everett Hawkins.

Hughes presents a vivid example of the transcontinental avant-garde dilemma. For all the romantic descriptions of spring in Paris with Anne Coussey, his *soignée* African British girlfriend, in seven vividly epicurean chapters of his autobiography, he held tight to the persona of the street-smart New Yorker. In addition to Alain Locke's tutelage on tour in Paris and Italy, Hughes's artistic growth was fostered by the sophisticated cultural tastes of Coussey, a protégée of Isadora Duncan who took him to museums and Versailles. Arnold Rampersad, Hughes's editor and biographer, reports that Coussey pointedly criticized the lowlifes in the Montmartre crowd and pushed him to return to college. A

letter she wrote on July 26, 1924, after reading his latest poems chided him: "I am afraid you are getting into a groove, there is a sameness about your things. I wonder if Paris is responsible, or it perhaps that you are not really original?"[2]

The Paris experience shaped his first two volumes of poetry, *The Weary Blues* (1926) and the regrettably titled *Fine Clothes to the Jew* (1927), published by Knopf at the urging of Carl van Vechten, who had met Hughes in Harlem and who later arranged for him to file stories about jazz on assignment for *Vanity Fair*. Why Knopf, when Sylvia Beach or Nancy Cunard could have found him a suitable small press in Europe? Just as Eliot, Pound, MacLeish, cummings, Crane, Fitzgerald, Hemingway, Pound, and Eliot sent their manuscripts back to editors in New York or London rather than publish locally (as Joyce did, having been prosecuted in New York), Hughes recognized that his ideal reader was more likely to be found slugging whiskey and tapping out the tempo to a stride piano solo in a club up on Lenox Avenue than leafing through *Vogue* in a corner of the Dome to the accompaniment of a wheezing accordion. Bookstores, record stores, galleries and radio stations — the ultimate destinations for poetry, novels, paintings, and music — offer a clue to one of the essential aesthetic issues of the time. Even the Europeans were not immune to catering to American audiences. Jean Cocteau and Le Corbusier scrupulously maintained their Parisian disdain for American vulgarity, but Léger, Igor Stravinsky, Darius Milhaud, Balanchine, and anyone with an eye on the potential marketplaces of New York and Hollywood all tapped source materials that specifically appealed to American tastes (such as Charlie Chaplin, cowboys, and the Charleston). In 1921 Joyce wanted *Ulysses* to reach New York readers and shock the prudes back home in Dublin. He was close to a deal with Boni and Liveright, publisher of cummings, Hemingway, Crane, and many others who skirted the line on censorship, but the obscenity trial in which John Quinn successfully defended an expurgated version of *Ulysses* was enough to scare the editors off.

The self-consciousness of Americans in Paris was a legacy from an earlier generation. It furnished Henry James and Edith Wharton with story lines (and Mark Twain with some of his best comic set pieces). With the next generation, far from innocent and embittered by postwar antipathy to flags in general, the question of Americanness was more

complicated. By the time Gershwin wrote his popular suite, there were 400,000 Americans annually in Paris, mostly tourists. The number of the real expatriates, the permanent residents, had grown rapidly from 1920, when there were only 8,000 Americans living in Paris, reaching 32,000 by 1923. Porter and Murphy made dual identity the premise of *Within the Quota*. When they were interviewed for the Paris edition of the *New York Herald* just before it opened, each had a comment on the ways that the expatriate life shaped their work. Porter noted: "It's easier to write jazz over here than in New York because you are too much under the influence of popular song in America, and jazz is better than that."[3] In the same article, Murphy ambiguously observed, "Paris is bound to make a man either more or less American."[4] Murphy received MacLeish's "American Letter" from the latter's Uphill Farm in Conway, Massachusetts (he had taken his children home so they would grow up American), in September 1928 just before the Murphys went home. The poem is dedicated to unpacking the duality of being Americans ("my native land") shaped by the productive years in France. It nostalgically confuses the notion of "home" by starting with a memory of sailing off St. Tropez, looking at red roofs and eating the incomparable olives of Provence. MacLeish wonders in conclusion about how "a wise man" such as Murphy can "have two countries."[5]

Hughes had three countries, if you count Africa as a country, but his writing was American fare. He agonized more over how far to push the dialect of Harlem blues for a downtown audience than over its exotic appeal to Europeans. Assimilation for Harlem Renaissance performers meant changing the set list for midtown. No centrifuge could precisely spin off the purely Parisian trace elements in his poetry, his Midwestern roots in St. Louis and Cleveland, his passionate attachment to Harlem, his selective attention to freshman humanities at Columbia, or the brief but meaningful encounter with Africa. The memoir records in idiomatic French his first dinner in Paris, *boeuf au gros sel* and the *fraises des bois, épaule de veau,* and *coeur à la crème* he split with Coussey on their last day together (her prosperous African British father had sent a doctor to escort her home to marry a wealthy colonial official). There are Francophone titles and phrases in the early poetry of the first two volumes, including two Pierrot pieces and a "Poème d'Automne." Combing the poems for subtle hints of reading Hughes may have done

turns up echoes of Charles Baudelaire, Arthur Rimbaud, and Laforgue, who loved to intersperse lines from popular songs with those in his own voice. Mallarmé's "Plainte d'Automne" and the unrequited desire in *L'Après-midi d'un faune* lingers in the background of Hughes's debut volume, *The Weary Blues*. Then there are the purely American inventions, similar to those of Crane and Williams, such as the snappily interspersed use of song lyrics in capital letters with bar dialogue in "The Cat and the Saxophone (2 A.M.)" which matches the banter of a cummings seduction scene. With an ear as finely attuned as that of any jazz composer, Hughes captures the blues phrasing and mood ("weary," but plugging along), steadily contracting the number of beats in both types of line to sharpen the end point. In his first two published volumes, he craftily interweaves tributes to jam sessions at clubs on Lenox Avenue with typically Continental fare, such as "Parisian Beggar Woman" and "Nude Young Dancer." Josephine Baker, with whom he shared a St. Louis background, was the "night-dark girl of the swaying hips."[6] She arrived in Paris after Hughes, who interviewed her in 1937. The prefiguration of Porter's tom-tom in "Night and Day" (written nine years later) is heard in the opening couplet of "Danse Africaine," which conjures up the shocking and popular tribal number in Baker's *Revue Nègre*:

The low beating of the tom-toms,
The slow beating of the tom-toms,
Low . . . slow
Slow . . . low—
Stirs your blood.[7]

An even more Parisian poem is the venting of the resentful voice of the kitchen hand watching the swells (lords, ladies, dukes, counts, American millionaires) "out for a spree" at the Grand Duc. He growls to the jazz band: "Play that thing."[8] It is the most overtly Continental poem in the second volume, which on the whole is more American in diction than the first. Published a year after the first volume, the second is also blacker and angrier. This overt protest attracted the political notice of both van Vechten and Cunard, who featured Hughes in *Negro*, her anthology. The chorus of dissent is sustained as well in another pointed lyric, comparable to the voice of Hughes from the kitchen of the Grand Duc. In a cautionary tale that might have been addressed

to any number of Harvard men then in Paris or Harlem, "For a Certain Ph.D. I Know," Hughes advises the "damned fool" to "forget those years" in the Ivy League as well as his "tourist-third summers" running around Europe or, most pointedly, the exotic forays uptown when he "discovered" Harlem.[9]

The world-weary "I Thought It Was Tangiers I Wanted" (an uncollected poem from the period) begins with the Seine. The tone is so disaffected that it is difficult to believe Hughes was only twenty-two when he lived in Paris. His better-known earlier poem, which starts "I have known rivers,"[10] excludes the Seine. As Cunard assembled itineraries in *Parallax*, Hughes uses rivers to trace his travels, and starts the poem with a glimpse of Notre Dame and the recognition that the Seine is now not just "a wriggling line on a map."[11] The rest of the poem gives a tour of his ports of call, from Paris to Antwerp, Genoa, Africa, and Venice, returning in resignation to the "sure thing" of Notre Dame being in Paris and the world-weary kicker: "But I thought it was Tangiers I wanted."[12]

Stein and Stravinsky translated cubism into poetry and music. Pablo Picasso, cummings, Crane, Fitzgerald, and Stuart Davis rendered jazz in art and text. Of these efforts to carry the aesthetic of one medium into another, Hughes is the most authentic at putting blues on the page because he had the prosody down cold. A prefatory note to his second volume spells out the formula — one long line repeated, the third line rhyming with the first two — he used to structure seventeen of the poems. With the right saxophone and fretless bass player and drummer as accompaniment, you could sing "Hey": "I feels de blues a comin', / Wonder what de blues'll bring?"[13]

Teasing out the threads of literary influence in Hughes's poems after his months in Montmartre is trickier than combing his Morningside Heights period, because there are still echoes of the books that ended up in the harbor off Manhattan as well as a whole new library. His short lines and rhymes (in "Beggar Boy" and "Joy") echo Blake's *Songs of Experience*, while the long-line celebrations of the downtrodden washerwomen and laborers are close to the work of Walt Whitman as well as such populists as Vachel Lindsay; Carl Sandburg; Dunbar, Hughes's mother's favorite; and the Jamaican-born Claude McKay, author of *Spring in New Hampshire* (1920) and *Harlem Shadows* (1922).

Even when the ostensible setting is Harlem, as in the "broken" heart punch of "Lenox Avenue: Midnight," the lyricism of the "swish of rain" and "rumble of street cars" in Harlem is filtered through Parisian "overtones/undertones," notably the grim recognition that "the gods are laughing at us."[14] Like Eliot or Cunard writing about London, or Joyce about Dublin, Hughes while he was living in Paris managed to conjure a Harlem rent party at midnight more vibrantly raucous because it is so dearly missed. The blues line leads, but the backup voices are French. The broken-down "weary heart of pain" is close to "le chair est triste, hélas"[15] — one of the most famously enervated openers in modern poetry, from "Brise Marine" by Mallarmé, which had gained a wider readership in the twenties thanks to the translations of Arthur Symons. By the time Hughes headed back to Harlem, he had enough poems for two volumes in a voice he could call his own. Just a few years later, Cunard would select his "I, too, am America. I am the darker brother" as the epigraph to *Negro*. She concluded the paragraph on literature in her foreword with this prophecy: "Langston Hughes is the revolutionary voice of liberation."[16]

9
MAKING IT IN THE
PARIS ART WORLD

Sidney Bechet, Josephine Baker, and Langston Hughes were not alone in Paris. Just as the musicians moved along the track from New Orleans to Chicago, Harlem, and then Paris, a group of painters followed a migratory route to France via the Art Institute of Chicago and illustration gigs in Harlem. They benefited from the Harlem Renaissance and the New Negro movement, commemorated in 1925 by the publication of a beautiful art deco anthology edited by the philosopher Alain Locke. Thriving journals such as the *Crisis* (1910–present), the *Messenger* (1917–28), *Opportunity* (1923–49), and *Negro World* (1918–33) hired, among others, William Edouard Scott, Albert Alexander Smith, Bruce Nugent, and Romare Bearden. In 1921, the New York Public Library held the first major New York show of black artists. The Art Institute of Chicago began an annual tradition of celebrating a "Negro in Art Week" in 1927, and a year later the crucially important Harmon Foundation sponsored its first touring exhibition of black painting.

Once in France, these artists fared even better. Henri Matisse and Auguste Rodin invited blacks and Asians to their studios. Ezra Pound's vortex included Hale Woodruff, a close friend of George Antheil. Gertrude Stein in the twenties, after an earlier commitment to Pablo Picasso and Matisse, turned her attention as a collector more to the figural and landscape art of black Americans. It was part of a broader, long-term artistic project started in spring 1905 when she wrote the intimate "Melanctha" section of her novel *Three Lives*, in which she delved into the life of a maid (a century before Kathryn Stockett's best-selling novel *The Help*). In 1934, *Four Saints in Three Acts*, Stein's opera with an all-black cast choreographed by Frederick Ashton and music composed by Virgil Thomson, opened in Hartford, Connecticut. Some of the best galleries at the right addresses, as well as the juried group shows such as the Salon d'Automne, Salon du Printemps, Salon des Tuileries, Société

des Artistes Indépendants (usually called the Salon des Indépendants), and Salon de Paris, opened their doors to include the work of black artists. A major group show dedicated only to black artists was held in 1927 at the Artists' Club on the Boulevard Raspail. Palmer Hayden showed at the prestigious Galerie Bernheim-Jeune, and Woodruff was represented by the Galerie Jeune Peinture. Major collectors pursued their work, such as Stein and Albert Barnes, a patron of William H. Johnson. The William E. Harmon Foundation was a New York–based, real estate–funded charity founded in 1922 that started building playgrounds and sports fields in the ghettos of small cities. Until 1933, when it ended along with the New Negro movement itself, it also offered a substantial $400 grant to artists. Other sources of funds for artists intent on making the trip abroad were the Julius Rosenwald Foundation (Sears Roebuck's charitable arm), the Carnegie Corporation, and the just incorporated Guggenheim Foundation. Historically black colleges began collecting art. Howard University's Galley of Art opened in 1928 in the chapel basement. In 1911 the Hampton Institute (renamed Hampton University) started to acquire paintings by the Jazz Age generation of black artists, and Fisk University started its art collection in the 1930s with works by a number of the artists who made the trip to Paris.

The movement of black artists included Woodruff, Hayden, Johnson, Gwendolyn Bennett, William Edouard Scott, Aaron Douglas, William Thompson Goss, Archibald J. Motley Jr., Nancy Elizabeth Prophet, Augusta Savage, and Lara Wheeler Waring. One figure at the center of their loose circle, a mentor who opened many doors, was Henry Ossawa Tanner. He had been in Paris since 1891, three decades before the first arrivals from Harlem began to knock on his door at 86 Rue Notre-Dame-des-Champs (the same street where Ernest Hemingway lived). Tanner was supposed to study theology, following in the footsteps of his father, a bishop of the African Methodist Episcopal church in Pittsburgh. He defied parental advice and accepted a scholarship to study art, becoming a pupil of Thomas Eakins at the Pennsylvania Academy of Fine Arts. He inherited his master's luminous palette, harmonically keyed to a dominant blue-green, as well as Eakins's technical panache. Tanner headed to Paris at age thirty-two and has a painting in the collection of the Louvre. He was elected president of the Société Artistique de Picardie and named a chevalier of the Légion d'Honneur.

Tanner managed to honor his father in his subject matter. Like the Nazarenes or pre-Raphaelites of a generation before, he painted narratives with religious themes. His style featured a postimpressionist manipulation of the paint in the service of capturing the play of light and shadow. A classic Tanner painting is his devoutly romantic and completely French depiction of the modest house of Joan of Arc in Domrémy. Completed in 1918, it contrasts a brightly lit yellow doorway with the crepuscular blue veils. His creamy impasto and mingled lavender and silvery whites read as mother-of-pearl, while the dominant harmony of his palette is an aquamarine that tinges the green cast of Eakins with blue glazes in which light seems trapped. He was also under the spell of Paul Cézanne, whose thin layers of blue and green over one another had the translucency of watercolor.

Many black painters retained their conservative taste in landscape and figure paintings, a commercially appealing aesthetic that dominated Right Bank galleries. A prime example of the genre is Scott's *Along the Seine* (1914), which certainly adheres to the Tanneresque palette and technique. The river placidly flows under a heavy curtain of blue-lavender sky, intensified around the deeper indigo and purple of the cathedral towers. Commingled greens and the signature sliver of gold and white of the sun are gestures from Tanner's bag of tricks. Scott left his home in Indianapolis to attend the School of the Art Institute of Chicago in 1904. After executing a few mural commissions depicting the black experience, he left for Paris in 1909 to study with Tanner as well as at the Académie Julian and the Académie Colarossi. A junior Tanner protégé who also studied at the Art Institute (as well as the Fogg Art Museum at Harvard) was Woodruff. Originally from Cairo, Illinois, he won his Harmon fellowship for bronze sculpture. In Paris he started his training with Tanner but moved on to the Académie Scandinave and the Académie Moderne. The closely fitted forms in a winter landscape he painted in 1928 follow the *cloisonniste* method of fauve and symbolist painters a decade before, but the high-volume palette of purples and oranges that Maurice Denis and Matisse unleashed has been chilled by whites and cool tones (Tanner's favorite corner of the color chart) to an ascetic harmony of gray-greens and blues. Woodruff returned to mural painting, for which he is best known, when he came back to the United States.

Not all the black painters in Paris were from the Midwest. Johnson was born in Florence, South Carolina, moved to Harlem to study at the National Academy of Design (1921–25), and then attended the Cape Cod School of Art in 1925. He became a studio assistant to George Luks, one of the prominent members of the Ashcan School. Johnson's other teacher was Charles Hawthorne, an academic painter and James Whistler's former studio mate. Johnson arrived at Tanner's door in 1926 and stayed in France for three years, doing his best work in Cagnes-sur-Mer, where Chaim Soutine, among others, had gathered. Johnson ventured further than many of the more conservative black painters of his generation into expressionist boldness, along the lines of formal freedom that Soutine also displayed, and turned loose the hotter tones of Paul Gauguin and Edvard Munch. Like Soutine, whose arching walls and sloping rooftops were the hallmarks of his townscapes, Johnson made the old houses and winding lanes in Cagnes-sur-Mer freely dance and bend in his paintings.

There is a stronger artist who pairs well with the ripe jazz flavors in the poetry of Hughes. Motley was a protégé of George Bellows at the Art Institute of Chicago in 1919. The twisting bodies of his master's large-scale crowd scenes are echoed in such complex party pictures as *Blues* (1929), which Motley painted in Paris while living on a Harmon stipend. The central couple in the whirl of dancing figures is a white or light-skinned flapper who bears a similarity to Nancy Cunard (whom Motley knew). She absentmindedly dangles a cigarette behind her black partner's back even as she trains her hungry eyes on one of the guys in the band. This is not a descent into the melancholy, dark blues of Hughes but a turn around the dance floor at a spotlit, upbeat Harlem or Montparnasse revel. It echoes not just the Laocoön-like pretzel configurations of Bellows but important French sources, bustling paintings of the Moulin de la Galette by Pierre-Auguste Renoir and Picasso as well as café-concert views by Henri de Toulouse-Lautrec and Edgar Degas that similarly scatter white accents of cuffs, collars, and pearls. Motley often used titanium white to make the smiling teeth of dancers and musicians flash. The tilted white disks of the tabletops and the precisely noted red wine in the stem glasses offer a handle of hard-edged geometry and precision. The *contrapposto* shimmying of the dancers is complemented by the trombone, trumpet, clarinet, and the head of a bass or

Archibald Motley's *Blues* (1929) captures the freedom of a "black and tan" club in Paris.

violin that curl their way around the writhing bodies, visually entwining the couples just as the music surrounds them. The painting pulses with the beat and proudly, defiantly displays black culture's allure.

Like a double shot of whiskey, neat, Motley's glimpse of the late-night action in a blues club makes a bold claim to truth through authenticity, down to the scrupulous recording of complicated gradations of skin tone (his *Octoroon*, painted in 1925, is almost painfully color conscious). Theresa Leininger, an expert in the art of Motley and other black artists of the era, observes: "In the tradition of explorers who have consciously or unconsciously linked travel with the search for the self, both the expatriates and those who returned to the United States gained a broader sense of themselves and the world from their sojourns. Paris was the proving ground for black Americans of the pre–World War II era whose success there greatly contributed to their artis-

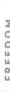

tic careers in the United States. Going abroad gave them the distance to better understand what DuBois called their 'double consciousness,' their dual identity as Americans and as persons of African descent."[1] This harmonizes with an interview Wynton Marsalis, the Louis Armstrong of our time, gave Geoffrey Ward for his multipart series on jazz, which dwelled on the crossroads of race in the musical community. Marsalis defined the trading zone in which musicians safely meet: "The real power and innovation of jazz is that a group of people can come together and create art — improvised art — and can negotiate their agendas with each other. And that negotiation *is* the art."[2]

Dozens of similar bicultural pilgrimages to Paris were made by brave artists leaving home behind to negotiate their own accords with modernism as it was being invented. Two women courageously took on the challenge alone. One was a nice Jewish girl from Brooklyn, while the other was a sharp-tongued rebel from China who paid the price for her supposed corruption at the hands of European teachers when she returned to teach in cosmopolitan Shanghai. Anna Walinska was the shy but determined daughter of a labor organizer in the Manhattan fur trade and an artsy mother. She was nineteen when she left the Art Students League for Paris in 1925. Her family balked at paying for her passage, so she cut a deal with her father's boss: she would bring back an oil copy of a masterpiece from the Musée du Luxembourg in exchange for the $2,000 she needed to spend a year abroad. You have to love the jackknife denouement to this tale. When she returned a year later with a creditable version of Paul Baudry's "La Fortune et le Jeune Enfant," the painting so delighted her dad that he paid the debt and kept the painting. In Paris Walinska lived on the Rue Madame and then on the Rue Stanislaus in Montparnasse, right around the corner from Stein, in whose salon she was frequently welcomed. She shared a café table with Picasso, who let her draw his portrait. She enrolled in the studio classes at the Académie de la Grande Chaumière, where Fernand Léger taught many Americans. She chose to study with André Lhote, a synthetic cubist and superb teacher. Walinska's accomplished synthetic cubist style became the underpinning of the abstract expressionist paintings she made back in New York in the 1950s. She frequently returned to Europe and then took a wild, round-the-world trip in 1954, being waylaid in Burma for four months where she became the court painter and

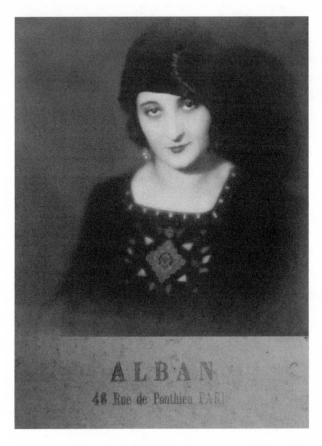

Anna Walinska painted in both the subdued palette of Picasso and the cubists and the bright colors of Matisse and the figurative artists when she studied in Paris from 1926 until 1930.

created portraits of the king. She had major shows at the Pennsylvania Academy, the Baltimore Museum, and the Jewish Museum in 1957.

According to Rosina Rubin, the artist's niece, Walinska was not exclusively an adherent of cubism: "My aunt was both a Picasso person and a Matisse person, an artist of line and an artist of color, a cubist and a realist. She did not believe in confining herself to one school."[3] At one point she is delineating the jaw line, hands, and shoulders of a harlequin with the steady line of the early Picasso, and at another she is brushing away at the edges of a landscape in the smoky style of Braque or Lhote. A pastel of one woman combing the hair of another has some of the blank absence of features that is found in the silhouettes of Édouard Vuillard, combined with the palette of Paul Sérusier or Pierre Bonnard. The combination looks ahead to the figural paintings of the later American master Milton Avery. It also resembles a painting made in 1923 (a

few years earlier) by Sonia Delaunay, couturier and artist, which also places one woman behind another in a bright, modern interior, implicitly in a fitting session at a couturier's. Walinska also painted from life, loosening her arm and wrist to trace the curves that became part of the gestural vocabulary of her abstract expressionist paintings, whose palette was often gray, black, and white. She had a way with grays, pearlescent and interrupted or tinged with yellows or lavenders, and cut with

On one of her first afternoons in Paris, Walinska found herself sharing a café table with Picasso and drawing his portrait.

streaks of white like the Chinese *fei bai* (flying white) stroke. In the bold vertical work *The Naked and the Dead*, the grays mingle with mustard yellows and browns. Forms descend in a swinging gestural motion like leaves rocking to the ground. I turned the painting over to have a look at the label and let out an involuntary gasp. There by the title was another one, "Holocaust," reminding me of the series the artist committed to an impossible aesthetic task. Returning to the central, almost figural form in the work, its contrapposto exposed a skeletal armature that reminded me not only of Alberto Giacometti's macabre floor sculpture often called "The Rape" but also of the large grisaille antiwar statement Picasso painted in June and July of 1945, *The Charnel House*—which takes its place by *Guernica* and the *War* and *Peace* murals as a raw response to barbarity. Picasso's thin black lines, tracing the crypt's architecture in the background, wend their way into Walinska's black-and-white paintings, and it is tempting to think that she might have been deliberately quoting the giant with whom she took coffee one day in 1925.

The other adventuress whose story is a parable of freedom and its price was Pan Yuliang, the first woman from the young Republic of China to earn a government scholarship to study art abroad. Born on June 14, 1895, in Yangzhou, a village in Jiangsu Province, her real name was Chen Xiuqing. Sold at fourteen to a brothel, she attracted the affections of an up-and-coming customs official, Pan Zanhua, in Sun Yat-sen's newly formed government. They moved to Shanghai in 1916, and she learned to read and write. Having been interested in drawing and embroidery (one of her few memories of her mother was of her embroidering), Pan displayed a natural talent that was nurtured by their neighbor, Hong Ye, a professional painter working in the Western medium of oils. She was in the first cohort of women to attend the Shanghai Art Academy, founded by the forward-looking Liu Haisu, who departed from traditional brush and ink studio practice and opened courses in Western oil painting, one of which was taught by Wang Jiyuan. Liu's more controversial move, however, was a short-lived experiment with life drawing. Crowds of enraged locals besieged the school. When Pan resorted to drawing in the public baths, she was attacked by a crowd of annoyed women who destroyed her sketches. Her problems with censorious Chinese prudes had only just begun.

Pan's progress was so rapid that she was accepted at the École des Beaux-Arts in 1922. She then won the Rome Scholarship and went to the Accademia di Belle Arti for a year. Like Motley's, her work concentrates on the figure and takes as its subject matter women of her own culture. By 1930, in part through encounters with the intense works of Matisse and earlier colorists such as Gauguin, her palette became bolder. A brooding self-portrait shows her defiantly staring at the viewer from before the glowing windows of her Paris studio. The broad apricot stripes on her blouse match her lipstick (apricot in Chinese is *xing*, a pun on good luck), and her cheeks are liberally rouged. The patterns and palette are similar to the interiors of Vuillard, while the pose and style are a firmly mimetic cross between André Derain and Amedeo Modigliani, with a hint of Matisse. Departing from the tradition of the Chinese *Mustard Seed Garden Manual of Painting* meant, for example, replacing the *kong bai* (blank leaving) compositional strategy, which left the negative space near the center of the paper empty, to fill the background with pattern. Two of Pan's most important Paris paintings were *Qingchen* (Dawn), which she painted in 1928, and *Chun* (Spring), completed in 1930. The latter has a strong family resemblance to the circling dance groups of Matisse, with a touch of the sun-dappled Bonnard. Phyllis Teo, an expert on Pan's work, notes that she tended to pick women of color for her models or use a mirror to create self-portraits. One Manet-like double portrait (made in 1939) juxtaposes a black model with a white woman. In her commentary on *Chun*, Teo writes: "Her rich palette of exuberant colors was something only rarely seen amongst the restrained expressions of existing Chinese oil paintings. Pan's style and technique bear [a] resemblance to that of French modernists like Matisse and André Derain; her human figures are depicted liberally with gestural brushwork and their forms simplified with rhythmic emphasis."[4] Her nudes also share the sinuous style seen in the work of Tamara de Lempicka, Marie Laurencin, and an earlier generation of Jewish painters in Montparnasse led by Modigliani (whose 1917 reclining nude series she saw), including Moïse Kisling and Chaim Soutine.

With her diploma from the world's most prestigious art school and medals from the Salon d'Automne in hand, Pan returned to Shanghai in 1928 to teach at her alma mater. Her rapid promotion to the rank of

full professor of Western-style painting provoked jealousy. She had five solo shows, but the nudes were still too provocative even for Shanghai, and angry crowds gathered at yet another opening. When her detractors dredged up references to her past, it was time for her to move on. The well-known modernist painter Xu Beihong, another École graduate, was running the new National Central University in Nanjing and invited Pan to teach there in 1931. When she exhibited a life study of a male nude at a faculty exhibition, her husband decided that he had had enough. He went back to his first wife, and Pan decided to return to Paris, where she remained until her death on July 22, 1977. Even after her death, the Communists made her the target of their anti-Western spiritual pollution campaigns. During an exhibition in Beijing in 1993, several of her nudes had to be removed because of the stir they caused. Many are signed with the seal she used when she was homesick: "Forever and ever toward the Jade Passage."[5] She was buried in the Cimetière du Montparnasse in traditional Chinese robes. In an ironic postscript, in November 2015 a Chinese billionaire bidding at Christie's in New York set a world record at auction for a patently erotic Modigliani reclining nude, *Nu Couché*, the centerpiece of a private museum he is building in Shanghai.[6]

It is a long way from Harlem hot spots to Shanghai, just as there is an immense gap between a former prostitute from the Chinese countryside and Cunard, the heiress. The privileged Ivy League coterie of Cole Porter and F. Scott Fitzgerald is far from the New Orleans circle that Bechet and Armstrong moved in, just as the manicured lawns and winding lanes of Monte Carlo, home to the Ballets Russes, is nothing like the rough neighborhood under the Brooklyn Bridge where Hart Crane sought inspiration. What brought all these figures together was the freedom they found briefly yet wondrously in Paris, whether joyous or destructive. In the same city, at the same time, a profoundly different aesthetic was also in the process of being discovered by a group of artists who decided that they would be free to return to order and reassert their creative control over a world nearly destroyed during World War I. Their stories, and the strikingly different art they made, are next in this exploration of the intimate circles that made Paris the artistic capital of the world in the Jazz Age.

Oh! Blessed rage for order
— Wallace Stevens,
"The Idea of Order
at Key West"

ORDER

BLESSED RAGE

If freedom was the dominant mode of the twenties, then its opposite number had an uphill battle to wage. The rectitude of a white cube house, the sharp black edge of a machine in a still life, the precise mathematical relations behind musical harmony and the strict periodic tables of world history may not be the first things that come to mind when the Jazz Age is mentioned. They imply too much discipline for an era when rules were meant to be broken. Yet Le Corbusier's immaculate purism, his partner Fernand Léger's tightly constructed paintings, the astonishingly prescient music theory of Ernest Ansermet (which predates by a century the omniscient algorithms of Google and Wall Street), and Oswald Spengler's best-selling *Decline of the West* converge in a movement to bring form under control. Le Corbusier's urgent call to order was heeded even by Pablo Picasso, the leader of the avant-garde pack. Its appeal was timely. During World War I, the younger generation saw more than its share of destruction. The clean and systematic approach to art and life restored a sense of restrained beauty.

As the Americans descended on Paris with their visual repertoire of Madison Avenue graphic design, together with the succinct style of advertising copy and headlines, they brought their own version of this tidy and economic aesthetic. Among painters, writers, and musicians, the current vogue in France was vague. Debussy's arpeggios and layered chromaticism rose into nebulae of harmonies that were the musical answer to Monet's atmospherics. The smoky blur of cubism, a

twilit *sfumato* that Picasso and Braque had used to dissolve the edges of café tables and absinthe glasses, was the painterly response to the atmospheric poems of Mallarmé, who insisted on keeping a cloud of pipe smoke between himself and the world. The precision of the still life paintings of Gerald Murphy and Stuart Davis, following closely upon the heels of Le Corbusier and Léger, cleared the air and filled the canvas with light. What had been bleary was sharpened into focus with a twist of the lens. The cold, hard line of machinery replaced the classic cubist arrangement of wine bottle, glass, pipe and café table-top. Steel, drop-forged or polished to a sheen that brought even more light to the composition, became the material of choice, an invocation of power in the studio that recalled the power it had represented on the factory assembly line or battlefield, particularly for Léger. Realism and its cousin surrealism diverted the linear progression from cubism to greater abstraction, prefiguring a style of precisionism that would flourish later, when the artists returned to the United States. In Paris, Picasso remained the leading light, even if he had left Montparnasse for his villas on the Côte d'Azur and in the suburbs, and the cubist idiom he had created remained a vital element in his stylistic development. The tight phase of painting ushered in by Le Corbusier and Léger did not forget the spatial lessons of cubism, but cleared the air to reveal the forms that had always been there.

Joseph Stella's *Study of the Brooklyn Bridge* (1922) was one
of many versions. Hart Crane was so inspired by the "divine"
approach to the subject that he commissioned Stella to write an
essay for *transition* and to illustrate the Black Sun Press edition
of *The Bridge*.

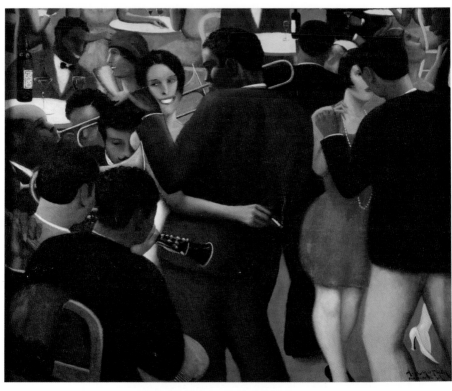

Archibald Motley's *Blues* (1929) captures the freedom
of a "black and tan" club in Paris.

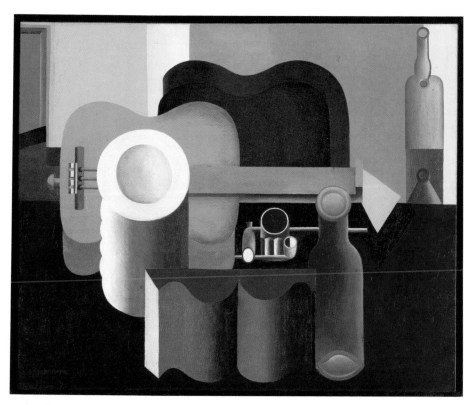

Le Corbusier's *Still Life* (1920) is an exemplary purist painting, meticulously defining the contours of "universal" machine-made bottles and objects, with a sly allusion to the cubist guitars of Picasso.

The monumental scale and precise edges of Fernand Léger's
Élément Mécanique (1924), suspended over an indeterminate
red background, emphasize his passion for the "objectivity"
of the machine.

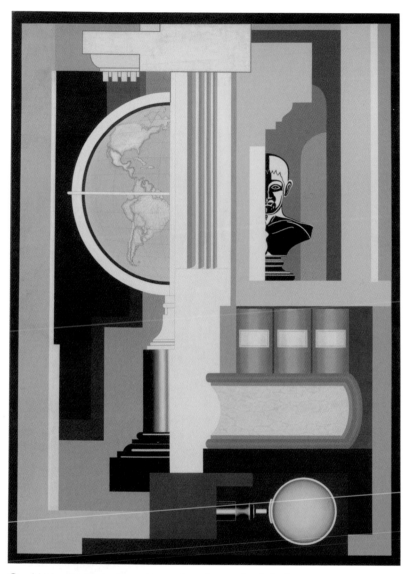

Gerald Murphy worked steadily on this tribute to his father's
Manhattan library, *Bibliothèque*, from 1926 to 1927, leaving the
titles of the books and the countries on the globe blank.

Pablo Picasso painted *Woman in White*, his portrait of Sara Murphy,
in the fall of 1923 when he returned to Paris from Cap d'Antibes, where
he had spent most of the summer on the beach with the Murphy family.

Mandolin and Guitar (1924) was one of a series of nine large still-life paintings that reflect Picasso's experience designing stage sets for Diaghilev.

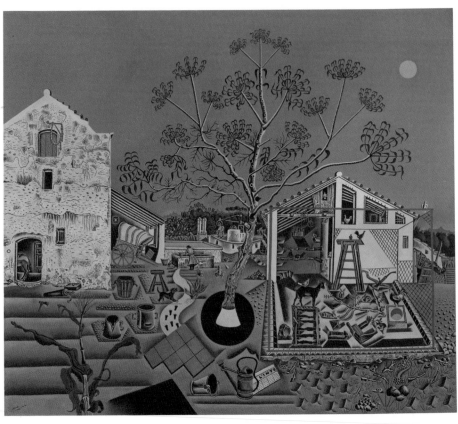

Ernest Hemingway acquired Joan Miró's *The Farm* (1921–22) as a birthday gift for his wife Hadley and later visited the artist's childhood home in Montroig where the work was started.

EXISTENTIAL OCTAVES

Ernest Ansermet

Everybody knows the stars of the era — Louis Armstrong, George Gershwin, Cole Porter, Duke Ellington, Igor Stravinsky, Erik Satie — but the transatlantic musical community needed a nodal figure to negotiate the contradictions between new and old. Cue Ernest Ansermet, carrying baton. Among the bons vivants in the circle of the Ballets Russes, none attended more opening nights, jam sessions, rehearsals, dinner parties, and café debates in Paris, the Côte d'Azur, New York, and London than this young Swiss conductor, raised in a village not far from where Le Corbusier was born. Ansermet was the first choice of ballet and opera companies to interpret contemporary music. Like Jean Cocteau, Eugene Jolas, and Carl van Vechten (all in his circle), Ansermet seems to have had the uncanny ability to befriend the most influential artists and possess the secret weapon of always being in the right place at the right time.

Classical music lovers may recognize his name because his recordings as conductor of L'Orchestre de la Suisse Romande, which he founded and conducted for more than five decades, garnered so much airtime back in the day when there were still enough classical radio stations on the air that some of the more serious ones would play full symphonies. The image of the white-haired Ansermet accurately beating the four-count tempo of a Haydn symphony hardly conveys the firebrand of the twenties, however. He was the go-to interpreter of the most advanced modernist composers, including Stravinsky, Anton Webern, Manuel de Falla, and many others. Born in Vevey in the Suisse Romande on November 11, 1883, he became the principal conductor of the Ballets Russes for their American tour in 1916 and was soon after a frequent guest conductor at the Metropolitan Opera House, Covent Garden, La Scala, and other major houses. In addition to his career in music, he was a professional mathematician. It was his major at the

Sorbonne, and the subject he taught at the Lausanne Gymnasium, his alma mater. It informed his reading of intricate scores and guided his deft hand in the engineer's booth during recording sessions, when he became the mainstay of London Decca's classical division. His grasp of sine waves and the physics of recorded sound gave him an advantage in the booth, where balancing the levels in the predigital age was a matter of having a sure hand on the dials.

A musical prodigy who first conducted at age seven in Montreux, Ansermet met Sergei Diaghilev through his mentor Pierre Monteux and became Stravinsky's choice to be at the podium for the premiers of *L'oiseau de feu* (Firebird, 1910), *L'Histoire du soldat* (1918, in Lausanne), *Symphony of Psalms* (1930), and other works. He was not the conductor of *Sacre du Printemps* on the night of the riot—that was Monteux. Because Diaghilev was among the first to embrace jazz, Ansermet diligently acquired impeccable jazz credentials. When he was in New York in 1918 he made a pilgrimage to Harlem to sample the piano wars when rivals alternated at the keyboard in the clubs along Lenox Avenue, and in Tin Pan Alley downtown he met Irving Berlin to learn about ragtime. Ansermet rapidly decoded the jazz use of $2/4$ time and the mysteries of syncopation.

My favorite Ansermet anecdote is an artistic rather than musical gem, testimony to his worldly skill in exploring the inner motivations of the geniuses with whom he collaborated. It was the spring of 1917, and Ansermet was preparing to conduct the premier of *Parade*. Pablo Picasso at the time was taking heat from his old cubist friends (led by Max Jacob) for running with the ballet crowd and painting his retrograde neoclassical portraits. One day he let Ansermet in on his personal view of the relationship between abstraction and realism. Just as Ansermet's career had shuttled between uptown and downtown, New York and Paris, and jazz and classical music, Picasso's excursion into the ballet theater had opened new possibilities to a hand that could accomplish anything. The conductor asked the artist about his controversial retrogression back to the figure. "But don't you see? The results are all the same!" Picasso bragged.[1]

Ansermet was uniquely qualified to understand that cryptic statement. He had participated in the progress of modernism with his friends Fernand Léger and Blaise Cendrars (also born in the Suisse

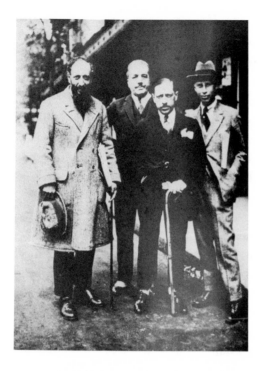

(From left) Ernest Ansermet, Sergei Diaghilev, Igor Stravinsky, and Sergei Prokofiev in 1921.

Romande, in the same mountain village as Le Corbusier). In the twenties, Ansermet was in the ranks when the expected march toward abstraction took a detour. He witnessed firsthand the way form was both assaulted and exalted as the music passed through his orchestra and the sets before him changed. Cubism and neoclassicism took turns from one evening to the next, even from scene to scene (in *Parade*, the Manager in his cubist costume literally cedes the stage to neoclassical decor). The equation Picasso proffered was not some flip comment about how adept his hand was, but an observation about the status of painting that could be readily applied to music or literature. Ansermet spent decades thinking it through in a spectacularly interdisciplinary theory of music and consciousness that embraced art, science, literature, mathematics, and philosophy. Published at last in 1961 by a small press in Switzerland, *Les fondements de la musique dans la conscience humaine* is a remarkable study that starts with the mathematics behind the laws of harmony, tonality, and rhythm. It advances rigorously through the physics and psychology of aural perception to a unified system of musical consciousness. In the preface, Ansermet explains that the

philosophical basis for his theory combines the phenomenology of Edmund Husserl and the existentialism of Jean-Paul Sartre. After hundreds of pages of inquiry into the logarithms and geometry that underlie the laws of harmony, the basic intervals, and even the physics and psychology of hearing itself, Ansermet rigorously demystifies the "magic of music" in terms of the calculations he mastered as a mathematician.[2] Among the many extramusical references are those to Hermann von Helmholtz, Bernhard Riemann, Pythagoras, Joseph Fourier, Georg Ohm, the Weber-Fachner law, Gottfried Leibniz, Albert Einstein, Niels Bohr, and Max Planck.

These are not the glancing allusions of a dilettante, as pages of equations and geometrical diagrams cogently transcribe the rational basis for the effects of octaves, scales, temperament, melody, and musical forms. Gradually the geometry, based on wavelengths and familiar Pythagorean proportions among intervals, leads to an image-based mode of thought. The "nervous energy" of the musical motif and its perception is a phenomenon that Ansermet describes in visual terms, distinguishing "real" space from the "purely subjective" space of music.[3] The images he offers (vectors, spirals, hyperbolic curves, and ellipses) are both geometrical and graphic. "Auditory consciousness and musical consciousness calculate the nervous energy of the ear," he observes.[4] The appeal, however, is to the eye — especially at the crucial juncture when Ansermet vehemently demands that music embody a truth that is ontologically and existentially valid through its "liaison au monde" (one of the chapter subheads).[5] Another dazzling book by a conductor, John Elliott Gardiner's recent biography of J. S. Bach, offers a similar riff on the pervasive ellipse in Bach's music, traced through an arched gesture in the manuscripts, tonal relationships in the cantatas and the Saint John passion, the "rainbow" structure of the bridge of the viola d'amore, and (I might add) the gesture made by the conductor.[6]

Applying philosophy to music, asserting the "existential direction of the octave," Ansermet relates melody to the line traced not just in space but also in time, an image that has its "affective" influence on consciousness and also takes its place among the noetic or phenomenologically established entities in the world outside subjectivity.[7] This is by no means the easiest moment in the book, but as Ansermet valiantly struggles to relate the sensory path (*chemin*) of time to conscious-

ness, it quickly becomes the dominant question. This phenomenology dead-ends at Sartre's *scissiparité*, the dual nature of self-consciousness. Translating Ansermet on this is a challenge: "At the heart of auditory consciousness, what is at the same time consciousness of the self as well as consciousness of perception as well as of the self, a sort of *scissiparité* (as Sartre puts it) operates between the two indissociable aspects of consciousness, *scissiparité* which in experience is insignificant, but is nonetheless true to life: auditory consciousness is as such, consciousness of perception: the feeling of melodic movement unfolding upon the new basis of harmony."[8]

Serious musicologists who might impatiently skip pages of mathematics and existentialism to see what Ansermet makes of their favorite composers in his survey of the history of music will not be disappointed. Ansermet breezes through the full story, from prehistoric European, Hindu, and Balinese sources through Delphic and Egyptian hymns, moving on to the break with imagery in medieval plainchant, the troubadours leading through Guillaume Dufay in the fifteenth century to Claudio Monteverdi, and then to the baroque, where the story becomes more conventional (heavier on the introverted Bach than the extroverted George Frideric Handel). Ansermet picks and chooses among successors to Bach, focusing on Richard Wagner and Franz Liszt rather than on Johannes Brahms, Felix Mendelssohn, and Pyotr Ilyich Tchaikovsky. The closer Ansermet draws to the twentieth century, his forte as conductor, the more interesting the selections become. He dwells on Claude Debussy's *L'Après-midi d'un faune* and offers a superb reading of the Stéphane Mallarmé text to which it is a prelude. Like so many Jazz Age musicians in Paris, Ansermet holds the score of *Pelléas et Mélisande* in a degree of reverence, calling it the "truth" of expressionism that "transcends" individuality.[9] Debussy gives him an opportunity to editorialize on the "congenital malady of French music,"[10] which turns out to be an extroverted lightness that jeopardizes the ethical and philosophical truths he has so assiduously pursued.

My favorite excursus is offered in this section, and it is easy to imagine the café conversation with Picasso and Cocteau that informed a perceptive essay on the postimpressionism of Paul Cézanne, whose stated mission was "la vérité en peinture" (the truth in painting; he wrote Émile Bernard, "I owe you the truth in painting and I shall tell

it to you").[11] Ansermet follows the well-worn path from Debussy to Claude Monet, then discerns the difference between the series of water lily paintings and the aesthetically more rigorous pursuit of the motif in Cézanne, epitomized by the asymmetrical trees in the landscape paintings near the family home in Aix. Art leads through cubism (Ansermet was an eyewitness in the studio) and surrealism to the recent work of Picasso, Le Corbusier, and Léger. The music Ansermet equates with cubism is by Stravinsky. Satie, more textual than purely musical, belongs among the surrealists. Ansermet the mathematician prefers the solid, rational realism of the architecture in surrealist works by Francis Picabia, Giorgio de Chirico, and Salvador Dalí, paintings that offer a spatial mise-en-scène through which the dreamier figures enact their strange dramas. The conclusion of the contemporary music section is a valuable section on jazz. After reading about the improvisations of Stravinsky at the piano, the reader is prepared for a wholehearted embrace of jazz in performance. Ansermet considers it a type of "folklore" founded on an oral tradition that is essentially religious. He was one of the first serious musicians to praise the sincere "unity of style" of jazz orchestras, with their syncopation that is "the effect of an expressive need."[12] Expertly teasing performance out of composition and improvisation in his critique of the New York Syncopated Orchestra, he noted the "strangely fused total sonority distinctly its own, in which the neutral timbres like that of the piano disappear, and which the banjos surround with a halo of perpetual vibration."[13]

Then Ansermet broadens his scope for a grand coda, a crescendo of philosophical observations that mercurially traverse politics (Charles de Gaulle makes a cameo appearance), economics, the life of public intellectuals in France, linguistics, religion, anthropology, and sociology, all of which are subjected to the mathematically trained philosopher-musician's truth test: "The original work creates its form, and that form always responds to a formal schema that conditions the dialectic of melody, the individual structure of form, the conduct of tone and the style can be extremely varied."[14] In music as in painting, architecture, fashion, and poetry, it always come back to form.

GEOMETRY AND GODS, SIDE BY SIDE

Le Corbusier

Purism had its beginnings in a small Swiss village nestled in the Jura mountains just a short distance along Lac Léman from Ansermet's hometown. La Chaux-de-Fonds is the hometown of Charles-Édouard Jeanneret, known today as Le Corbusier. Before the famous black-framed glasses became his trademark, the fifteen-year-old Jeanneret's first lenses were a set of jeweler's loupes. As an apprentice engraver of watches working for the family firm (his father painted the faces with enamel), he formulated an aesthetic of extreme order and control that was eventually embraced by an international following of designers. He was hired by the architect Auguste Perret (an early adapter of re-inforced concrete as a structural material) to draft and make blueprints in his Paris studio. In the evenings Le Corbusier painted. A soft-spoken still life, his first major painting, uses minimal geometry to depict the mantelpiece in his apartment. It floats a small white cube with the ra-diance of marble on the plane of the shelf against the pale sand color of the wall and the rich ochre of the mantel. A single fragment of orna-ment, the curling top of the surround, seems luxuriant in contrast with the straight orthogonal cube. Stark yet absorbing, fastidiously painted — with a convincing realism in the reflection of the glowing white face on the surface of the shelf — yet abstract in demeanor, the painting is a gem. Le Corbusier brought this elegance to his first architectural com-mission, his parents' home on the shore of Lac Léman. It displayed the quintessential clean lines and geometric discipline for which he would become famous. Its most endearing feature is an immense picture win-dow overlooking the water, which funnels the gaze from the interior right through the unadorned frame out to the lake and mountains.

Trust a sober Swiss *horloger* to issue the call to order in Paris at the height of the party of the century. "Enough of games. We aspire to a

serious rigor," he declared in the manifesto "After Cubism."[1] His co-author and longtime design partner was the painter Amédée Ozenfant (who used his mother's name, Saugnier, as a pseudonym on occasion). Ozenfant coined the term "purism" in 1916 in an article for a journal he cofounded, *L'Élan*. "Purism is like fresh water after cocktails," Ozenfant declared.[2] He was proud to have vacuumed the apartment of Stendhal, turning a place identified with romanticism and the previous century into the ultramodern, sterile white space he and Le Corbusier preferred for their "laboratory."[3] The two men loved the geometric logic of their machines, from the cameras, planes, and ocean liners that Le Corbusier celebrated to the sports car with a lightweight aluminum body that Ozenfant built for himself in 1918 to rocket around Paris. A third major figure renowned for his clear-eyed rendering of machinery joined their ranks after the war ended: Léger taught painting with Ozenfant at the Académie Moderne. Léger's work was frequently featured in the journal *L'Esprit Nouveau*, which Le Corbusier and Ozenfant launched in 1920.

Le Corbusier the writer and publisher is not as familiar as the starchitect and controversial urban planner. In 1925 he devised his high-rise Plan Voisin, with which he proposed to replace the houses in the Beaubourg area of Paris (razing most of the third and fourth *arrondissements*) with a business district of eighteen cruciform glass-and-steel office towers. It was rejected as inhuman. Corbusier, undeterred, eventually designed the first housing project — the twelve-story Cité Radieuse apartment complex in Marseille, started in 1947, which was the debut of an urban planning concept that Le Corbusier called *l'Unité d'Habitation*. The design challenge posed by war-ravaged cities fortified his commitment to the rational approach to reconstructing what had been destroyed during both world wars. His solution, the modern skyscraper with its curtain wall, is as attributable to Le Corbusier as it is to the Bauhaus masters Walter Gropius and Ludwig Mies van der Rohe.

The first thing to realize about Le Corbusier is that he was an idealist. While his commitment to machines and the priority of function was as pragmatic as that of the Bauhaus architects, he shared their utopian view of a building as a Platonic ideal immaculately realized in steel, glass, and concrete. Six weeks on the Acropolis during his first trip outside of Switzerland, when he caressed the stones and drew the Parthenon, established the paradigm for his dream building, whose ratios

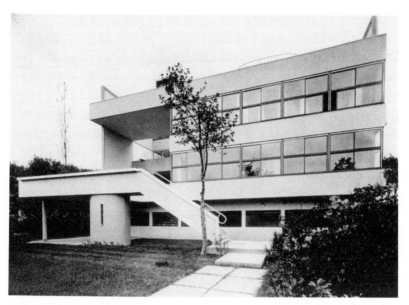

With an open floor plan and suspended or "free" glass-and-concrete façade, "Les Terrasses," the villa built for Michael Stein (brother of Gertrude) and his wife Sarah Stein, was a masterpiece well ahead of its time when it was completed in 1928.

could be mathematically explained by his countryman Ansermet. Le Corbusier translated that elegant geometry into the breakthrough pavilion at the Exposition Universelle in Paris in 1925. It informs the clean, white villas he designed in the twenties for such clients as Pierre Savoye and Michael and Sarah Stein, brother and sister-in-law of Gertrude. Decades before Philip Johnson's Glass House and Mies van der Rohe's Farnsworth House, Le Corbusier turned white concrete smoothed like primed canvas and shaped along right angles into the "machine for living."[4] Nearly every preliminary drawing for these buildings features a similar moment, when Le Corbusier focuses the eye on a large rectilinear window framing a tightly controlled exterior landscape just as he had channeled the view in his parents' home outward to the mountain peaks. Like the columnar realization of the golden section of the Parthenon, the right angles framing space are the tonic major of his forms, and white is the base of his palette. A model of probity, he used asceticism to break the romantic hold of Beaux-Arts overstatement, and the gleaming white exteriors countered the lingering memories in Paris,

London, and Berlin of the charred ruins of buildings caught in the crossfire of war's bombardments.

The clear-eyed idealism of the urban planner and designer of perfect white cubes is also revealed in Le Corbusier's writing. He was a mesmerizing arts journalist and gifted editor, bending text and graphic design to his purposes and never allowing polemic to stand in the way of the reader's enjoyment of the next disruptive turn in his critical reasoning. Paging through the early issues of *L'Esprit Nouveau* offers a chance to accompany him along the rapid course of his rise as a public intellectual whose theories were tested continually by the necessities of sound architectural practice. Other architects have assumed the role of starting a movement, including Adolf Loos in Vienna, Karl Friedrich Schinkel in Berlin, Johnson in New York, and—more recently—Robert Venturi and Rem Koolhaas. When Koolhaas joined forces with Bruce Mau to produce the tome *S,M,L,XL*, they took a page from Le Corbusier's book, weaving together incongruous images from the mass media and jaunty text, bits of which Oedipally assail the "dry theoretical pretentiousness" of Le Corbusier.[5] A favorite device of both Corbusier and the team of Mau and Koolhaas archly pairs a deliberately banal, ugly news photo with a rhapsodic text in a rebus that tests the reader's logical capabilities and patience.

Editing a publication is a decision-making process, as are drafting architectural plans or painting still lifes. The early issues of the journal gave way to the more permanent tracts gathered in *Vers une architecture*. From the start, the urgency of the call to order was a signal:

> Now that the machine age has let loose the consequences attaching to it, *progress* has *seized on a new set of implements with which to quicken its rhythm*, this it has done with such an intensification of speed and output that events have moved beyond our capacity to appreciate them; and whereas mind has hitherto generally been in advance of accomplished facts, it is now, on the contrary, left behind by new facts whose acceleration continues without cease; only similes can adequately describe the situation; submersion, cataclysm, invasion. This rhythm has been accelerated to such a point that man—(who has after all created it with his small individual inventions, just as an immense conflagration can be started with a few pints of petrol and one little match)—man lives in a perpetual state of instability, insecu-

rity, fatigue, and accumulating delusions. Our physical and nervous organization is brutalized and battered by this torrent; it makes its protest, of course, but it will soon give way unless some energetic decision, far-sighted and not too long delayed, brings order once more to a situation which is rapidly getting out of hand.[6]

As rhetorically gifted as Le Corbusier was, grant him the sincerity of this passage, written on the fly as a journalist making sense of a breaking crisis on deadline. He boldly launched the attack on cubism in 1917, the year of *Parade* — just when Picasso and Georges Braque were reaching the peak of their renown. Le Corbusier fought back out of a sense of history as well as a commitment to the future. As with Oswald Spengler's dire prognostications, Le Corbusier's anxiety over entropy and "acceleration" is understandable for anyone who witnessed the insanity of World War I. The answer to that destruction (including the perceived demolition in cubism) is Euclidean geometry and the reliability of the machine, as this passage from "The Lesson of the Machine" makes clear: "The machine is all geometry. Geometry is our greatest creation and we are enthralled by it. The machine brings us shining disks, spheres, and cylinders of polished steel, shaped with a theoretical precision and exactitude which can *never be seen in nature itself*. Our senses are moved, and at the same time our heart recalls from its stock of memories the disks and spheres of the gods of Egypt and the Congo. Geometry and gods side by side!"[7] Diaghilev had proclaimed that the artist "must be as free as gods,"[8] and Le Corbusier placed form on the adjacent throne.

This impassioned ideal informs his painting as well as the invention of the house as a "machine for living," carried over from theory to practice in a series of advanced villas, polished white cubes taken straight from the block of marble on the mantelpiece in that first major painting. The villas were created for avant-garde patrons, including the Savoye and Stein families and the Steins' friend and American journalist William Cook (in Boulogne-sur-Seine, 1926). The architecture of necessity had gained fame with the epochal pavilion for the 1925 Exposition Internationale des Arts Décoratifs, where Le Corbusier's utopia met its public. The material innovation that bridged drafting board and site was a basic innovation: reinforced concrete. This was coated

in a French enamel-based house paint called Ripolin that left a perfect, hard white finish. Developments in the industrial chemistry of the age, as was the case with the paint used by the impressionists a generation earlier, had a substantial impact on aesthetics. The binder of the original Ripolin was linseed oil, and the high gloss together with toughness was made possible by the addition of resins.[9] Starting in 1927, the nitrocellulose used as a binder for many white paints was replaced by alkyds, polyester polymers mixed with oils that lend density. For a wall, this means improved coverage in a single coat. For an artist at the easel, it guaranteed a fast-drying opacity. If Le Corbusier's ascetic disruption of the prevailing Beaux-Arts, art nouveau, and art deco styles of design can be described in one phrase, it would be the "law of Ripolin," sealing polished concrete of the building in a smooth coat, polished and primed like a canvas, then left unadorned in the "blank stronghold"[10] of purity (to borrow Mallarmé's splendid phrase for the white sheet of paper before the ink mars it). That same structural white was also used on canvas, not just by Le Corbusier but by Picasso, who started using Ripolin as early as 1912. It is the basis of so much high modernist art of the period, including not just the purist still lifes of Le Corbusier and Ozenfant but the neoplastic paintings of Piet Mondrian and the bold geometric abstraction of the Russian suprematists. It is also the tonic major of the sculpture of the time, such as the polished white surfaces of Constantin Brancusi's marble, Elie Nadelman's plaster figures, and early Alberto Giacometti's plaster plaques. The importance of this pure field for the paintings of Léger, Gerald Murphy, Le Corbusier, and others cannot be overstated. Precise craft requires strong light and effective contrast. The fine edges that define tightly ordered objects and the glint of light playing across the surface of steel cylinders owe their sharp edges to the titanium white out of the tube and the new ultrawhite ground brushed on gessoed close-woven linen. Even the studio conditions are part of this clean approach. The canvas was prepared under strong, cool-toned electric illumination in the laboratory of the studio. On the basic retinal level, the luminous effect of the white cube after the mahogany and brown stone of preceding decades is significant. The white cube remains the *locus amoenus* of contemporary art to this day. Galleries and museums are dedicated to this ideal space that framed the purity of minimalist and color field paintings. Huge Arctic

expanses of gleaming white in London, Paris, Berlin, and New York gallery and museum spaces offer a steroidal expansion of Le Corbusier's laboratory of eight decades before.

In addition to the ancient Greek paradigm that had become the modern ideal of the white cube, Le Corbusier selected a strange model for order: the American-style office, with its systematic ranks of desks, complete with filing cabinets—the predecessors of the Knoll and Steelcase maze of cubicles usually associated with the regimented aesthetic of the Bauhaus. Within that austerely Platonic realm, he trained his lens on a seemingly innocuous detail, the standardized format for a sheet of business correspondence, set by manufacturers at 8½ x 11 inches, a ratio on which the entire filing system of corporate life is pegged. In an oddly verbose footnote to *Vers une architecture*, he telescopically riffs on the relationship between the matrix of the "commercial format" of stationery and the golden section, which gave its name to a group of geometrically inclined artists, including Léger:

> Typewriters, file-copies, filing trays, files, filing drawers, filing cabinets, in a word the whole furnishing industry, was affected by the establishment of this standard, and even the most intransigent individualists were not able to resist it. . . . In all things that are in universal use, individual fantasy bows before human fact. Here are some figures: The ratio of vertical to horizontal dimension in the commercial format is 1:3. That of a sheet of Ingres paper is 1:29. That of the sections of the plan of Paris established by Napoleon I is 1:33; that of the Taride plans 1:33. That of most magazines 1:28. That of canvases for figure painting (time-honored) is 1:30. That of daily newspapers from 1:3 to 1:45. That of photographic plates 1:5; that of books 1:4 to 1:5, that of kitchen tables in the Bazaar de L'Hôtel de Ville 1:5, etc.[11]

This reliance on quantitative measure, like Ansermet's theory, is obsessive yet understandable. In our time, the algorithm tyrannically governs Wall Street trading and online marketing. In the studio, the elemental first choice of a painter or designer is the selection of the canvas or sheet of paper that will be the ground. In the essay "After Cubism," Le Corbusier and Ozenfant zero in on the 40F format as the ideal set of proportions (it measures 39⅜ x 31⅞ inches, but the neat calculation in centimeters is nine by ten squared, or 81 x 100 centimeters). Beginning in the nineteenth century, French art suppliers used a numerical

scale from 0 to 120, with "F" designating *figure* in contrast to "P" for *paysage* (landscape) and "M" for *marine* (seascape). Le Corbusier builds his paintings on that strict base, its proportions governed by the golden section traced back to the Parthenon and calculated by Pythagoras and Fibonacci. The uniform, canonic format guaranteed a stable harmony. The rules of the purist still life conformed to an agreed-on vocabulary that included the right Bordeaux bottle with its distinctive punt, the location in a corner space, a vocabulary of "object types,"[12] as Corbusier and Ozenfant called them, the tabletop setup echoing the typical repertoire of cubist still life.

Does a format risk becoming formulaic? Le Corbusier's enthusiasm for the perfect industrial product, mass-produced with no deviation, celebrated a catalogue of contemporary objects, many of which appear not only in his paintings but also in those of Ozenfant, Léger, Murphy, Stuart Davis, and other painters who subscribe to the aesthetic of extreme order during the period. Standardization demands an original twist to be art, however. One of Le Corbusier's significant breakthroughs had far greater significance than historians have credited, including those who have picked over the Picasso and Léger canon so thoroughly: the "marriage of contours."[13] Like the choice of format, it is essentially a linear rather than a chromatic element. The "common contour" (as it is also called) is a shared outline that travels along two or more objects in a picture, linking them and locking them into place in a way that particularly suits the stillness of the still life. Its essential psychological basis, as with the rationale of the format, is the craving for order.

The vocabulary of the paintings follows logically. In the essay "After Cubism," Le Corbusier enumerated the possibilities: "Our Modern life, when we are active and about (leaving out the moments when we fly to gruel and aspirin) has created its own objects: its costume, its fountain pen, its ever-sharp pencil, its typewriter, its telephone, its admirable office furniture, its plate glass and its 'Innovation' trunks, the safety razor and the briar pipe, the bowler hat and the limousine, the steamship and the airplane."[14] An entire exhibition of high modernist still lifes could be assembled from this list, and it would include Murphy's paintings of a watch, razor, cocktail shaker, and other implements as well as works by Léger; Davis; Patrick Henry Bruce; and—often left out of the Jazz Age roundup—the Belgian René Magritte, whose precise bowler hats

and pipes made their debut in the 1920s in Paris. A common art school technique connects these artists, who were trained in the "Guillaume method" of drawing by establishing a silhouette from cast shadows.

Le Corbusier raised the Phileban solids (cylinder, pyramid, cube, and sphere) to the symbolic status of "object types," which he deployed to codify the shift from atmosphere (as in the unstable deformation of objects in cubism) to substance. A clue to their concentrated presence, so different from the flickering mutability of the still lifes of Cézanne or Picasso, is found in the way Le Corbusier read the early modernist poetry of Mallarmé: "He was not trying to achieve abstract form devoid of content; to the contrary, he sought intensified meaning by reducing the form and number of 'words' to bare essentials."[15] In each medium (language, print, paint, glass, and concrete), Le Corbusier stripped ideas down to fundamentals.

Just as the edge must be clean, the application of the paint has to be cautious, and the challenge is to "execute perfectly."[16] To some this could seem arrogant if not ludicrous, but the degree of control over accident and ambiguity was possible, in the purists' view, by a dramatic limitation of the elementary constituents of the work to a manageable repertoire. As with the precision of the minimalists (the 1970s-era knife-edged steel boxes of Donald Judd are paradigmatic), the exactitude of purism is attained under laboratory conditions. The connection of technique and knowledge is tautly etiological. The mental conception relies on "perfect" execution. Unlike so much in modernism — which privileges the contingent, ephemeral, and fragmented — the ideal of Le Corbusier is permanent and whole, from the concept through its reification as painting, building, or object (such as his furniture). As the scale of his paintings expanded from small studies to works 31⅞ inches high by 39¼ inches wide, their grandeur supported their claim to monumentality, a characteristic they shared with the large-format still lifes of Léger, Picasso, and Murphy considered in this part of the book. The objects in isolation — a bottle, a guitar, clay pipes, and a section of molding, for example — are secured by the painting as "constants of the psyche."[17] Just as architects and the minimalist sculptors insisted on truth to materials, the strict theoretical axioms and careful studio practice of the purists promised their own access to truth.

One of the most compelling of Le Corbusier's major still lifes, cre-

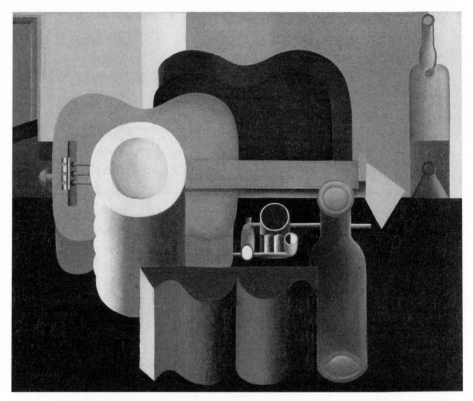

Le Corbusier's *Still Life* (1920) is an exemplary purist painting, meticulously defining the contours of "universal" machine-made bottles and objects, with a sly allusion to the cubist guitars of Picasso.

ated in 1920, is in the collection of the Museum of Modern Art, bought in 1937 with the van Gogh Purchase Fund. A serene yet complex picture, it features the canonic objects of the purist movement in a regimental array on a dark blue tabletop before a pale light window or wall. In the middle ground the reclining nude of a guitar undulates, a parodic wave of the cape before the horns of Picasso. In the background, a bottle just a third full of rosé or a young merlot adds the hottest chromatic note to an otherwise pale palette. The other warm tones are the blond wood of the guitar and a sand-colored window frame. The bone white of a vase and the clay of the pipes is more an accent than a body color, as grays predominate. Le Corbusier, like Léger and Murphy, uses gradations to indicate volume, where curved edges lead around to shadow.

The S-curve of the molding, its edge a solid body of deep blue mixed with gray, harmonizes with the pale background.

Reading the open mouths of the vase, bottles, and pipes, the viewer realizes something is odd about the pictorial space. While the wine bottle in the background appears to sit flat on the sill, its mouth incongruously tilts to the viewer, as do the other apertures and the top of the molding. The cubists played this optical game, their tabletops raked toward the viewer, as did Henri Matisse and Joan Miró with their sharply tilted tables and Vincent van Gogh with the floor of his yellow house pictures. The raked stage is an old theater trick as well. Ballet and opera stages descend from the back of the stage to the apron, to make the dancers and singers easier to view for those in the orchestra seats. Architects have a term for this depiction of space, by which the interior spaces of a plan are rendered three-dimensionally from an elevated view, if not in textbook perspective. In contrast with an elevation, in which the structure is presented in cross section, the type of drawing that lifts the viewpoint above the building or room is called "axonometric." Le Corbusier's still lifes put this spatial device to work in a meticulously even, geometrically calculated way, with the angle of the objects maintained with precision across the whole painting. The objects stay put where they are placed, and the static equilibrium conveyed is a stark contrast to the shifting, unsteady aspect of apples in a Cézanne watercolor, the vibrating silhouettes of Georges Seurat (no matter how stiff the posture of his figures), or the atmospheric comma strokes of Monet and the impressionists. Pointedly, the steady hand of a Le Corbusier still life is the antidote to the blur of what he called the "troubled art of a troubled era":[18] the cubism of Braque, Picasso, and Juan Gris.[19] The crowded desktop clutter in one of the acknowledged masterpieces of the movement, Picasso's The Architect's Table (1912), would never have been permitted in the laboratory of Ozenfant and Le Corbusier, where one expects that the desktops of the junior staff would have been clear at the start and finish of every day.

The "marriage of contours" and axonometric space became Le Corbusier's way of troping on the strong aesthetic of cubism in the sense that Harold Bloom, in his theory of the "anxiety of influence," notes the ways in which modern poets confront tradition to assert their individual talents.[20] The purist still life isolates the objects, examining them in

the clear, cold light of Cartesian analysis, and then builds from those parts a stable whole. The "marriage of contours" does its subliminal best to erotically link forms, joining the pieces of an analytical puzzle in a "constructed" order (to appropriate one of Le Corbusier's pet terms). This aptly describes a whole genre of Jazz Age still life painting that so effectively controlled the picture plane and the even presence of color on its surface that it paved the way for later movements, including color field painting in the 1970s and neo-geo a decade later. The meticulously controlled, brushed monochrome planes of Josef Albers, Barnett Newman, Ad Reinhardt, Frank Stella, and Ellsworth Kelly (to name just a few masters of the effect) emerge out of the even expanses found in the backdrops to the bottles, tabletops, architectural fragments, and objects in paintings by Le Corbusier, Ozenfant, Léger, and Murphy. Later in this study we will connect them with Léger and Roy Lichtenstein vis-à-vis the grammar of industrial forms, the shared palette of primary colors, and the tendency to use black outlines. The sticking point is the question of whether truth is sacrificed in paintings that rely on tricks. Axonometric drawing is a device to make the impossible simultaneous view of exterior and interior possible. The "marriage of contours" is a brilliant studio trope, a theoretical and optical coup rather than an example of mimetic fidelity to nature. The numerology of the golden section is a familiar invocation of mathematical certainty in the arts. These ideas govern what is applied to the surface of the painting. Truth requires more than theory and technique.

Le Corbusier confronted this quandary while on a plane to Berlin in October 1928, en route to Russia for a meeting with the filmmaker Sergei Eisenstein. As Nicholas Fox Weber records in his superb biography of the architect, Le Corbusier pursued an elusive truth: "Architecture and cinema are the only two arts of our time. In my own work, I seem to think as Eisenstein does in his films. His work is shot through in the sense of truth, and bears witness to the truth alone. In their ideas, his films resemble closely what I am striving to do in my work."[21] Le Corbusier translated the "marriage of contours" elegantly from the canvas to architecture. It is now almost a century after the completion of the twenties-era villas and the groundbreaking pavilion on which Le Corbusier's case for modernism was built. Retrospectives and reassessments have been unkind to his urban planning (megalomaniacal was

the general verdict on the Plan Voisin of 1925, and the housing projects he advocated have been the battleground for race riots as recently as a few years ago), but the villas have only gained in renown as examples of poetic sculpture. Reviewing an exhibition of Le Corbusier's drawings (1912–62) at the Museum of Modern Art for the *New York Times* in 1978, the powerful critic Ada Louise Huxtable focused on the villas "as objects of intense aesthetic research and analysis" in her conclusion to the review, titled "The Changing 'Truth' of Le Corbusier" and later collected in a volume of her writings. Huxtable dispatched not only the wacky excesses of the Plan Voisin but the "sophistry" of supposing that one can create health and happiness by opening living spaces to sunlight and white walls. She focused instead on the way Le Corbusier advanced modernism as a timeless aesthetic:

> All of the buildings are conscious and powerful essays in abstract composition from strict geometry to complex free form. . . . In the interpretation, the transparent and overlapping planes of cubist painting, with their many ambiguous readings of the picture plane, are transferred to the composition of the Stein house at Garches. Almost limitless meanings are suggested in the arrangement of clear and opaque surfaces, of physical fact and visual effect. In the seventies, then, a Le Corbusier house is no longer viewed as a "machine to live in" or as an instrument for revolutionary social change. These drawings reveal houses, and other buildings, as objects of intense aesthetic research and analysis. And thus today a sophisticated high-art game has supplanted social reform. This is the "truth" of Le Corbusier's work for a generation concerned with a return to the art of architecture, beyond technology, sociology, and politics. Perhaps tomorrow still another truth will emerge.[22]

12 CONNOISSEUR OF CONTRASTS
Fernand Léger

He may not have been as successful as Pablo Picasso or as influential as Le Corbusier, but the Jazz Age was good to Fernand Léger. Thrilled to be alive after four years of battle, having survived the trenches in the Argonne Forest and a mustard-gas attack at Verdun, he was back in a Paris studio and happily married to Jeanne-Augustine Lohy. Having been part of the cubist movement from its inception, Léger had a deep investment in its ideology, so his turning away from it was as dramatic on a private level as the anticubist manifestos of Le Corbusier were on the public level. Nine months older than Picasso, Léger was the burly son of a cattle farmer and butcher from the Norman town of Argentan. His gift as a draftsman was discovered at his religious boarding school in Tinchebray, and he became an apprentice to a local architect, which led to a two-year appointment with an architect in Caen. He supported himself as an architectural draftsman when he moved to Paris in 1900, but he failed the entrance examination to the École des Beaux-Arts. He was still supporting himself with architectural drafting when, at nineteen, he entered military service in 1902 in the Second Regiment du Génie de Versailles, an engineer's outfit. An early assignment had him painting camouflage on the rooftops of hangars and barracks, which taught him to break the picture plane and create an illusion. The tactical lesson was more pressing—how to render equipment, and himself, invisible while under attack.

After a year in the military, a year as a private painting student of Jean-Léon Gérôme, and rehabilitation in Corsica, he was back in Paris in 1909, taking a studio at the legendary Ruche (beehive) in Montparnasse with Alexander Archipenko, Sonia Delaunay, Amedeo Modigliani, Henri Laurens, Jacques Lipschitz, Chaim Soutine, and Marc Chagall, and moving in the circles that included both Picasso and Henri Rousseau (known as Le Douanier). The cubists embraced Léger

as one of their own. The mighty art dealer Daniel-Henry Kahnweiler signed a contract to represent him in October 1913 (Léger's mother, incredulous, demanded that a notary authenticate it). His paintings were included in the cubist room at the landmark 1911 Salon des Indépendants exhibition, in the Maison Cubiste of 1912, and in the 1913 Armory Show in the United States, yet there was always a way to distinguish Léger's bolder palette and slightly more realistic modeling from the less immediately legible, more fractured images delivered in a subdued silver palette of Picasso, Georges Braque, Albert Gleizes, Jean Metzinger and the other cubists. The painter John Golding considered Léger to be more a synthetic than an analytic cubist. He based this conclusion on Léger's alertness to the mediation between figure and ground:

> From synthetic Cubism Léger adapted a form of composition that relied for its effects on a surface organization in terms of predominantly upright, vertical areas, often rendered now in unmodulated color. Mechanical, tubular forms, like great shafts of metal, appear with frequency, but these are now tied into, and indeed made subsidiary to, a flatter treatment of the picture surface; the colored shapes tip and tilt, fanning out towards the edge of the canvas, only to meet opposing forces which tie them back again tightly into the overall jazz-like rhythms of the composition. The bright raw colors call to each other across the surface of the canvas, pulling it taut like a drum. The vitality of the forms is such that at times they appear to advance towards us, so that we seem to share, palpably, in the painting's beat.[1]

The war brought Léger's major break from *la bande à Picasso*. During the fighting, Picasso was safely in Paris enjoying the windfall of major exhibitions and commissions from the Ballets Russes. Léger was recalled to the infantry in August 1914, at age thirty-three, not as an officer but as a *poilu* or sapper assigned to the trenches. By October he was in the heaviest fighting of the war in the Argonne Forest, on the western front. The brutality, the leveling of social classes, and the dire need to survive replaced the urgent arguments over abstraction in art with a commitment to truth. It is little surprise that he, Ernest Hemingway, and John Dos Passos hit it off when they met. In 1915, Léger had been a stretcher-bearer, just as they had been in the ambulance corps. Léger kept his artistic hand in by drawing his fellow soldiers playing cards, and he mounted his only paintings on the wooden tops of ammunition

boxes. He experienced a battlefield epiphany literally looking down the barrel of a gun:

> I left Paris in a period of abstraction, of pictorial liberation. Without any transition I found myself shoulder to shoulder with the entire French nation; assigned to the sappers, my new buddies were miners, laborers, wood and ironworkers. . . . I was dazzled by the breechblock of a seventy-five millimeter gun opened in the sun, the magic of light on polished metal. That was just what it took to make me forget the abstract art of 1912–14. Since I got my teeth into that reality the object has never left me. The breechblock of that seventy-five millimeter gun opened in the sun taught me more for my artistic evolution than all the museums in the world.[2]

Léger spent the latter part of 1917 and the spring of 1918 in and out of hospitals recovering from the effects of mustard gas. When it came time for him to exhibit his work again in Paris, he was still classified a cubist by dealers and collectors, but now with a difference. According to Christopher Green, "paradoxically, Léger's anti-harmonious art was invited into the very center of the crystal cubist circle immediately on his return to his Montparnasse studio from hospital, which had occurred by 1 July 1918 when he signed a contract with Rosenberg. In February 1918 it was at Rosenberg's gallery that he was given his first post-war exhibition, so that he became, in a real sense, an aesthetic saboteur working from within — his intended victim being the Cubist good taste of his own sponsor, Léonce Rosenberg."[3]

Just as Le Corbusier and Amédée Ozenfant had launched purism with a repudiation of cubism, Léger devised a new idiom for his *période mécanique* that broke with Picasso and Braque, veering closer to the machine aesthetic of the purists. They were some of the reliable sources of career support for Léger (in 1920 Le Corbusier started cutting him in on mural commissions and showcased his painting in the landmark pavilion at the International Exposition in 1925), along with Americans including Hemingway and Ezra Pound, who lived on the Rue Notre-Dame-des-Champs near Léger's studio, and Gerald Murphy, who became a trusted friend. Thanks to Katherine Dreier, an American collector, he had his first exhibition of a dozen paintings in New York in 1924, and by the time the Guggenheim Museum was ready to display nonobjective art in 1939, including his pivotal work *Contrast*

of Forms (1913), he was already a familiar name in art circles from Manhattan to San Francisco.

Le Corbusier devised the "marriage of contours,"[4] but Léger took as his early compositional principle the "contrast of forms" (the original 1913 compositions featured disks in primary colors or black against white) and developed an ever-more complex vocabulary inspired by machinery and the city. He was not the only artist in Paris to limit the palette to primary colors. Piet Mondrian had returned from Holland in mid-1919, and in the next year he had painted the first neoplastic painting, a black-and-white grid with red, yellow, and blue panels. The reduction of the palette to primaries was part of the program of the De Stijl group, headed by Theo van Doesburg and including not just Mondrian but the Hungarian Vilmos Huszár; the Belgian sculptor Georges Vantongerloo; and the Belgian architects Gerrit Rietveld, Jacobus Oud (known as J. P. P. Oud), Jan Wils, and Robert van 't Hoff. Their furniture, interiors, and paintings all confined themselves to geometric essentials and the basic triad of red, yellow, and blue. The Russian suprematists, for their part, favored the further limitation of the palette to red and black on a pure white ground.

Léger's writings from the period are certainly on the same page as Le Corbusier's, as in this essay on "A New Realism — the Object" from 1926: "One can assert this: a machine or a manufactured object may be beautiful when the relation of the lines which define its volume are balanced in an order corresponding to those of preceding architectures."[5] Understanding the role of the machine as muse is essential to reading the paintings of the 1920s. In a superb essay on Léger's "Subjects and Objects," Matthew Affron explored its importance to Léger's sense of both reality and beauty:

> Offering organized and dynamic relationships of line, volume, and basic color, the machine functioned as a paradigm of aesthetic harmony and a model for a painting practice that made the investigation of plastic relationships its fundamental goal. This *deus ex machina* served as the vehicle for Léger's personal articulation of general Cubist aesthetic precepts. Rather than imitating the machine in paint, he hoped to locate the perception of a more essential reality in its inherent qualities of artifice and abstraction. He set up the machine as the epitome of expressive form and as proof that the

beauty that is the raw material of creative perception is to be found literally throughout the everyday environment.[6]

Léger found a way to burst through the mimetic link between painting and truth to a "more essential reality" by virtue of objectivity at its basic level, because the object in isolation was his source. Everywhere he looked after the trenches, he saw what others might take to be commonplace things but for a former poilu were cherished signs of life. He roamed Paris with a vast, romantic hunger for sensation sharpened by deprivation. As he wrote to his childhood friend Louis Poughon: "I'll fill my pockets with it, and my eyes. I'll walk about in it like I've never before walked about there. . . . I'll see in things their 'value,' their true, absolute value, for Christ's sake! I know the value of every object, do you understand, Louis, my friend? I know what bread is, what wood is, what socks are, etc. Do you know that? No, you can't know that because you haven't fought a war."[7]

That voracious looking was what heightened Léger's celebration of objects, which he elevated to the heroic level of monumentality in the 1920s with works that drove the cubist experiment's tense relationship between perception and painting to another epistemological level. Mimesis and abstraction played their parts, both within limits. "A bad artist copies the object and is in a state of imitation, a good artist represents the object and is in a state of equivalence," Léger cautioned students in 1922.[8] The cubists would use trompe-l'oeil elements in their still lifes, famously by depicting the cane rushing of seat covers and the faux wood grain of furniture. Léger's answer was the exquisitely rendered reflective surface of a steel cylinder with bright highlights. Just as Picasso's technique permitted the kinetic effects of cubism to animate the painting, Léger's architectural labors, together with his experience in designing movie and ballet sets for the lens or the theater viewer, made a certain kind of controlled three-dimensional perception possible. Expanding the scale not just of the object but of the painting (many were five feet high), so that the figure floated on a broad expanse of unmodulated color (red is particularly effective), he drove the old idea of contrast in new directions. Straight lines vied with curves; concave alternated with convex; flat areas were juxtaposed with three-dimensional, shaded portraits of objects. The critic John Berger, an able draftsman himself, points out

that Léger's heroic style springs from his particular aptitude for convincingly translating the appearance of the object to the plane: "He learned how to manage solids — how to manufacture them, how to preserve a surface with paint, how to dazzle with contrasts, how to assemble mass-produced signs with contrasts."[9] Whereas Picasso pursued the flicker of light in the leaves of Paul Cézanne's trees, Léger saw the solid tree trunk, the rocks in the quarry, the dome of the card player's hat. With the precision and respect for materials that a gunner develops as he polishes and oils his weaponry, Léger's constructions restored epistemological certainty to the shattered sensory data of cubist still lifes.

A twist of the focusing mechanism advanced the lens and cleared the blur of cubism, zooming in on brightly lit details that were somehow both more real and more abstract. A perfect example is offered by *Élément mécanique*, a large vertical still life painted in 1924 that is now at the Centre Georges Pompidou, in Paris. Its ground is a vivid brushed red, presenting an uncertain architectural space that permits the isolation of a group of steel parts to grow up through its center. The descendants of Léger's disks from the teens linger in the semicircular shapes of a cascading trio of open tubes cut in section (the contrast of forms paintings were often vertical, with a tumbling motion of disks on a central axis). Convex and concave, they open on a recessionary view of flat planes bounded in straight, black edges. Here and there a light touch of decorative pattern emerges, an IXIXIX inscribed in black against white, a lattice of Roman numerals through which more tubes and sections can be glimpsed. The pattern recalls his native Normandy, where timbered houses have crisscrossing beams of black against white walls. The shading that Berger so admires lends the tubes their three-dimensional illusion, and the solidity of the mechanical objects, with their surfaces gleaming and the edges sharp, is never in doubt even if the function of the machine remains a puzzle.

When Léger was not making up for lost time by painting steadily, not just on canvas but murals, he was teaching, writing, and pursuing a prodigious range of sidelines. His experiments in other media took him into film, theater, the ballet and concert hall, and book publishing. In 1912, when he joined Léonce Rosenberg's Section d'Or, one of the group's aims was the interdisciplinary presentation of music, stage, literary, and artistic performances. Léger poured ten thousand francs

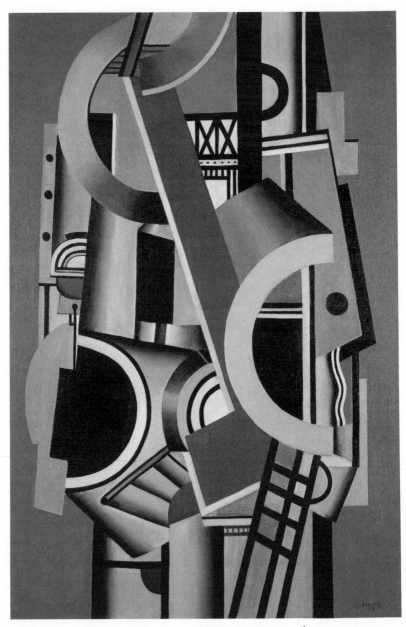

The monumental scale and precise edges of Fernand Léger's *Élément Mécanique* (1924), suspended over an indeterminate monochromatic background, emphasize his passion for the "objectivity" of the machine.

into making several film versions of the *Ballet Mécanique,* a fourteen-minute, rhythmic succession of objects no longer frozen into still lifes but dancing jauntily to an ambitious jazz score by George Antheil. Isolated objects and numbers are intercut with haunting glimpses of the mouth and eyes of Kiki de Montparnasse, the notorious model and muse. "This film is objective, realistic, and in no way abstract," Léger insisted, although it lacked a narrative and shared the disorienting quality of Man Ray's often-abstract photography.[10] Ray was a technical advisor on the film. Léger started the Club des Amis du Septième Art, a "ciné-club" for artists interested in film, whose members included Blaise Cendrars, Maurice Ravel, Marcel L'Herbier, and Louis Delluc. Léger and Cendrars were artists on Abel Gance's crew for the movie *La Roue* in 1922, and in 1923 Léger was the set designer for L'Herbier's *L'Inhumaine* (he created the mad scientist's laboratory). He participated in dadaist collective events at the Salle Gaveau and the Théâtre Michel. He published illustrated volumes with André Malraux and Cendrars. For the *Sacre*-like ballet *La Création du Monde,* the Ballets Suédois production that shared the bill with *Within the Quota,* he created the curtain, sets, and costumes in a raw, tribal style dominated by bright primary colors and zigzagging geometric shapes. He also designed the light-hearted ballet *Skating Rink,* based on a movie starring his beloved Charlie Chaplin, for the same company. His film and theater posters, with their muscular graphic forms and bright colors, reflected his fascination with advertising and billboards. He was the design chief of the Grand Bal Travesti/Transmental at the Salle Bullier, a fashionable charity ball organized by the Union des Artistes Russes in February 1923. He provided the murals for the French ambassador's pavilion, designed by Robert Mallet-Stevens, at the Exposition Internationale des Arts Décoratifs et Industriels Modernes, where—at the Pavillon de l'Esprit Nouveau—Le Corbusier had hung his painting *Le Balustre.* Léger even took part in presenting Josephine Baker's "Danse Sauvage" at the Théâtre des Champs-Élysées in October of 1925 (Mondrian attended at least one of the performances). Léger's accomplished hand kept pace with his restless appetite for an encyclopedic range of images and ideas. In the next decade, after a pivotal visit to New York in 1931 sponsored by Murphy, Léger would expand his repertoire from deified machines to nothing less complex than the impossible theme of *La Ville* (The city).

13 TRANSFIGURATIONS OF THE COMMONPLACE

Gerald Murphy

In the twenties, Fernand Léger was a cheerful, avuncular presence among the young American, Russian, and English expatriates on the Left Bank. One novice painter who took him as a mentor and earned his respect was Gerald Murphy. The two men met in the fall of 1921, not long after Gerald and Sara Murphy had arrived in Paris, in September, and soon after a life-changing encounter Murphy had with a window full of cubist art on the Rue la Boétie, just off the Champs-Élysées. Returning to their apartment, Murphy told his wife, "If that's painting, that's the kind of painting that I would like to do."[1] They took private painting lessons with Natalia Goncharova at her studio on the Rue de Seine on the Left Bank. They started with abstraction, and for the next six months obeyed Goncharova's strict orders and the critiques of her husband, Mikhail Larionov. The Murphys were enlisted as unpaid volunteers at the scenery shop for the Ballets Russes in Belleville and worked daily with a staff of Russians under the direction of not only Sergei Diaghilev but also Pablo Picasso himself. They attended rehearsals and watched as Igor Stravinsky laced into Vaslav Nijinsky while working on the new ballet *Le Renard*. Léger probably met them either at the scene-painting atelier or through Goncharova and Larionov, who had unsuccessfully acted as his go-betweens with Diaghilev for nearly four years.

Scenic flats are so big the muslin has to be fastened to the floor and painted with huge, soft, broom-like brushes. As in any studio, the tools are the rules, defining the types of gesture that can be made. To be read as they would be in the theater by spectators at a distance, and to ascertain the depth relations in the compressed pictorial space of the set designs, the painters ascended thirty-foot ladders to look down on flats in progress. A photograph of Picasso and the Russians with his set for

Gerald Murphy made this multiple portrait in 1930, when his son Patrick was under treatment for tuberculosis. The artist wrote to MacLeish at the time, "One is *never* oneself for a moment."

Tricorne was taken from this angle. The point of view from above recalls the axonometric perspective of Le Corbusier's still lifes. The elevated perspective and the giant scale of the theater sets are crucial aspects of this aesthetic. Within three years, Gerald Murphy's name would be made by two huge projects, a massive painting that dwarfed all others at an exhibition at the Grand Palais and the black-and-white curtain for *Within the Quota*, a vast parody of a newspaper front page that occupied the whole proscenium.

Just as his friend Archibald MacLeish would make a daring commitment to a life of poetry rather than a safe career in the law, Murphy deferred his installation in the executive suite at Mark Cross to make the leap into art. He prefaced his European adventure with graduate study in landscape architecture at Harvard University, where he was enrolled for a year after earning his bachelor's degree (his academic average hovered around the gentleman's C, although he was tapped for Skull and Bones) at Yale University. When he signed the lease on a sculptor's studio on the Rue Froidevaux, beside the Montparnasse cemetery, Murphy found himself in possession of the right kind of an open room, with a thirty-foot ceiling, cement floor, and huge uninterrupted walls. In the spirit of Le Corbusier, he scrubbed it down and painted the walls

bright white. The first paintings he made, now lost, were *Turbines* and *Pressure*, based on an ocean liner's boiler room and some unidentifiable machines. As with Léger's mechanical still lifes, Murphy's paintings started with drawings (Léger preferred pencil and charcoal on paper, while Murphy used gouache for color). Murphy prepared full drafts in small scale on paper, transferring the image by a grid to a large canvas. His preferred support, airplane linen tightly stretched across three-ply panels, was perfect for tight details and the even application of color fields, the sort of hard-edged, superflat technique used by Roy Lichtenstein, James Rosenquist, and today's Japanese pop sensation Takashi Murakami. The Léger painting that comes closest to Murphy's large still lifes is a boldly graphic, five-by-four-foot painting of ball bearings made in 1926 that shares not only Murphy's fascination with objects but the sort of linear black framing device he favored. Murphy's notes indicate that he also created a painting, now lost, called *Roulement à Billes* (ball bearing), a year before Léger's. In this Paris residence Murphy kept a large, polished ball bearing set on a pedestal on the piano as a found sculpture, one of the modernist decorative touches that impressed the Murphy circle.[2]

Murphy's auspicious and surprising public debut consisted of four paintings at the annual exhibition of the Salon des Indépendants, which opened on February 10, 1923, only a year after his lessons were over. Léger was represented in the show, along with Larionov and Goncharova, and so were Bonnard, Max Ernst and Francis Picabia. Murphy made an even bolder impression a year later at the same event in the Grand Palais, when his eighteen-by-twelve-foot behemoth, *Boatdeck*, was hung over the main staircase in the rotunda. Although the work no longer exists, a black-and-white photograph records that it was a killer painting, a tightly cropped upward view of the three funnels of an ocean liner, the first cut off at the top and each raked slightly backward to add to the impact of a work that dared convey that sense of being dwarfed by a ship's architecture. Its looming sense of immensity is true to the experience of climbing to the boat deck of a liner and looking up at the stacks looming against the sky. All that is missing is the tremulous basso profundo of the horn sounding, the Wagnerian signal of departure from port. At the base of the bicolor stacks is a cluster of ventilating pipes, the openings of some shown in cross-section, and two with

their valve control wheels precisely rendered. Along with black lines for rigging and a slender white antenna mast, these provided just the level of detail to satisfy the most fastidious marine painting buff. Although the work has flat expanses of pure color, it is far from abstract. The artist did not omit the finer details in spite of the colossal scale of the image, and he had over sixty photographs taken on deck during transatlantic crossings on the *Paris* and *Aquitania* to use as references. Yet for all its realism, this painting had a modernist statement to deliver, decades before similar mural-size pop paintings by Rosenquist or Lichtenstein that delivered some of the same shock value. As Amanda Vaill recounts, Murphy later commented on the painting that he had been "struck by the look (especially with the floodlights at night) of the huge almost vertical red-lead-colored smoke-stacks against the sky and the wires of the radio-telegraph, at their base the squat conglomeration of rectangular, ships-white-with-black-trim officer's cabins, dead-white mushrooming ventilators with black, gaping pure-circle mouths cut across with white rods spaced into six geometrical segments. Gray, white, black & red-lead: the whole."[3] The local artists inhospitably rallied to have the billboard-sized painting removed from the show, claiming that it was only included because of some insiders' cabal, but the executive committee voted to keep it in place. Meanwhile, the press was covering the controversy over the American who stopped traffic into the main hall, running images of Murphy standing on the steps before the painting in a bowler hat, with a bow tie and pinstripes. Murphy joked with the reporter from the *Herald*: "If they think my picture is too big, I think the other pictures are too small. After all, it is the *Grand* Palais."[4] A more intriguing comment about the visual basis for his painting is directly related to the object under a zoom lens: "I seem to see in miniature detail but in giant scale."[5]

The connection between Léger and Murphy deepened in 1923 when their ballets shared a double bill on the Paris stage. Murphy and Cole Porter created *Within the Quota*, while Darius Milhaud and Léger, who had just missed scoring a Diaghilev commission despite their earnest efforts, presented *La Création du Monde*. By this time Le Corbusier, Ozenfant, Léger, and Murphy were working on large-scale, architecturally informed still life paintings that shared a family resemblance of sharp contours, flat and boldly colored areas outlined in black, a devo-

tion to machinery bordering on cathexis, and a monumental inflation of proportions that harmonized with Picasso's contemporary neoclassical giants and giantesses. In his memoir, *The Best Times*, Dos Passos (another painter) rapturously recalls encountering Murphy and Léger on a June day in 1923 on one of their periodic strolls along the Seine. Léger, hunting for subject matter, directed their attention to the hardware on the barges, the way the lines were stowed, and the portholes of tugs. "An apostle, a mentor, a teacher" in Murphy's eyes, Léger revealed to them a keen, scrubbed vision of the city in all its colors, which they reflected faithfully in their paintings.[6] He found in the eager Americans a pair who understood what it meant for him to make objects visible again, after the terrible "gray" years of the war: "Léger was a hulk of a man, the son of a Norman butcher. He seemed to me to have a sort of butcher's approach to painting, violent, skillful, accurate, combined with a surgeon's delicacy of touch that showed up in the intricate gestures of his hands. . . . As we strolled along Fernand kept pointing out shapes and colors. . . . Gerald's offhand comments would organize vistas of his own. Instead of the hackneyed and pastel tinted Tuileries and bridges and barges and *bateaux mouches* on the Seine, we were walking through a freshly invented world. They picked out winches, the flukes of an anchor, coils of rope, the red funnel of a towboat. . . . The banks of the Seine never looked banal again after that walk."[7]

The heightened sensitivity of a painter is a tool of the trade that can lead anywhere in a city, as the greedy ears of George Gershwin led him to track down the taxi horns in the shops of the Grande Armée or as the alert Hemingway caught the bored chatter of two waiters late at night in a café and turned it into the short masterpiece, "A Clean, Well-Lighted Place." Léger was especially attuned to flashes of pure color because of the war, when any bright tone made a target and the invisibility of camouflage was a means of survival: "A light, a color, even a tone was forbidden under pain of death. A blind man's life, in which everything that the eye could see or register was obliged to hide and disappear. . . . A vast symphony unrivalled to date by the work of any musician or composer: Four Colorless Years."[8] Just the mention of the coiled rope is enough to lead, like Ariadne's thread, through a number of Léger's works in which the rhythmic weave of the rope, or a looping curve or neat coil, offered him opportunities to rhyme shapes and define colored spaces.

Calvin Tomkins draws a distinction between studying with Léger (he says Murphy was not really a student in the proper sense) and the peripatetic colloquies in Paris that made a deep impression on Murphy's thinking. While Léger was more than capable of showing Murphy how to paint (he was one of the star instructors at the Académie Moderne at the time, a trained technician who had studied under Jean-Léon Gérôme), in this story it is clear that he preferred to teach Murphy how to see. "Murphy had no desire to paint like the Paris artists who were his friends, and while his work shows Léger's influence, it is not derivative," Tomkins writes.[9] In a comparable way, Picasso's long conversations with Murphy, as often about the ballet as about art, opened the poetic potential of using unlikely, even absurd, forms that would bolster Murphy's confidence in his choices of subject matter. Of all the professional artists in the Ballets Russes circle, Goncharova was the instructor who guided Murphy's studio practice.

It looks unfair to hang Murphy and Léger side by side (dealers would give the nod to Léger's more muscular wall power as well as the draw of the name), but the comparison is not as unbalanced as presumed, and the dialogue is historically valid. Léger painted in a studio in a *bastide* (farmhouse) that was on a parcel of land the Murphys purchased alongside the Villa America in the summers after the house was completely renovated in 1925. He became one of the enchanted circle whose members gathered around the Murphy family starting that summer, a group that grew to include the Fitzgeralds, Hemingways, MacLeishes, Porters, Dos Passos, and so many others. His watercolors of Gerald and Sara Murphy aboard their sailboat are among the most evocative portraits we have of the couple, despite being almost abstract, avoiding faces or particulars of gesture yet somehow distilling the healthful radiance and easy intimacy of the couple.

Murphy's surviving paintings from the two years of unalloyed pleasure and productivity, 1924 and 1925, are large-scale still lifes in high-volume color on bright white grounds, the signature look of the period. They followed their own rules in response to modernist trends that went back a decade. Cubism had devised certain orthodoxies of still-life arrangement, starting with the confinement of the volumes to the objects that would fit on a typical café tabletop. This challenge led to limited variations on the usual cup, bottle, saucer, glass (including ab-

sinthe, with all its paraphernalia), newspaper, pipe, book, and the occasional musical instrument. Most of these conceptual decisions are made early in the process, before the artist starts to paint. Establishing a pictorial vocabulary, like setting the array of the palette, predicts the outcome to a certain degree, but there are still the distortions and magnifications, adjustments, and liberties of style to come. The most strict prescriptivists were the purists, who even stipulated the type of wine bottle and reasoned with Platonic earnestness that these "object types"[10] transcended the formal substructure of cubist destruction and formed a cast of noble objects exemplifying the standard, mechanically produced perfection (in their eyes) of the modern era. When F. Scott Fitzgerald considered the permanent significance of *The Great Gatsby* once the timely references to 1922 had faded, he defined it in terms of creating the types by which the era would be remembered.

Among Murphy's paintings, a similar logic prevailed. Not quite as modest in the selection of subject as the cubist repertoire of pipes and coffee cups, nor so archetypically utopian as Le Corbusier's glassware, Murphy's objects were loaded with personal significance that generally pertained to the life of his father, who had traveled Europe with a gimlet eye for discovering commonplace objects that could be reproduced in fine materials, such as the company's famous leather, to become luxury items for the nouveau riche market back home. When Murphy's father acquired the Boston saddle manufacturing company Mark Cross, he moved it to New York and made it a retailer on Fifth Avenue at 25th Street. His marketing strategy anticipated the path to mass-market international success followed in our time by Prada, Louis Vuitton, Gucci, and Coach (which bought out the design rights to Mark Cross goods when the company went under). This metamorphosis of the utilitarian into the desirable, attended by the usual marketing strategies such as print ads and window displays, was Murphy's training for the family business. The plan "to re-present . . . real objects which I admired . . . along with purely abstract forms" offers a crucial biographical key to the iconography of his paintings.[11] The disposable razor was a bittersweet reminder that his father had asked him in 1915 to handle a major project, designing a safety razor. King C. Gillette narrowly beat the Murphys to the patent by a couple of months. The large, square painting *Watch* pays homage to the wristwatches that officers had worn in the

trenches and that soon after, with tooled leather straps, became part of the Mark Cross line. The fragments of other watches and refracted outline of the case would appear to be cubist, but the pattern is not as prismatic and broken as a cubist painting. The radiant whirl is more kaleidoscopic than cubist in its repetitions. The wheel-upon-wheel device may actually owe a great deal to Léger's poster made in 1922 for Gance's film *La Roue* (The Wheel), about a year before Murphy began his painting. The dial in the upper right-hand of the Murphy painting corner archly presents the Roman numerals counting down clockwise from four to two at the bottom, where six ought to be, a sly commentary on time made in the year of Murphy's dear friend Fitzgerald's great meditation on the reversal of time in *The Great Gatsby*, the best parts of which were written during those days when the two men were in close touch. The circle within the square with the outstretched parts suggests an object-oriented version of Leonardo da Vinci's brilliant *Vitruvian Man* drawing, and it could be just a coincidence that a former student of architecture might appreciate — but the texts of architecture's first great theorist, Vitruvius, were just being rediscovered and retranslated in that era, published in 1931 by the distinguished Loeb Classical Library. The fourth book on the orders offers words of wisdom for the purists of Vitruvius's day (he was the Le Corbusier of his time, instrumental in the rebuilding of Rome under Augustus). His paean to perfection chimes especially well with the paintings of Le Corbusier, Léger, and Murphy: "For, by an exact fitness deduced from the real laws of nature, they adapted everything to the perfection of their work, and approved what they could show by argument, to follow the method of reality."[12]

Murphy's best-known painting, *Cocktail*, is a poignant recollection of his father's drinks tray, complete with shaker, corkscrew, glasses, and cigar box. Patrick Murphy's library is the Proustian locale of *Bibliothèque*, a (possibly unfinished) work. Cocktail shaker, cigar box, railroad timepiece, razor, fountain pen, reading glass — all were immortalized on a monumental scale in a neoclassical mode seasoned with the graphic snap of newspaper advertising or signs. This suited Léger, whose enchantment with the billboards and posters in the Place Clichy had informed his first versions of *La Ville* as early as 1919. Le Corbusier's illustrations scattered though his four books on design were drawn from catalogues and the advertising pages of illustrated magazines. The typographical

and textual innovations of Dos Passos (especially in *U.S.A.*, where he played with headline and ad copy lines) and Hart Crane (who used billboards flashing by a train window in *The Bridge*), and the eyes of T. J. Eckleburg (the most famous billboard in literature) in *Gatsby* reflect a similar invasion of high art by low commercial sources.

The psychological ramifications of Gerald Murphy's subjects are rife with irony. If they are elegies, they accomplish their task with a remarkably frosty asceticism, clinically laying out the elements of the paternal cocktail tray with precision, exposing the movement of the watch, or invading the silence of the library on 57th Street without a trace of nostalgia. Borrowing from Léger the shading of the solids and the plumb lines of the architectural setting, and from the purists the "marriage of contours," Murphy adds a suave dash of his theatrical experience and marketing savvy. The *mise-en-place* of traditional still-life arrangement, like window dressing on the avenue, becomes a mise-en-scène for a quiet drama. In addition to the works of the purists and Léger, the paintings anticipate the moody boxes of Joseph Cornell and the strangely human cast of Giorgio Morandi's paintings of bottles and ceramics. They also manage to look back to the emotionally charged, often polemical, Dutch tradition of the memento mori, in which every detail takes its place in a sermon. William Rubin, the curator of the Museum of Modern Art (MoMA) who wrote the catalogue essay for the 1974 exhibition of Murphy's work, observed: "When he started painting in Goncharova's atelier, Gerald had wanted to represent real objects as abstractions; but what had begun as an exercise in formalism had become a means to put distance between himself and images that carried a heavy load of personal connotation."[13] That dignified distance, which reminds us of T. S. Eliot's "objective correlative,"[14] was also a personal quality that lingered in the memory of those who knew both Sara and Gerald Murphy, the most dignified figures in their circle. Tomkins, for example, characterizes the style as "midway between realism and abstraction . . . astonishingly close to the ironic factualism of American Pop art."[15] He cites Gerald Murphy's own precise terms for the way the paintings ride the edge of real and abstract, the tipping point of twenties' aesthetics: "Real objects which I admired had become for me abstractions, or objects in a world of abstraction. . . . My hope was to somehow digest them along with purely abstract forms and *re*-present them."[16]

Murphy's *Watch, Razor, Cocktail,* and *Bibliothèque* invite close al-
legorical readings, and a number of recent scholars have volunteered
mainly biographical interpretations that can seem projected and pushy.
Murphy has become the subject of a cottage industry of criticism,
thanks to a retrospective in 2007 at the Williams College museum, the
first since the 1974 MoMA exhibition that began the process of redis-
covering his work. While the Oedipal strain of psychoanalysis has per-
sisted with regard to the paintings about his father's things, the most
recent wave is a determined effort to recognize Murphy as a gay artist
whose enlarged fountain pens and corkscrews offer coded ripostes to
the embedded allusions of his dear friend Porter's lyrics. The danger
lies in regarding the work as polemic or sexual confession rather than as
paintings taking part in the development of a certain strain of modern-
ism that consciously opted for impersonality rather than expressionism.

While the loving attention to detail and scrupulous finish of *Cocktail*
propels it to the front ranks of Murphy scholarship and the Whitney
Museum's collection, the (probably) unfinished state of *Bibliothèque,*
like many works in progress, permits us to draw closer to the artist as
painter and thinker. It was in the studio at the same time as *Cocktail,*
both of them prompted by a brief return visit to New York in the fall
of 1926. Unlike *Cocktail, Watch,* and *Wasp and Pear, Bibliothèque* was
regularly omitted from exhibitions—including "American Genius in
Review" in 1960, which revived interest in Murphy's work. Now in the
Yale University Art Gallery, it remained rolled up in storage in Sneden's
Landing, New York, until after Murphy's death in 1964. It was unveiled
in the 1974 MoMA retrospective that MacLeish initiated. Its omission
from exhibitions in the artist's time might be confirmation of its in-
complete state, in deference to Murphy's penchant for perfectionism
—evinced not only by his paintings but also by his sartorial fastidious-
ness, the diamond crease of his fedora or the razor-sharp crease of his
trousers, and the angled origami of the ideal pocket square. It is also a
last-place finisher for many writers on Murphy. Vaill consigns its "sober
palette" to "the gloom of a Victorian town house." Pointing out the un-
titled books and unlabeled Americas on the globe, she suggests that
"the New World, the world of his father, is an empty world, and it's not
clear that he is ready to reenter it."[17]

I respectfully disagree. The painting even in this suspended state is

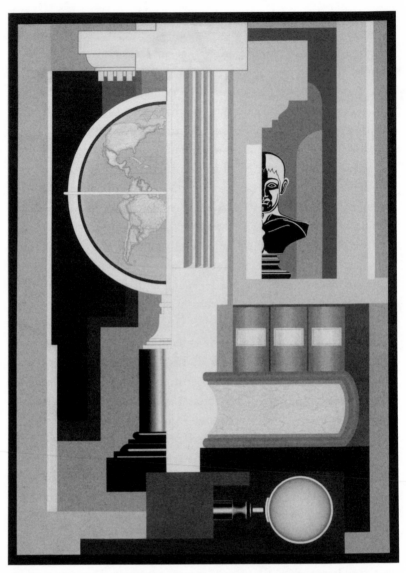

Gerald Murphy worked steadily on this tribute to his father's Manhattan library, *Bibliothèque*, from 1926 to 1927, leaving the titles of the books and the countries on the globe blank.

exquisite, not just in its detail but in the balanced pianissimo of its pastel palette. A delicate red ruled line traces the shape of the proscenium and the top of a column. Murphy follows Léger in the formal contrast of curves and plumb lines, and *Bibliothèque* is the best example of Murphy's use of the purist "marriage of contours." The subtle poetry of its hushed intimacy is brilliantly achieved by Murphy's style of seeing in cross-section (a trait found in other paintings, such as the treatment of the lemon in *Cocktail*). Almost all of the objects are offered as halves (the globe, bust, and arches are all bisected). The painting is a departure for Murphy in many other respects. While *Watch*, *Razor*, and *Cocktail* all hewed to the square, with *Bibliothèque* Murphy pursued the vertical format that Léger exploited to such monumental effect. The vertical elements in the composition are notably strong, from the fluted column at its center to the black onyx (one assumes, or lacquer) pedestal of the globe painted in "blk. fond" (deep black, in his notes) and the three thick book spines, bound in the rich leather that the head of Mark Cross would insist upon for his library, so tightly spaced on the shelf.[18]

Again following Léger's lead, Murphy surrounds all in a strong but slim framing band of black, inside of which he builds an echoing series of blue-gray and gray panels that make right-angle turns inward toward the contents of the library and anticipate the conduits that led to and from the cells of the neo-geo paintings made by Peter Halley in the 1980s in a palette that similarly mixed a range of blue grays with browns. Murphy uses these rectilinear bands of flat color to insulate an inner sanctum of taciturn imagery. It makes sense as an evocation of the sumptuous but subdued library, with its cherry-wood, floor-to-ceiling bookshelves and the lightly tinted globe set against the deep brown in the background. The glowing nimbus on the vacant lens of a magnifying glass becomes a source of light. You can almost hear the tall-case clock in a corner ticking toward the hour. Along the edge of the pages of the book lying on its cover, and in the light tracing of faux marbling in pale blue against the paper, Murphy the bookman's knowing addition of a few brown spots of foxing near the paper's edge is a formidable dash of photo realism, worthy of the cigar box top and the wood grain of the corkscrew handle in *Cocktail* or the etched silver plate in *Watch*. It was probably rendered with the same supersharp, two-hair brush. He started the job on the web of topographical details within

the pink, green, and yellow borders of the globe but then seems to have stopped. These close-ups are a telling contrast to the blank white regions at the center and top that imply the unfinished status of the work. Even the architectural schemata of the fluted column and molding, anticipating Lichtenstein's entablatures, are more shaded outline than the finish of the lens or the map. As a record of Murphy's modus operandi, the work in process reveals the fantastic gift for focus that the compulsive rendering of the globe and its highly polished base required. Of all the moments in the painting that arrest attention, the bust of Ralph Waldo Emerson glowering from its niche must be the most compelling, if only because it offers a rare glimpse of portraiture in a career dominated by still lifes that function as portraits. The portrait in this case is not from life. The late Roman style bust was in his father's library, somber as Augustus and emphasizing stoicism and purpose. Just a year before in Juan-les-Pins, where Murphy is likely to have seen it, Picasso had placed a black-and-white rendition of a plaster Roman bust in exactly the same place in a painting, eyeing the viewer sternly from the upper right in a huge still life that also runs architectural borders around the objects.

Three times in *Bibliothèque* Murphy trills on the chiaroscuro of polished jet-black surfaces reflecting stark white highlights. The bust can also be read as white marble cast in deep shadow. The face is cut off by the edge of the column and subdivided cleanly again by vertical bands of black and white. The breaking down of the bust's formal properties is in synch with the fragments of architecture piled against one another that surround it, like the fractured planes of *Watch*. The confident linear shorthand of the bust's eye and the jagged fringe of the bangs across the forehead, together with the white accents along the collarbone, are testimony to Murphy's supple wrist. As with the blank titles of the three book bindings, the literary game started by the choice of Emerson is tantalizing. The books and bust announce the classics section. Emerson's place of honor in the paternal library (as in the libraries of the private university clubs in midtown Manhattan) is no great surprise, given his popularity with that generation of self-made, prosperous New Englanders, and he is a perfect emblem for the intellect of Patrick Murphy.

The perceptual puzzle posed by still lifes of this kind, including many of the purist ones, as well as the popular imagery of M. C. Escher,

is formed by the way the artist swaps positive for negative spaces, shadows for substance, and concavities for convexities. Gerald Murphy's magnifying glass boasts a convincingly convex lens, and the logical recess of the niche behind the bust is clarified by the overlap of the shoulder before it. Yet this flattens into a striped passage in the upper-right corner of the work that would, on its own, constitute the substance of an abstract color-field painting of the 1970s or after. These spatial ambiguities offer a technical path from representation to abstraction, with both ends patently in evidence. The convincing highlights wrapping around the pedestal of the globe, as photographically accurate as comparable details in a work by Léger, are surrounded by abstraction, to which they are chromatically linked. Picking tones from within the realist pieces — the sky blue of the oceans on the globe and the grayer blue at the edge of the lens — Murphy applies them to the geometric forms of the borders, echoing the ombré effect from the globe in the delicately shaded left-hand panel of blue. Just as a graphic designer in our day can pick up a blue from the iris of a movie star's eye and use it as the tone for display type or to tint a box, Murphy matches the abstract and realist passages chromatically by maintaining the tone on his palette and applying it faithfully in both passages. The mystery of the painting's degree of completion adds another layer of perceptual complexity to the balance between realism and abstraction, at a moment in art history when these two were in a tense standoff. The blank center and T-shape at the top are primed for further development, one assumes. The painting as is remains tight, in part because that white area provides such an effective backdrop to the carved edge of the book. Even the lighter green square extending a lip toward the lens seems as though it could be an undercoat for a grayer, deeper tone, or interpreted as having a bounce that is effective as a final gesture. This is the type of dual efficacy that charges the painting with added appeal and interest, even for those who know the unquestionably finished works by Murphy.

Maybe it is the cool palette, the frustration of those blank spaces, or the austerely distant stare of Emerson on his pedestal, but *Bibliothèque*, an essay in purism, leaves viewers cold. For all the bonhomie of the Villa America set and Murphy's obvious talent for friendship, one of the qualities that struck his contemporaries and his biographers was the essentially aloof manner that at first put off MacLeish, e. e. cummings,

Fitzgerald, Picasso, Hemingway, and Dos Passos, if all the evidence of the memoirs and biographies is totaled. "Gerald seemed cold and brisk and preoccupied,"[19] Dos Passos wrote after they met, although he had warmed immediately to Sara. Some recognized Gerald's WASP-ish tendency to avoid emotional sharing or other public displays of affection, certainly a mechanism he would have acquired at the Hotchkiss School and Yale if not in his Irish Catholic home, where his father exercised an autocratic restraint. Despite the marvelously open and honest exchanges of feelings in his letters to Sara, which could furnish many couples with a guide to the importance to communications almost as impressive as the stack of letters between Winston and Clementine Churchill, Murphy was an introvert. The closely prescribed range of materials for his paintings reflected the inherently conservative tenor of his views as compared with such famous extroverts as Scott and Zelda Fitzgerald and Ernest and Hadley (to be closely followed by Pauline) Hemingway, all of whom struggled to draw Murphy out. His version of a library is an ascetic retreat conveying a solitude by no means unique to him. One finds it as well in the "reticence" that MacLeish mentions in his portrait of Sara,[20] the silhouette of Gatsby alone on his dock or in his own library, or the remoteness of George Balanchine's Apollo posed as an archer. It is the "Homeric solitude"[21] that Le Corbusier sought to create in the monastic white cells of the hospital he designed in Vence, lit by skylights: "Daylighting remains well distributed as was the room temperature so that the patient can enjoy calm isolation," Le Corbusier stated.[22]

For an antidote to that fresh purist water, on the strength of subject alone *Cocktail* is the kind of painting to get a party started. When the Whitney Museum opened its vast new Renzo Piano–designed building in the spring of 2015, *Cocktail* was hung in a position of honor beside a raucous Stuart Davis in the top-floor galleries devoted to the historical core of the permanent collection. Glassed over in the same overcautious manner as other highlights by Edward Hopper, Jasper Johns, Arshile Gorky, and Frank Stella, because the conservators are concerned about damage that might be done by the crowds expected, it seemed more fragile than its image in books might convey, less like the boldly jazzy statement of the Davis to its left or the solid Léger paintings of the same period. While it reads in reproduction like a sophisticated and

clean statement of graphic design, in person it is more human, with a surprisingly gentle touch and faint, modulated colors. I had forgotten, for instance, how lightly Murphy painted the cigar box top and perforated label, in tiny strokes as delicate as a brush with only two hairs could manage rather than the intense drops and flecks of vivid colors a miniaturist would use to transfer a confined design of its kind to porcelain or enamel. It took Murphy four months to complete that passage. The sheer labor of creation suggests it was slow going all along. The rigorously shaded metallic sheen of the cocktail shaker is so meticulous in its striations of grays, whites, and blacks that mimic the polished surface of the chrome that it calls out the master of the metallic cylinder, Léger himself. The black perimeter wobbles a bit where the painting had been stretched, less firmly ruled than the corrected image conveys in print (when it does reproduce the painted black line). The Le Corbusier–like echoing silhouette of the glass, scaling upward along the left edge, and the reference to Picasso or Braque in the faux wood grain of the corkscrew handle are easy quotations to identify, but the oddly murky tone of the lemon rind, the diagram-like section of the fruit itself with its pips and sections, and the architectural space of the joined orthogonals is as unique to Murphy as the fantastic cross-sections of the ventilation shafts in *Boatdeck*, the fruit in *Wasp and Pear*, and the elegant townhouse interior of *Bibliothèque*.

Other surprises presented themselves when I revisited the painting in person. For the first time I noticed the difference between the middle cigar in the box and the four others. While the others are deftly shaded in matching brown, to offer the three-dimensional contour of the cylinder, the central one is left blank, bound to the row with a correctly finished blue label but otherwise a white, oddly flat and vacant shape in the center not just of the box, but of the whole painting. Why, in a painting as worked as this, leave a central section, however small, empty?

Another puzzle is posed by the top of the cigar box. The picture of the lady pointing to the globe is so convincingly commercial in stiffness, color, and scale that the viewer expects Murphy is copying faithfully, making a direct transcription from the original box (still in the family collection). To assume perfect fidelity would be to miss the sly coded inventions Murphy inserted about his own (rather than his

father's) interests, such as the miniature yacht, the flywheel like those in *Watch*, and the artist's palette. The deviation from the photographic documentation of the actual cigar box, like the little parables slipped into Dutch still lifes or the messages in a trompe l'oeil by William M. Harnett (just a generation before Murphy chronologically, although he seems a distant antecedent), brings to mind statements about reality made in two of the most telling and heart-rending letters in Murphy's eloquent correspondence, from the awful period after the crash when his sons fell ill; was forced to return to the office at Mark Cross; and was frequently away from Sara, who tended to Patrick during his battle with tuberculosis. Gerald returned to New York in September 1930, but he disobeyed Sara's pleas for him to let MacLeish and other friends know he was in town. MacLeish, Fitzgerald, Dorothy Parker, and the rest of their circle found out, of course, and Murphy wrote a long letter to MacLeish about friendship, the dread of deception, and reality. He tried to explain his evasive behavior as a means of avoiding the awful risk of "disfiguring one of the few phantom realities of my life, my friendship with you both." MacLeish, who wrote a similar letter to his mother (to be considered in the next part of this study), understood his friend's awareness of being trapped in the "unreal," even as his circle of admirers considered him so fortunate. Murphy confessed:

> After all these years — and in one sudden year — I find myself pried away from life *it*self by the very things that make up *my life*. . . . It is never quite possible to believe that *all* that one does is unreal, or that one is *never* oneself for a moment — and that the residue of this must needs be a sense of unreality, all-pervading. I don't think I hoped to beat *life*. Possibly I thought that mine was one way of living, among many thousand ways. . . . And so I have never felt that there was a place in life as it is lived for what I have to give of myself. I have doubtless ended by trying, instead, to give of my life as I lived it. My subsequent life has been a process of concealment of the personal realities, — at which I have been all too adept. . . . The effect on my heart has been evident. It is now a faulty "instrument de précision" working with accuracy in the direction of error.[23]

An even more soulful letter is dated December 31, 1934, at just about the darkest hour in the Murphy family saga, roughly a decade after their golden days in Antibes. It was written just months after his healthy son

Baoth had died of meningitis at boarding school, and as his other son Patrick was fading fast (he was already down to under sixty pounds) in a tuberculosis clinic on Saranac Lake, in New York State. Both Sara and Gerald were corresponding with Scott Fitzgerald, who was dealing with Zelda's hospitalization at the time. The awful premise of many of the letters is not just the need for condolences about Baoth's death, or the nostalgia for the Villa America days, but the apologies Fitzgerald owed for the awful betrayal represented by the publication of *Tender Is the Night* that year, dedicated to the Murphys even as it twisted them into pathetic versions of Scott and Zelda. On New Year's Eve, with one child gone and the other fading fast, Gerald decided it was time to tell Scott the truth:

> Of all our friends, it seems to me that you alone know how we felt these days — still feel. You are the only person to whom I can ever tell the bleak truth of what I feel. Sara's courage and the unbelievable job she is doing for Patrick make unbearably poignant the tragedy of what has happened — what life has tried to do to her. I know now that what you said in "Tender is the Night" was true. Only the invented part of our life, — the unreal part — has had any scheme any beauty. Life itself has stepped in now and blundered, scarred and destroyed. In my heart I dreaded the moment when our youth and invention would be attacked in our only vulnerable spot, — the children, their growth, their health, their future. How ugly and blasting it can be, — and how idly ruthless.[24]

This is Murphy without the protective shell. En route to considering what the distinguished art historian T. J. Clark calls the "truth"[25] in painting as embodied in a Picasso still life from the same year and the further examination of truth in the writings of Hemingway, Fitzgerald, and MacLeish, the statement about "the invented part" takes on aesthetic as well as personal relevance. The glamorous, Gatsby-like parties on the Riviera and in Paris and the costume balls and picture-perfect table settings at the Villa America qualify as one alluring and shallow version of what "the invented part of our life" could mean, but there is a deeper interpretation as well. A common thread of invention in the sense of fabrication connects the reversed numbers on the watch, the sly alterations of the image on the cigar box, the blank cigar, the white labels on the three books in the library, and the empty spaces on the

globe. These openings identify painting as *verum factum* (the truth that is made), constructed on a plane literally equal to that of the scrupulously rendered trompe l'oeil of the top of the cigar box.

The formidable Tomkins, chief art critic at the *New Yorker* in the 1980s, profiled the Murphys for the magazine in 1962. It was a brilliant long-form piece based on interviews with the couple as well as redcheck sources such as MacLeish and Dos Passos. Expanded a decade later, it became the first substantial group portrait of the Villa America circle under the same catchy title as the magazine headline, *Living Well Is the Best Revenge*. Tomkins is an enviable authority, an insider in the contemporary art world and an expert in studio visits who is just the right choice for an assignment when the artist is a notoriously hard interview subject to crack (it never seems to hurt, either, when the subject is either wealthy and socially prominent or at least collected by those who are). Tomkins's reliable portraits of Johns, Robert Rauschenberg, Lichtenstein, and Marcel Duchamp offer rare insight into enigmatic figures who resist the usual intrusions. Since Tomkins's critical judgment is so sure-footed and well-informed, and his range of comparisons among painters is so broad, the reader interested in placing Murphy in the canon yearns for a summary observation on the eight paintings collected for a solo show in Paris at Georges Bernheim's gallery in 1929. The news peg for the story might have been Murphy's rediscovery in an exhibition of five neglected American painters under the title "American Genius in Review," organized by Douglas MacAgy, curator of the Dallas Museum for Contemporary Arts, where it opened in May 1960 (just two months before Tomkins's article appeared, and as it was being finished) and went on tour. Murphy found the experience so gratifying that he donated *Watch* and *Razor* to the Dallas museum. Yet there was one tacit no-go zone for the interviews: the interconnected death of the boys and Murphy's abandoned career as an artist.[26]

The tone of Tomkins's profile is admiring, based on long days and evenings with the couple in Sneden's Landing, where they were his neighbors. Tomkins, who went to the Berkshire School and then Princeton University, clearly found common ground with the patrician Murphy, who called him "Tad." He would eventually be a pallbearer at Murphy's funeral. However, a quotation late in the magazine version of the story is revealing: "Murphy no longer painted; he had stopped abruptly when

Patrick first became ill, and he never took it up again. (His own explanation is that he realized by then that 'I was not going to be first rate, and I couldn't stand second-rate painting.')"[27] This was an echo of Murphy's reply to an earlier suggestion by Tomkins that he write an autobiography: "I have too much respect for the craft of writing to take it up as a second-rate practitioner."[28] When Tomkins augmented his consideration of the paintings in a still cursory appendix to his book, he expanded on the exchange with an oblique reference to MacLeish ("those closest to him") in an afterthought that led to the book's finale:

> Asked once why he had stopped painting in 1930, Murphy replied that he had simply realized his work was not first-rate, "and the world was full of second-rate painting." Those closest to him found different explanations. Perhaps the attempt to make one's own life into a work of art becomes, in the end, inimical to serious work in any field: "Either a comfortable life and lousy work or a lousy life and beautiful work," Léger once remarked. Living well, however, was not a sufficiently adequate revenge for Murphy. He once told a friend that he had never been entirely happy until he began painting, and that he was never really happy again after he stopped.[29]

There is no need to consign Murphy to the status of Sunday painter. The mystery of why he put his brushes down is less baffling in the context of those poignant letters about the impact of his sons' deaths, so soon after each other. Each person reacts to the unexpected incursion of mortality in his or her own way. Tragic and elegiac art is supposed to help both the maker and the audience survive trauma. The postwar generation faced its demons on its particular terms. Some, including Murphy and Léger, turned to order as a riposte to destruction. Le Corbusier planned pure white urban geometry for bombed sites. Stravinsky, Picasso (including *Guernica*), Dos Passos, cummings, Hemingway, and Eliot ("These fragments I have shored against my ruins"[30]) put the shattered world on canvas and paper in hopes of catharsis. Art's capacity to even the scales against death is no simple equation.

In a brilliant essay on the balancing act between reality and the imagination (which he called "noble," an apt adjective for Murphy), Wallace Stevens countered the Freudian surrender to reality (specifically as spelled out in *The Future of an Illusion*) with an assertion of the imagination's capability to push back with a force of its own: "It is not an artifice

that the mind has added to human nature. The mind has added nothing to human nature. It is a violence from within that protects us from a violence from without. It is the imagination pressing back against the pressure of reality."[31] Murphy was a central figure in the creative vortex of the Jazz Age, connecting geniuses with each other and staking his own claim to the artistic legacy of a time when painters, composers, and writers redeemed part of the destruction they had seen. If in his later years he concluded that "only the invented part" held permanent meaning, then his case is not much different from the grand illusions of Fitzgerald, the epiphanies of Hemingway, or the spectacles of the Ballets Russes. After all, he had been present at the creation.

PROPHET OF DISORDER

14

Oswald Spengler

The artists and architects were not the only Jazz Age thinkers concerned with imposing order on the chaos wrought by World War I. Imagine the problem faced by contemporary historians, convinced that the so-called war to end all wars had just concluded and an era of permanent peace had begun. Formulating a tidy and systematic view of world history from that perspective was a perilous project. One contrarian who managed to impose an elaborate order on the events of his time and correctly predict the even greater catastrophe to come became an intellectual authority and source for several figures in this study, including F. Scott Fitzgerald and Hart Crane. The popularity of Oswald Spengler's *Decline of the West* is an oddity of publishing history (like the best-seller status of George Santayana's philosophical novel *The Last Puritan* at about the same time). The dark mood of Spengler's book defied the contemporary zeitgeist as well as the views of professional academics. The first volume of Spengler's magnum opus, *Decline of the West: Form and Actuality*, appeared in July 1917, and within two years it had become one of the most controversial books on both sides of the Atlantic. It is the work of a German who hated barbarism, offering a formal paean to order, a morphology of history that in its tabular symmetries harmonized entirely with the neoclassical validations of form traced in the works of Le Corbusier, Léger, Murphy, Balanchine, and Picasso. Like Ernest Ansermet, who drove his study of music to the conclusion that form would prevail, Spengler was a committed formalist. His aesthetic appeal has been overshadowed by his reputation for uncanny prophetic accuracy (he predicted the rise of the Third Reich). Cultural historians should take another look at this impassioned yet "ordered presentation of the past, an inner postulate the expression of a capacity for feeling form." Before one has a moment to let this desideratum comfortably

sink in, Spengler raises a typical cautionary finger: "But a feeling for form, however definite, is not the same as form itself."[1]

While not everyone was enamored of the broad-brush history under the pressure of the necessary *Gestalt* (form) and *Gesetz* (law) — Thomas Mann thought Spengler a lightweight — for Dos Passos, cummings, Fitzgerald, Crane, Hemingway, and the rest of their generation the "world-picturing" in the book was inspiring.[2] The rhapsodic high style probably contributed to the spell Spengler cast. The Nietzschean baritone from the mountaintop is thrilling, especially in an age still shaken by its brush with chaos in World War I and searching for the Euclidean clarity of a thinker who appears to have embraced all knowledge and art. Spengler offers footnote-worthy insights not only into architecture, art, and design but also into mathematics, music, literature, history, politics, economics, anthropology, religion, and the sciences. Practically the only omission is of a contemporary figure who might have validated his argument not just about a unified theory but the Faustian soul of Europe and its destructive capacity: Albert Einstein.

For young artists in Paris, the heroic exhortations of Spengler's challenges could also be taken as a benediction: "All art is mortal, not merely the individual artifacts but the arts themselves. One day the last portrait of Rembrandt and the last bar of Mozart will have ceased to be — though possibly a colored canvas and a sheet of notes may remain — because the last eye and the last ear accessible to their message will have gone."[3] One of the attractions of this eschatological drama was its *amor fati*. After the trauma of the war, the yearning for order was entwined with a sense of *Götterdämmerung*, the premonition of further doom, and exhaustion. In this sense, Spengler as well as Edward Gibbon or Georg Wilhelm Friedrich Hegel were seen as poets of decadence for whom entropy (a key word in *The Decline of the West*) as the world edges toward what he derisively called "megalopolitan man" is a chilling inner fear.[4] Around that core of apprehension, Spengler built an elaborate system of spatial and logical precision symbolized by the set of tables that appear as gatefolds in the appendix, a crystalline diagram so balanced and tidy as to be worthy of Immanuel Kant. As ardent as Le Corbusier's call to order, Spengler's insistence on "discipline" in the "somatic" delineation of patterns (beginning with mathematics and culminating in the tables that collate the mathematical

epochs with spiritual, cultural, and political developments) is a firm re-
buttal of the nonchalant reputation of the lost generation. "Once upon
a time, Freedom and Necessity were identical; but now what is under-
stood by freedom is in fact indiscipline," Spengler grumbled.[5] Unafraid
of citing such masterpieces as the self-portraits of Rembrandt, the late
string quartets of Ludwig van Beethoven, and the invention of algebra,
Spengler offers the Apollonian form-world as binding, a philosophical
rationale for the neoclassical pursuit of perfection. The undercurrent is
that inexorable return to entropy, which appealed to those who — hav-
ing witnessed trench warfare — correctly believed that a worse scenario
was possible. In Spengler's case, there is the eerie prediction of the
massive devastation of the atomic bomb. He wrote: "In every culture,
thought mounts to a climax, setting the questions at the outset and an-
swering them with ever-increasing force of intellectual expression and,
as we have said before, ornamental significance — until exhausted; and
then it passes into decline in which the problems of knowing are in
every respect stale repetitions of no significance."[6] Spengler's conclu-
sion is a dark prophecy of formlessness, a reminder that his doctoral
dissertation was on the master of entropy, Heraclitus: "The Faust of the
Second Part is dying, for he has reached his goal. What the myth of
Götterdämmerung signified of old, the irreligious form of it, the the-
ory of Entropy, signifies today — world's end as completion of an in-
wardly necessary evolution."[7] Weary and resigned to catastrophe, the
Spengler of the final pages is a far cry from the irrational exuberance
surrounding him in Jazz Age Germany. That is why he appealed to The-
odor Adorno, the dour philosopher of the Frankfurt School who, in
the sixties (amid similar popular trends toward what Spengler would
call "indiscipline") devoted an essay to an appreciation of the perfect
"sphere" of the Spenglerian model of history. Adorno commented: "To
escape the charmed circle of Spengler's morphology, it is not enough
to defame barbarism and rely on the health of culture. Spengler could
laugh in the face of such blissful confidence. Rather, it is the barbaric
element in culture itself which must be recognized. The only consid-
erations that have a chance of surviving Spengler's verdict are those
which challenge the idea of culture as well as the reality of barbarism."[8]
The critic and philosopher George Steiner refers to Spengler as a "ter-
minalist"[9] in that Nietzschean vein of his stern warnings, which were as

vehemently resisted as Cassandra's in an optimistic era and only later gained credence as the hermeneutics of suspicion swept through academe. Its imprint can be discerned in the darkness of Hemingway's short fiction (notably "The Big, Two-Hearted River," "A Clean Well-Lighted Place," and "The Snows of Kilimanjaro") and in the sober exploration of the perils of walking on the edge of the abyss so touchingly set down in Fitzgerald's *The Great Gatsby* by a young author who was about to plunge over that edge. The tidy spatial rigor of Spengler is also reflected in the compositional formats of purist and De Stijl paintings and the symmetries of Balanchine's great masterpiece of the era, *Apollon Musagète*. Together with Ansermet's similar theory of the epochs of music, Spengler offered a guide to where the Jazz Age would take its place in history even as it unfolded. Freedom and order vied for supremacy in a vision whose truth would only later become apparent.

TRUTH
THE TRUEST SENTENCE

Even if beauty took a back seat in the wake of the disastrous deceit passed like counterfeit coin down the chain of command during World War I, the will to truth engendered a reactionary wave of realism during the Jazz Age that was as urgent as the lust for freedom or the idealization of order. Alongside the apostles of order, another cohort, led by Archibald MacLeish and Ernest Hemingway, had its own marching orders that honored the world as they experienced it.

Realism ebbs and flows with the taste of various periods, but the desideratum of truth remains, locked into such terms as *vraisemblance*, "verisimilitude," *l'effet de réel*, "veracity," and "fidelity." The burden of truth telling fell mainly on the writers, but there was also a stirring resurgence of realism in painting, from the Neue Sachlicheit to the fastidious still lifes of Pablo Picasso, Joan Miró, and Fernand Léger. It was pushed to subconscious or hyperconscious limits in surrealism. The figure in art enjoyed a resurgence through the nudes of Amedeo Modigliani, André Derain, Pierre Bonnard, Henri Matisse, Aristide Maillol, and the pioneering Chinese feminist Pan Yuliang. Their curves were different from the angles of the cubist fourth dimension, the axonometric still lifes of Le Corbusier, and even the Albertian perspective of the old masters. Geometric abstraction was one utopian step removed from the truth in painting. In music, the veracity of the blues and the dystopian dissonances of *Zeitoper* as direct expressions of raw experience made the buoyancy of popular songs, the symbolic rhetoric

of grand opera, and the rule-bound theory of Arnold Schoenberg appear false and remote from real life.

Veterans unleashed the grim details of trench warfare in novels and memoirs (including *A Farewell to Arms, For Whom the Bell Tolls, The Enormous Room, Three Soldiers, The Good Soldier, Parade's End, Goodbye to All That,* and *All Quiet on the Western Front*) in violation of the decorum of patriotic war writing. An obligation to bear witness offered Hemingway and his many imitators an abundance of vivid material for the sympathetic reader to devour. It also presented the immense artistic and ethical challenge of finding the form, medium, and diction that could adequately represent the atrocities. Hemingway agonized over the difficulty of keeping his talent sharp enough to write the "one true sentence" or build "the one true thing" into what was after all just a story.[1] As a battleground journalist (notably in Spain), he knew that the shaping of a news story conforms to conventions at the expense of the direct recording of the action, in a way that would not apply to unfiltered live coverage. The newsroom model remains the inverted pyramid, at the top of which the freshest and most vital details are placed according to the rule if it bleeds it leads. Narrative form and fidelity to the facts can be at odds. Hemingway was not the only writer who thought this through. Eugene Jolas had a remarkable role in the reform of European newsrooms to institute American-style, evidence-based reporting standards in place of opinionated coverage, and MacLeish was on the founding team of Henry Luce's *Fortune* magazine, which set the gold standard for fact checking by neutral reporters. James Joyce snugly tied the details of *Ulysses* to a single issue of the Dublin *Evening Telegraph* for Thursday, June 15, 1904, priced at one halfpenny (one of Vladimir Nabokov's favorite tidbits when teaching mimesis). Even Fitzgerald, hardly Hemingway's peer in the realm of truth telling in person, would ground *The Great Gatsby* in the headlines of 1922. He alerted his editor that part of his revisions to the novel during December 1924 would rely on details from the Fuller-McGee case of the misappropriation of a stock brokerage's assets (one of the brokerage's owners, Edward M. Fuller, lived near the Fitzgeralds in Great Neck, New York, and did business with the gambler Arnold Rothstein—the model for Meyer Wolfsheim, "the man who fixed the World's Series back in 1919"[2]). One recent study of Fitzgerald assigns a central role in the novel's backstory

to the sensational story of the double murder of Eleanor Mills and Edward Hall in September 1922.[3]

Writers versed in objectivity demanded truth from fiction as well as journalism. It was the backlash against the perceived falsehoods of the era that had just passed, including the political run-up to the American involvement in the war; the improbable Wall Street fortunes leveraged fifty to one; the pseudo-European mansions along the Gold Coast of Long Island; and the wild exaggerations of advertising, which Fitzgerald, Gerald Murphy, and Hart Crane had known from the inside as copywriters. Veterans had a growing suspicion that the next assertion of peace in our time would be as empty a promise as any rumors of a swift end to fighting they had heard in the trenches in 1914, 1915, 1916, or 1917. The heart punch in Wilfred Owen's profoundly nonidealistic poem "Dulce et Decorum" is delivered by the irony of the penultimate line, which sets up, the dismissive phrase "that old lie," the familiar sentence from Horace that is carved in the stone of war memorials across Europe and the United States: "Dulce et decorum est pro patria mori."[4]

The only adequate response to "that old lie" would be an insistence on the truth. Summarizing the trajectory of his generation, Fitzgerald progressed rapidly from the illusionistic nationalism of his childhood ("jingo was the lingo") to the confusing experience of being "at once pre-war and post-war." He summarized that trajectory in this way: "So we inherited two worlds — the one of hope to which we had been bred; the one of disillusion which we had discovered early for ourselves."[5] MacLeish credited T. S. Eliot and Ezra Pound with the realization of how the world of their childhood had vanished. "It was not the Lost Generation which was lost: It was the world out of which that generation came. And it was not a generation of expatriates who found themselves in Paris in those years but a generation whose patria, whatever it may once have been, was now no longer waiting for them anywhere."[6]

As with the shifts from cubism to neoclassicism or from romanticism to jazz, this commitment to realism came at an awkward moment in the modernist program, which was supposedly headed toward abstraction. Painters who returned to the figure, writers who hewed closely to traditional narrative, and musicians who revived the dance looked like traitors to the movement. The Jazz Age artist was unafraid

of major projects from symphonic jazz to the epics of Pound, Joyce, and John Dos Passos, and the mural-scale still lifes of Picasso, Murphy, Léger, and Le Corbusier (who wanted nothing less than to redesign part of Paris). Just a few years before, when Albert Einstein (whose most famous equation is the astonishingly minimalist $E = mc^2$) and Niels Bohr were shrinking physics down to the atom and turning matter into energy, modern art was enjoying the heyday of the fragment. The two-line imagist haiku of Pound, the one-minute orchestral pieces by Anton Webern or Alban Berg, Béla Bartók's segments of *Mikrokosmos* for piano that were just a few seconds long, and the tight scale of Kurt Schwitters's collages are all examples of a focused interest in the intimate experience of the miniature.

Among the large-scale canonic works that slipped into the conversation, Shakespeare's *Hamlet* wove its way conspicuously in and out of the poems, novels, and essays of the era. Why *Hamlet*? It is a play dedicated to the struggle of both characters and playwright to determine the objective truth (of the murder of a king). For Eliot, who dedicated his graduate study in philosophy to the epistemological aspect of this problem (drawing on the work of Frances Herbert Bradley, Ludwig Wittgenstein, and Bertrand Russell), *Hamlet* was the test case. Eliot's own method of adequately conveying emotion through the life of the "objective correlative" was formulated through a reading of the play.[7] Words in *Hamlet* are the problematic external signs of inner states, none of which Shakespeare was successful (insists Eliot) in making knowable. The final sentence of the essay, published in 1919, states: "We should have to understand things which Shakespeare did not understand himself."[8] Later in this book, the responses of Joyce, MacLeish, and Eliot to *Hamlet* are considered in depth. The play poses a test case in the struggle with the medium (language, music, or paint) to tell the truth, an *agon* intensified when the emotional stakes are high. As Eliot wrote, paving the way to his own poetry of the period: "Hamlet (the man) is dominated by an emotion which is in excess of the facts as they appear."[9] A. D. Nuttall uses Shakespeare to advocate "a new mimesis" as a healthy antidote to the excessive relativism of postmodernism or deconstruction. He could be referring as easily to Hemingway or the blues as to Shakespeare when he writes: "It pierces by its truth."[10]

For the veterans of the war as well as for an artist such as Picasso who

was never satisfied with the correlation between his art and his ideas, the appeal is obvious. Picasso sacrificed beauty to truth; Hemingway and Dos Passos renounced novelistic decorum; and Louis Armstrong roughened the sweet, clear notes of Bix Beiderbecke to give his instrument and voice the texture of real emotion. They were all negotiating a place for naturalism. Jazz Age writing tapped into the tradition of Émile Zola, Honoré de Balzac, and Charles Dickens as the appropriate models for *verum factum*. The situation is all the more complicated because this was also the era in which philosophers from Vienna to Oxford and in both Cambridges became sticklers regarding ontological, mathematical, and especially linguistic claims to truth. Simply put, realism in writing or even art was problematic if the truth value of language and painting themselves was under suspicion. A central thinker in this skeptical movement was Wittgenstein, who returned home from the English Cambridge to enlist in the Austro-German infantry in 1914 out of a sense of duty and was posted to the Eastern Front by August. He wrote anguished letters to his dear friend Russell not only about the likelihood of dying but also about the awful prospect of fighting against the English. He sent Russell the manuscript of his philosophical masterpiece, the *Tractatus Logico-Philosophicus* (eventually published in 1921 with the opening sentence, "The world is everything that is the case"[11]), which blew apart current theories with the efficiency of one of the howitzers he was aiming at the Cossacks, as his men called the Russians. His skills as a professional mathematician had led to his reassignment from foot soldier to officer in an artillery unit, but he, like Léger, was always on the front line, where the action was both exhausting and exhilarating. Suddenly math and language were no longer abstractions. Calculate correctly, relay an observation with clarity, and the target is hit. Some of Wittgenstein's most compelling arguments build on the impossibility of accurately relating pain from one individual to another using mere words to describe what is felt (a chronic problem for medics and other health care professionals). These were the substance of the entries he heroically penciled, fueled by nonstop coffee and adrenalin, in notebooks that track his desperate effort to solve a problem with *das erlösende Wort* (the word that would deliver us from evil).[12] He used the lulls in action to fill his notebook with skeptical progressions of aphoristic observations on the impossible need to tell the whole truth using

mere language or mathematics: "You can't be reluctant to give up your lie, and still tell the truth."[13]

Wittgenstein points to a fundamental yet forgotten tenet of many Jazz Age artists: the radical questioning of the media they used. From the baroque twisting of etymology and sense in the polyglot writing of Jolas, Joyce, and Pound to the convoluted syntax of Gertrude Stein, English was tested in the laboratory, spun in centrifuges to reduce it to its trace elements, and mixed in reactions with other languages with often-explosive consequences. This doubt could also be moving, as in the anguished letters MacLeish sent to his mother about the inadequacy of English to the elegiac mission of visiting the crash site in Belgium where the fighter plane of his brother, Kenneth, had been shot down. In poems and theories, writers used language to interrogate language. Music had its own version of this basic inquiry, not just in the creation of the jazz scale but also in the rethinking of the relationship between tone and sound. Composers as different as Cole Porter and Erik Satie sat quietly at their keyboards (George Antheil, not so pianissimo) sounding out monotones, while Ernest Ansermet mathematically drilled deep into the effects of those subtle sounds on consciousness. Following the masterful if restive example of Paul Cézanne, everybody's hero, even the supremely self-assured Picasso rethought the status of paint as medium in a series of still lifes that delved into the optical and symbolic qualities of single colors, particularly blue (which had been so important to his early career). Instead of assuming the verisimilitude of their media, by testing with a Wittgensteinian rigor the means to the truth as end a committed group of artists conscientiously responded to "that old lie" with their own answers.

Truth in an era of abstraction was not the same as it had been during the earlier periods dominated by realism. In the tightly mimetic phase of the nineteenth century and before, truth was measured according to the accuracy of the mirror image. Photographic realism in the life drawings of students at the École des Beaux-Arts up until the twenties (and even after) gave validity to mimesis. Sculpture and painting were based on the correct depiction of the figure or landscape, the mirror held up to nature. But truth in the Jazz Age was not a matter of fidelity to nature, and its philosophical status was problematic. Léger's insistence on truth was part of the blunt impatience of a veteran of the trenches

who started his military service as a camouflage painter. T. J. Clark finds more "truth"[14] in the ugly still lifes painted by Picasso after his theater years (when artifice presumably would be the agenda) than in the "untruth" of cubism and its tricks. Like Russell urging democratic citizens to develop their "immunity to eloquence"[15] or Jolas's early warnings about Adolf Hitler's first speeches, these writers and artists were justifiably suspicious of rhetoric, facile design, and sentimental music.

The cold precision of the still life is the epitome of the pursuit of both order, as we have seen in the previous part, and truth. Those two values may not be on the same side if order is imposed at the expense of truth, as in the tables of history prepared by Oswald Spengler or the neat color charts created in the era for painters by Bauhaus masters Johannes Itten and Wilhelm Ostwald. Clarity, maximal contrast tending toward use of the primary colors, clean edges, and a vocabulary keyed to ordinary objects are hallmarks of the intersection between graphic design and high art. We approach this look through the perspective of an abstract age (not just abstract expressionism, but also the Bauhaus, the suprematists, the minimalists, and the neo-geo painters of the 1980s). This retrospective view seems to validate the steady march of painting toward the monochrome as predicted by Alfred Barr's celebrated diagram for the arrangement of the collection of the Museum of Modern Art (MoMA). From Kazimir Malevich's *White on White* or *Red Square* to the twenties-era grids of Piet Mondrian, the line leads through the still lifes of Le Corbusier and Léger to the monotonal masterpieces of Ellsworth Kelly, Josef Albers, Yves Klein, Barnett Newman, and so many others hanging on the walls of MoMA and Chelsea galleries today. The isolation of a color by a painter (or a sculptor, as in the case of Donald Judd's radioactive orange and his championship of specificity as a way of achieving truth to materials) can be an exploratory commitment, an inquiry into optical, epistemological, and aesthetic control. Nobody would mistake Léger's *Le Mécanicien*—half-man, half-machine—for the actual mechanic. Léger painted a type, using a visual language that emerged from cubism but diverged from it in important ways involving color and form that stressed opacity over the transparency of the usual realist style. The pursuit of truth arises from a similar source. I see and hear it in the era's use of the monotone. Stravinsky pounded a dissonant chord in groups of eight so insistently in *Le*

Eugene Jolas, who republished *Tender Buttons* in 1928, called Gertrude Stein the "dean of exiles." This photographic portrait was made by Carl van Vechten.

Sacre du Printemps that even Diaghilev thought he had gone mad. Cole Porter pushed the idea of the jazz blue note to an almost absurd length in the introduction to "Night and Day," with its heartbeat-echoing repetition of the monosyllables ("beat," "tick," and "drip") that signals the obsessive quality of love.[16]). Its precedent is the hypnotic A-flat that pulses through the length of Frédéric Chopin's "Raindrop" prelude. No less than thirty-five times the G sounds at the top of "Night and Day," then Porter audaciously rises a half step to an A-flat (nine times), and another half step to an A natural (five times) before slipping back to that pounding, insistent G until suddenly it swings into the chorus, on, of course, the same damn G: "Night and day you are the one." Then it breaks free in the phrase about the "hungry yearning, burning inside of me" rising at last to a C major, shaking off the ties of the monotone.

As so often in songs of the period, here Porter is partly aiming for comic overstatement, but there is another aspect of the remarkable thirty-five-note sequence. Like George Gershwin's use of the meditative A-flat in *Rhapsody in Blue*, to which he returns insistently as though he were trying out a new Steinway, Porter experiments by testing the sonic qualities underlying the tone itself, activating the undertones and

building the independent sensual architecture of the note, investing it
with meaning that is both dramatic and musical. By the end of the in-
troduction, the note is attached firmly to one word repeated by a voice
inside the singer: "*You, you, you.*" Porter, Gershwin, and other jazz com-
posers who strained the limits of good taste (or boredom) by returning
to one note for extended rhythmic figures reestablished the place of
the tone in the scale by inquiring so rigorously into its sound qualities.
Porter's thirty-five Gs are not throwaway beats, the long pedal point
that rhythmically underlies Antonio Vivaldi's concerti functioning like
drones. Porter tested the truth of that note.

If the idea sounds familiar, compare it to Stein's habit of sounding
the monosyllable, especially in her domestic mode. This is not the in-
famous "rose" in "Rose is a rose is a rose is a rose."[17] Consider her de-
ployment of the article "a" in the course of *Tender Buttons*, both in the
paragraph headings and in the texts. It recurs a Porter-worthy thirty
times in the first few paragraphs, beginning with the one headed "A
Petticoat" with its single, spare line: "A light white, a disgrace, an ink
spot, a rosy charm."[18] The rhythmic pattern of the texts has been set,
but the tonic key is "a." In the next section, "A Waist," the phrases extend
a few syllables further, but rely on the monosyllable for each initial:
"A star glide, a single frantic sullenness, a single financial grass greedi-
ness."[19] Other literary examples of the monotone, abstract in an aural
way, recur in Hemingway (follow his use of "and" through one of the
endless sentences of *For Whom the Bell Tolls* or *The Sun Also Rises*) and
the incantatory endings of so many Eliot poems of the Jazz Age, not the
least of which is the Sanskrit coda to an Upanishad, a mantra repeated
three times at the end of *The Waste Land*: "Shantih shantih shantih."[20]
The other modernist landmark published that year, *Ulysses*, concludes
with a virtuosic monologue, a mimetic transcription of an orgasm in
stream of consciousness, which runs from "Yes" at its opening through
153 repetitions of that monosyllable to the final words of the novel, "yes
and his heart was going like mad and yes I said yes I will Yes."[21]

15 THE TRUTH IN PAINTING
Pablo Picasso

As in practically every decade from the beginning of the twentieth century to his death in April 1973, Pablo Picasso takes his star turn during the twenties, but not without a few catcalls from an audience sprinkled with loyalists to the avant-garde agenda. The undeniable majesty of the Blue Period portraits and the originality of the cubist still lifes established his standing as an innovator. The former are examples of tragic realism, an elevated level on which Picasso's preternatural technique in modeling and contour painting from life would carry the effect miles beyond the work of even Henri de Toulouse-Lautrec and Edgar Degas to the emotionally loaded, virtuosic masterpieces that secured his place alongside the old masters. Picasso was only twenty-three when he created the profoundly affecting *Woman Ironing*, now at the Guggenheim Museum. Among the many monumental works in this firmly mimetic vein (which owed stylistic debts to Cézanne, Toulouse-Lautrec, Degas, Raphael, and Ingres) were *Boy Leading a Horse* and the portrait of Gertrude Stein, both dated 1906. Within months, he departed from realism and, with the drawings for the huge work that would later be known as *Les Demoiselles d'Avignon* (the title André Salmon gave it in 1916), began the heroic invention of cubism. That put modernism in forward gear, launching a destructive style that appealed to adherents of the avant-garde from the teens through the Jazz Age and into the thirties and forties, during which it swept, radical as ever, through the galleries and museums of Paris, New York, Moscow, London, Tokyo, Chicago, and San Francisco. The destination foretold by cubism was from the beginning identified as the eventual condition of absolute abstraction. Even before abstract expressionism, color field, and minimalism, the nomenclature offered by such artists as Barnett Newman, Ad Reinhardt, Mark Rothko, and Frank Stella, the paintings of Piet Mondrian, Kazimir Malevich, and Wassily Kandinsky, and the late work of

Joan Miró intimated the imminence of two-dimensional fields of pure color that eschewed the illusionistic principles of recessive perspective, figuration, architectural simulations, and references to imagery. It was all spelled out in cubism.

The paintings by Picasso under consideration in this chapter were created between the rigors of analytic cubism and the many versions of abstraction that succeeded it in his career from *La Danse* (1925) through *Guernica* and the "weeping woman" series in 1937, all the way through the loose, brushy variations on themes by old masters such as Diego Velázquez, Eugène Delacroix, Lucas Cranach, Gustave Courbet, and others that he continued to paint into his nineties. Today it seems heretical to designate any period of Picasso as unloved, given the seemingly universal approbation of his complete work, the auction house records set in sales of his late paintings, and lines outside the Gagosian Gallery in Chelsea in spring 2009 to see the nonagenarian's last works. Yet the Jazz Age paintings were misunderstood in their time and continue to be problematic entries in the (as yet nonexistent, because of the volume and value of the work) *catalogue raisonné*. His neoclassical return to the figure that began in 1919 and reached its height with *Woman in White* was too regressively mimetic for the partisans of abstraction. Max Jacob and others in the bande à Picasso from the old Montparnasse days resented his divestiture from (they would say abandonment of) cubism at the same time that they fumed over the time he was lavishing on his newfound social set, aristocratic and wealthy patrons of the Ballets Russes. When Picasso chose the wrong bank of the Seine, he gave his inferiors a rare opportunity to mock the artist as affected and effete (his chauffeur and limousine, as well as his black-tie attire with a jaunty Catalan cummerbund, were particular targets for the old Bateau Lavoir gang).

One insider who quickly perceived the portents of change was Stein. The collections of Gertrude, Leo, Michael, and Sarah Stein and their fabulous salon were not in the twenties what they had been a decade before, at their height—when Picasso was the golden boy. A recent exhibition that layered by chronological stages the collections of the Steins revealed the ripple effect of his inclusion in their circle, and then the less familiar impact of his estrangement from Gertrude Stein (including harsh words between them after the funeral of Juan Gris in

1927) that led to her assembling a different coterie, shading toward the figure and away from abstraction, opening the door a crack for surrealism. As the Jazz Age began, it was clear that the Steins were winding down the process of deaccessioning some of their most abstract works by Picasso, Braque, Gris, Matisse, and others. An earlier split in 1907 had occurred when Leo Stein decamped for Venice with the major Cézanne still lifes. Much of this involved speculation in the art market, including short-selling cubism and squeezing out Picasso's longtime dealer Daniel-Henry Kahnweiler. Gertrude Stein was more interested in the figure in the Jazz Age. As happened with her abrupt dismissal of Ernest Hemingway at the same time, Stein could be brutal when she turned her broad back. She had predicted the volatility of the artist she most admired, as adumbrated in this passage from a portrait of Picasso written during the good times in 1910–11 and first published by Alfred Stieglitz in August 1912 in a special issue of *Camera Work*:

> This one always had something being coming out of this one. This one was working. This one always had been working. This one was always having something that was coming out of this one that was a solid thing, a charming thing, a lovely thing, a perplexing thing, a disconcerting thing, a simple thing, a clear thing, a complicated thing, an interesting thing, a disturbing thing, a repellant thing, a very pretty thing. This one was one certainly being one having something coming out of him. This one was one whom some were following. This one was one who was working.[1]

Stein was no longer a crucial critical influence on Picasso in 1923, when he found himself in another cultural world dominated by his longtime association with Sergei Diaghilev (a collaboration by then in its sixth year) and Jean Cocteau. Although the Catalan was always surrounded by an international set (including the Barcelona bohemians; Miró, his compatriot; Guillaume Apollinaire, born in Italy but of Polish descent; and the Italian Marchesa Luisa Casati), the Ballets Russes gathered a polyglot mélange, from its aristocratic Russian founder and his compatriots to brash Americans. In part the resentment of the Parisians was xenophobic, as Picasso learned on the opening night of *Parade*. The changing cast of characters, especially the dancers and the beach crowd at Antibes, is reflected in the different style of the paintings. Diaghilev was responsible for taking Picasso to Italy twice, the first

time with Cocteau and Leonid Massine, the second and more important time with Igor Stravinsky and Ernest Ansermet to Rome, Naples, Pompeii, and Herculaneum. The advent of neoclassicism in Picasso's work has been attributed in part to his excitement over the Farnese marbles and his first encounters with the work of Michelangelo. The muscular limbs of the mannerist anatomy in *Three Women at the Spring* (1921) and the sturdy column of Sara Murphy's neck and the arch of her ample thighs in *Woman in White* (1923) are testimony to the impact of the collection of monumental Greek and Roman sculpture at the Museo Nationale in Naples. The biographer John Richardson says it took Picasso the next three years to digest the experience.[2] The effects of the colossal Hercules and Hera, the gigantism of the figures he painted, are the background for our consideration of *Woman in White.*

A recent exhibition at the Museum of Modern Art of Picasso's sculpture reveals some interesting patterns. After a few bronzes modeled in the manner of Degas and Auguste Rodin, Picasso made wooden constructions on a small scale in his cubist period in conjunction with the spatial puzzles he was working out in two dimensions with drawings, collages, and paintings. Then he turned to the stage, using tabletop models to build the sets in miniature. During the twenties, he essentially put sculpture on hold, but he returned to it in the thirties and later with materials that ran the gamut from plaster and terra cotta to welded steel and a return to bronze. As Richardson brilliantly points out, sculpture and painting align: "Signs that their three-dimensional monumentality would alternate with the flatness of synthetic cubism first occur in his 1920 figure paintings. From then on the gigantism of the Farnese marbles will make itself felt in the increasingly sculptural look of his paintings as well as in his actual sculptures. Indeed, one might say that Picasso's rebirth as a great sculptor was a direct consequence of the revelation of the Farnese galleries. The marbles would give Picasso back the sense of scale that cubism had denied him by limiting the image to the size of the subject. They would classicize his work far more effectively than the antiquities he had studied in the Louvre."[3]

The first response to *Woman in White* and other neoclassical paintings by Picasso castigated them as being retrograde and commercial. Selling out is never an easy charge to parry. It implies not just greed but weakness. Jacob and even Braque suggested Picasso had gone soft

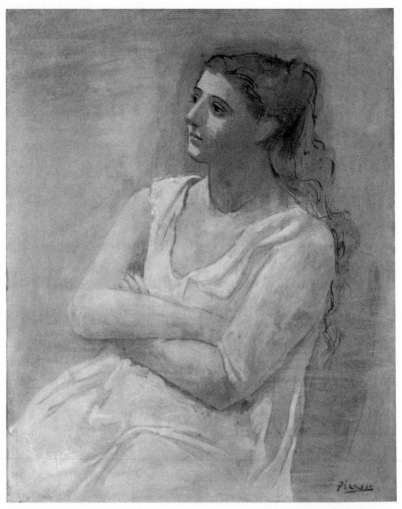

Pablo Picasso painted *Woman in White*, his portrait of Sara Murphy, in the fall of 1923 when he returned to Paris from Cap d'Antibes, where he had spent most of the summer on the beach with the Murphy family.

in the pursuit of applause and gold from his wife Olga's glittering coterie in Monte Carlo. Instead of driving modernism in high gear, Picasso had slammed his sports car into reverse. "Bonjour, Monsieur Ingres!" he said to his reflection in the mirror, according to Ansermet. In the often comical story of Picasso's courtship during the Ballets Russes tours of the reluctant Olga, who held out for an engagement ring, Ansermet always seems to have been assigned to the hotel room next door

to Olga, at the Hotel Minerva in Rome and elsewhere, listening as the artist banged on her door and pleaded in vain to be admitted. Ansermet is also the source of the anecdote, related earlier and not corroborated by Richardson, that can be applied to so many aspects of the Ovidean mystery of Picasso, the master of change. Picasso told Ansermet how he could manage simultaneously to be a cubist, a figural artist, a neo-classicist, and a designer of sculptural sets ("But don't you see? The results are all the same!").[4] The remark could be taken as a blithe dismissal of the controversy that his return to figuration was sparking, but it can also be read as a candid exclamation of confidence in his medium. He and Ansermet were in a theater, where Picasso was rapidly finding that painter and performer have similar roles — especially at the high-risk level of the virtuoso whose technique, pushed to extremes, bursts through limits not just to originality but to new levels of knowledge.

Consider another, similar contemporary source who was as close to Picasso as Ansermet was: Cocteau. Picasso and Cocteau's adaptation of *Antigone* ran for a hundred performances in Paris in 1923. On the eve of the dress rehearsal, the artist once again pulled out of his magic hat the décor for the play (the costumes, in heavy wool, were by Coco Chanel). A long excerpt from Cocteau's journal records the crisis when a blue back cloth with openings for the chorus to speak through and a few masks designed by Picasso were all that was ready at the last minute before the opening night:

> Picasso walked up and down.
>
> He began by rubbing red chalk over the panel, which turned the unevenness of the wood into marble. Then he took a bottle of ink and traced some majestic looking lines. Abruptly he blackened a few hollow spots and three columns appeared. The apparition of these columns was so sudden and so unexpected that we began clapping.
>
> When we were in the street, I asked Picasso if he had calculated [the apparition of the columns]. . . . He answered that the artist is always calculating without knowing, that the Doric column came forth, as a hexameter does, from an operation of the senses, and that he had perhaps just invented that column in the same way the Greeks had discovered it.[5]

The cocky exchanges with Ansermet and Cocteau reveal an artist who felt his hand was capable of solving any visual problem. In Renais-

sance terms, he let *disegno* lead *inventio*. When the Bateau Lavoir group expressed anguish over his repudiation of their style, he was pointing out that it was all just a matter of making marks on paper and canvas. As tones were sound to Ansermet, paint was paint for Picasso, and the more truthful use of paint was its direct application to a flat surface that did not disguise its two-dimensional quality. Both men were rethinking the truth values of their artistic languages.

Even today, art historians struggle with how to place Picasso's neo-classicism, much as musicologists stumble to backtrack in their accounts of Stravinsky's related change in course. When Robert Storr assembled his "Anti-Modernist" album for a Museum of Modern Art series of exhibitions in 2000 (which also accorded prominent places to Le Corbusier, Fernand Léger, and Gerald Murphy), he leaned heavily on the figural drawings and paintings Picasso made at Fontainebleau in 1921 as well as the Riviera paintings. Storr embraced them for their historicism and craft. In the catalogue he observed: "Picasso, the insurgent, had become an assiduous but promiscuous lover of tradition, mixing, matching, and mismatching styles with such agility, sped, and aplomb that the results caught the breath of even those who objected to his shifting allegiances. Tradition's weight is palpable in the work, however, particularly in the full-blown neoclassical images. Earthy hues, lumbering bodies, and impassive faces are typical of these pictures, whose muscular forms have ossified."[6]

Other historians are far less receptive. Isabelle Moned-Fontain, deputy director of the Musée National d'Art Moderne in Paris and the co-curator of the endlessly fascinating Matisse-Picasso blockbuster show that appeared at the Museum of Modern Art in 2003, presented a luke-warm introduction to a neoclassical portrait of Olga from 1920. She said that Picasso was searching "for a standardization, a serialization of the ever-expanding figure, systematically blown up and equipped with oversized hands and feet."[7] The low wattage of her enthusiasm dims as she continues: "Jean Cocteau described them generically as 'Juno with the eyes of a cow, whose hands clench a stone towel,' in a formula recapping several references visible here: the status of goddess conferred to figures domestically draped in bathrobes, the vacuous gaze of their eyes, their statuesque weight, and more generally the evocation of Roman antiquity."[8] The eminent art historian Rosalind Krauss takes an

even more skeptical view, relating the outlines to the mechanical rigidity of Amédée Ozenfant and Le Corbusier. For her, the distancing effect of precision is nothing more than pastiche, a term that Richardson also used to describe the work: "The styling that settled in as the hallmark of mid-1920s *rappel à l'ordre* was, however, the particular blend that Picasso had already fashioned in 1916–17 in the grip of reaction formation against classicism's supposed opposites. And it is this character of a line not so much drawn as styled that generates the strange paradox of the draughtsmanship—namely, the extraordinarily depersonalized feeling of the line to which the name of Picasso will henceforth be attached."[9] She denigrates the stiffness of drawings copied from the ballet company's publicity photos, which lack the *sprezzatura* of the open-line Picasso drawings as imitated by Cocteau, Matisse, and Ellsworth Kelly, among others.

There is an authority in an artist's interpretation of art that I welcome when assessing a work from a period as vexed as the Jazz Age (the vigorous disputes between Richardson and William Rubin, Richardson and Lawrence Gowing, and Krauss and T. J. Clark are typical). One reliable guide to Picasso's paintings in the 1920s is Frank Stella, whose brilliant Charles Eliot Norton lectures at Harvard on "working space" concluded with a defense of their merits:

> It was realism, hammering home the lessons of the past, drawing the concerns of volume, mass, and three-dimensional rendering relentlessly forward, that denied abstraction the promises of its future. A future that cubism had seemed to assure sank under the weight of Picasso's retrenchment. The huge stone feet of the classical seashore bathers, sinking in the sand, should have crushed their way through the paintings around plane, and the mass of figures themselves should have forced out all the viable pictorial space. These paintings should have failed. Realism itself should have collapsed with this effort, and if it had not been for Picasso's genius, it would have.[10]

The *Woman in White*, Picasso's undeniably pretty portrait of Sara Murphy, presents the perfect target for detractors of his return to realism. Next to the contemporary portraits of Olga, with which it has sometimes been confused, it poses a challenge that starts with the identities of the sources, for Picasso was a great synthesizer of different

181

features from women captured along the beach in his sketchbook, the Juno of the Farnese marbles, Sara Murphy, the genial and patient Eugenia Errázuriz, and Olga's choral colleagues from the Ballets Russes among them. A cheekbone or nose here, an elbow there, breasts and calves, the play of different women's features across the portraits kept even the studio intimates guessing as to whose physiognomy the artist had in mind. The pose and setting of Sara's portrait are not entirely new to Picasso. As remote as Sara seems from the bleak inmate he caught in the moonlight at her cell window at the women's prison of Saint-Lazare in 1901, or the gaunt angularity of the *Woman Ironing* (1904), a few key points of resemblance do present themselves — the filmy white dress, open at the neck, and the stray filaments of drooping hair are among the delicate details common to *Woman Ironing* and *Woman in White*. The sternly crossed arms look back to an oil life study of a Dutch schoolgirl made on cardboard in 1905 when Picasso visited his friend the writer Tom Schilperoont at his home in Schoon, Holland.

The most important ancillary works in the Picasso catalogue, however, are the contemporaneous portraits of Olga and Sara, particularly a slightly larger oil on canvas created in Paris at precisely the same time, fall 1923. Olga, from whom the artist was already partly estranged after the birth of their son, sits bolt upright in an Empire-style chair, her right wrist resting on her crossed right leg, her left elbow casually leaning against the back of the chair, her chin level, and her gaze directed obliquely to her right. Not only is the expression clearly Olga's, even if her clothes are Spanish, but her Slavic melancholy is also tinged with a ballerina's dutiful self-consciousness while holding a pose.

The antithesis to this heavily formal portrait in dark, thick masses of paint is the diaphanous *Woman in White*. By contrast with the high-volume palette and thickly opaque application of paint in the still lifes of the following year, the portrait has such a light touch and uses milky white, delicate flesh tones and a bit of green that are so thinned that they read translucently, much as Cézanne would thin his oils to the consistency of watercolor washes. Picasso sweeps these delicate strokes of white like a veil back and forth across the figure and chair to soften the blue outline of her dress in a gauzy filter. He has turned Sara into an immaterial presence. Even the darker, more substantially modeled face and head, with deep-set eyes and pressed lips, is softened

by highlights. Kenneth Silver singled out *Woman in White* for praise in his book on classicism and showcased the work in the exhibition at the Guggenheim in 2010 entitled "Chaos and Classicism." The company the painting kept included works not just by Aristide Maillol but also by Otto Dix, Giorgio de Chirico, André Derain, and Balthus. The range of historical references ran the gamut from Hans Holbein and Nicolas Poussin to Jacques-Louis David, Jean-Baptiste-Siméon Chardin, Ingres (*comme d'habitude*), and Pierre Puvis de Chavannes (I would have added Pierre-Auguste Renoir). Silver broadens the associations to include the clean lines of pavilions by Le Corbusier and Ludwig Mies van der Rohe and the elegant Apollo of George Balanchine. In the catalogue Silver wrote: "We seem to observe this classic figure through the veil of time since the artist reveals how the picture was made: we see the original charcoal sketch of the figure (particularly apparent in the drapery of her lap); then the first painted essay that includes the chair; then the scumbling that washes over the entire canvas, obliterating the figure's means of support (making her, in effect, balance by her own magical powers of equilibrium)."[11]

The story of the portrait of Sara has been narrated by no fewer than three important writers, who present widely different accounts of Picasso's role in the lively circle of Americans that gathered at Antibes. There is no argument that it dates to the summer that started on July 3, 1923, when the Murphys arrived at the Hôtel du Cap d'Antibes, on a rocky cliff overlooking the little Garoupe beach below. Their friend Picasso, with Olga and their two-and-a-half-year-old son, Paulo, arrived in early August to stay at the practically deserted hotel (it was not fashionable to go to the Riviera in the heat of the summer until the Porters and Murphys made it so) before renting a villa in Juan-les-Pins, just on the other side of the peninsula. Picasso was so comfortable with the Murphys that he invited his mother, Dona Maria, to come and babysit, her first visit to France and the first time she saw her grandson. The two families often ate together in the hotel restaurant. They had picnics, boat trips, and daily swims and sunbathing on the Garoupe beach. The Count de Beaumont as well as Philip and Ellen Barry took villas nearby, and then Stein and Alice B. Toklas arrived in late summer. Sara's Kodak camera captured this astonishing group, and Picasso, according to Amanda Vaill, kept one large print of a picture of the two of them until he died.

In August, Sara and Gerald Murphy joined Cole and Linda Porter in Venice at the Piazza Barbaro, where the men were working on *Within the Quota*. Sara tired of the nonstop parties and returned to Antibes after two weeks, leaving Gerald in Venice for a week on his own. At this point the accounts diverge. Rubin, then the chief curator of the Museum of Modern Art, announced in 1994 that X-rays of a neoclassical *Toilet of Venus* painted by Picasso in 1922 revealed that Sara Murphy was its subject and that Picasso had created almost forty paintings and more than 200 drawings of Sara, including a series of nudes made during that week on the beach in August 1923. The telltale pearls Sara often wore at the beach are in the drawings. Rubin concluded that she and Picasso had had a "short-lived sexual adventure,"[12] and that a painting of Picasso as Mars and Sara as Venus was planned to commemorate their "mystic marriage."[13] Richardson categorically rejected the quantity of paintings and drawings as "sheer fantasy" and dismissed Rubin's supposition about the sexual encounter in three words: "Sheer novelettish fantasy."[14] As he contends in his biography, "Sara was beautiful, intelligent, warm, and motherly, and Picasso, like many of her men friends, was attracted to her, but she was impervious to sexual advances. She figures in some of Picasso's sketches of bathers on the beach, wearing pearls down their backs as Sara did. He also executed two likenesses of her in oil paint and sand at La Garoupe." He added that Picasso did not have affairs with women who had children, and Sara "adored her adoring, albeit far-from-heterosexual husband and was famously faithful to him."[15] According to Richardson, the best summer Picasso spent with the Murphy clan was the first, at the Hôtel du Cap. He returned in 1924, the summer he painted the huge still lifes, when the Fitzgeralds, Dos Passoses, MacLeishes, Barrys, and other American couples were on holiday with Gerald and Sara, but he found the constant need to listen to English and Zelda's erratic behavior tiresome and distracting. As the biography relates with incontrovertible directness, Sara and Gerald Murphy were not all that important to Picasso: "The artist told me he was beginning to tire of them en masse — too rowdy, no common language, too many cocktails."[16]

Vaill dutifully reports Rubin's thesis about the affair between Picasso and Sara and then quotes an interview with Richardson, conducted before the second volume of his biography was published (it came out

well after her own book), in which he said "it would have been hard for her to resist."[17] Then Vaill offers her verdict: "If Picasso and Sara had an affair, it would have happened then. In this version of that summer's events, Sara would have been responding not only to Picasso's animal magnetism but to her own frustration at being abandoned in favor of her husband's homosexual friend. But such a scenario seems unlikely. . . . However attractive Picasso might have seemed, her unwavering integrity and her very real love for Gerald and her children made any long-term backdoor relationship impossible."[18] To wade in at this point, without any new documentary evidence, is only to muddy the waters further. Yet I will add that body language suggests that Vaill and Richardson are right. Those mightily crossed arms in every painted portrait of Sara (there are two others), that defiantly upturned chin, and her remote gaze are my answer.

Picasso worked on the portrait in Paris in the fall, addressing the complex stylistic, psychological, and historical problems in a large work of remarkable economy. He could scarcely have been immune to the physical and social charms that had worked their magic on Archibald MacLeish, Hemingway, F. Scott Fitzgerald, Philip Barry, and so many others, even if he did not capitalize on Gerald's absence. The pose and her far-off gaze impose a distance between viewer and subject that is only amplified by the powerful diagonal sweep from the lower left to the head, angled upward into the right top corner of the canvas. The compositional strategy is similar to Alberto Giacometti's recessionary handling of the head of women in portraits and sculpture, accentuating the intense separation of artist and model and conveying his own dread at the proximity of women. Picasso had no such restraint. He was on other occasions more than ready to pull the face and figure of women into aggressive close-up, twisting them left and right in anguished portraits as in the "weeping woman" series based on Dora Maar. The most sexually direct portraits raise the arms of the woman above her head, lifting her breasts in the familiar pose of Venus and an odalisque. He was also adept at keeping women at arm's length, especially when they wielded a certain androgynous power, as in the imposing *Demoiselles d'Avignon*. In contrast with these variations on his theme of artist and model, Picasso seems lost in thought with Sara. Vaill offers a welcome, sensible coda to the gossip, citing Sara's ability to balance friendship

and Eros in playful letters to Picasso as well as Fitzgerald and other admirers. She includes Fitzgerald's favorite poem by Keats in this valuable passage: "This wasn't coquetry. It was a kind of chaste sensuality that was as new to Picasso as it was to others who would encounter it, a spirit that was mirrored in the Garoupe drawings, the sand paintings, *Woman in White*. It's the spirit of unfulfilled desire and ineffable promise that has animated neoclassicism since Keats's 'Ode on a Grecian Urn.' As paradoxical as it seems today, perhaps it was Sara's withdrawal, rather than her surrender, that inspired the work Picasso did that summer."[19]

What a contrast to *Woman in White* is found in the large still-life paintings made just a few months later in 1924 and into 1925! Although one of them was bought from Picasso by Sara Murphy's sister, Hoytie Wiborg, it is fair to admit that they are probably nobody's favorite Picassos today. By comparison with the seductively moonlit tragedies of the Blue Period, the stately romanticism of the Rose Period, the cerebral wonders of cubism, or the emotionally charged wail of *Guernica*, these cumbersome collections of often unidentifiable objects in clashing colors against preposterously fake interiors are just too ugly to love. Yet T. J. Clark recently pointed out they have a lesson to impart about the truth of painting that redeems these homely works, moving them from the margin of Picasso's career to a central place in our gathering of the truth-tellers of the Jazz Age.[20]

Like the too beautiful neoclassical paintings, the hybrid cubist-purist still lifes of the 1920s prompt mixed critical reaction. Some historians have also used the term "pastiche" to dismiss them, and the most doubtful just think of them as huge mistakes in taste. Richardson does not hide his uneasiness with the group of large paintings started in the summer of 1924 at a grand villa called La Vigie (the lookout) in Antibes, where the empty garage was commandeered for a studio. He categorizes the second in the group, *Still Life with Mandolin* (now in the National Gallery of Ireland), as "shrill and assertive — a bit like its first owner, Sara's impossible sister, Hoytie Wiborg." While other *ekphrases* of more ingratiating works in Richardson's magnificent, four-volume biography soar poetically, the description of this painting uncharacteristically sputters: "The star-studded fruit dish and the wonky bottle look as if they have been fighting each other. The electrical brightness

of these objects against the darkness of the foliage establishes this as a night painting, set out of doors. To steady this unsteady still life, Picasso plants it on an ornate base that matches the striped and scallop-edged canopy over the front entrance to La Vigie."[21]

Richardson's appraisal of *Mandolin and Guitar*, the work we will consider here in depth, is more generous. Starting with the fruit on the table, which to me look like apples but which he reads as oranges, he frames the absurdity of the subject using Picasso's Neapolitan experience and the commedia dell'arte tradition as filtered through a modernist opera by Sergei Prokofiev, *The Love for Three Oranges*. Richardson's commentary belies the resistance his trained eye meets in the huge (55⅜ x 78⅞ inches) horizontal work. The leading expert on Picasso's life seems flummoxed by this monster picture:

> This grand coup de théâtre exemplifies a new, more supple and expressive form of late cubism. . . . It is booby-trapped with visual jokes — including perspectival ones, like those to be found in the eye-teasing engravings of M. C. Escher. Take the seemingly matter-of-fact railings in a row outside the window, which are echoed in a second row between the legs of the table. Are they fencing us in or fencing us out? Same with the window on the left. At first sight, it seems quite normal. Look again and you will see that the top pane faces away from you, while the bottom one faces directly at you. Picasso plays similar games elsewhere in the painting, not least in the crisscross triangles above the window. Just as he had used perspective against itself in cubist works to bring things back within reach, Picasso uses perspective against itself to perplex us — anything to hold our attention.[22]

A starkly original reading of the same work is offered by Clark, a gadfly to experts in modern and contemporary art (he considers Jackson Pollock overrated, for example). In a series of lectures sponsored by the National Gallery in Washington, Clark's iconoclastic stratagem inverted the usual hierarchy that gives priority to cubism over the stratagems that Richardson identified. Clark states that the technical bravura of cubism is a lie, using novelty and legerdemain to create an illusion of the famous four dimensions, while the still life offers the truth, a presentation of paint as what it is. Exhibit A in his case is Picasso's largest still life, made in Juan-les-Pins in 1924, *Mandolin and Guitar*. Compositionally complex, its high-value palette is aggressively graphic, laying

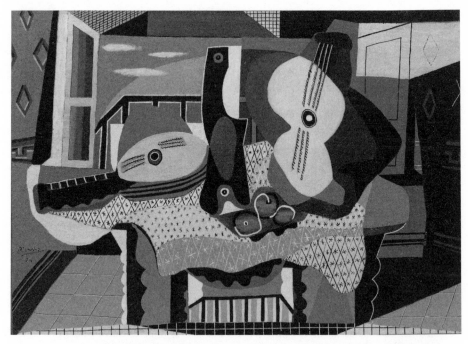

Mandolin and Guitar (1924) was one of a series of nine large still-life paintings that reflect Picasso's experience designing stage sets for Diaghilev.

down intense reds, blues, yellows, and especially blacks with an opacity that is balanced by the delicate patterning of the table cloth and a grid that cuts into the ceiling as well as sweeps across the floor in an arch. There are no thin washes of diluted oil in this painting—the surfaces are all covered opaquely. It shifts gears so often from this density to lightness (one curvaceously turned leg of the table is limned in delicate white, the other is surrounded in a heavy black shadow cut straight as any lumber) that, in its immensity, it could be cut into several paintings easily, recalling the anecdote about Miró and the plan to make separate still lifes and landscapes from his large painting, *The Farm*.

Clark takes us inside the studio to read *Mandolin and Guitar* not as an image but as a painted surface: "Painting will pull back from the threshold—the window and the balcony, and place its objects firmly in the room. Room-space remains its reality. Objects and bodies are only given weight and identity in painting by being enclosed—by existing in relation to a finitude they call their own. Being is being 'in.' But this

kind of enclosure is no longer a given. It has to be brought to life in each painting, seemingly ad hoc, and doing so can now only be managed differentially: an inside becomes vivid only in relation to an outside — to what is not."[23] Following his lead, and thinking of the importance of the monochrome in literature or the monotone in music, I concentrate on the flat, opaque areas of blue or red and agree that there is a forthright, Hemingway-esque honesty in the way that Picasso isolates a color, applies it from the palette to the canvas directly in a solid passage from which his usual fluttering brushstroke is exiled, and makes it stick. It pretends to be nothing other than itself, playing no role other than that of paint on canvas.

To support his view with research into the intentions of the artist, Clark cites a letter to the printmaker Tériade in which Picasso insists on a rigor that would have made Le Corbusier proud: "It was just at this period that we were passionately pre-occupied with exactitude. One can only paint out of a view of reality, which we tried through dogged hard work (how we applied ourselves to this side of things!) to analyze in pictorial terms. There is no painting or drawing of mine that does not respond exactly to a view of the world."[24] For Clark, whose criteria are reminiscent of E. H. Gombrich's distinction between making and matching in the seminal work *Art and Illusion*, the test of this mimetic exactitude is the relation of the painted forms to one another, the room and a created exterior, rather than to any objects on a table in the studio or the world outside the frame.

Building on this argument along the lines of the "firm" deployment of objects in space, we consider the intersection of Picasso's theater work and this painting. The set and curtain for *Tricorne*, the walking sculptures and off-kilter architecture in *Parade*, the reinvented columns of *Antigone*, and the puppet-like silhouettes in *Mercure* are all vivid examples of the way Picasso synthesized cubism, neoclassicism, and the practical lessons of theater optics based on the angles from which audience members read the set and the proportions of dancers or actors on the stage. The fake three-dimensionality of a stage set is a given. Instead of the vanishing point of perspective, a raked stage and angled flats create artificial middle grounds and foregrounds that are different from the mimetic representation of reality. The crucial element is the controlled view of the stage from above, head on (as from the orchestra

seats), even from the wings, sometimes as seen through the lenses of opera glasses. Picasso worked out all these points of view in drawings, maquettes, painted flats and curtains, costumes in bright hues, and even the direct application of makeup to the dancers' faces in the wings as they headed for the stage. The effect is therefore drawn, painted, and built, a three-dimensional invention through which performers move, their forms magnified so they register from a distance. Picasso even amplified his colors to suit the theater, taking a page from the manual of Léon Bakst. He had various tricks to make colors read better from the balcony, such as adding white metallic powder to black, giving the lines and shadows in the architectural simulacra of the sets more weight. The beveled sides, convex floor, and tray ceilings in the large still lifes of 1924 all suggest that Picasso translated the scenic space into pictorial space and then made characters of his mandolin, guitar, fruit, and plaster head. Clark severely distances this flat and bounded style from the sfumato of cubism. Because Picasso delivers it with the wink that connotes complicity, assuring the viewer that he or she is in on the secret of the illusion, it becomes sincere. He writes: "Untruth in Picasso is always terrible. It is a pressure from elsewhere — collapsing space, producing disfigurement. It is a condition, a fate, *a thing entering the interior of the mind.* This is the point — the intentionality — of the inside-outside distinction in Picasso. The outside coming into the room is Untruth triumphant, brilliant and glittering, but profoundly to be feared."[25]

If there is an acknowledged masterpiece that emerges from the common core of these two vastly different works of art (*Woman in White* and *Mandolin and Guitar*), it is the towering icon known as *La Danse* (1925), one of the joys in the permanent collection of the Tate Modern. It offers Picasso's mid-decade answer to the Bacchic rites of the summer bash in *The Great Gatsby* or the "Nighttown" episode in James Joyce's *Ulysses*, a prelude to Balanchine's *Apollon Musagète*, a party in a painting. This is what you see when ballerinas cut loose after dinner during the dancing part of a company gala. The source of its fascination is the movement it embodies in gestures that are uninhibited yet stylish. The power stems from its subtle adumbration of mortality. Picasso based it in part on one of his favorite pastimes while working with the Ballets Russes, those moments of down time when the overbearing Diaghilev and his martinet dance master Massine were not around

and the dancers were relaxing. In particular, it dates to April 1925 in Monte Carlo when Vernon Duke (born Vladimir Dukelsky), a twenty-year-old protégé of Stravinsky and Prokofiev, was at the piano creating a score for *Zéphire et Flore*. Duke, who changed his name in New York in 1922 at the suggestion of his friend George Gershwin (born Jacob Gershowitz), is best known for his songs "April in Paris" and "Autumn in New York." Dukelsky would play "Lady Be Good" and "Stairway to Paradise" while the professional dancers shimmied the Charleston and Picasso drew. That is why the posture of the central figure, straight up the axis of the huge vertical canvas, is so elegant, her left arm deliciously extended to the perfectly placed right hand of her shadowy partner. As a type, she could be Nancy Cunard, Hart Crane's Helen, Fitzgerald's Daisy, or America's Sweetheart in Cole Porter's *Within the Quota*. Richardson has a theory that the central prima ballerina might be based on Nina Payne, an American tap dancer who was the "rage of the Riviera" that year. He also adds an irresistible innuendo: "There may also be a dash of Zelda Fitzgerald, who still aspired to be a dancer."[26] Who are we to argue with an authority as eminent as Richardson?

Taking the possibility a step further offers a bridge to a daring theory by the interdisciplinary scholar Wendy Steiner about why Picasso's painted women, starting in the twenties, are often so ugly. Anyone can see that his portrait of Sara Murphy, beautified by its diaphanous whites and loving vraisemblance, is miles from the disturbingly macabre death's head and grimaces of *La Danse*. Steiner addresses why an artist who could make anyone and anything so lovely would transform women or objects on a table into grotesqueries. She writes in *Venus in Exile*, her account of the attack on female beauty in twentieth-century aesthetics: "From expatriatism to the Jazz Age and the Surrealists' fascination with Poe's 'Imp of the Perverse' and the Marquis de Sade, modernists sought out the thrilling 'Other' in order to experience the allure and charm they had eliminated from their art."[27] In Steiner's hard-hitting theory Zelda Fitzgerald plays the role of stereotypical flapper who deliberately makes herself an ornament to bolster her "exchange value" in the marketplace: "All that Zelda Fitzgerald could do to defend the decorative woman was to appropriate the current defense of art: that in the benighted reality of the twentieth century the artifice of female beauty is a compensation and redemption. . . . The pathos and

inadequacy of Zelda Fitzgerald's defense of ornamental beauty were proved out in the ruin of her madness, her life consumed in a desperate attempt to achieve perfection as a dancer, writer, painter."[28] In a different chapter, Steiner delivers a blunt verdict on Picasso: "Picasso, like other modern painters, transformed the allure of the female subject into the formal beauty of line and volume, and in the process transferred our response from admiration of her beauty to admiration of his virtuosity. . . . Out goes the woman; in comes the discipline of form, which just happens to mimic the look of the primitive cult object."[29]

Neither Steiner nor Cocteau was the first to notice that Picasso had a particularly high regard for his own technical virtuosity. Even his father's colleagues at the art school back in La Coruña resented his tendency to show off when he was only seven. For Steiner, the obliteration of a woman's beauty at the hand of an artist whose technique is so masterful is a contemptible victory for form at the expense of real life. She spins this forward in ways that could as easily be applied to the women of Egon Schiele, Willem de Kooning, George Condo, Lisa Yuskavage, and so many others:

> The procedure has turned the reception history of modern art into a repetitive farce, each episode of which typically begins with outrage concerning some shocking subject matter packaged in unprecedented formal means and ends with an act of aesthetic mystification; the taming, denaturing, and stilling of threat by the calming discovery of form. It is a little allegory of Enlightenment triumph — a cold triumph by our day. In the shrill, scandalous, often unenlightening history of modernism, the rewarding values of aesthetic experience — communication, mutuality, understanding — are seldom in evidence. Instead, our attention is focused on social fault lines, differences in belief and behavior dramatized by sublime scandal. In eliminating the female beauty-as-interaction, the analogy between art and human intersubjectivity is destroyed, and the result has been an exaggeration of the cruelty of unmitigated reason.[30]

Even though I disagree with her conclusion ("farce" and "exaggeration"), I admire the identification of the momentous twenties-era paintings as a turning point. I think Picasso leering at a ballet dancer doing the Charleston saw more than a chance to put on his own show. A shadowy profile hovers over these shapely pink revelers wildly cut-

ting the rug inside while the bright blue sky of a perfect summer day in Monte Carlo fills the window behind them. The "sublime scandal" is that they are at the same time beautiful young women and corpses. Pierre Daix, a Picasso biographer with a vehemently different interpretation from that of Richardson, contends that the painting was made in Paris in May, not in Monte Carlo in April, and that the skull is a response to the death of his friend Ramon Pichot, the shadow of whose profile is on the right.[31] That intimation of death is all the more reason to propose that Picasso's *La Danse* is the consummate painting of the truth of the Jazz Age in all its comic and tragic reality. Even the three patches of blue in the open windows are not just a sign of eternal summer, but specific mixtures from the same basic hue held captive in the bounding black lines of the window, where their subtly different value and chroma deliver a lesson in perception and color theory. Earlier I cited Cocteau's gushing description of Picasso charming the ballerinas backstage with his drawing. A different tone imbues a later passage in Cocteau's memoirs about a talent held tightly in constraint that is the dark opposite of the usual characterization of Picasso as the genius soaring free:

> When you watch him work you have the impression that like the rest of us he's imprisoned in a very confined space and possesses working tools different from anyone else's. In fact he's a prisoner between four walls, and when I say four walls, our dimensions are unfortunately three and not four. What does this prisoner do? He draws on the walls. He carves with his knife. If he has nothing to paint with, he paints with blood and fingernails then he tries to get out of this prison and starts to attack the walls which resist and to bend the bars of his cell. This man is continually struggling with the desire to get out of himself, and when he finishes a piece of work you have the impression that this person's in jail, and the work an escaping convict, and that it's natural for many people to join the hunt with guns and dogs.[32]

16 WORDS IN A STRANGE LANGUAGE

Archibald MacLeish

Another great artist created a hauntingly intimate portrait of Sara Murphy in the same year that Pablo Picasso painted *Woman in White*. It is a pity that nobody reads or teaches the poetry of Archibald MacLeish any more. Like Conrad Aiken, an apt contemporary comparison in terms of style, MacLeish has had his achievement reduced to a predictable poem or two in anthologies, notably the quotable "Ars Poetica," with its concluding axiom: "A poem should not mean / But be."[1] His poetry is as impressive as his biography. A varsity football player and big man on campus at Yale University; a lawyer who abruptly ditched the path to partnership in the prestigious Boston firm of Choate, Hall, and Stewart to write poetry in Paris; a star journalist at Henry Luce's Time Inc.; a presidential advisor and the librarian of Congress, MacLeish as an artist-statesman left a legacy that remains obscure by comparison with those of similar men of parts (such as Václav Havel, Loren Maazel, or Mario Vargas Llosa). MacLeish was the ultimate insider, not just in Paris at the peak of the Jazz Age but as a top-level advisor during Franklin Delano Roosevelt's presidency and a mentor to John F. Kennedy. MacLeish's extraordinary life, summarized in a highly readable autobiography and a biographical tome by Scott Donaldson, shuttles dutifully between the arts and public service.

What critics and historians have missed, however, is the way his poetry was shaped by the web of connections through which MacLeish and his talented wife, Ada, a soprano known for her modernist repertoire, were linked to avant-garde developments in poetry, criticism, art, theater, and music from 1923, when he arrived in Paris, right through the Jazz Age. The trail leads to the studio doors of Picasso, Fernand Léger, Gerald Murphy, and other painters as well as the salons and apartments of James Joyce, Ezra Pound, Gertrude Stein, Ernest Hemingway, Igor

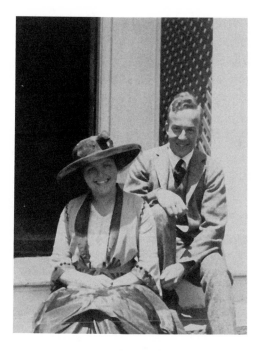

Ada Hitchcock MacLeish and Archibald MacLeish on their honeymoon in 1916. She was an opera singer who studied with Nadia Boulanger, and he would win three Pulitzer Prizes.

Stravinsky, Erik Satie, George Antheil, Ernest Ansermet, Cole Porter, e. e. cummings, Eugene Jolas, Hart Crane, John Dos Passos, T. S. Eliot, and others. MacLeish was welcome backstage at the Ballets Russes, in the offices of literary journals, at the gatherings where Joyce and Eliot would read aloud their preliminary drafts, in the salons of Stein and Natalie Barney, on the beach at La Garoupe with the Murphys, and just about anywhere in Paris where history was being made. In choice anecdotes retailed frequently in other figures' biographies, MacLeish is perpetually cast in the role of indispensable designated driver and lawyer on call, extricating the soused F. Scott Fitzgerald and pugnacious Hemingway from potential disorderly conduct charges, standing by the Murphy family in their time of catastrophe, generously dispensing free legal counsel on censorship and copyright issues to Joyce and Jolas. Yet these unfailingly admiring anecdotes offer little insight into MacLeish's poetry, which (as is the case with the similarly capable professionals Wallace Stevens, William Carlos Williams, and the composer Charles Ives) comes across as obliquely connected to the sybaritic pleasures of a privileged expatriate life backed by the security of a lucrative profession and enjoyed with panache.

MacLeish's poetry merits revival, much as his dear friend Gerald Murphy's painting invites more serious study or Antheil's music ought to be programmed. In the twenties his peers viewed MacLeish as one of the top talents in the expatriate literary community. Begin by pairing his lyric portrait of Sara Murphy, "Sketch for a Portrait of MME. G— M—," with Picasso's magnificent painting. They connect poet and painter through the central, strong presence of the muse, capturing her dignity as well as her beauty. Both artists were accustomed to turning an inamorata into creative capital. Picasso was notorious for portraits of new and discarded conquests, while the more circumspect MacLeish was discreet enough by the standards of the day to avoid trouble in Washington, but his dalliances (scrupulously tracked in Donaldson's biography) are detectable in the poetic souvenirs he wrote using Eliot-like indirection. However, the portraits of Sara Murphy are something entirely different. Neither man could claim to be her lover, elevating their art to a higher agenda conveyed by the ironic distance between sitter and artist.

As Nancy Cunard and Gertrude Stein were frequently painted, photographed, and sculpted, the assembled portraits of Sara could fill a long shelf of books and an art gallery. Fitzgerald caught her perfectly in the opening pages of *Tender Is the Night*. Where Fitzgerald focused on her looks and lifestyle, Philip Barry transcribed the Villa America banter almost verbatim in *Paris Bound* (1927), *Holiday* (1928), and *Hotel Universe* (1930), offering us a sense of her voice. Hemingway, who never spared the acid in his biting portraits of rich women, viciously turned on Sara after the fact in the posthumously published *A Moveable Feast*. Léger painted a watercolor of her back and shoulder while they were on the *Weatherbird* (the Murphy yacht), the sleeve of her blue and white print sundress pulled well down on her arm and a billowing bonnet obscuring her expression but not the strong neck and chin, which emerge from under its brim as she contemplates the blue horizon of the Mediterranean off the bow. The portraits by Picasso and MacLeish are a cut above all these, taking their places among the masterpieces of the decade and highlights of their respective creators' careers while doing justice to Sara's dignity and intellect.

MacLeish uses a visit to her home to evoke Sara via a haunting description of the large three-story Murphy house fifteen minutes by

train from Paris in Saint-Cloud. Once the residence of the composer Charles Gounod, its hushed interior is as keenly observed in the poem as a parlor scene in the fiction of Marcel Proust, Henry James, or Edith Wharton. We know that MacLeish, their neighbor and an insider in the Murphy set not just in Paris but also in Antibes, would have spent hours in the Murphy homes when they were filled with party guests or family. He remained an avuncular presence throughout the lives of the Murphy children and a lifelong confidante of both Sara and Gerald, a fellow alumnus of the Hotchkiss School and Yale University (both men were tapped for the secret society Skull and Bones), and their friendship solidified when they met again in France in 1923. Murphy, Hemingway, and Jolas admired the bold decision MacLeish made that year to give up an offer of partnership in a prestigious law firm to be a poet in Paris. MacLeish himself captures the decisive moment when he decided not to take the train and took two hours to walk from the Boston office on State Street to his home in Cambridge, where Ada was sick with worry:

> I was simply a young man, not so young as I had been once, trying to teach myself to write better than I had written. . . . I was opposite Eliot House when the moon went down. So that was what I'd done . . . had not done. I had prepared, provided, made arrangements for a time to come, for work to come, for art to come. There is no art to come: there's only art — the need, the now, the presence, the necessity . . . the sun.
> It was the art I owed.
> I started up the little path beside the river. Ran. Turned off beyond the Landing. One light in the little house. "Where were you? I've been telephoning. . . ." "I know. I have to talk to you. I don't want anything to eat. . . ." We talked all night or most of it. She seemed to know what I would say before I'd said it. We made our plans, rose early . . . and the ironies began.[2]

After a few months of studying modern French poetry in the Bibliothèque Nationale and wending his way through the literary and artistic inner circles of Paris, MacLeish started writing the best poetry of his life and quickly had enough material for his first book. The placement of poems in a volume is significant. MacLeish reserved a notable spot for the poem about Sara in this breakthrough book, *Streets in the Moon*, written in France but published back in Boston by Houghton Mifflin in

1926 (an earlier volume, mainly of student pieces, had been published in 1917). The poem directly follows his all-time hit, the heavily anthologized "Ars Poetica." Both titles deploy a coy archaism, gently invoking Horace in the title of the first and the use of the "ubi sunt" trope in the second. The "sketch" in MacLeish's title is a disclaimer. The portrait of Sara is not a heavily reworked, finished painting, the Jazz Age answer to the full-length portrait of expatriate American beauties such as those by James Whistler and John Singer Sargent. Instead, it favors the light touch used by Picasso, Jean Cocteau, Henri Matisse, and Amedeo Modigliani when they swiftly penciled a profile in an open, cursive style. Another artistic comparison is offered by the wire portraits by Alexander Calder of Josephine Baker, Calvin Coolidge, and the tennis star Helen Wills. Calder would carry around a coil of wire and a pair of needle-nose pliers, twisting the wire into the airy likenesses of celebrities or his friends right at the café table.

The typescript for MacLeish's poem, included in the collection that the bookseller Maurice Firuski donated to the New York Public Library, is carefully double-spaced on thin paper, folded in three parts as if to fit in a business envelope. Names that are italicized in published editions (Mireille and Baucis) are underlined in the clean copy. On the fourth page, at the end of this poem, it is "signed" but not dated, with MacLeish's Saint-Cloud address: "Archibald MacLeish / 10 Parc de Montretout / St Cloud, S&O, France." The Murphy and MacLeish homes were similarly stately and chic, not so bohemian as Hemingway's apartment over the sawmill in Montparnasse and not quite so grand as the amazing palatial apartment of Cole and Linda Porter, with its salon partly dominated by a zebra-skin rug and its all-white music room (white piano, furniture, and even pencils for composing).

The poem opens with MacLeish sitting in the sitting room of the Murphy house alone ("her room," he insistently calls it, noting there are seven others in the home), maybe nursing a sidecar or martini while waiting for Sara and Gerald to return from shopping or the studio. Her absence makes the fully realized characterization a tour de force. The intimacy is partly in the details, along with the casually "sketchy" premise for stopping in. The poet, strolling by on the way home from the Bibliothèque Nationale, where he has been reading Jules Laforgue and Paul Valéry, may have been invited to dinner, or dropped in "to see /

The last Picasso," or just happened to stroll by on a nice day ("because the sun / Blazed on her windows as you passed").[3] It is a casual gesture, worthy of a Proustian flâneur who drops in and finds himself left alone to poke about and ponder. There is a hesitancy to the opening lines, reflected in the reliance on em dashes, the recurrence of "or" and "somehow," miming the tentative steps of a guest who wanders through the rooms and then lays his hand on the doorknob to the sanctum sanctorum.

No matter who wielded the brush or pen, the intriguing problem of Sara as subject was the distance her formality imposed between herself and the portraitist. To close that gap, Fitzgerald tried the guise of the drunken jester, firing impertinent questions at her that were meant to help him fill out his depiction of Nicole Diver in *Tender Is the Night*. The tactic failed. Even the laser gaze of Picasso and his vaunted magnetism could not breach the distance. He wisely let a dreamy detachment imbue *Woman in White*, particularly in the upturned chin and averted eyes. MacLeish adopted his own tactical approach, circling for a closer look ("as though the room / itself were nearer her") yet admitting that "it was not / A room to be possessed of, not a room / To give itself to people." This remoteness dominates the final section of the poem, dedicated to the link between Sara's "reticence" and "her power," and like the place she was "not a room / To give itself to people." MacLeish repeats "Her room" and capitalizes in an orthographic flourish similar to Picasso's casting Sara as a divinity in the neoclassical mode of the Farnese marbles. For MacLeish, the sphinxlike silence of his self-possessed subject is a source of fascination in "her power / Of feeling what she had not put in words."[4]

The looming central absence passes elegantly from the objects in the room to the mirrors (the house's salon was fully mirrored, as are many nineteenth-century second-floor reception areas in Paris). As the evening descends, obscurity leads to deeper intimacy with glimpses of the private thoughts "unvoiced . . . The shape of something she was thinking of."[5] The elegiac tone deepens. Those snows allude to one of the great leitmotifs in literary history, "où sont les neiges d'antan?" (where are the snows of yesteryear?) in Francois Villon's "Le Testament: Ballade des Dames du Temps Jadis," — itself an echo of the "ubi sunt" motif in Horace's *Odes*.

The portrait of Sara is meaningfully placed at the center of Mac-Leish's first fully Parisian book. For connoisseurs of the volume as a poetic form, *Streets in the Moon* is more than just a beautifully printed album. Its tripartite form, with the poem about Sara as axis, includes a prologue and an epilogue that ends in a bang, an existential tale of a circus tent that blows its top, revealing suddenly the black "pall" of "nothing, nothing, nothing—nothing at all."[6] It is a stunning finale to a collection that moves symphonically through the spectrum from white (Sara's portrait, a symphony in white like Picasso's) through a range of cool, lunar hues that harmonize with the work of French symbolists such as Stéphane Mallarmé and Charles Baudelaire to the all-consuming black of that night sky over the destroyed tent. The most famous set piece in the book, "Ars Poetica," has shrunk over time and overuse to the curt and starkly minimalist aphoristic couplet at the ending. On closer inspection, it has twenty-two earlier lines of sensual, lushly romantic lyricism, including the Keatsian comparison of the "sleeve-worn stone" of silence to "casement ledges where the moss has grown."[7]

That counterpoint between cold, concise modernism and hot, expressive romanticism is a hallmark of MacLeish's poetry. He alternates between the two when he takes on the challenge of writing about the Great War and the loss of his younger brother, a fighter pilot. He was proud that the heroic Kenneth lasted almost two years as a Navy flier on the front (most pilots made it through only a few months of combat). Lieutenant Kenneth MacLeish was posthumously honored when the destroyer uss *MacLeish* was named in his memory. Even six years after his Sopwith Camel was shot down, his brother (who also served) was shaken to the core and weary with survivor's guilt. Like Dos Passos, cummings, and Hemingway, all close friends, Archibald MacLeish wrote through the stages of grief and recovery while agonizing over the question of whether language and truth are compatible. During the fall of 1923, a crucial season in the poet's Paris adventure, the two crises in MacLeish's life converged. The intensely personal poetry might seem at odds with the coolly intellectual contemplation of a problem in linguistics, but MacLeish fuses them in his poetry. The psychological key to negotiating the problem is revealed in an intimate series of letters from that time. Writing to his mother on October 14, the sixth anniversary

of his brother's death, MacLeish begins with a gloriously vivid description of the landscape of Schoore, Belgium ("bright sun in the morning with clouds nacreous and shining and clear lakes of blue . . . ash trees along the road were in silver leaf like apple blossoms"), that shimmers with the light of a work by Camille Pissarro (who brilliantly painted the same region). When a plane appears, MacLeish understandably cannot bear to watch it cross the sky. The last sentence of this brilliant and touching letter echoes Hemingway's habitual conversations on truth. MacLeish refers to accompanying Hugh A. Bayne, an American attorney who served as one of the three judges for the Reparations Commission on a case involving the competing claims of Belgium and Austria, on an official visit to the crash site where his brother died: "We remember that the world loses its most beautiful, but we forget that beauty is revenged by its own completeness upon such a world. Only it is true that a man is something more than a representation. He is a combination of a great many vitalities held in a momentary restraint. . . . A child lighting a candle for the resting of a soldier's soul — that at least is simple and true and pure. I cannot think simply about it and my thoughts are not pure."[8]

This is entirely the tone expected of a letter to his mother in memory of her younger son. Then, self-effacing and still in tune with the heartfelt sorrow they share, he adds this seemingly innocuous afterthought, with its little gesture toward Hamlet's "words, words, words." They inevitably fall short: "I have only words. And those wordy."[9] MacLeish composed a letter at the Café Central to a stateside friend, Francis Hyde, on November 15. He shifts gears to the literary problem posed by Eliot's essays, including the brilliant essay on *Hamlet* that MacLeish had been reading over the summer: "The truth is, I want to get at a certain angle or possibility of truth."[10] This candid revelation of a writer's ambition, drawing on a lawyer's comprehension of the rules of evidence in the ascertainment of truth and anticipating the importance of an "angle" to the fact-checking journalist he would become, the young poet considers the drawbacks of his medium by comparison with the paint and stone of an artist. MacLeish continues in a direction familiar to readers of contemporary linguistics as well as the philosophers led by Ludwig Wittgenstein and the logical positivists gathering at that moment in Vienna to found a school of philosophy that might offer a breakthrough

to the solution of the mathematical challenges to earlier definitions of "truth": "A word is not a theory but the Name for a thing. . . . At best it is never quite successful, a gap and fissure, between any word or group of possible words, and the thing meant."[11]

Poetry remains an art of words, yet in the twenties the mistrust of language was in the air. The litany of skepticism is recited by Eliot, Hemingway, Samuel Beckett, Stein, Cunard (it is the thematic core of *Parallax*), and even Fitzgerald. They departed from the confidence of romanticism (William Wordsworth's "emotion recollected in tranquility,"[12] Percy Bysshe Shelley's view of language as mirror, and Mallarmé's belief in the conjuring power of language, always tinged with irony). MacLeish's letter refers to the seductive sounds of Algernon Swinburne and the psychological theories of William James, whose work at Harvard University he (and Stein) followed at first hand. MacLeish sounds like both James and Eliot: "To create an emotion by the imperfect representation in words of objects which are imperfectly associated with the emotion desired. The effect desired is the direction of attention."[13]

This clarity of analysis is the surprising consequence of deep feelings on the occasion of a cathartic visit to Kenneth's grave as well as the crash site, emotions captured in a pair of poems as well as in one section of an abruptly autobiographical, wholly convincing section of *The Hamlet of A. MacLeish*, the long poem that MacLeish published in a separate volume in 1928. Their "real-life" basis is recorded in another long letter to his mother that combines the awful reality of the task at hand with professorial ruminations on literary technique. On May 31, 1923, he wrote to her from Belgium. The poet appears to be discussing aesthetics and Eliot's theory of the "objective correlative"[14] with his mother, and at the same time attempting to convey to her the combined rage and aching sorrow of the occasion. He wrestles with the surreal: "Kenny's name on the grave is like the cry of a hurt child. . . . It seems to me grotesque, absurd, silly that that beautiful boy should be lying under the sand in a field he never saw—for nothing—for nothing. . . . A hideous joke."[15] The last letter of this kind he wrote to his mother about Kenneth was written in New York. There is a similarity between its reference to abstracting his observing mind from himself to the incisive passage in *The Great Gatsby* when the drunken Nick conceives of himself both as an observer on the sidewalk and as a participant in the party upstairs, the

condition of parallax or *scissiparité* that Ansermet valued. MacLeish's ponderous monosyllables imitate the arduous gait of a man who has lost someone he loved, plodding down Fifth Avenue in a stupor while New Yorkers hurry by him: "I do not recognize the world. I have never seen it. I have never been in this city before. What I must do is to step aside into the quiet and think. . . . I am nothing and never lived and the roar of the wheels will roll over me."[16]

The triumphant answer to those private bouts of despair is "Memorial Rain," a poem in two voices that delivers its emotional punch without descending to bathos or compromising on the cool modernist principles of formalism that MacLeish borrowed from Eliot. MacLeish has it both ways, mourning his brother in an elegiac invention of undeniable eloquence and also casting a cold eye in the Yeatsian or Eliotic sense on the power of words to translate feeling and thought. William Butler Yeats was also a public figure, an Irish senator, who distinguished between the lyric and political voices in this famous and correct formulation: "We make out of the quarrels with others, rhetoric, but of the quarrel with ourselves, poetry."[17] In "Memorial Rain," the most ironic of MacLeish's poems (particularly given his later role writing the high-minded catch phrases in speeches delivered by President Roosevelt) he sardonically recounts the memorial service in a way that plays poetry against rhetoric. It alternates between the long-winded, tin-eared address by an American official and the poet's inner monologue. The italicized voice is the droning of Ambassador Puser reminding himself and the crowd in French ("felicitous tongue"[18]) of "that old lie"[19] about why these "young men no longer" died.[20] He recites clichés of the kind that MacLeish as a speechwriter knew all too well, including the stock reference to "these happy, happy dead" who "enjoy their country's gratitude." Alternating with this parody of official rhetoric, MacLeish after a sleepless night imagines his brother, "a stranger in that land," buried in the sand and "listening" to the pompous speech. When "a heavy drag of wind in the hedges" stirs a sense of an impending change in the weather, the poet senses his brother's attentive anticipation: "I felt him waiting."[21]

The technical achievement of the poem is the accuracy with which MacLeish satirically catches the moment. The attorney and future speechwriter knew just the tone to strike to mock the rhetoric of the ambassador, emptying the claim to truth when premises are insincere.

Everybody knows the empty, even embarrassing, falsity of the memorial service conducted by a member of the clergy who never knew the deceased. Those telltale gaffes betray not just ignorance but a *mauvaise foi* that lazily relies on stock figures of speech to fake it through the service. In MacLeish's view, this is as corrupt an abuse of the language as the speeches that erroneously brought war in the first place. He implies that the innocent mediatory role of language will not be automatically recovered once it has been misappropriated in this cynical way. The final line of the poem — "And suddenly, and all at once, the rain!"[22] — strikes the reader as both faithful to what happened and superbly symbolic, silencing the empty "gratitude" and bringing life to the arid sand. MacLeish is expressing the core of a deep-seated resentment shared by many of the writers in this book. Cummings paid the dearest price: he went to military jail for uttering this thought in letters home from the front during World War I. He used his controversial novel *The Enormous Room* (1922) to lambast the empty-headed and mendacious political leaders and military officers who twisted words to fit their own needs. Dos Passos wrote his own postwar screeds in a similar vein, and both *One Man's Initiation* and *Three Soldiers* incurred the wrath of censorious editors, reviewers, and officials. It took Hemingway two novels to purge the bilious strain, both wickedly critical of the irony and pity of blowhards and liars. Cunard savaged the British and French side of the same worthless coin in several poems published just after the war and supported the surrealists because she found in them an effective way to expose, artfully, the hypocrisy: "All the jingo values of La Patrie and La Gloire, the militarism so real to France, were anathematized, and colonialism was consistently denounced."[23] Later, Jolas was livid about the corruption of German by the Nazis and adamant about the return to fact in the European press offices he personally established after World War II.

Among World War I elegies, "Memorial Rain" transcends the category (anthologies full of war poems, including Cunard's, had already crammed the bookstores by the time it was published). The reason it leaps over the limits of the genre (in a way that invites comparison to the classics, including John Milton's "Lycidas," Shelley's "Adonaïs," and W. H. Auden's "In Memory of W. B. Yeats") is the lasting coherence of the well-wrought lyric and the ambitious foray it launches into

truth-telling. MacLeish extends the philosophical inquiry from a convincing proof of the capacity of poetic diction to surpass in veracity the prose of officialdom, to the further challenge of rising to the task of original and meaningful elegiac music, testing the limits of poetry on the spot.

MacLeish returned five years later to the experience of the memorial service in Belgium in the most heart-rending scene of his long poem, *The Hamlet of A. MacLeish*. Each era shapes *Hamlet* to its needs, and the twenties brought three major literary reimaginings, culminating in the little-known masterpiece *The Hamlet of A. MacLeish*. American and British avant-gardists adopted the tastes of French modernists not just in painting but in literature. This trend begins in the Belle Époque with the brilliant Tuesday evening conversations of Mallarmé, for whom Hamlet represented an archetype comparable to what Oedipus was for Freud (Hamlet as a model of repression). Tracing the course from Mallarmé to MacLeish, the fictive or poetic responses also include a major prose poem by Laforgue (translated into English in the mid-1920s by the notorious Frances Newman), two extended scenes in the novels of Joyce, and a major essay and several glancing poetic allusions by Eliot. In October 1886, Mallarmé took his seat as a reviewer at the Théâtre Français for a performance starring Jean Mounet-Sully (a paramour of Sarah Bernhardt whose Oedipus was famed) as the prince of Denmark. The experience transformed the poetry of contemporary France thanks to Mallarmé's deep influence not only on his symbolist contemporaries but on that generation of modernists who held him in reverence. Specifically it was the "mournful mood of dead leaves" of the soliloquies, externalizing an interior reality, that seemed so intensely modern. As Mallarmé wrote:

> There steps forth the latent lord who cannot become, the juvenile shadow of us all, and this partaking of myth. His solitary drama! And who, sometimes, so much does the wanderer of his labyrinth of trouble and grief lengthen its circuits through the suspension of an accomplished act, seems to be the very spectacle for which the stage exists, the footlights defining and defending a golden, quasi-moral space. For there is no other subject, note it well: the antagonism created by dreams within the Fate of Man's daily existence, fate distributed by bad luck.[24]

From the lyrical magic of Mallarmé, the inner virtuoso of Hamlet shifts into the ironic mode with Laforgue. Originally published as one of the *Moral Tales* in 1883, a translation by Newman, whose novel *The Hard-Boiled Virgin* was the scandalous hit of 1926, appeared in 1928 and had an immediate impact on writers in English, including MacLeish. Laforgue sets a whimsically interpretive pattern by making Yorick the illegitimate brother of the prince (this accords with the tradition of demonizing Claudius as a libertine as well as a murderer). The epigraph to the poem, as translated by the famously licentious Newman, is "I cannot help it."[25] This decadent Hamlet for the Jazz Age is a jaded, wise-cracking narcissist who makes us laugh at the expense of the dull-witted courtiers and peasants. Every modern parodist toys with the most famous soliloquy. For Laforgue, the tone is dispirited as well as disrespectful, the "whatever" that plagues adolescent diction in our time: "To be — well, if one must."[26] Hamlet is less interested in revenge than in taking over as playwright: "To have the whole play to myself and reduce the rest of life to a curtain-raiser."[27] Laforgue was one of the masters of expressing cruelty, and his *Hamlet* is vicious. Delving into the gravediggers' failure to recognize the returning prince in the original play, Laforgue renders his Hamlet an obscure coward: "Prince Hamlet is hardly recognized these days. The people hesitate, but do not bow. And how could they when faced with such an insignificant little character?"[28] The comic tone is particularly sharp in the missed confrontation with Laertes at the end of the graveyard scene (in the original, they challenge one another but part). Hamlet hides while Laertes mourns his sister: "Hamlet, being a man of action, naturally doesn't leave his hiding place until he is sure that the brutal Laertes has filed out with the rest of the company."[29]

This in turn narrowly approximates Joyce's reading of the play, the literary highlight of both the *Portrait of the Artist as a Young Man* and *Ulysses*. While Homer is unquestionably the primary literary source for *Ulysses*, the recurring thematic significance of *Hamlet* to the development of Stephen's intellect makes it an essential point of reference. Joyce himself invokes Mallarmé's essay. In the dazzling chapter set at the library, Joyce manages to mention every play and major poem of Shakespeare. He debates the authorship controversy and invokes the Irish writers George Bernard Shaw, Oscar Wilde, George William Russell

(who used the pen name A.E.), and John Millington Synge. From the first paragraph and its quick glancing blow at "arms against a sea of troubles"[30] and the admission that no Irish writer has "yet to create a figure which the world will set beside Saxon Shakespeare's Hamlet,"[31] the lecture rises to a formidable literary height even if the reader is prepared for the ironic popping of the bubble. This occurs when the inner thoughts of Stephen, guilty over missing his mother's death because he was in France, are interrupted by the humorous entrance of Buck Mulligan. When Mulligan discovers the topic of the day's debate, Shakespeare's genius, he reflexively starts to mock Stephen:

> Buck Mulligan thought, puzzled:
> — Shakespeare? he said. I seem to know the name.
> A flying sunny smile rayed his loose features.
> — To be sure, he said, remembering brightly. The chap that writes like Synge.[32]

Mallarmé, Laforgue, Eliot, and Joyce are the closely spaced steppingstones to *The Hamlet of A. MacLeish*, the culmination of his Paris years in a slim, single-poem volume published by Boni and Liveright. Like the Irish writers in *Ulysses*, it confronts the provincial identity of an ambitious American with world-weary Continental literary taste. Joyce was a personal friend as well as literary hero of MacLeish, and MacLeish played an important role in the group of admirers marshaled by Sylvia Beach, owner of the bookstore Shakespeare and Company. The friendship took a professional turn in 1927 when MacLeish, described by the biographer Richard Ellmann as "the only lawyer in the Joyce circle,"[33] drafted a petition to stop the unauthorized publication of bowdlerized excerpts from *Ulysses* in the United states by Samuel Roth in his *Two Worlds Monthly* magazine (the petition was signed by Albert Einstein, E. M. Forster, Hemingway, Bertrand Russell, W. Somerset Maugham, Eliot, André Gide, Thornton Wilder, D. H. Lawrence, H. G. Wells, Virginia Woolf, and Yeats but not by Pound or Shaw, who refused). Joyce also valued MacLeish's literary opinion, especially when it was supportive at times of doubt — as when *Finnegans Wake* seemed too recondite to be widely understood. In March 1927 Joyce sent MacLeish new poems, receiving two letters that were enthusiastic enough for Joyce to include them in a volume called *Pomes Pennyach* that was published on July 7 of

that year (Joyce gave MacLeish one of the thirteen limited-edition copies). When Joyce gave a reading of the "Anna Livia Plurabelle" section of *Finnegans Wake* on Halloween in 1927, MacLeish was in the audience of fewer than thirty members of the inner circle. He was also in charge of trying to sell an inscribed proof copy of *Dubliners* (the Maunsel edition) to Abraham Rosenbach, an American collector of rare books.

Two themes intersect in *The Hamlet of A. MacLeish*, both of deep significance to the major writers of the Jazz Age. Just as Fitzgerald's *The Great Gatsby*, Eliot's *The Waste Land*, and Joyce's *Ulysses* all drew a strong contrast between the ancient past and the disappointing present, MacLeish announces his preference with the poem's epigraph: "in the old time. Now it is not so." MacLeish makes this duality of the deep past and Paris in the twenties a refrain in the early pages of the poem with a return to the phrase "olden time" as a period when people understood "the mystery."[34]

The other conflict, one dear to MacLeish's heart and the main message of "Ars Poetica," is the faltering connection between words and the world. The mimetic validity of language was jeopardized by changes that left the present false, in contrast with the presumptive truth of a distant past — a golden age when life and language fit together. In these passages, MacLeish echoes not only his own penetrating discussions of language and its inadequacies with Hemingway and others, but also the brilliant and widely read "Letter of Lord Chandos," a wrenching essay by Hugo von Hofmannsthal on a Shakespearean theme. It takes the form of a letter addressed to the Vicomte Francis Bacon at the time of *Hamlet*'s premier (it is dated August 22, 1603). Lord Chandos explains why his literary career has ceased. "I have lost completely the ability to think or to speak of anything coherently," he calmly explains.[35] "Everything that existed, everything I can remember, everything touched upon by my confused thoughts, has a meaning."[36] With the relentless philosophical questioning of his fellow Viennese, Wittgenstein, this drama of the revolt of words against intention perfectly corresponds to Shakespeare's play ("Words, words, words") and to MacLeish's anxious interrogation of the poetic medium itself. The breakdown is invoked in the entrance of Hamlet just before his most famous soliloquy, "reading the books" as in the Shakespeare play, but they are written (or "overheard") like music "in a strange language."[37]

The relationship of language to truth is in question. The next section takes this inquiry in the direction of an exercise in epistemology. As the words dwindle to "shapes of things that seem," Hamlet scribbles brief catch-phrases "on pieces of paper," some of them poetic ("Bells / Plunged in the wind"), eventually dwindling to the monosyllable: "I have written 'Like.'"[38] Almost immediately after this interruption, the breakdown is complete and there is a terrifying moment of aphasia: "I cannot read what the words say."[39] MacLeish is so clearly convinced of the limits of language that this becomes the source not just of Hamlet's frustration but of that of the poet himself when Hamlet cedes the stage to him in the volume's most poignant moment. A dark scene reverts to the sleepless night he spent in Belgium before the service he captured in "Memorial Rain." It is close in mood to the paranoid atmosphere of Shakespeare's Danish court, but by now, thanks in part to the letters home, we also know MacLeish's personal circumstances as he passes the night sleeplessly "staring at the flame, / Forefeeling terror."[40]

MacLeish uses a marginal gloss, a technique copied by Crane in *The Bridge*, to assist the reader in placing the action of the poem in relation to the play. The note near this section indicates, "Form of the thing, each word made true and good, the apparition comes."[41] As a reading of Shakespeare's ghost, who demands an oath from Hamlet and his conspirators, this delivers another sense of being true to one's word, as well as to form. Abruptly the poem swerves from the Shakespearean scenario back to the more autobiographical voice, and we recognize the wrenching emotions MacLeish felt the night before he visited the site of his brother's fatal plane crash in Belgium. The correlated scene in the play is when Claudius kneels in prayer, one of the tensest scenes in Shakespeare but an odd choice, as Claudius is the guilty party. Where "Memorial Rain" had refuted "that old lie" of officialdom, in this poem the deeper truth is revealed when MacLeish is confronting his own sense of guilt ("Running. I am cold with fear").[42] The rage builds again as he grapples with his inability to exact revenge for the death of his brother. He was absent when Kenneth died. The poem rises to a passionate vow not just to "tell it" but to "shriek" the truth, a far cry from the earlier injunction to be silent: "The sky's there!"[43] From this peak of intensity the work moves toward its end in a decrescendo of acceptance and reflection, the answer to Hamlet's calm injunction to Horatio

to "absent thyself from felicity a while" and relate his demise calmly. "Whilst we have slept we have grown old" is MacLeish's diminuendo.[44] The poet retreats to the Shakespearean catharsis ("it is time we should accept") on a note of resignation, selecting for its ending an early moment of confession in the original, when Hamlet confides to Horatio the dis-ease of his mental condition: "Thou wouldst not think / How ill all's here about my heart!"[45]

There are many types of madness in the original and in MacLeish's troubled version, including the aphasia that rendered him incapable of speech as well as the depression occasioned by mourning. MacLeish is certainly not alone in diagnosing the age as unhealthy—the same sort of dire malady was noticed by Beckett, Crane, Stein, Hemingway, and Fitzgerald. By striding on stage himself, however, MacLeish takes a brash and yet vulnerable step in the direction of a later wave of confessional poetry, more readily associated with Robert Lowell or Philip Larkin in the fifties. Hamlet's paralysis is contagious. Even in the twenties, MacLeish was known as a man of action, the friend to whom all the expatriates turned in a crisis, the sort of capable fellow who got things done in courtrooms or offices. Deep down, however, he feared the loss of language that would jeopardize the eloquence of a superbly trained attorney, brilliant conversationalist, and poet. The anxiety gripping Hamlet/MacLeish was not clinical (personal) but a reflection of the epoch's mental health. The long and now generally forgotten poem will never be as influential as the wittier "Ars Poetica," with which it shares a suspicion of rhetoric, partly because it is so much more darkly personal, revealing the terrifying doubts of a young literary talent who confronted not just the uncertainty of his own originality but the viability of words on the page and the morbidity of an age so emptily optimistic. Would it amount to giving MacLeish too much credit to suggest that the poem turns the disillusionment of postwar experience into a Spenglerian prophetic sense of impending darkness ("forefeeling terror")? Published in 1928, it is an astonishingly prescient testimonial to the clarity and candor of the mind of a figure who would play an historic role in Roosevelt's management of the next cataclysm.

Before that chapter in MacLeish's life, however, he returned to the United States and the pursuit of truth in an altogether different role, albeit one in "active affairs," as his family referred to law and politics.[46]

Henry Luce had decided to start *Fortune*, a magazine devoted to business ("the enemy," as MacLeish joked[47]), and the bloom was still on the rose of American corporate reputations in 1929 when MacLeish agreed to sign on to the publication. However, the first issue of *Fortune* made its debut in February 1930, having been written and laid out while the stock market crash occurred. MacLeish was the star in a small group of intellectuals—most of whom had gone to prep schools and Ivy League colleges—recruited by the idealistic Luce for *Time* and *Fortune*. MacLeish wrote the bulk of the stories in almost every issue of *Fortune*, which became his personal platform for a different form of truth from his poetry. As Robert Vanderlan notes in his admiring history of the role of intellectuals at Luce's company, "trained for cultural and political leadership, they were also attracted to the life of the mind. They were drawn to Time Inc. by their own ambivalence about the intellectual's detachment from and lack of relevance to American society and by their desire to participate in Luce's experiments in journalism. Though they might sneer at *Time*'s vulgarity or cringe at *Fortune*'s ostentation, they shared Luce's progressive, Lippmann-influenced assumptions about the function of the media."[48] The mention of Walter Lippmann, another White House insider and the leading voice of media criticism from inside both government and the newsroom ("manufacturing consent" is his major idea[49]), raises an important point about MacLeish. Trained to ascertain the truth in a legal context and unafraid to express the truth in a confessional poem, he was on the front lines of the reform of twentieth-century journalism to momentarily establish a path to objectivity. The crash opened the previously opaque activities of corporations to investigative reporting, and the long-form investigative features in *Fortune* and *Time* pursued a rigorous line of inquiry that led straight to the works of Sinclair Lewis, Walker Evans, and James Agee. Evans and Agee's *Let Us Now Praise Famous Men* began as an assignment to cover sharecroppers in 1936, was rejected because it was turned in to an editor who had not assigned it (the original editor had left) at an impossible eighty pages (nobody knows where the original manuscript is today) and because the opening of the text is an alienating attack on journalism itself. Five years later it became a book, now a classic. MacLeish was in the vanguard of this type of hard-hitting journalism and part of the team that institutionalized the fact-checking

system according to which the writers were vetted objectively by researchers and checked for possible libel by in-house corporate counsel. MacLeish came home from Paris to play an historic role in holding his fellow intellectuals accountable on two fronts: engaging in a life of action and using language to tell the truth.

THE MALADY OF LANGUAGE 17
Eugene Jolas

In an era of complex identities, the "American" writer Eugene Jolas remains a singularly labyrinthine figure. Among the people considered in these pages, only Langston Hughes knew such ambivalence about roots. Proud to have been born in New Jersey, "the man from Babel" (as Jolas titled his autobiography) grew up in a trilingual household in an Alsatian village. He returned to New York as a teenager and cut his teeth as a journeyman newspaper reporter not just in Manhattan but also in Pittsburgh and Cleveland. Then he served in the US Army during World War I. During the peak years of the avant-garde (1922–26), he shuttled back and forth between Europe and New York, one of the leading voices in transatlantic literary journalism. In 1922, he took over the culture column ("Rambles through Literary Paris") that Ford Madox Ford had written for the *Tribune*; founded and edited the review *transition*; translated Franz Kafka, Alfred Döblin, and others, and line-edited the thorniest pages of James Joyce's *Finnegans Wake*. He married Maria McDonald, a singer from Kentucky, and his brother Jacques counted George Antheil among his close friends. Blessed with the journalist's dream talent of being in the right place at the right time, in the twenties and the next three decades he was the ultimate literary insider. When he was not running *transition* or shaping the manuscripts of his friends, he concocted an eccentric poetry that exploited the linguistic resources of a trilingual writer with a fearless penchant for experimental anomalies.

Historians and biographers of major figures in the Jazz Age have always relied on the splendidly quotable and reliable eyewitness accounts of prolific journalists and diarists such as Jolas, Malcolm Cowley (a friend of Jolas), Edmund Wilson, and Carl van Vechten. Look in the indexes of books about Franz Kafka, James Joyce, Hart Crane, Ernest Hemingway, and T. S. Eliot, and you inevitably find the name Eugene Jolas. He had a hand in revising and publishing many of the

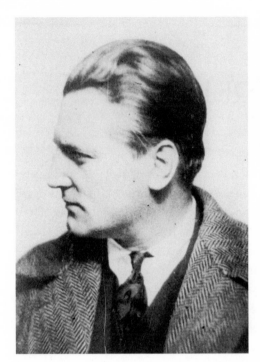

The New Jersey–born Eugene Jolas was a multilingual poet, journalist, editor, and translator, and the founder of *transition*, the preeminent English-language literary review in Paris.

masterworks in the anthologies that exclude his own work. Rather than employ him again as a secondary source, I will use a close reading of his poems, essays, and memoirs and a detailed consideration of his editorial decision making to provide an intimate glimpse into the rough drafts of the modernist revolution in literature and spotlight a talent that has too long remained in the shadow of others in the pantheon who grab the headlines, as is so often the editor's role.

The pursuit of truth for Jolas began with what he called the "malady of language,"[1] a pathological welter of misunderstanding that he addressed as a translator, trilingual journalist (what a difference it makes when you pose a question in the source's native tongue!), editor, and theorist. He was admirably attuned to what he regarded as the ethical dimension of language and philology, especially when it came to discerning the nuances of German, French, and American expressions. For example, even as a young boy he was sensitive to the epistemological toll taken by the cultural differences between his own German and French halves. "Around me I heard the clash of the Latin and Teutonic vocables," he wrote in the early pages of his memoirs.[2] When he

As a photographer and journalist, Carl van Vechten was, like Nancy Cunard and Gertrude Stein, an ardent champion of African American musicians and writers.

enlisted in 1917, he rode a troop train down to a Southern cantonment, and the trip was a "babel fantasy" of linguistic revelation:

> But what interested me most was the variety of American speech that I heard about me: new words that surprised me — words from the workers' universe or from that of small towns; words that were signs for precise objects, words that came from ancient English traditions. They were profane words, crude words, voluptuous words, occult words, concrete words. There were turns of speech I had not heard before, a scintillating assemblage of phonetic novelties that enlarged my vision. . . . The lexical and grammatical deviations from the norm in which the aliens indulged amused me at first, but they also gradually came to irritate me, for I was engaged in a pilgrimage to the precisions of American grammar and syntax, and these foreign aberrations disturbed me. I had gone beyond this rudimentary phase of my linguistic Americanization, and the half-American, half-European periphery on which my friends were still content to live seemed to me to be a sign of mental inferiority.[3]

The linguistic excess so overstimulated Jolas that he ended up in the camp clinic talking to a psychiatric counselor. The pattern is set for a re-

lationship between language and truth that is different from any other encountered in this study. That relationship laid a foundation for his instant appreciation of the poetry of Hart Crane or the "night mind" of Joyce's *Finnegans Wake*.[4] Unlike the skeptics — from Ludwig Wittgenstein through Archibald MacLeish — who doubted the power of any language to pinpoint the truth, Jolas felt that there was always some hybrid tongue which might be capable of curing the "malady." He would abandon English for French or German, rerouting both semantics and syntax to elude the roadblock of the inadequate signifier (a technique Hemingway adopted brilliantly in "A Clean Well-Lighted Place" with the Spanish word *nada*). At one point, aggrieved by listening to Adolf Hitler speak in the Saarland in 1935, Jolas crusaded for a language he eventually called Atlantica that would fuse all Western languages. Hemingway and Gertrude Stein contracted their diction to the monosyllable. Jolas turned in the other direction and heaped syllables upon syllables, German upon French and English, saturating a single text with etymological and semantic associations in a shotgun blast of polyglot excess.

When Jolas called his journal *transition* he announced a program of postwar literary redemption of a chaotic age through a deliberately international mix of content. He energetically exploited not just languages but the jargon of psychoanalysis, the surrealists, various mystical cults, and the futurists in a receptivity that few writers of manifestos, who typically stick to the clubby confines of their in-groups, display. Nearly every number of the journal carried a manifesto. In "Suggestions for a New Magic," which appeared in the third issue, Jolas used the examples of Stein, Joyce, Crane, and Louis Aragon to argue for the expansion of the poet's palette: "We need new words, new abstractions, new hieroglyphics, new symbols, new myths. . . . By re-establishing the simplicity of the word, we may find again its old magnificence."[5]

Jolas's experimental poetry, like Joyce's polylingual crosscurrents in *Finnegans Wake*, weaves English, French, and German in a way that strikingly dramatized the fertile cross-pollination of language in Paris of the time, when monolingual writers were the exception. Like so many others in that era, Jolas revered Stéphane Mallarmé, whose bilingual (English and French) alternation between quirky fashion and cultural journalism and serous lyric poetry parallels Jolas's ambidextrous writing career. Jolas assiduously acquired the up-to-date methods of tabloid

journalism in the United States and then added the fiercer diction of the veteran war correspondents. Later he became the most capable and unflinching of reporters covering the rise and demise, including the postwar trials, of the Nazis.

The literary legacy of Jolas has three formidable parts. His own poetry is relentlessly avant-garde, pushing the experiments by Joyce, Blaise Cendrars, and Guillaume Apollinaire to limits of excess and inaccessibility. Jolas was determined not to abandon any of his three languages. He slips the German "glocke" and French phrases ("S'enfuit dans les ombres") into "Polyvocables," alongside Joycean neologisms: "Lallwords darklehaunt the heart and the corybantic light-music / S'enfuit dans les ombres and the caverns hide the weary birds."[6] With dictionaries in hand and the requisite familiarity with the work of Joyce, Eliot, and Pound, this poem is not as difficult as it may look. Once the scene is set, the poet — who wanders in the wilderness like one of the solitary figures in a moonlit landscape by Caspar David Friedrich — shuns the easy words ("ages" become "aeons" and "shadows" turn into "ombres") to close the distance between sensation or thought and what ends on the page. A dash of Joyce's *Wake* and a soupçon of Gerard Manley Hopkins are added with "darklehaunt." The thesaurus becomes a Rosetta stone with no boundaries. When the French *ombres* seem better than English "shadows," or the German *glocke* denotes an instrument that has the particular usefulness that "chimes" would not, then the substitution is made. Once past the experimental playfulness that challenges a monolingual reader, the method is far from madness and is a sensible transcription of what polyglots do in their dreams, conversations, and writing. Search for the mot juste in any available language and deploy it where it has the greatest meaning and cuts closest to the bone of truth.

Literary historians have been more generous in their accounts of Jolas the brilliant editor than in their treatment of him as a poet, giving him credit not only for the epochal (and gutsy) publication of *Finnegans Wake* in serial form, but also for republishing Stein's *Tender Buttons* in 1928 as well as parts of Crane's *The Bridge*, along with essays that prepared the public for their reception. Many of the works under consideration in this study were first read, edited, and published by Jolas. Remember that during the twenties Joyce's fiction was leaked well ahead of publication to insiders like Jolas, Samuel Beckett, and

Eugene Jolas

217

MacLeish, who were members of the elect circle invited to hear it read. Before *transition* was founded in 1927, installments in *The Little Review* preceded the publication of the full *Ulysses* on February 2, 1922, Joyce's fortieth birthday. It became a landmark like the Arc de Triomphe at one end of modernism's boulevard, with Eliot's *The Waste Land* — published in the same year — like the obelisk in the Place de la Concorde at the other end. For insiders like MacLeish and Jolas, the Jazz Age test case was the subversive *Finnegans Wake*, previews of which were in circulation and published in Eliot's *Criterion* (one episode), *Le Navire d'Argent*, *Contact Collection of Contemporary Writers*, *This Quarter*, and *Transatlantic Review*. It ran serially in *transition* as fast as the episodes could be typed at the journal's office (which was jokingly called "la maison de Joyce"[7]). The first item in the table of contents of the first issue of *transition*, printed in February 1927 but delayed for weeks by a bureaucratic snafu, was "Opening Pages of a *Work in Progress*." It offered an unprecedented disintegration of conventional English as crystallized in the dictionaries and grammar handbooks, twisting syntax and opaquely coining new words. As Jolas wrote in his memoirs, this championship of Joyce as well as his editing and translating was part of what he called the "Revolution of the Word." He evens the playing field between prose and poetry, as did Pound (with whose antics he actually had little patience) at the time. There is a place for the absurd, for "mantic" metaphysics, and a Le Corbusier–like dedication to grammatical purity and order in the "laboratory." This leveling is the linguistic version of Pablo Picasso's revealing remark about abstraction and realism leading to the same end. Jolas wrote:

> *Transition* interested me more and more as an adventure in language. I became intensely aware of the interrelationship of three great tongues, each of which was part of my own patrimony, and all three, I felt, were passing through a crisis. Experiencing this pathology on a triple plane, I prodded other writers into answering questions concerning their own linguistic experiences, with the result that the review gradually became a laboratory into which I tried to gather the forces that sympathized with my desire for a renewed logos. I sought a new style, something between prose and poetry, with which to express the experiences of the inner "I," as well as the unconscious experiences of dreams, daydreams and hypnogogic hallucina-

tions. In Anglo-Saxon writing, the language of poetry began here and there to show the influence of our experiments. Poets seemed to become more language-conscious, and some of them began to abandon "imagistic" fatuities in favor of a richer and more sensitized style. . . . We encouraged word innovations even to the point of absurdity, as well as syntactical research. We elicited new metaphors and made possible word-associations that were not only more musical but created a quite different universe.[8]

Like Diaghilev summoning the A team of collaborators, Jolas enlisted the editorial participation of MacLeish, Sherwood Anderson, Kay Boyle, William Carlos Williams, Hemingway, Crane, and lesser-knowns including Matthew Josephson, Ludwig Lewisohn, Gottfried Benn (who was ditched when his pro-Nazi activities came to light), and Carl Sternheigen, among many others. Then there is the stunning catalogue of Jolas's translations, some made in collaboration with his wife, Maria — notably of Carl Jung's essays on art and literature, Kafka's *The Judgment* (1928) and *The Metamorphosis* (his debut in English), and Döblin's *Berlin Alexanderplatz* (1931), which is still the official version. Bringing Kafka to an English-speaking public is enough to qualify for historic status. Jolas was editor in chief of *transition* through the twenty-seven issues published in Paris from 1927 through 1938, as well as three issues edited in New York, an achievement that testifies as much to the skills he had as an editor, entrepreneur, and administrator as to his role as theorist, poet, and man of letters. Producing a magazine no matter how "little" entails more than just writing and editing—you have to hire printers and negotiate with paper merchants, while supervising typesetters, designers, contributors, and accountants. Jolas had a brief and embarrassing brush with the government authorities when he had to persuade the local policeman to act as the journal's official liaison with the government, a formality required of all media at the time.

Jolas did not just talk about language and truth, he did something. Just as MacLeish proved his abilities as a hard-hitting reporter and editor of *Fortune* magazine, so Jolas in the 1930s moved impressively from the café culture of literary Montparnasse to high-ranking military positions that used his journalistic skills. He had been on the police and city beats at the *Savannah Morning News*, *Waterbury Republican*, and *New York Daily News* (the landmark building where he worked still stands

on 42nd Street). American tabloid newspapers competed for hard news. Jolas exported this fact-based approach to reportage to Germany at a time when the news was especially grim. He was also the capable agent who helped the Joyce family escape Paris through Vichy France to Switzerland in 1940. While the aesthetic idealism of his work at *transition* has that European character of many avant-garde movements, Jolas's role in the history of European journalism during and after World War II strikes me as more American. Although historically beyond the scope of the present study, it deserves mention. Jolas landed on Utah Beach during the Normandy invasion as a member of the Psychological Warfare Division. By January 1945 he had founded the first democratic newspaper of postwar Germany, the *Aachener Nachrichten*, wielding American news values and standards in the cause of denazification, countering the opinion-heavy style of the *feuilleton* tradition that had lent itself too readily to propaganda. In the fall of that year, he opened a school of journalism in Bad Hauheim while covering the Nuremberg trials and assembling an editorial board for *Die Wandlung*, a journal that included writers no less distinguished than Karl Jaspers and Hannah Arendt. Determined to discharge the "Gutenbergian rite" of reclaiming the German language from its perversion under the Third Reich,[9] Jolas published a terrifying poster of war crimes in a 40,000-copy run. His most lasting achievement in this line was the creation of the Deutsche Allgemeine Nachrichten-Agentur (DANA), which later became the Deutsche Presse-Agentur (DPA) — still the principal news agency in Germany. Jolas served as editor in chief of *Die Wandlung* from 1945 until 1950, during which time he worked for the US Office of War Information and Information Control Division of Occupied Germany. In the epilogue to his memoirs, he recalled the temporary "Lord Chandos" moment of paralysis in the face of atrocity after World War I and the ways in which Joyce and the poets of his vortex nearly "exorcised the curse of Babel."[10] Starting over again as a migrant journalist in New York during the Cold War, he had not abandoned hope: "I felt: as man wanders anguished through this valley of crises and convulsions, his language and languages wander with him. . . . The malady of language can be cured in the kinesis of our nomadic urges."[11]

THE REAL THING

Ernest Hemingway

By 1925 the charismatic Hemingway was already a Paris tourist attraction, sitting at a café table and drawing the envious or adoring looks of American writers eager to follow his example. MacLeish included a cameo in the poem "Years of the Dog" in which he described "the lad with the supple look like a sleepy panther" who "whittled a style for his time" while living over a carpenter's shop. MacLeish observed that Hemingway had been a war veteran at twenty, a celebrity at twenty-five, a "master" at thirty. The poem glanced ahead to the shadows of the future: "And what became of him? Fame became of him."[1] Following in the footsteps of Anderson, his mentor, Hemingway arrived in Paris on December 21, 1921, and stayed through the rest of the decade, integrating himself far more fully into the literary and artistic life of the city than most expatriates did. Before the year was out, he had obtained his borrower's card from Sylvia Beach's Shakespeare and Company, and he had read all of Joyce by the end of eighteen months. The Murphy circle embraced him instantly, convinced that he was a greater talent than the more celebrated F. Scott Fitzgerald. Jolas, Pound, and Stein all recognized Hemingway's potential. But as they watched him grow into the foremost novelist of the era, the Murphys and the MacLeishes saw him ruin his personal life, too. In his first four years in Paris, Hemingway was lucky enough to be married to Hadley, who was supportive, cultivated, and kind. In the spring of 1925, a chic pair of sisters, the Arkansas heiresses Pauline and Jinny Pfeiffer, turned up in Paris and at Antibes. Pauline, who was thirty and sharp-witted, was writing for *Vogue*. She befriended Hadley but set her sights on Ernest. By the next winter, Pauline had achieved her goal, although in May Hadley and Ernest were back visiting the Villa America and sailing on the Murphy yacht. A jealous Fitzgerald, who had just a year before recommended Ernest to Maxwell Perkins at Scribner's, disgraced himself at a champagne and

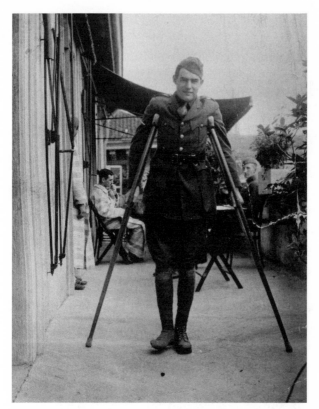

In July 1918, the eighteen-year-old Hemingway was wounded by an Austrian mortar. His recovery at a hospital in Milan gave him material for *A Farewell to Arms*. The ending of the novel went through forty-seven drafts, including one suggested by F. Scott Fitzgerald.

caviar party that the Murphys gave in Hemingway's honor. Hemingway summarized the triangle: "An unmarried young woman becomes the temporary best friend of another young woman who is married, goes to live with the husband and wife and then unknowingly, innocently and unrelentingly sets out to marry the husband. . . . The husband has two attractive girls around when he has finished work. One is new and strange and if he has bad luck he gets to love them both."[2] By the following August, when Hadley and Ernest were back at Villa America again, their marriage was on the rocks. Ernest's friends John Dos Passos and e. e. cummings gathered in support. Gerald Murphy loaned Hemingway his studio on the Rue Froidevaux and slipped $400 into his account at the Paris branch of the Guaranty Trust. MacLeish took Hemingway out of town on a bicycle tour.

Hemingway, who never attended college, was surrounded by Ivy League graduates, such as Murphy and MacLeish from Yale, cummings

and Dos Passos from Harvard, and Fitzgerald from Princeton. Hadley, who left Bryn Mawr before earning a degree, brought to their marriage a studious understanding of the canon in art, music, and literature as well as sense of the East Coast taste that Ernest's upper-middle-class, suburban Chicago upbringing had not provided. In a manner similar to Fitzgerald, Hughes, George Gershwin, and Cole Porter, Hemingway in Paris found his literary voice and the intellectual framework for his own dogged pursuit of truth. Jolas had been a news reporter, and Hemingway's sense of the relationship between language and fact was also grounded in reportage. Like Le Corbusier and Picasso, he was determined to sharpen his instrument to translate the fidelity of mimesis to the page. As he wrote in the preface to his stories of the era: "In going where you have to go, and doing what you have to do, and seeing what you have to see, you dull and blunt the instrument you write with. But I would rather have it bent and dull and know I had to put it on the grindstone again and hammer it into shape and put a whetstone to it, and know that I had something to write about, than to have it bright and shining and nothing to say, or smooth and well-oiled in the closet, but unused."[3]

Paris for Hemingway was not just a source of lively and elegant material (the "moveable feast" of his book by that name), but a university, laboratory, and haven. There are many possible approaches to his writing of this period, including the path from journalism, but one of the overlooked angles is its relationship to the art of the time. Hemingway, Dos Passos, and cummings were as likely to be found in painting studios and galleries as at literary gatherings. While Hemingway became a collector and part-time critic, Dos Passos and cummings, as we have seen, were painters in a similar fauvist style. Paris was an art classroom as much as it was a writer's colony, and the professor's office was 27 Rue de Fleurus, not far from Hemingway's apartment in Montparnasse, where he would conclude a day spent at the museums with a tutorial held by Stein on reading a painting. He had started his course of study with the impressionist and postimpressionist galleries at the Art Institute of Chicago, and he continued at the Musée du Luxembourg where he often spent his afternoons. But as the natural light faded his habit was to turn toward the Stein home, passing from the realism of the Belle Époque to the freshest examples of modernism. Hadley was

with him on March 8, 1922, the first time he attended the vaunted Saturday afternoon salon. He bragged to Anderson two days later: "Gertrude Stein and me are just like brothers, and we see a lot of her."[4] Stein would sit in front of her 1907 portrait by Picasso, and each time Hemingway arrived he was likely to be challenged to respond to a different group of paintings and drawings, starting with such heavyweights as Henri Matisse (a study for *Music*), Picasso (*Woman in a Hood, Young Acrobat on a Ball,* and the *Standing Female Nude along with Violin*), or Paul Cézanne (portrait of his wife and *Landscape with Spring House, Bathers*).

Collecting contemporary art is a game for initiates, not amateurs or outsiders. When Stein and her guests revealed the back stories and secrets of the paintings (instead of talking about the prices, a topic that too often occupied the conversation at the Rue de Fleurus), Hemingway paid close attention. He quickly grasped the central importance of Cézanne and traced his influence through Picasso, Joan Miró, Matisse, Alberto Giacometti, and others, most of whom were available personally for the journalist to check theory against intention by making studio visits. One of the most affecting passages in *A Moveable Feast* is his ode to Cézanne:

> You got very hungry when you did not eat enough in Paris because all the bakery shops had such good things in the windows and people ate outside at tables on the sidewalk so that you saw and smelled the food. When you had given up journalism and were writing nothing that anyone in America would buy explaining at home that you were lunching out with someone, the best place to go was the Luxembourg gardens where you saw and smelled nothing to eat all the way from the Place de l'Observatoire to the rue de Vaugirard. There you could always go into the Luxembourg museum and all the paintings were sharpened and clearer and more beautiful if you were belly-empty, hollow-hungry. I learned to understand Cézanne much better and to see truly how he made landscapes when I was hungry. I used to wonder if he were hungry too when he painted; but I thought possibly it was only that he had forgotten to eat. It was one of those unsound but illuminating thoughts you have when you have been sleepless or hungry. Later I thought Cézanne was probably hungry in a different way.[5]

Questioning the artists was an essential part of the experience that strengthened Hemingway's own writing because it taught him to test

the sensations, symbols, gestures, and structural experiments that made modern art so varied and so new. There was something even more exciting afoot at Stein's salon, however, and it bears directly on the pursuit of truth in painting as well as writing. The Steins' method of not just collecting but also discussing their Picassos and Matisses was shaped by a new, scientific Anglo-American school of art historical analysis. As Claudine Grammont points out in an essay in *The Steins Collect*, the method began to shape Leo Stein's thinking after he had an encounter with the Renaissance expert Bernard Berenson in 1900. Berenson's teaching stressed the "elimination of inessentials." Grammont writes: "The art collections assembled by the Stein family were among the first to be informed by a current of Anglo-Saxon aesthetic thought that emerged around 1905. Psychological aesthetics — which gave rise to the formalism of Bernard Berenson, Roger Fry, and Clive Bell, among others — considered the work of art in its formal reality no longer as an object of contemplation but rather as the framework of an experience: 'We have ceased to ask, What does this picture represent? and ask instead, What does it make us feel?,' wrote Bell."[6] Other strong intellectual influences included the Harvard philosophers George Santayana, Charles Peirce, and William James, as well as Giovanni Morelli and the Hungarian art historian Julius Meier-Graefe — who, like Berenson, focused on method, physical and tactile characteristics, formal problems, and the need for an individual work of art to embody a totality on its own. A sense of how this changes the perception of art is offered by the experience of engaging with the Barnes Collection (especially in its original incarnation, cloistered in the suburbs of Philadelphia), because John Dewey had shaped Albert Barnes's educational theories.

The empirical reading of paintings informed Hemingway's approach to literature. The Stein circle intersected with that of Beach, whose Shakespeare and Company was Hemingway's home base from his arrival in Paris. He had a monthly subscription (costing twelve francs) that permitted him to take two volumes out at a time, and Hadley had her own card. The records indicate that she borrowed novels by Henry James, one of the many authors she generously introduced to her husband. By the end of the decade Hemingway's photograph took its place on the shop's wall of fame beside those of Joyce, Pound, Joseph Conrad, and D. H. Lawrence. Young as he was, Hemingway was deeply involved

in the literary life of expatriates in Paris. He was associate editor of the *Transatlantic Review*, under the stewardship of the distinguished English novelist Ford Madox Ford, the British version of Anderson. Together with Jolas and Pound, Hemingway was a regular at the literary gatherings and cafés where manifestos were drafted and journals planned with breathtaking momentum and resounding significance for the history of modernism.

The ravishing descriptions in *A Moveable Feast* give a strong taste of the powerful role that art played in the life and thought of Hemingway. The highlight of his experience as a collector of art offers insight not just into his range of intellectual interests, but also into what he was trying to do as a writer. His acquisition of Miró's greatest painting, *The Farm*, is more than just an anecdote illustrating a little-known artsy side to "Papa" Hemingway, so different from the machismo stories of his pounding poor Morley Callaghan in the boxing ring, cycling with Dos Passos, drilling tennis balls through the racket of Pound, boozing with matadors, and eventually slaying lions. Miró had actually been time-keeper during some of Hemingway's boxing workouts, and Hemingway visited the Miró family farm in Montroig, Spain, near Tarragona, in 1929 after he bought the work. The large (four feet by four and a half feet) painting was the main attraction in Miró's one-man exhibition at the Galerie Pierre in the spring of 1926, but connoisseurs had begun talking about it five years before. It took Miró ten months to paint in his studio on the Rue Blomet. It was completed in 1922 and shown at the Salon d'Automne the next year (a show in which Murphy had two paintings), and in a letter written many years later Hemingway said he was smitten by the painting right at the opening. It was offered to two galleries (those of Léonce Rosenberg, best known for representing the cubists, and Pierre Loeb), but the sheer scale of the work made it difficult to sell. Miró nonetheless had major supporters early in his career, including Gertrude Stein, an admirer of the still life and landscape paintings he made in Horta, his home village in Catalonia. She praised the way they conveyed "the flatness of the continuous present," a phrase that could be applied as well to both her writing and Hemingway's.[7] This evenly illuminated, tightly rendered adherence to form is also the essence of the large-scale still lifes that T. J. Clark called Picasso's most truthful,[8] and of the still lifes Murphy painted at the same time.

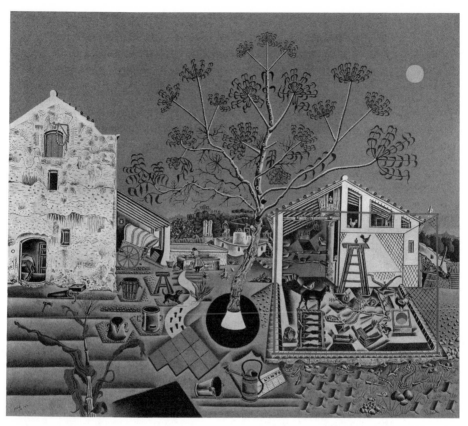

Hemingway acquired Joan Miró's *The Farm* (1921–22) as a birthday gift for his wife Hadley and later visited the artist's childhood home in Montroig, where the work was started.

The big guns of the surrealist movement turned out at the gallery opening on June 12, 1926, when *The Farm* returned to public view. Hadley canvased the attendees for the autographs of people such as Max Ernst, Aragon, and André Breton, all listed in the catalogue. The centerpiece of the show was placed on hold at first by Hemingway's friend Evan Shipman, who said yes to the 5,000-franc asking price but failed to leave a down payment. Hemingway had the 4,000-franc ($250) advance for *In Our Time* from Horace Liveright burning a hole in his pocket. Hadley's thirty-fourth birthday was coming up on November 9, and he had a guilty conscience not just for spending the income from her trust fund but for other well-known reasons. Shipman, who

was in on the birthday present scheme, consented to roll the dice for the chance to buy the Miró. Hemingway returned to the gallery the next day with a 500-franc deposit, and in September he borrowed the rest from the wealthy Dos Passos. Hemingway hung the work over the bed in his and Hadley's second-floor apartment on the Rue Notre-Dame-des-Champs.

Among the cognoscenti, *The Farm* was already deemed a major aesthetic statement in 1926, and an essay by Hemingway enhanced its reputation. Today its art-historical significance is assured, in part because it advanced not just Miró's career but modernism itself in an unexpected direction, serving as the pushing-off point for a type of realism that diverged from cubism's promise of abstraction (so much so that the surrealists pounced, claiming Miró as their own much as they tried to corral Picasso). Like Murphy, Le Corbusier, Fernand Léger, and Stuart Davis, in the Montroig paintings Miró emphasized tight brushwork, close focus on details, and the application of flat colors bounded in fine lines. In the next decade a committed group of American painters, led by George Ault, Charles Sheeler, and Charles Demuth and working with photographers under the aegis of Alfred Stieglitz, would develop precisionism, in part from this idiom. Miró himself would eventually leave the referential connection to the farm behind but retain the graphic style in which elegantly delineated figures become abstract (the dreamlike, biomorphic forms in their floating state have been related to the hallucinations the painter experienced as he fainted from hunger).

Miró's *The Farm* bears comparison with Murphy's *Watch*, started at the same time and completed before Miró's painting was finished. Hemingway and Dos Passos were among those who would have seen these two related works in progress, although there is no evidence that Miró himself saw Murphy's painting. While Miró in Paris was re-creating each corner of the farmyard in Montroig, Murphy was combining the features of a railroad watch made for Mark Cross with those of a gold pocket watch that Sara had given him. Both artists turn interiors into exteriors. Miró offers a *masia*, or typical Catalan farmhouse, with the inner space of the barn revealed in cross section, the edges of the walls traced in a schematic red square. Murphy pries open the case of the watch to examine the mechanism. The firm geometry of their compositions frames squares within squares and circles within circles. Miró's

full moon and the shadowy elliptical interiors of the cistern and buckets rhyme with the curves of the gears and winding stem in the Murphy painting. Just as Miró rendered each evenly lit leaf on the delicate tree, each tile on the roof, and the stones in the yard with calligraphic precision, Murphy scrupulously etches the gear teeth and springs and faithfully traces the anatomy of the watch movement's forms, as tightly locked together as the gears themselves.

Did this detailism motivate Hemingway? Miró models a visual clarity that the writer, for whom the sun was a central symbol, used in the descriptive passages with which so many of his works begin. With Hemingway's writing, this is not a passive record of the scene, but the probing vigilance of the hunter, fisherman, and combat veteran. Like Miró's painting, Hemingway's landscapes are as analytic as early cubism yet move away from its impressionist blur. They adhere to the firm pragmatism of Thorstein Veblen, William James, and Dewey. In his major late book *Experience and Nature*, published in 1925 and a major influence on Stein and Barnes, Dewey observed: "A bare event is no event at all; something happens. What that something is, is found out by actual study."[9] That same year, MacLeish observed: "To write one must take the world apart and reconstruct it."[10] John Updike was fascinated by the connection between Miró and Hemingway through this masterpiece. In an essay on Miró, Updike reads a great painting and tries imaginatively to recapture what another novelist saw in the work, finding that the connection is "an ecstasy of simple naming":

> One tries to look at *The Farm* with Hemingway's eyes, seeing what made him fall in love. Under a cold blue sky and small gray moon, a landscape and two white buildings hold a meticulous inventory of tools, furniture, and farm animals; like Hemingway's early prose, the painting is possessed by an ecstasy of simple naming, a seemingly innocent directness that is yet challenging and ominous. He and Miró, their reminiscences reveal, were both often hungry in Paris, and hungry people see with a terrible clarity.[11]

The line from Miró through Dewey to Hemingway's fiction is direct. The novel he was writing when *The Farm* hung on his wall, *A Farewell to Arms*, opens with a Miró-worthy binocular view from an isolated Italian village on a hilltop:

In the late summer of that year we lived in a house in a village that looked across the river and the plain to the mountains. In the bed of the river there were pebbles and boulders, dry and white in the sun, and the water was clear and swiftly moving and blue in the channels. Troops went by the house and down the road and the dust they raised powdered the leaves of the trees. The trunks of the trees too were dusty and the leaves fell early that year and we saw the troops marching along the road and the dust rising and leaves, stirred by the breeze, falling and the soldiers marching and afterward the road bare and white except for the leaves.[12]

Many have connected the spare, unflinching observation in passages of this kind to Hemingway's journalism, his "10,000 hours"[13] (to borrow Malcolm Gladwell's helpful formulation) as a reporter. The credibility that supports the illusion of the fiction is built on such unfiltered mimetic touches as those dusty trees, which, like the delicately rendered tree in Miró's painting, can be registered only through firsthand observation. As the painter evened out the touch of his strokes from edge to edge, keeping the light level steadily bright across the farmyard, so Hemingway drops the monosyllable "and" into those signature long sentences to hold the diction to a certain uniform level. Miró was withholding painterly technique so assiduously that some have called *The Farm* a primitivist work, like the popular, flat style of Henri Rousseau, but I think it is closer to the constrained painterly strategies of Picasso, Corbusier, and Léger. Hemingway's virtuosity (with that long sentence and the impossible excess of "and") is understated in a similar way — the touches of white and blue are hardly expressive — and the transparent effect gives the reader confidence, in the first sentences of the novel, in the accuracy of what follows. The groundwork for truth is laid.

This visual tour de force sets up one of the most breathtaking of the mimetic impossibilities in all of Hemingway's fiction, the direct account (and he had the scars to support it) of what it is like to be killed — almost. Left for dead in an Italian church after being injured in a mortar blast, Hemingway had more than enough material for the action scenes in *A Farewell to Arms*. In chapter 9, the medic corps comes under heavy fire as they try to extricate the wounded from a battle along a river where only one road is available for their four ambulances. An officer gamely pours a glass of cognac, the members of the crew

drink wine from their canteens and try to eat *pasta asciutta* with some
cheese, even as the shells drop closer to their dugout. Then there is the
description of what it is like to take a direct hit from a trench mortar.
You cannot make this up:

> I ate the end of my piece of cheese and took a swallow of wine. Through the
> other noise I heard a cough, then came the chuh-chuh-chuh-chuh — then
> there was a flash, as when a blast-furnace door is swung open, and a roar
> that started white and went red and on and on in a rushing wind. I tried to
> breathe but my breath would not come and I felt myself rush bodily out of
> myself and out and out and out and all the time bodily in the wind. I went
> out swiftly, all of myself, and I knew I was dead and that it had all been a
> mistake to think you just died. Then I floated, and instead of going on I felt
> myself slide back. I breathed and I was back. The ground was torn up and
> in front of my head there was a splintered beam of wood. In the jolt of my
> head I heard somebody crying.[14]

Denigrators over the years have picked at Hemingway's reputation
for a multitude of sins such as betraying Hadley, slaying lions and mar-
lins, and acting like a bully and a blowhard and a jealous schoolboy,
but in a passage such as this the brutal honesty redeems these faults.
He has just recounted his own death, which does not even seem pos-
sible logically, psychologically, or technically. Another connoisseur of
truth-telling, MacLeish, read an early copy of the book in 1929, and he
wrote an admiring letter on September 1 that offers a singular contrast
between his own struggles with language and Hemingway's mastery:
"The seriousness and precision and candor of your writing makes you
feel the way you feel after tears when everything is suddenly simple
and profoundly clear and perfectly tender. . . . What has happened is
that you have mastered the self-imposed problem of your technique.
There was a time when I wondered whether the restrained and tense
understatement of your prose would not limit you to a certain kind of
material."[15]

Whatever worries over the self-imposed constraints may have ex-
isted, achievements such as *The Sun Also Rises* and *A Farewell to Arms*
(which appeared within three years of one another) put to rest. Just
as he grudgingly admitted the achievement of Fitzgerald's stylistic tri-
umphs, Alfred Kazin had reservations about Hemingway the man ("he

brought a major art to a minor vision of life"), but he put Hemingway and cummings together for the austere and "ruthless" prose that met the horrors of their combat experience head-on.[16] In Hemingway's words, this hard prose that cummings had devised caught "the truth about his own feelings at the moment when they exist."[17] As Kazin observed in 1942, while Hemingway was still at the top of the American charts, "to Hemingway life became supremely the task of preserving oneself by preserving and refining one's art. Art was the ultimate, as it was perhaps the only, defense. In a society that served only to prey upon the individual, endurance was possible only by retaining one's identity and thus proclaiming one's valor. Writing was not a recreation, it was a way of life; it was born of desperation and enmity and took its insights from a militant suffering. Yet it could exist only as it purified itself; it had meaning only as it served to tell the truth."[18]

The heroism of the writer dedicated to this "way of life" is the stuff of anecdotes, from the legendary line-up of dozens of sharp pencils on his desk to the Flaubertian revision of each sentence, draft upon draft (there were forty-seven different versions of the ending to *A Farewell to Arms*), to meet his high standards of "understatement." As Picasso enlisted his brush hand to render the visible and invisible simultaneously in a still life ("an inside becomes vivid only in relation to an outside — to what is not," as Clark observed[19]), Hemingway in the paragraph depicting his death in *A Farewell to Arms* offers his own "to be or not to be" moment. As with Crane's image of the jumper in his white shirt leaning out from the Brooklyn Bridge, I wince whenever Hemingway mentions suicide. This seems morbid, given the ending to his story as well as those of his father and his granddaughter Margaux, but I respect the fatalism that Kazin noticed and the way that writing "purified" it. Hemingway's references to suicide are his own version of Nancy Cunard's parallax, that *scissiparité* we tracked from Ansermet's theory through the scene in *The Great Gatsby* when Nick feels as though he is simultaneously on the sidewalk and inside the apartment at the party, as well as the conflation of the primal origins of Long Island with the arcadian landscape of Gatsby's garden in 1922. Hemingway was unflinching in his approach to the theme.

In a spectacularly economical short story, "A Clean, Well-Lighted Place," he lays out the fate of three unnamed men whose lives intersect

late one night in an outdoor café. The mise-en-scène offered in the opening paragraph is a verbal equivalent of the great late café paintings of Vincent van Gogh — specifically the *Night Café*, painted in Arles in 1888 and well known to Hemingway. After a brief descriptive opening, as carefully depicted as the van Gogh or Hemingway's own Miró, the dialogue between a young waiter and an old one that composes the bulk of the story begins:

> It was late and every one had left the café except an old man who sat in the shadow the leaves of the tree made against the electric light. In the day time the street was dusty, but at night the dew settled the dust and the old man liked to sit late because he was deaf and now at night it was quiet and he felt the difference. The two waiters inside the café knew that the old man was a little drunk, and while he was a good client they knew that if he became too drunk he would leave without paying, so they kept watch on him.
> "Last week he tried to commit suicide," one waiter said.
> "Why?"
> "He was in despair."
> "What about?"
> "Nothing."
> "How do you know it was nothing?"[20]

With only three characters, and a conversation between two waiters hovering on the level of the banal, the essence of the story seems as simple as if Hemingway were transcribing the chat toward closing time at his local café. The longer the dialogue continues, however, the more clear the meaning becomes. The older waiter defends the deaf old man's right to linger until closing time, when he wanders off alone as his younger counterpart hurries home to his wife. The old waiter is an insomniac whose loneliness mirrors that of their patron, whose place at the café table he will inevitably take after the old man's death, even as the young waiter will take his role as the senior waiter and another, still younger, will take that of the young waiter. Hemingway reveals the four stages of their lives simultaneously. The infinite regression of identical figures succeeding one another in a *mise-en-abyme* through eternity powers the parallax of Cunard or Fitzgerald, which simultaneously offered the contrast of youth and age, past the boundary of one lifespan. When the older waiter closes his café he seeks another clean, well-

lighted refuge before returning to his room, where he will lie in bed until he falls asleep at daylight. Hemingway delivers an interior monologue that is in part a nihilistic parody of the Lord's Prayer (surprising in that his new wife, Pauline, was a staunch Catholic), his version of "that old lie."[21] It also uses a monotone, and an example comparable not only to Stein's tolling nouns but, with the incursion of the Spanish words, to the way Jolas found a substitute in other languages for words in English. Hemingway had set it up perfectly with the "nothing" in that opening dialogue:

> What did he fear? It was not fear or dread. It was a nothing that he knew too well. It was all a nothing and a man was nothing too. It was only that and light was all it needed and a certain cleanness and order. Some lived in it and never felt it but he knew it all was nada y pues nada y nada y pues nada. Our nada who art in nada, nada be thy name thy kingdom nada thy will be nada in nada as it is in nada. Give us this nada our daily nada and nada us our nada as we nada our nadas and nada us not into nada but deliver us from nada; pues nada. Hail nothing full of nothing, nothing is with thee. He smiled and stood before a bar with a shining steam pressure coffee machine.
> "What's yours?" asked the barman.
> "Nada."[22]

This depth-defying "nada" is a grim note on which to end a celebration of the art, music, and literature made during the most scintillating decade of the twentieth century. However, the story is a brilliant synthesis of the freedom that made the era so seductive (the linguistic play of parody) and the strict observance of unity that imposes its incomparably tight order. The sobering nihilism grounded in the author's experience opens a seam of truth that belies the status of fiction. Like the shadows closing in on Picasso's dancers, or the shift from major to minor in the serious music of Porter, Hemingway ventures from the light of a sun-filled moment in literature into the darker side of history. He offers a courageous premonition of the clouds that were gathering toward its end, and of his own future.

Hemingway did not have an exclusive on truth in the Jazz Age, even if the clarity of his prose takes its place in the philosophical tradition that privileges the direct approach (from Aristotle through Immanuel

Kant and the logicians of the twenties). The precise attack of the short stories cuts straight to the emotional edge of trauma and survival in an unblinking style that imitates the brightly illuminated details of the Miró painting Hemingway loved. Others faced their fates in their own way. The rapture of Fitzgerald, Crane, Cunard, and Gershwin and the fluid wit of Porter and cummings flowed directly from their fast lives and the pleasures that cost them dearly. Rhapsodes have always played a vatic role, and the apostles of freedom embodied even as they created truths of the time in a more lyrical mode than Hemingway. The brevity of the sprint from war to prosperity and the even more breathtaking rush to the crash gave *The Great Gatsby* and *The Bridge* as well as the cityscapes of Dos Passos and Léger their prophetic character even before the decade was half finished. It is astonishing to consider how much of the art, music, literature, film, architecture, fashion, and design in the ensuing decades owed to the artists of the Jazz Age. Literature after Joyce's *Ulysses* and the polyglot experiments of Jolas, or the hard-bitten realism of Dos Passos and Hemingway, progressed in different directions to postmodernism on the one hand and socially conscious realism or minimalism on the other hand. Painting spun unstoppably into the polymorphous nightmares of surrealism and the (related, in many cases, by being made by the same hands and minds) jazz-inflected movement of abstract expressionism. Music careened from the blues and orchestral suites toward bebop, where conventional melody and rhythm were further dismantled in ways that made syncopation look tame. The artists of the thirties and later who inherited the mantle of freedom drove risk further into the territory that had been explored in the wake of *Finnegans Wake* and cubism.

The other kind of truth that emerged as the legacy of the age came from the adherents of order. Everywhere you look in a city, the "machine for living"[23] that Le Corbusier invented is the paradigm of architectural integrity. The path to pop, which many have ascribed to the response to abstract expressionism, was cleared by Léger as well as Picasso (who is never considered a progenitor of pop) in the name of a type of painting that was direct rather than rhetorical, an example of order rather than expression. These formalists were prophets of extremity in their own right, steering their art to an ordered truth that reflected past experience as well as sound premonitions of inevitable

disorder. Far from innocent, they had interrogated the truthfulness of their media (as MacLeish and Hemingway tested language, Ansermet quizzed music, and Picasso rethought the relationship of paint to illusion) to establish a new level of truth telling. Its first test, which it passed with flying colors, was to examine what was past, passing, and to come.

Introduction

1 Shead, *Music in the 1920s*, 1.
2 Vaill, *Everybody Was So Young.*
3 Owen, *The Collected Poems of Wilfred Owen*, 55.
4 Birmingham, *The Most Dangerous Book.*
5 Coward, *The Letters of Noël Coward*, 52.
6 Quoted in Garafola, *The Ballets Russes and Its World*, 93.
7 Le Corbusier, *Essential Le Corbusier*, 148.
8 Quoted in Clark, *Picasso and Truth*, 43.
9 S. Ball, *Ozenfant and Purism*, 59.
10 Veblen, *Conspicuous Consumption*, 8–9.
11 Le Corbusier, *Towards a New Architecture*, 10.
12 Clark, *Picasso and Truth*, 1.
13 Eliot, "Hamlet and His Problems," 124.
14 Eliot, "Tradition and the Individual Talent," 10–11.
15 Hemingway, *A Moveable Feast*, 19.
16 Quoted in Herschdorfer and Umstatter, "Making Images," 16.
17 Mann, "The Extremely Moving Pictures," 312.
18 Cendrars, *Night in the Forest*, 35.
19 Ibid., 37.
20 Root, "The Flying Fool," 326.
21 Quoted in Tomkins, *Living Well Is the Best Revenge*, 25.

Part 1. Freedom

1 Dos Passos, "His Mirror Was Danger," 71.
2 Dos Passos, *The Best Times*, 47.
3 Hemingway, *A Moveable Feast*, title page.
4 Cunard, *Parallax*, 16.
5 Quoted in Unterecker, *Voyager*, 579.
6 Jolas, *Man from Babel*, 87.
7 Quoted in Garafola, *The Ballets Russes and Its World*, 93.
8 Cowley, introduction, xvii.
9 Quoted in Ward, *Jazz*, 159.
10 Quoted in ibid., 74.
11 Ansermet, "A 'Serious' Musician Takes Jazz Seriously," 10.
12 Kolodin, *In Quest of Music*, 7–8.

13 Quoted in Ward, *Jazz*, 106.

14 Quoted in Arnold Shaw, *The Jazz Age*, 36.

15 Ibid., 37.

16 Quoted in Ward, *Jazz*, 140.

17 Sudhalter, *Lost Chords*, 413–14.

18 Moody, *Ezra Pound Poet*, 2:60.

19 Pound, *Ezra Pound and Music*, 198.

20 Jablonski, *The Encyclopedia of American Music*, 198.

21 Quoted in Moody, *Ezra Pound Poet*, 2:55.

22 Ibid., 2:58.

23 Reprinted in Pound, *Ezra Pound and Music*, 205.

24 Reprinted in ibid., 59.

25 Moody, *Ezra Pound Poet*, 2:62.

26 Antheil, "The Negro on the Spiral," 214–16.

27 Ibid., 215.

28 Shead, *Music in the 1920s*, 93.

29 Banting, "The Dancing of Harlem," 203.

30 Ward, *Jazz*, 99.

31 Goffin, "Hot Jazz," 238–39.

32 Shaw, *The Jazz Age*, p. 159.

1. Enter the Ballets Russes

1 Quoted in Ross, *The Rest Is Noise*, 135.

2 Ibid., 100.

3 Quoted in Steele, "Dance and Fashion," 38.

4 Quoted in Garafola, *The Ballets Russes and Its World*, 83.

5 Quoted in ibid., 93.

6 Craft, "'Sacre' at Seventy-Five," 136.

7 Quoted in Richardson, *A Life of Picasso*, 34.

8 Quoted in Daix, *Picasso*, 156.

9 Quoted in Richardson, *A Life of Picasso*, 52.

10 Quoted in Garafola, *The Ballets Russes and Its World*, 165.

11 Richardson, *A Life of Picasso*, 148.

12 Kendall, *Balanchine and the Lost Muse*, 177.

13 Quoted in Garafola, *The Ballets Russes and Its World*, 163.

14 Taper, *Balanchine*, 98.

2. Cole Porter

1 Quoted in Barron, "Cole Porter Revue Discovered."

2 Quoted in ibid.

3 Quoted in Rubin, *The Paintings of Gerald Murphy*, 24–25.

4 Ibid., 131.

5 Ibid., 131–32.

3. George Gershwin

1 Jablonski, *Gershwin*, 58.

2 Quoted in ibid., 71.

3 Quoted in Everdell, *The First Moderns*, 332.

4 Quoted in Jablonski, *Gershwin*, 157.

5 Quoted in Ward, *Jazz*, 116.

4. John Dos Passos and e. e. cummings

1 Dos Passos, *Manhattan Transfer*, 489.

2 Cummings, *The Complete Poems*, 279.

3 Ibid., 283.

4 Ibid.

5. Nancy Cunard

1 Arlen, *The Green Hat*, 21–22.

2 Cunard, *Parallax*, 8.

3 Eliot, *Complete Poems and Plays*, 41.

4 Cunard, *Parallax*. 14.

5 Ibid.

6 Gordon, *Nancy Cunard*, 121.

7 Cunard, *Parallax*, 23.

8 Fitzgerald, *The Great Gatsby*, 159.

9 Cunard, *Parallax*, 24.

10 Yeats, "Sailing to Byzantium," 192.

11 Cunard, *Parallax*, 6.

12 Quoted in Nixon, *Samuel Beckett's German Diaries*, 157.

13 Rilke, *Duino Elegies*, 75.

14 Quoted in Danchev, *Cézanne*, 355.

15 Stein, *Writings 1903–1932*, 289.

16 Cunard, *Parallax*, 13.

17 Beckett, *Nohow On*, 87.

18 Quoted in Danchev, *Cézanne*, 339.

19 Quoted in Doran, *Conversations with Cézanne*, 23.

20 Cunard, *Parallax*, 13.

6. F. Scott Fitzgerald

1 Le Vot, *F. Scott Fitzgerald*, 221.

2 Quoted in Bruccoli, *Some Sort of Epic Grandeur*, 206.

3 Quoted in ibid., 69.

4 Tomkins, *Living Well Is the Best Revenge*, 17.

5 Fitzgerald, *The Great Gatsby*, 82–83.

6 Ibid., 155.

7 Quoted in Bruccoli, *Some Sort of Epic Grandeur*, 216–17.

8 Corrigan, *So We Read On*, 102.

9 Quoted in Bruccoli, *Some Sort of Epic Grandeur*, 213.

10 Quoted in ibid., 206.

11 Fitzgerald, *The Great Gatsby*, 7.

12 Fitzgerald, *My Lost City*, 112.

13 Fitzgerald, *The Great Gatsby*, 41 and 47.

14 Ibid., 43.

15 Ibid., 7.

16 Ibid., 10.

17 Ibid., 11 and 159.

18 Ibid., 19.

19 Ibid., 44–45.

20 Ibid., 87.

21 Ibid., 101.

22 Ibid., 102.

23 Ibid., 143.

24 Crane, *The Complete Poems of Hart Crane*, 49.

25 Fitzgerald, *The Great Gatsby*, 35–36.

26 Ibid., 45, 48, and 57.

27 Ibid., 156.

28 Ibid., 11.

29 Ibid.

30 Ibid., 99.

31 Ibid., 83.

32 Ibid, 79.

33 Ibid., 151.

34 Ibid., 155 and 156.

35 Ibid., 158.

36 Kazin, *On Native Grounds*, 244.

37 Fitzgerald, *The Great Gatsby*, 158–59.

38 Ibid., 159.

39 Fitzgerald, *My Lost City*, 137.

40 Bruccoli, *Some Sort of Epic Grandeur*, 291.

41 Ibid., 356.

42 Quoted in ibid., 375.

10 Ibid., 1:36.

11 Ibid., 1:192.

12 Ibid., 1:193.

13 Ibid., 1:75.

14 Ibid., 1:32.

15 Mallarmé, *Oeuvres Complètes*, 38.

16 Cunard, foreword, xxxii.

9. Making It in the Paris Art World

1 Leininger, "The Transatlantic Tradition," 17.

2 Quoted in Ward, *Jazz*, 116.

3 Interview with the author, August 12, 2015.

4 Teo, "Modernism and Orientalism," 71.

5 Epstein, *The Painter from Shanghai*, 408.

6 Qin, "Chinese Taxi Driver Turned Billionaire Bought Modigliani Painting."

10. Ernest Ansermet

1 Quoted in Cooper, *Picasso Theatre*, 31.

2 Ansermet, *Les fondements de la musique dans la conscience humaine*, 9. All quotations from this work are my translations.

3 Ibid., 27.

4 Ibid.

5 Ibid., 70.

6 Gardiner, *Bach*, 380–381.

7 Ansermet, *Les fondements de la musique dans la conscience humaine*, 76 and 143.

8 Ibid., 63.

9 Ibid., 582.

10 Ibid.

11 Cézanne, *The Letters of Paul Cézanne*, 356.

12 Ansermet, "A 'Serious' Musician Takes Jazz Seriously," 10.

13 Ibid.

14 Ansermet, *Les fondements de la musique dans la conscience humaine*, 606.

11. Le Corbusier

1 Quoted in S. Ball, *Ozenfant and Purism*, 148.

2 Quoted in ibid., 60.

3 Le Corbusier, *Essential Le Corbusier*, 2.

4 Le Corbusier, *Towards a New Architecture*, 10.

5 OMA, Koolhaas, and Mau, *S,M,L,XL*, 363.

6 Le Corbusier, *Essential Le Corbusier*, 85–86.

7. Hart Crane

1 Fitzgerald, *The Great Gatsby*, 159.
2 Crane, *Complete Poems and Selected Letters*, 746.
3 Ibid., 160–63.
4 Unterecker, *Voyager*, 284.
5 Ibid., 29.
6 Ibid.
7 Quoted in Unterecker, *Voyager*, 581.
8 Bromwich, *Skeptical Music*, 51.
9 Quoted in Mariani, *The Broken Tower*, 434.
10 Quoted in McMillan, *transition*, 127.
11 Quoted in ibid., 134.
12 Ibid., 142–44.
13 Quoted in Unterecker, *Voyager*, 580.
14 Quoted in ibid., 583.
15 Crane, *The Letters of Hart Crane*, 342.
16 Crane, *The Complete Poems of Hart Crane*, 77.
17 Ibid., 43–44.
18 Fitzgerald, *The Great Gatsby*, 63.
19 Quoted in McMillan, *transition*, 138.
20 Fitzgerald, *The Great Gatsby*, 24.
21 Fitzgerald, *A Short Autobiography*, 56.
22 Crane, *The Complete Poems of Hart Crane*, 32.
23 Ibid., 36.
24 Ibid., 57.
25 Ibid.
26 Ibid., 97.
27 Ibid., 98.
28 Quoted in Goldberg, *George Gershwin*, 48.
29 Quoted in Unterecker, *Voyager*, 605.

8. Langston Hughes

1 Hughes, *The Big Sea*, 3.
2 Quoted in Hughes, *The Collected Works of Langston Hughes*, 1:90.
3 Quoted in Vaill, *Everybody Was So Young*, 130.
4 Quoted in ibid., 133–34.
5 MacLeish, *The Human Season*, 84.
6 Hughes, *The Collected Works of Langston Hughes*, 1:29.
7 Hughes, *The Collected Works of Langston Hughes*, 1:59.
8 Ibid., 1:106.
9 Hughes, *The Collected Works of Langston Hughes*, 1:53.

7 Le Corbusier, *The Decorative Art of Today*, 103.
8 Quoted in Garafola, *The Ballets Russes and Its World*, 93.
9 P. Ball, *Bright Earth*, 322–23.
10 Mallarmé, *Oeuvres Complètes*, 455 (my translation).
11 Le Corbusier, *The Decorative Art of Today*, 76.
12 Le Corbusier, *Essential Le Corbusier*, 87.
13 Ibid., 8.
14 Ibid.
15 Le Corbusier, *Essential Le Corbusier*, 88.
16 Ibid., 146.
17 Quoted in P. Ball, *Bright Earth*, 138.
18 Quoted in ibid., 132.
19 Le Corbusier, *Essential Le Corbusier*, 132.
20 Bloom, *The Anxiety of Influence*, 6.
21 Quoted in Weber, *Le Corbusier*, 280.
22 Huxtable, "The Changing 'Truth' of Le Corbusier," 160.

12. Fernand Léger

1 Golding, *Léger and Purist Paris*, 12.
2 Handler, "1914–1920," 174.
3 Green, *Léger and the Avant-Garde*, 136.
4 Le Corbusier, *Essential Le Corbusier*, 8.
5 Léger, "A New Realism," 278.
6 Affron, "Léger's Modernism," 124.
7 Lanchner, "Fernand Leger," 18.
8 Quoted in De Francia, *Fernand Léger*, 214.
9 Berger, "Léger," 240.
10 Quoted in De Francia, *Fernand Léger*, 60.

13. Gerald Murphy

1 Quoted in Vaill, *Everybody Was So Young*, 104.
2 Ibid, 173.
3 Quoted in ibid., 135–36.
4 Quoted in ibid., 136.
5 Quoted in ibid., 108.
6 Ibid., 114.
7 Quoted in Lanchner, "Fernand Leger," 25.
8 Quoted in De Francia, *Fernand Léger*, 35.
9 Tomkins, *Living Well Is the Best Revenge*, 136.
10 Le Corbusier, *Essential Le Corbusier*, 87.
11 Quoted in Vaill, *Everybody Was So Young*, 143.

12 Vitruvius, *Vitruvius on Architecture*, 216. The original is: "Omnia enim certa proprietate et a veris naturae deducta moribus transduxerunt in operum perfectiones, et ea probaverunt, quorum explicationes in disputationibus rationem possunt habere veritatis."

13 Rubin, *The Paintings of Gerald Murphy*, 8.

14 Eliot, "Hamlet and His Problems," 124.

15 Tomkins, *Living Well Is the Best Revenge*, 26.

16 Quoted in ibid., 133.

17 Vaill, *Everybody Was So Young*, 193.

18 Quoted in ibid.

19 Dos Passos, *The Best Times*, 145.

20 MacLeish, *New and Collected Poems*, 109.

21 Quoted in Jencks, *Modern Movements in Architecture*, 162.

22 Quoted in ibid., 163.

23 Quoted in Vaill, *Everybody Was So Young*, 222.

24 Quoted in ibid., 270.

25 Clark, *Picasso and Truth*.

26 Vaill, *Everybody Was So Young*, 344.

27 Tomkins, *Living Well Is the Best Revenge*, 43.

28 Quoted in Vaill, *Everybody Was So Young*, 342.

29 Tomkins, *Living Well Is the Best Revenge*, 148.

30 Eliot, *Collected Poems*, 50.

31 Stevens, *The Necessary Angel*, 36.

14. Oswald Spengler

1 Spengler, *The Decline of the West*, 15.

2 Ibid., 97.

3 Ibid., 168.

4 Ibid., 365.

5 Ibid., 352.

6 Ibid., 365.

7 Ibid., 423–24.

8 Adorno, *Prisms*, 71–72.

9 G. Steiner, *On Difficulty and Other Essays*, 186.

Part 3. Truth

1 Hemingway, *A Moveable Feast*, 12.

2 Fitzgerald, *The Great Gatsby*, 67.

3 Churchwell, *Careless People*.

4 Owen, *The Collected Poems of Wilfred Owen*, 55.

5 Fitzgerald, *A Short Autobiography*, 157.

6 MacLeish, *Six Plays*, x.
7 Eliot, "Hamlet and His Problems," 124.
8 Ibid., 126.
9 Ibid., 125.
10 Nuttall, *A New Mimesis*, 73.
11 Wittgenstein, *Tractatus Logico-Philosophicus*, 31.
12 McGuiness, *Wittgenstein*, 193.
13 Wittgenstein, *Culture and Value*, 39e.
14 Clark, *Picasso and Truth*, 136.
15 Russell, *The Basic Writings of Bertrand Russell*, 678.
16 Porter, *The Complete Lyrics of Cole Porter*, 108.
17 Stein, *Writings 1903–1932*, 395.
18 Stein, *Tender Buttons*, 24.
19 Ibid.
20 Eliot, *The Complete Poems and Plays*, 50.
21 Joyce, *Ulysses*, 783.

15. Pablo Picasso

1 Stein, *Writings 1903–1932*, 283.
2 Richardson, *A Life of Picasso*, 29.
3 Ibid., 28.
4 Quoted in Cooper, *Picasso Theatre*, 31.
5 Quoted in Richardson, *A Life of Picasso*, 220.
6 Storr, *Modern Art Despite Modernism*, 47.
7 Moned-Fontaine, *Matisse-Picasso*, 193.
8 Ibid.
9 Krauss, *The Picasso Papers*, 153.
10 Stella, *Working Space*, 79.
11 Silver, *Chaos and Classicism*, 212.
12 Quoted in Vaill, *Everybody Was So Young*, 126.
13 Ibid., 127.
14 Richardson, *A Life of Picasso*, 223, 238.
15 Ibid., 223–24.
16 Ibid., 266.
17 Quoted in Vaill, *Everybody Was So Young*, 127.
18 Ibid., 128–29.
19 Ibid., 129–30.
20 Clark, *Picasso and Truth*.
21 Richardson, *A Life of Picasso*, 268.
22 Ibid., 269–70.
23 Clark, *Picasso and Truth*, 104.

24 Quoted in ibid., 43.

25 Ibid., 136.

26 Richardson, *A Life of Picasso*, 282.

27 W. Steiner, *Venus in Exile*, 49.

28 Ibid., 71.

29 Ibid., 50.

30 Ibid., 94.

31 Daix, *Picasso*, 189.

32 Cocteau, *My Contemporaries*, 66–67.

16. Archibald MacLeish

1 MacLeish, *New and Collected Poems*, 107.

2 MacLeish, *Six Plays*, xi–xii.

3 MacLeish, *New and Collected Poems*, 107–8.

4 Ibid., 109.

5 Ibid.

6 Ibid., 89.

7 Ibid., 106.

8 MacLeish, *The Letters of Archibald MacLeish*, 106.

9 Ibid., 107.

10 Ibid., 110.

11 Ibid., 111.

12 Wordsworth, "Preface to the Lyrical Ballads," 940.

13 MacLeish, *The Letters of Archibald MacLeish*, 111.

14 Eliot, "Hamlet and His Problems," 124.

15 MacLeish, *The Letters of Archibald MacLeish*, 136–37.

16 Ibid., 234.

17 Yeats, "Per Amica Silentia Lunae," 331.

18 MacLeish, *New and Collected Poems*, 102.

19 Owen, *The Collected Poems of Wilfred Owen*, 55.

20 MacLeish, *New and Collected Poems*, 102.

21 Ibid., 102.

22 Ibid., 103.

23 Gordon, *Nancy Cunard*, 110.

24 Mallarmé, *Selected Poetry and Prose*, 70.

25 Laforgue, *Six Moral Tales*, unpaginated frontmatter.

26 Laforgue, *Moral Tales*, 9.

27 Ibid., 10.

28 Ibid., 21.

29 Ibid., 31.

30 Joyce, *Ulysses*, 184.

31 Ibid., 183.

32 Ibid., 198.

33 Ellmann, *James Joyce*, 598.

34 MacLeish, *The Hamlet of A. MacLeish*, 13.

35 Hofmannsthal, *Selected Prose*, 133.

36 Ibid., 138.

37 MacLeish, *The Hamlet of A. MacLeish*, 16.

38 Ibid., 17.

39 Ibid., 18.

40 Ibid., 10.

41 Ibid., 13.

42 Ibid., 43.

43 Ibid., 44.

44 Ibid.

45 Ibid., 45.

46 Vanderlan, *Intellectuals Incorporated*, 35.

47 Quoted in ibid., 38.

48 Ibid., 89.

49 Lippman, *Public Opinion*, 248.

17. Eugene Jolas

1 Jolas, *Man from Babel*, 271–72.

2 Ibid., 8.

3 Ibid., 34–35.

4 Ibid., 96.

5 Quoted in McMillan, *transition*, 38.

6 Jolas, *Man from Babel*, 113.

7 Quoted in McMillan, *transition*, 179.

8 Jolas, *Man from Babel*, 107.

9 Kramer and Rumold, introduction, xxiv.

10 Jolas, *Man from Babel*, 271.

11 Ibid., 271–72.

18. Ernest Hemingway

1 MacLeish, *The Human Season*, 38.

2 Quoted in Reynolds, *Hemingway*, 317.

3 Hemingway, *The Short Stories*, vi.

4 Quoted in Reynolds, *Hemingway*, 36.

5 Hemingway, *A Moveable Feast*, 69.

6 Grammont, "Matisse as Religion," 151.

7 Debray, "Gertrude Stein and Painting," 228.

8 Clark, *Picasso and Truth.*

9 Dewey, *John Dewey,* 13.

10 Quoted in Hemingway, *Ernest Hemingway,* 101.

11 Updike, *Just Looking,* 138.

12 Hemingway, *A Farewell to Arms,* 3.

13 Gladwell, *Outliers,* 35.

14 Hemingway, *A Farewell to Arms,* 54.

15 MacLeish, *The Letters of Archibald MacLeish,* 230.

16 Kazin, *On Native Grounds,* 257 and 252.

17 Quoted in ibid., 252.

18 Ibid., 253.

19 Clark, *Picasso and Truth,* 104.

20 Hemingway, *The Short Stories,* 379.

21 Owen, *The Collected Poems of Wilfred Owen,* 55.

22 Hemingway, *The Short Stories,* 383.

23 Le Corbusier, *Towards a New Architecture,* 10.

1918–1958, la Côte d'Azur et la Modernité. Paris: Réunion des Musées Nationaux, 1997.

Adorno, Theodor W. *Prisms*. Translated by Samuel Weber and Shierry Weber. Cambridge, MA: MIT Press, 1982.

Affron, Matthew. "Léger's Modernism: Subjects and Objects." In *Fernand Léger, Fernand Léger*, edited by Carolyn Lanchner, 121–48. New York: Museum of Modern Art, 1998.

Allen, Frederick Lewis. *Only Yesterday*. New York: Harper Perennial, 2010.

Anderson, Jack. *The One and Only: The Ballet Russe de Monte Carlo*. London: Dance Books, 1981.

Ansermet, Ernest. *Les fondements de la musique dans la conscience humaine*. Neuchâtel, Switzerland: Éditions de la Baconnière, 1961.

———. "A 'Serious' Musician Takes Jazz Seriously." In *Keeping Time: Readings in Jazz History*, edited by Robert Waiser, 9–11. New York: Oxford University Press, 1999.

Antheil, George. "The Negro on the Spiral, or A Method of Negro Music." In *Negro: An Anthology*, edited by Nancy Cunard, edited and abridged by Hugh Ford, 214–19. New York: Continuum, 1996.

Arlen, Michael. *The Green Hat*. London: Collins, 1924.

Baer, Nancy van Norman, ed. *The Art of Enchantment: Diaghilev's Ballets Russes, 1909–1929*. San Francisco: Fine Arts Museums, 1988.

Ball, Philip. *Bright Earth: Art and the Invention of Color*. New York: Farrar, Straus and Giroux, 2001.

Ball, Susan L. *Ozenfant and Purism: The Evolution of a Style, 1915–1930*. Ann Arbor, MI: UMI Research Press, 1981.

Banting, John. "The Dancing of Harlem." In *Negro: An Anthology*, edited by Nancy Cunard, edited and abridged by Hugh Ford, 203–4. New York: Continuum, 1996.

Barron, James. "Cole Porter Revue Discovered." *New York Times*, June 23, 2014.

Barry, Philip. *States of Grace: Eight Plays by Philip Barry*. Edited by Brendan Gill. New York: Harcourt Brace, 1975.

Beckett, Samuel. *Nohow On*. New York: Grove, 1996.

Berger, John. "Léger." In *Modern Art and Modernism: A Critical Anthology*, edited by Francis Frascina and Charles Harrison, 239–41. New York: Harper and Row, 1982.

Berman, Ronald. *"The Great Gatsby" and Fitzgerald's World of Ideas*. Tuscaloosa: University of Alabama Press, 1997.

Bernadac, Marie-Laure, and Christine Piot, eds. *Picasso: Écrits*. Paris: Gallimard, 1989.

Bernard, Catherine. *Afro-American Artists in Paris, 1919–1939*. New York: Berthe and Karl Leubsdorf Art Gallery, Hunter College, 1989.

Birmingham, Kevin. *The Most Dangerous Book: The Battle for James Joyce's "Ulysses."* New York: Penguin, 2014.

Bloom, Harold. *The Anxiety of Influence: A Theory of Poetry*. New York: Oxford University Press, 1973.

Blume, Mary. *Côte d'Azur: Inventing the French Riviera*. London: Thames and Hudson, 1992.

Bordy, Elaine. *Paris: The Musical Kaleidoscope, 1870–1925*. London: Robson Books, 1987.

Bromwich, David. *Skeptical Music: Essays on Modern Poetry*. Chicago: University of Chicago Press, 2001.

Bruccoli, Matthew. *Some Sort of Epic Grandeur: The Life of F. Scott Fitzgerald*. New York: Harcourt, Brace 1981.

Burns, Eric. *1920: The Year That Made the Decade Roar*. New York: Pegasus, 2015.

Carter, Graydon, ed. *Bohemians, Bootleggers, Flappers, and Swells: The Best of Early Vanity Fair*. New York: Penguin, 2014.

Cendrars, Blaise. *Night in the Forest*. Columbia: University of Missouri Press, 1985.

Cézanne, Paul. *The Letters of Paul Cézanne*. Edited and translated by Alex Danchev. Los Angeles: Getty Publications, 2013.

Cheever, Susan. *E. E. Cummings: A Life*. New York: Random House, 2014.

Churchwell, Sarah. *Careless People: Murder, Mayhem, and the Invention of "The Great Gatsby."* New York: Penguin Press, 2013.

Clark, T. J. *Picasso and Truth: From Cubism to Guernica*. Princeton, NJ: Princeton University Press, 2013.

Cline, Sally. *Zelda Fitzgerald: Her Voice in Paradise*. New York: Arcade, 2003.

Cocteau, Jean. *My Contemporaries*. Translated by Margaret Crosland. Philadelphia, PA: Chilton Book Company, 1968.

———. *Past Tense: Diaries*. Translated by Richard Howard. San Diego, CA: Harcourt, Brace Jovanovich, 1988.

———. *Souvenir Portraits: Paris in the Belle Époque*. Translated by Jesse Browner. New York: Paragon House, 1990.

———. *The White Book*. Translated by Margaret Crosland. San Francisco: City Lights Books, 1989.

Collier, James L. *The Making of Jazz*. Boston: Houghton-Mifflin, 1978.

Cooper, Douglas. *Picasso Theatre*. New York: Abrams, 1968.

Corrigan, Maureen. *So We Read On: How "The Great Gatsby" Came to Be and Why It Endures*. New York: Little, Brown, 2014.

Coward, Noël. *The Letters of Noël Coward*. Edited by Barry Day. New York: Knopf, 2007.

Cowley, Malcolm. *Exile's Return*. New York: Penguin Classics, 1994.

———. Introduction to F. Scott Fitzgerald, *The Stories of F. Scott Fitzgerald*, selected with an introduction by Malcolm Cowley, vii–xxv. New York: Scribner's, 1951.

Craft, Robert. "'Sacre' at Seventy-Five." In Robert Craft, *Small Craft Advisories*, 130–43. New York: Thames and Hudson, 1989.

Crane, Hart. *Complete Poems and Selected Letters*. Edited by Langdon Hammer. New York: Library of America, 2006.

———. *The Complete Poems of Hart Crane*. Centennial ed. Edited by Marc Simon. New York: Liveright, 2000.

———. *The Letters of Hart Crane, 1916–1932*. Edited by Brom Weber. 1st California paperbound ed. Berkeley: University of California Press, 1965.

Cummings, e. e. *The Complete Poems, 1904–1962*. Edited by George J. Firmage. New York: Liveright, 1994.

Cunard, Nancy. Foreword to *Negro: An Anthology*, edited by Nancy Cunard, xxxi–xxxii. New York: Continuum, 1996.

———, ed. *Negro: An Anthology*. Edited and abridged by Hugh Ford. New York: Continuum, 1996.

———. *Parallax*. London: Hogarth Press, 1925.

Daix, Pierre. *Picasso: Life and Art*. Translated by Olivia Emmet. New York: Icon, 1994.

Danchev, Alex. *Cézanne: A Life*. New York: Pantheon, 2012.

Dardis, Tom. *The Thirsty Muse: Alcohol and the American Writer*. New York: Ticknor and Fields, 1989.

De Francia, Peter. *Fernand Léger*. New Haven, CT: Yale University Press, 1983.

Debray, Cecile. "Gertrude Stein and Painting: From Picasso to Picabia." In *The Steins Collect: Matisse, Picasso, and the Parisian Avant-Garde*, edited by Janet Bishop, Cecile Debray, and Rebecca Rabinow, 223–41. San Francisco: San Francisco Museum of Modern Art, 2011.

Des Rochers, Jacques, and Brian Foss, eds. *1920s Modernism in Montreal: The Beaver Hall Group*. Montreal: Montreal Museum of Fine Arts, 2015.

Dewey, John. *John Dewey: The Later Works*. Edited by Jo Ann Boydston. Carbondale: Southern Illinois University Press, 1981.

Donnelly, Honoria Murphy, with Richard N. Billings. *Sara and Gerald: Villa America and After*. New York: Times Books, 1982.

Donaldson, Scott. *Archibald MacLeish: An American Life*, Boston: Houghton Mifflin, 1992.

Doran, Michael, ed. *Conversations with Cézanne*. Translated by Julie Lawrence Cochran. Berkeley: University of California Press, 2001.

Dos Passos, John. *The Best Times: An Informal Memoir*. New York: New American Library, 1966.

———. "His Mirror Was Danger." *Life*, July 14, 1961, 71–72.

———. *Manhattan Transfer*. New York: Library of America, 2003.

Douglas, Ann. *Terrible Honesty: Mongrel Manhattan in the 1920s*. New York: Farrar, Straus and Giroux, 1995.

Eliot, T. S. *Collected Poems, 1909–1950*. New York: Harcourt, Brace and World, 1971.

———. *The Complete Poems and Plays, 1909–1950*. New York: Harcourt, Brace and World, 1971.

———. "Hamlet and His Problems." In T. S. Eliot, *Selected Essays of T. S. Eliot, 1917–1932*, 121–26. New York: Harcourt, Brace, 1960.

———. "Tradition and the Individual Talent." In T. S. Eliot, *Selected Essays of T. S. Eliot, 1917–1932*, 3–11. New York: Harcourt, Brace, 1960.

Ellmann, Richard. *James Joyce*. New York: Oxford University Press, 1959.

Epstein, Jennifer Cody. *The Painter from Shanghai*. New York: Norton, 2008.

Etchells, Frederick. Introduction to Le Corbusier, *Essential Le Corbusier: "L'Esprit Nouveau" Articles*, translated by John Rodker and James Dunnett, v–xxv. Oxford: Architectural Press, 1998.

Everdell, William R. *The First Moderns: Profiles in the Origins of Twentieth-Century Thought*. Chicago: University of Chicago Press, 1997.

Fitzgerald, F. Scott. *The Great Gatsby*. New York: Scribner's, 1925.

———. *My Lost City: Personal Essays, 1920-1940*. Edited by James L. W. West III. Cambridge: Cambridge University Press, 2005.

———. *A Short Autobiography*. Edited by James L. W. West III. New York: Scribner, 2011.

———. *The Stories of F. Scott Fitzgerald*. Selected with an introduction by Malcolm Cowley. New York: Scribner's 1951.

———. *Tender Is the Night*. New York: Scribner's, 1934.

Gallup, Donald, ed. *The Flowers of Friendship: Letters Written to Gertrude Stein*. New York: Octagon, 1979.

Garafola, Lynn. *The Ballets Russes and Its World*. New Haven: Yale University Press, 1999.

García-Márquez, Vicente. *The Ballets Russes: Colonel de Basil's Ballets Russes de Monte Carlo, 1932–1952*. New York: Knopf, 1990.

Gardiner, John Eliot. *Bach: Music in the Castle of Heaven*. New York: Knopf, 2013.

Gladwell, Malcolm. *Outliers: The Story of Success*. New York: Little, Brown, 2008.

Goffin, Robert. "Hot Jazz." Translated by Samuel Beckett. In *Negro: An Anthology*, edited by Nancy Cunard, edited and abridged by Hugh Ford, 238–40. New York: Continuum, 1996.

Golan, Romy. *Modernity and Nostalgia: Art and Politics in France between the Wars*. New Haven, CT: Yale University Press, 1995.

Goldberg, Isaac. *George Gershwin: A Study in American Music*. New York: Ungar, 1958.

Golding, John. *Léger and Purist Paris*. London: Tate Gallery, 1970.

Gombrich, E. H. *Art and Illusion*. Princeton, NJ: Princeton University Press, 1972.

Gopnik, Adam, ed. *Americans in Paris: A Literary Anthology*. New York: Library of America, 2004.

Gordon, Lois. *Nancy Cunard: Heiress, Muse, Political Idealist*. New York: Columbia University Press, 2007.

Grammont, Claudine. "Matisse as Religion: The 'Mike Steins' and Matisse, 1908–1918." In *The Steins Collect: Matisse, Picasso, and the Parisian Avant-Garde*, edited by Janet Bishop, Cecile Debray, and Rebecca Rabinow, 151–65. San Francisco: San Francisco Museum of Modern Art, 2011.

Green, Christopher. *Léger and the Avant-Garde*. New Haven, CT: Yale University Press, 1976.

Handler, Beth. "1914–1920: World War I and the Mechanical Period." In *Fernand Léger*, edited by Carolyn Lanchner, 174–77. New York: Museum of Modern Art, 1998.

Hansen, Arlen J. *Expatriate Paris: A Cultural and Literary Guide to Paris of the 1920s*. New York: Arcade, 1991.

Harding, Jason. *T. S. Eliot in Context*. Cambridge: Cambridge University Press, 2011.

Hemingway, Ernest. *Ernest Hemingway: Selected Letters, 1917–1961*. Edited by Carlos Baker. New York: Scribner's, 1981.

———. *A Farewell to Arms*. New York: Scribner's, 1929.

———. *A Moveable Feast: Sketches of the Author's Life in Paris in the Twenties*. New York: Scribner's, 1964.

———. *The Short Stories*. New York: Scribner's, 1938.

Herschdorfer, Nathalie, and Lada Umstatter, eds. *Le Corbusier and the Power of Photography*. London: Thames and Hudson, 2012.

———. "Making Images." In *Le Corbusier and the Power of Photography*, edited by Nathalie Herschdorfer and Lada Umstätter, 14–29. London: Thames and Hudson, 2012.

Hofmannsthal, Hugo von. *Selected Prose*. Translated by Mary Hottinger, Tania Stern, and James Stern. New York: Pantheon, 1952.

Howard, Jean. *Travels with Cole Porter*. New York: Abrams, 1991.

Hughes, Langston. *The Big Sea*. New York: Hill and Wang, 1993.

———. *The Collected Works of Langston Hughes*. Vol. 1. Edited by Arnold Rampersad. Columbia: University of Missouri Press, 2001.

Hutton, Elizabeth, and Elizabeth Garrity Ellis. *Americans in Paris: Man Ray, Gerald Murphy, Stuart Davis and Alexander Calder*. New York: Counterpoint, 1996.

Huxtable, Ada Louise. "The Changing 'Truth' of Le Corbusier." In Ada Louise Huxtable, *On Architecture: Collected Reflections on a Century of Change*, 157–60. New York: Walker and Company, 2008.

Illies, Florian. *1913: The Year before the Storm*. Translated by Shaun Whiteside and Jamie Lee Searle. New York: Melville House, 2013.

Jablonski, Edward. *The Encyclopedia of American Music*. New York: Doubleday, 1981.

———. *Gershwin: A Biography*. New York: Da Capo, 1998.

Jencks, Charles. *Modern Movements in Architecture*. New York: Anchor, 1973.

Jolas, Eugene. *Man from Babel*. Edited by Andreas Kramer and Rainer Rumold. New Haven, CT: Yale University Press, 1998.

Joyce, James. *Ulysses*. New York: Random House, 1961.

Kazin, Alfred. *On Native Grounds: An Interpretation of Modern American Prose Literature*. New York: Anchor, 1956.

Kendall, Elizabeth. *Balanchine and the Lost Muse*. New York: Oxford University Press, 2013.

Kennedy, J. Gerald, ed. *Hemingway and Fitzgerald Abroad*. New York: St. Martin's Press, 1999.

Kimball, Robert, ed. *The Unpublished Cole Porter*. New York: Simon and Schuster, 1975.

Kluver, Billy. *A Day with Picasso*. Cambridge, MA: MIT Press, 1999.

Kolodin, Irving. *In Quest of Music: A Journey in Time*. New York: Doubleday, 1980.

Kramer, Andreas, and Rainer Rumold. Introduction to Eugene Jolas, *Man from Babel*, edited by Andreas Kramer and Rainer Rumold, xi–xxxi. New Haven, CT: Yale University Press, 1998.

Krauss, Rosalind E. *The Picasso Papers*. New York: Farrar, Straus, 1998.

Kuenzli, Rudolf E., ed. *Dada and Surrealist Film*. New York: Willis Locher and Owens, 1987.

Laforgue, Jules. *Moral Tales*. Translated by William Jay Smith. New York: New Directions, 1985.

———. *Six Moral Tales*. Edited and translated by Frances Newman. New York: Liveright, 1928.

Lanchner, Carolyn. "Fernand Léger: American Connections." In *Fernand Léger*, edited by Carolyn Lanchner, 15–70. New York: Museum of Modern Art, 1998.

Le Corbusier. *The Decorative Art of Today*. Translated by James Dunnett. Cambridge, MA: MIT Press, 1987.

———. *Essential Le Corbusier: "L'Esprit Nouveau" Articles*. Translated by John Rodker and James Dunnett. Oxford: Architectural Press, 1998.

———. *Towards a New Architecture.* Translated by Frederick Etchells. London: Architectural Press, 1927.

Le Vot, André. *F. Scott Fitzgerald: A Biography.* Translated by William Byron. New York: Doubleday, 1983.

Lees, Gene. *Meet Me at Jim and Andy's: Jazz Musicians and Their World.* New York: Oxford University Press, 1988.

———. *Singers and the Song.* New York: Oxford University Press, 1987.

———. *Waiting for Dizzy: Fourteen Jazz Portrais.* New York: Oxford University Press, 1991.

Léger, Fernand. *Lettres à Simone.* Edited by Christian Derouet. Paris: Skira, 1987.

———. "A New Realism—the Object." In *Theories of Modern Art,* edited by Herschel B. Chipp, 278–79. Berkeley: University of California Press, 1968.

Leininger, Theresa. "The Transatlantic Tradition: African American Artists in Paris, 1830–1940." In *Paris Connections: African American Artists in Paris,* edited by Asaka Bomani and Belvie Rooks, and curated by Raymond Saunders, 9–23. San Francisco: QED Press, 1992.

Leonard, George. *Into the Light of Things: The Art of the Commonplace from Wordsworth to John Cage.* Chicago: University of Chicago Press, 1994.

Levant, Oscar. *Memoirs of an Amnesiac.* New York: Bantam: 1966.

Lippmann, Walter. *Public Opinion.* New York: Harcourt, Brace, 1922.

Lowe, David Garrard. *Art Deco New York.* New York: Watson-Guptill, 2004.

Mackrell, Judith. *Flappers: Six Women of a Dangerous Generation.* New York: Farrar, Straus and Giroux, 2013.

MacLeish, Archibald. *The Hamlet of A. MacLeish.* Boston: Houghton-Mifflin, 1928.

———. *The Human Season.* Boston: Houghton Mifflin, 1972.

———. *The Letters of Archibald MacLeish.* Edited by R. H. Winnick. Boston: Houghton-Mifflin, 1983.

———. *New and Collected Poems, 1917–1976.* Boston: Houghton Mifflin, 1976.

———. *Six Plays.* Boston: Houghton Mifflin, 1980.

———. *Streets in the Moon.* Boston: Houghton-Mifflin, 1926.

Mallarmé, Stéphane. *Divagations.* Translated by Barbara Johnson. Cambridge, MA: Harvard University Press, 2007.

———. *Oeuvres Complètes.* Paris: Pléiade, 1945

———. *Selected Poetry and Prose.* Edited by Mary Ann Caws. Translated by Patricia Terry, Morris Z. Schroder, Frederick Morgan, Bradford Cook, Brian Coffey, Hubert Creekmore, Robert Greer Cohn, and Roger Fry. New York: New Directions, 1982.

Mann, Thomas. "The Extremely Moving Pictures." In *Bohemians, Bootleggers, Flappers, and Swells: The Best of Early Vanity Fair,* edited by Graydon Carter, 311–13. New York: Penguin, 2014.

Mariani, Paul. *The Broken Tower: The Life of Hart Crane*. New York: Norton, 2000.

Maxwell, Elsa. *RSVP: Elsa Maxwell's Own Story*. New York: Little Brown, 1954.

McAuliffe, Mary. *When Paris Sizzled*. Lanham, MD: Rowman and Littlefield, 2016.

McGuiness, Brian. *Wittgenstein: A Life*. Berkeley: University of California Press, 1988.

McMillan, Dougald. *transition: The History of a Literary Era, 1927–38*. New York: George Braziller, 1975.

Mellow, James R. *Hemingway: A Life with Consequences*. New York: Houghton Mifflin, 1992.

Merleau-Ponty, Maurice. "Cézanne's Doubt." In Maurice Merlean-Ponty, *Sense and Non-Sense*, translated by Hubert and Patricia Dreyfus, 9–25. Evanston, IL: Northwestern University Press, 1992.

Moned-Fontaine, Isabelle. *Matisse-Picasso*. New York: Museum of Modern Art, 2002.

Moody, A. David. *Ezra Pound: Poet*. Volume 2: *The Epic Years, 1921–1939*. New York: Oxford University Press, 2014.

Moos, Stanislaus, and Arthuer Ruegg, eds. *Le Corbusier before Le Corbusier: Applied Arts, Architecture, Painting, Photography, 1907–1922*. New Haven, CT: Yale University Press, 2002.

Nichols, Roger. *The Harlequin Years: Music in Paris, 1917–1929*. Berkeley: University of California Press, 2002.

Nixon, Mark. *Samuel Beckett's German Diaries, 1936-1937*. London: Continuum, 2011.

Norman, Charles. *E. E. Cummings: A Biography*. New York: Dutton, 1967.

Nuttall, A. D. *A New Mimesis: Shakespeare and the Representation of Reality*. London: Methuen, 1983.

OMA, Rem Koolhaas, and Bruce Mau. *S,M,L,XL*. New York: Monacelli, 1998.

Owen, Wilfred. *The Collected Poems of Wilfred Owen*. Edited by C. Day Lewis. New York: New Directions, 1965.

Peters, Arthur King, ed. *Jean Cocteau and the French Scene*. New York: Abbeville, 1984.

Porter, Cole. *The Complete Lyrics of Cole Porter*. Edited by Robert Kimball. New York: Knopf, 1983.

Pound, Ezra. *Ezra Pound and Music: The Complete Criticism*, edited by R. Murray Shafer. New York: New Directions, 1977.

Powell, Richard J. *Homecoming: The Life and Art of William Henry Johnson*. Washington, DC: Smithsonian Institution Press, 1991.

Qin, Amy. "Chinese Taxi Driver Turned Billionaire Bought Modigliani Painting." *New York Times*, November 10, 2015.

Reynolds, Michael S. *Hemingway: The Paris Years*. New York: Norton, 1989.

Richardson, John. *A Life of Picasso: The Triumphant Years, 1917–1932*. New York: Knopf, 2007.

Rilke, Rainer Maria. *Duino Elegies*. Translated by J. B. Leishman and Stephen Spender. New York: Norton, 1963.

Root, Waverley. "The Flying Fool." In *Americans in Paris: A Literary Anthology*, edited by Adam Gopnik, 318–27. New York: Library of America, 2004.

Ross, Alex. *The Rest Is Noise: Listening to the Twentieth Century*. New York: Farrar, Straus and Giroux 2007.

Roulston, Robert, and Helen H. Roulston. *Winding Road to West Egg: The Artistic Development of F. Scott Fitzgerald*. Lewisburg, PA: Bucknell University Press, 1995.

Rowell, Margit. *Objects of Desire: The Modern Still Life*. New York: Museum of Modern Art, 1997.

Rubin, William. *The Paintings of Gerald Murphy*. New York: Museum of Modern Art, 1974.

———. *Picasso and Portraiture: Representation and Transformation*. New York: Museum of Modern Art, 1996.

———. "The Pipes of Pan: Picasso's Aborted Love Song to Sara Murphy." *ArtNews*, May 1994, 138–47.

Russell, Bertrand. *The Basic Writings of Bertrand Russell*. New York: Simon and Schuster, 1961.

Rybczynski, Witold. *How Architecture Works*. New York: Farrar, Straus and Giroux, 2013.

Shaw, Arnold. *The Jazz Age*. New York: Oxford University Press, 1987.

Shead, Richard. *Music in the 1920s*. New York: St. Martin's, 1976.

Shouvaloff, Alexander. *The Art of the Ballets Russes: The Serge Lifar Collection of Theater Designs, Costumes, and Paintings at the Wadsworth Atheneum*. New Haven, CT: Yale University Press, 1997.

Silver, Kenneth. *Chaos and Classicism: Art in France, Italy, and Germany, 1918–1936*. New York: Guggenheim Museum, 2010.

———. *Making Paradise: Art, Modernity, and the Myth of the French Riviera*. Cambridge, MA: MIT Press 2001.

Spengler, Oswald. *The Decline of the West: Form and Actuality*. New York: Knopf, 1926.

Stearns, Marshall. *The Story of Jazz*. New York: Oxford University Press, 1956.

Steele, Valerie, "Dance and Fashion." In *Dance and Fashion*, edited by Valerie Steele, 7–104. New Haven, CT: Yale University Press, 2013.

Stein, Gertrude. *Tender Buttons*. Corrected centennial edition. Edited by Seth Perlow (San Francisco: City Lights, 2014.

———. *Writings, 1903–1932*. Edited by Harriet Chessman and Catherine Simpson. New York, Library of America, 1998.

Steiner, George. *On Difficulty and Other Essays*. New York: Oxford, 1978.

Steiner, Wendy. *Venus in Exile: The Rejection of Beauty in Twentieth-Century Art*. New York: Free Press, 2001.

Stella, Frank. *Working Space*. Cambridge, MA: Harvard University Press, 1986.

Stevens, Wallace. *The Necessary Angel*. New York: Vintage, 1942.

Storr, Robert. *Modern Art despite Modernism*. New York: Museum of Modern Art, 2000.

Strasburger, Barbara F. *Artists and Their Museums on the Riviera*. New York: Abrams, 1998.

Sudhalter, Richard M. *Lost Chords: White Musicians and Their Contribution to Jazz, 1915–1945*. New York: Oxford University Press, 1999.

Taper, Bernard. *Balanchine: A Biography*. New York: Times Books, 1984.

Teo, Phyllis. "Modernism and Orientalism: The Ambiguous Nudes of Chinese Artist Pan Yuliang." *New Zealand Journal of Asian Studies* 12, no. 2 (2010): 65–80.

Tomkins, Calvin. *Living Well Is the Best Revenge*. New York: Dutton, 1971.

Unterecker, John. *Voyager: A Life of Hart Crane*. New York: Liveright, 1987.

Updike, John. *Just Looking: Essays on Art*. New York: Knopf, 2007.

Vaill, Amanda. *Everybody Was So Young: Gerald and Sara Murphy, a Lost Generation Love Story*. Boston: Houghton, Mifflin, 1998.

Vanderlan, Robert. *Intellectuals Incorporated: Politics, Art, and Ideas inside Henry Luce's Media Empire*. Philadelphia: University of Pennsylvania Press, 2010.

Veblen, Thorstein. *Conspicuous Consumption*. New York: Penguin, 2006.

Vitruvius. *Vitruvius on Architecture*. Book IV. Edited and translated by Frank Granger. Cambridge, MA: Loeb Classical Library, 1931.

Ward, Geoffrey C. *Jazz: A History of America's Music*. New York: Knopf, 2000.

Wayne, Kenneth. *Impressions of the Riviera: Monet, Renoir, Matisse and Their Contemporaries*. Portland, ME: Portland Museum of Art, 1998.

Weber, Nicholas Fox. *Le Corbusier: A Life*. New York: Knopf, 2008.

Wheeler, K. W., and V. L. Lussier, eds. *Women, the Arts and the 1920s in Paris and New York*. New York: Transaction, 1982.

Wittgenstein, Ludwig. *Culture and Value*. Translated by Peter Winch. Chicago: University of Chicago Press, 1980.

———. *Tractatus Logico-Philosophicus*. London: Routledge and Kegan Paul, 1981.

Wordsworth, William. *The Poetical Works of Wordsworth*, edited by Thomas Hutchinson, 934–42. New York: Oxford University Press, 1933.

Yeats, William Butler. "Per Amica Silentia Lunae." In William Butler Yeats, *Mythologies*, 317–66. New York: Collier, 1969.

———. "Sailing to Byzantium." In William Butler Yeats, *The Collected Poems of W. B. Yeats*, 191–92. New York: Macmillan, 1956.

abstract expressionism, 10, 107, 235
abstraction, 11, 41, 73, 112, 114, 115, 136, 148, 153, 167, 170, 171, 174, 175, 228
Académie Colarossi, 162
Académie de la Grande Chaumière, 105
Académie Julian, 102
Académie Moderne, 102, 120, 145
Académie Scandinave, 102
Accademia di Belle Arti, 109
Adorno, Theodor, 163
Aeolian Hall (New York), 2, 31, 53
Affron, Matthew, 135
Agee, James, 211
Aiken, Conrad, 194
Albers, Josef, 10, 130, 171
All Quiet on the Western Front (Remarque), 166
American in Paris, An (Gershwin), xi, xii, 17, 47, 49, 51, 52, 55
Amphion (Honegger), 31
Anderson, Sherwood, 4, 59, 74, 83, 85, 219, 221, 224, 226
Ansermet, Ernest, x, 20, 21, 24, 26, 29, 40, 52, 67, 111, 113–18, 119, 121, 125, 161, 164, 170, 177, 178, 179, 180, 195, 203, 232, 236
Antheil, George, 10, 18, 20, 25–28, 31, 49, 54, 73, 100, 139, 170, 195, 213
Antibes, 5, 71, 72, 85, 156, 176, 178, 183, 190, 197
Apollinaire, Guillaume, 176, 217
Apollon Musagète (Balanchine), 3, 16, 41, 42–44, 45, 50, 89, 164
Après midi-d'un faune, L', (Mallarmé), 34

Aragon, Louis, 59, 62, 216, 227
Arlen, Michael, 62–63
Armory Show, 58, 73, 133
Armstrong, Louis, 18, 19, 20, 23, 24, 30, 64, 113, 169
arrangers, 31–32
"Ars Poetica" (MacLeish), 194, 198, 200, 208, 210
art deco, 9, 100, 124
Art Institute of Chicago, 100, 102, 103, 223
art nouveau, 124
Ashcan School, 11, 103
Ashton, Frederick, 100
Astaire, Fred and Adele, 54, 56
Auric, Georges, 29, 33

Bach, Johann Sebastian, 21, 28, 54, 116, 117
Baker, Hobey, 78–79
Baker, Josephine, 1, 20, 22, 30, 62, 97, 100, 139, 198
Bakst, Léon, 38, 190
Balanchine, George, 3, 16, 29, 37, 41, 42, 43, 44, 50, 89, 95, 154, 161, 164, 183, 190
Ball, Susan, 7
Ballet Mécanique (Léger and Antheil), 18, 26, 54, 139
Ballets Russes, x, 3, 12, 15, 21, 30, 33–44, 46, 58, 59, 74, 110, 113, 133, 140, 145, 160, 175, 176, 178, 182, 190, 195
Ballets Suédois, 46, 139
Bankhead, Tallulah, 62
Banting, John, 30
Barnes, Djuna, 62

Barnes, Dr. Albert, 101, 225, 229

Barney, Natalie, 26, 195

Barr, Alfred, 10, 171

Barry, Philip, 56, 59, 183, 185, 196

Bartók, Béla, 24, 52, 168

Baudelaire, Charles, xi, 97, 200

Baudry, Paul, 105

Bauhaus, 120, 125, 171

Beach, Sylvia, 26, 73, 95, 207, 221, 225

Beaton, Cecil, 62

Beaumont, Count and Countess, 33, 34, 40, 183

bebop, 235

Bechet, Sidney, xi, 10, 18, 21, 22–24, 48, 100, 110

Beckett, Samuel, 30, 62, 67, 68, 69, 202, 216, 217

Beckmann, Max, 59, 73

Beethoven, Ludwig van, 24, 30, 163

Beiderbecke, Bix, 2, 23–24, 169

Belasco, David, 77

Bellows, George, 103

Benchley, Robert, 56, 83

Bennet, Robert Russell, 31

Bennett, Gwendolyn, 101

Bennett, Richard Rodney, 49

Berenson, Bernard, 225

Berg, Alban, 10, 20, 55, 168

Berg Collection (New York Public Library), xi, 91

Berger, John, 36–37

Berlin, Irving, 19, 32, 46, 52, 153, 114

Bernhardt, Sarah, 42, 205

Bernheim, Georges, 158

Bibliothèque (Murphy), 12, 147–54, 155

"Big Two-Hearted River" (Hemingway), 9

Black and Tan Fantasy (Ellington), 31

Black Belt (Gershwin), 54

Black Sun Press, 86, 88

Bliss, Arthur, 52

Bloch, Ernest, 26

Blue Monday (Gershwin), 25, 51, 52, 55

Blues (Motley), 103–4

blues, 7, 17, 19, 23, 51, 52, 55, 97, 99, 165, 168, 235

Boatdeck (Murphy), 142–43, 155

Boeuf sur le Toit, Le (Cocteau), 47

Bohr, Niels, 77, 116, 168

Bolero (Ravel), 7

Boni and Liveright (publishing house) xi, 58, 85, 95, 207

Bonnard, Pierre, 46, 106, 109, 142, 165

boogie-woogie, 7

Borlin, Jean, 46

Borly, Jules, 69–70

Bouguereau, William-Adolphe, 10

Boulanger, Nadia, 24, 28, 55, 195

Boulez, Pierre, 29

Boyle, Kay, 62, 86, 219

Brancusi, Constantin, 9, 25, 124

Braque, Georges, 3, 34, 61, 106, 112, 123, 129, 133, 134, 155, 176, 177

Breton, André, 227

Brice, Fanny, 26

Bridge, The (Crane), 9, 12, 17, 64, 65, 78, 83, 84, 86, 87, 88, 89, 91, 92, 110, 148, 209, 217, 235

Bromwich, David, 85

Brooklyn Bridge, 87, 88, 89, 110, 232

Brown, Sterling, 94

Bruccoli, Matthew, 81

Bruce, Patrick Henry, 126

Busoni, Federico, 24

Calder, Alexander, 198

Callaghan, Morley, 226

call to order (rappel à l'ordre), 1, 9, 122, 181

Cantos (Pound), 64

Cardillac (Hindemith), 29

Carmichael, Hoagy, 19

Index

Carpenter, John Alden, 31
"Cat and the Saxophone (2 A.M.), The"
(Hughes), 97
Cendrars, Blaise, 10, 12, 25, 46, 65, 90,
114, 139, 217
censorship, 5–6, 58–59, 108–109
Cézanne, Paul, xii, 3, 58, 60, 61, 67–70,
87, 102, 117–18, 127, 129, 137, 170, 174,
176, 182, 224
Chaliapin, Fyodor, 36, 54
Chanel, Coco, 3, 11, 30, 34, 42, 62, 179
Chant du Rossignol (Stravinsky), 34
Chaplin, Charlie, 16, 95, 139
Charleston (dance), 7–8, 10, 16, 30, 31,
84, 95, 191, 192
Charleston Rhapsody (Bennet), 31
Charnel House (Walinska), 108
Chen, Xiuqing (Pan Yuliang), 108–10
Chicago, 7, 19, 20, 21, 57, 100, 174
Chirico, Giorgio de, 28, 34, 118, 183
Chopin, Frédéric, 7, 54, 172
Chun (*Spring*) (Pan), 109
Clarence Williams Blue Five, 23
Clark, T. J., 11, 157, 171, 181, 186–190,
226, 232
"Clean Well-Lighted Place, A"
(Hemingway), 9, 144, 164, 216,
232–236
Cocktail (Murphy), xi, 18, 147–149, 151,
154
Cocteau, Jean, 1, 4, 15, 26, 35, 38–41, 47,
59, 95, 113, 117, 176, 177, 179, 180, 181,
192, 193, 198
Coleridge, Samuel Taylor, 87
Colin, Paul, 22
Columbia Records, 19
Concerto in F (Gershwin), 54–55
Coney Island, 59
Conrad, Joseph, 93, 225
Conspicuous Consumption (Veblen), 8
Copland, Aaron, 29, 31, 50

Corbusier, Le (Charles-Édouard
Jeanneret), x, 1, 2, 7, 8, 9, 10, 11, 12,
23, 28, 37, 38, 42, 43, 60, 74, 95, 111,
112, 113, 115, 119–31, 132, 134, 135, 139,
141, 143, 146, 147, 154, 155, 159, 161,
162, 165, 168, 171, 180, 181, 183, 189,
218, 223, 228, 230, 235
Corrigan, Maureen, 74
Corrupt Coterie, 62
Coussey, Anne, 94, 96
Coward, Noël, 1, 6, 8, 19, 56, 83
Cowley, Malcolm, 4, 17, 70, 92, 213
Crane, Hart, ix, x, xi, 2, 5, 7, 8, 9, 12, 15,
17, 18, 29, 39, 41, 47, 64, 65, 68, 73,
74, 78, 83–92, 95, 97, 98, 110, 148, 161,
162, 167, 191, 195, 209, 210, 213, 216,
217, 219, 232, 235
Création du Monde (Milhaud), 18, 25,
46, 74, 139, 143
creole, xi, 22, 23
Crosby, Bing, 19
Crosby, Caresse, 85, 92, 91
Crosby, Harry, 4, 17, 83, 85, 86, 92
cubism, 3, 6, 10, 11, 13, 33, 38–41, 58, 67,
69, 72, 73, 98, 106, 111, 115, 118, 125,
126, 132, 134, 135, 136, 137, 140, 145,
147, 171, 175, 177, 179, 181, 187, 189,
228, 229, 235
Cugat, Francis, 12
Cullen, Countee Sterling, 94
Cummings, Ann, 92
Cummings, e. e., x, xi, 1, 4, 5, 8, 16, 17,
25, 39, 57–61, 68, 73, 74, 83, 85, 87, 92,
95, 97, 98, 153, 159, 162, 195, 200, 204,
222, 223, 232, 235
Cunard, Maud, 62
Cunard, Nancy, ix, x, xi, xii, 1, 2, 11, 15,
21, 25, 27, 30, 62–70, 73, 77, 84, 87,
91, 95, 97, 98, 99, 103, 110, 191, 196,
202, 204, 215, 232, 233, 235
Curtis Institute of Music, 29

dadaism, 33, 40, 41, 139

Damon, S. Foster, 57

Damrosch, Walter, 31, 52, 54

Danilova, Alexandra Dionisevna, 34

Danse, La (Picasso), 175, 190–93

Daphnis et Chloé, 36

Davis, Stuart, 10, 47, 90, 98, 112, 126, 154, 228

De Gaulle, Charles, 118

De Kooning, Willem, 10, 192

Debussy, Claude, x, 23, 24, 27, 29, 30, 32, 38, 46, 49, 50, 54, 55, 111, 117, 118

Decline of the West (Spengler), 8, 36, 75, 111, 161–64,

Degas, Edgar, 39, 103, 174, 177

Delaunay, Sonia, 107, 131

Demoiselles d'Avignon, Les (Picasso), 174, 185

Demuth, Charles, 228

Denis, Maurice, 102

Derain, André, 9, 59, 61, 109, 165, 183

Désormière, Roger, 29

De Stijl, 135, 164

Deutsche Allgemeine Nachricht-en-Agentur (DANA), 220

Deutsche Presse-Agentur (DPA), 220

Dewey, John, 225, 229

Diaghilev, Sergei, 3, 7, 12, 15, 16, 29, 31, 33, 34, 35, 36, 37, 38, 40, 46, 114, 115, 123, 140, 143, 172, 176, 188, 190, 219

D'Indy, Vincent, 28, 50

Diver (Johns), 90

Döblin, Alfred, 213, 219

Doesburg, Theo van, 135

"Do It Again" (Gershwin), 53

Donaldson, Scott, 194, 196

Donaldson, Walter, 53

Doran (publishing house), 5, 58

Dos Passos, John, x, xi, 4, 5, 8, 12, 15, 16, 17, 39, 47, 57–61, 71, 73, 74, 76, 83, 84, 85, 90, 133, 144, 145, 148, 154, 158, 159, 162, 168, 169, 184, 195, 200, 204, 222, 223, 226, 228, 235

Doubrovska, Felia, 42–43

Douglas, Aaron, 161

Douglas, Norman, 64

Downes, Olin, 53

Dreier, Katherine, 134

Dreiser, Theodore, 3, 64, 74

Dreyfus, Max, 52

Du Bois, W. E. B., 64, 105

Duchamp, Marcel, 58, 73, 158

Dufay, Guillaume, 117

Duino Elegies (Rilke), 69

Duke, Vernon (Vladimir Dukelsky), 191

Dunbar, Paul Laurence, 94, 98

Duncan, Isadora, 3, 34, 94

Eakins, Thomas, 101, 102

Eastman School of Music, 29

École des Beaux Arts, 28, 109, 110, 132, 170

Eight Bells/Folly (Hartley), 90

Einstein, Albert, 77, 116, 162, 168, 207

Eisenstein, Sergei, 130

Élément Mécanique (Léger), 137–38

Eliot, T. S., ix, x, xi, 5, 6, 11, 16, 25, 41, 62, 64, 65, 67, 70, 74, 83, 86, 95, 99, 148, 159, 167, 168, 173, 195, 196, 197, 201, 202, 203, 205, 207, 208, 213, 217, 218

Ellington, Duke, 21, 31, 52, 113

Enormous Room, The (cummings), 57, 58, 166, 204

Ernst, Max, 142, 227

Errázuriz, Eugenia, 38, 182

Europe, James Reese, 21

Evans, Walker, 83, 92, 211

"Experiment in Music" (Gershwin and Whiteman) 51, 53

Exposition Internationale des Arts Décoratifs et Industriels Modernes, 2, 121, 123, 134, 139

expressionism, 1, 8, 10, 16, 73, 103, 117, 149

fact checking, 166, 211
Falla, Manuel de, 31, 113
Farewell to Arms, A (Hemingway), 12, 166, 222, 229, 230, 231, 232
Farm, The (Miró), 188, 226–29
Fauré, Gabriel, 28, 38
fauvism, 58, 102, 223
Finnegans Wake (Joyce), x, 41, 73, 207, 208, 213, 216, 217, 235
Firebird (Stravinsky), 36, 114
Fisk University, 101
Fitzgerald, F. Scott, ix, x, 1, 2, 3, 4, 5, 7, 8, 9, 10, 12, 16, 17, 39, 46, 48, 51, 59, 60, 62, 63, 67, 71–82, 83, 84, 85, 88, 89, 90, 91, 95, 98, 110, 145, 146, 147, 154, 156, 157, 160, 161, 162, 164, 166, 167, 184, 185, 186, 191, 192, 195, 196, 199, 202, 208, 210, 221, 222, 223, 231, 233, 235
Fitzgerald, Scottie, 71
Fitzgerald, Zelda, x, xiii, 1, 4, 48, 62, 71, 72, 73, 76, 81, 83, 154, 157, 191, 192
flappers, xiii, 8, 12, 30, 71, 75, 78
Fletcher, Thomas Fortune, 94
"Flivver Ten Million" (Converse), 18
Fogg Art Museum (Harvard), 102
Fokine, Michel, 42
Fondements de la musique dans la conscience humaine (Ansermet), 115–18
Ford, Ford Madox, 213, 226
formalism, 6, 16, 118, 192, 192, 235
Fortune magazine, 84, 166, 211, 219
Four Saints in Three Acts (Thomson and Stein), 31, 100
For Whom the Bell Tolls (Hemingway), 166, 173
fox-trot, 21, 30, 48

Freud, Sigmund, 159, 205
Furtwängler, Wilhelm, 29
Future of an Illusion (Freud), 159
futurism, 33, 72

Gance, Abel, 139
Garbage Man (Dos Passos), 60
Garden, Mary, 54
Gardiner, John Elliott, 116
Gaudier-Brzeska, Henri, 25
Gauguin, Paul, 3, 103
Gauthier, Eva, 52–55
Gérôme, Jean-Léon, 132, 145
Gershwin, Frances, 45
Gershwin, George, ix, x, xi, 2, 3, 7, 8, 16, 17, 18, 19, 31, 32, 46, 47, 49, 51–56, 91, 96, 113, 144, 172, 173, 191, 223, 235
Gershwin, Ira, 19, 32, 53, 55
Giacometti, Alberto, 69, 108, 124, 185, 224
Gide, André, 20, 207
Gielgud, John, 6
Gillespie, Dizzy, 18
Ginsberg, Allen, 68
Gladwell, Malcolm, 230
Gleizes, Albert, 133
Glückliche Hände (Schoenberg), 29
Golding, John, 133
Gombrich, E. H., 189
Goncharova, Natalia, 38, 140, 142, 145, 148
Goodbye to All That (Graves), 166
Goodman, Benny, 20, 53
Good Soldier, The (Ford), 166
Gorky, Arshile, 154
Gorman, Ross, 53
Gottschalk, Louis Moreau, 28
Gouel, Eva, 38
Gounod, Charles, 197
Gowing, Lawrence, 181
Graham, Martha, 89

Grainger, Percy, 31
Grammont, Claudine, 225
Grand Canyon Suite (Grofé), 31
Grand Central Station (New York), 18, 90
Grand Palais, 141, 143
Gray, Gilda, 19
Great Gatsby, The (Fitzgerald), 2, 4, 7, 9, 12, 17, 51, 60, 63, 71, 72, 73, 74, 75, 76, 77, 78, 79, 80, 83, 85, 87, 88, 89, 146, 147, 148, 154, 164, 166, 190, 202, 208, 232, 235
Great Neck, New York, 4, 76
Green, Julian, 4
Green Hat (Arlen), 62–63
Griffith, D. W., 12
Gris, Juan, 15, 129, 175, 176
Grofé, Ferde, 31–32, 50
Gropius, Walter, 120
Guernica (Picasso), 108, 159, 175, 180
Guggenheim, Harry F., 76
Guggenheim Foundation, 101

Hall, Edward, 167
Hamlet (Shakespeare), 41, 69, 168, 201, 205–6
Hammerstein, Oscar, 32
Hammett, Dashiell, 4
Hammond, John Hays, 54
Handel, George Frideric, 29, 117
Handy, W. C., 19
Harcourt Brace, 60
Hard-Boiled Virgin (Newman) 206
Harlem, 19, 20, 30, 31, 51, 63, 65, 93, 94, 96–99, 100, 103, 110, 114
Harlem Hellfighters (Fifteenth New York Regiment), 20–21
Harmon Foundation, 100–101, 102, 103
Harnett, William M., 156
Harper and Brothers, 60
Hart, Lorenz, 19

Hartley, Marsden, 83, 87, 90
Harvard University, 57, 59, 60, 98, 102, 141, 181, 223
Havel, Václav, 194
Hawkins, Coleman, 30
Hawkins, Walter Everett, 94
Hawthorne, Charles, 103
Hayden, Palmer, 101
Hayes, Helen, 12
Heidegger, Martin, 68, 69
Hemingway, Ernest, x, xi, 1, 2, 3, 4, 5, 7, 8, 9, 10, 11, 12, 15, 23, 25, 26, 27, 48, 57, 58, 59, 62, 68, 72, 74, 76, 82, 83, 84, 85, 95, 101, 133, 134, 144, 154, 157, 159, 160, 162, 165, 166, 168, 169, 173, 176, 185, 189, 194, 195, 196, 197, 200, 202, 204, 207, 208, 210, 213, 216, 219, 221–36
Hemingway, Hadley, 154, 221–22, 223, 225, 227, 228, 231
Hemingway, Margaux, 232
Henderson, Fletcher, 18, 31
Hennessy, Delage, 53
Herbert, Victor, 32
Him (cummings), 60
Hindemith, Paul, 24, 29, 30, 52
Hines, Earl "Fatha," 20, 21, 30
Hoff, Robert van 't, 135
Hofmannsthal, Hugo von, 208
Hogarth Press, 64
Holiday (Barry), 196
holocaust, 78, 108, 187
Holst, Gustav, 23
Honegger, Arthur, 31, 33 46
Hopkins, Gerard Manley, 217
Hopper, Edward, 154
Hotchkiss School, 154, 197
Hotel Jacob, 15
Hotel Universe (Barry), 196
Houghton Mifflin, 197
Hours Press, 64

Howard, Lesley, 92
Hughes, Langston, ix, xi, 7, 64, 91,
 93–99, 100, 103, 213, 223
Hurston, Zora Neale, 64
Huszár, Vilmos, 135
Hutcheson, Ernest, 54
Huxley, Aldous, 62
Huxtable, Ada Louise, 131
hybrid art, xi, 16, 30, 213

"I Get No Kick from Champagne"
 (Porter), 6
"I Got Plenty of Nuttin'" (Gershwin), 18
"I'll Build a Stairway to Paradise"
 (Gershwin), 51, 53
"I'm Just Wild about Harry," 20
impressionism, 1, 10, 24, 28, 58, 129, 229
"In a Mist" (Beiderbecke), 23
Ingres, Jean-Auguste-Dominique, 10,
 29, 174, 178, 183
In Our Time (Hemingway), 58
Itten, Johannes, 171
Ivanova, Lidia (Lidochka), 42
Ives, Charles, 195

Jacob, Max, 114, 175, 177
James, Henry, 73, 95, 197, 225
James, William, 3, 202, 225, 229
Janáček, Leoš, 49
Jazz Symphony (Antheil), 31
Jean Goldkette Orchestra, 23
John Tait's Café Band, 31
Johns, Jasper, 90, 154, 158
Johnson, Philip, 121, 122
Johnson, William H., 101
Jolas, Eugene, x, 2, 10, 16, 59, 70, 76, 83,
 86, 89, 113, 166, 170, 171, 172, 195, 197,
 204, 213–20, 221, 223, 226, 234, 235
Jolson, Al, 20, 51
Jonny Spielt Auf (Krenek), 31
Josephson, Matthew, 83, 219

Joyce, James, ix, x, 1, 5, 6, 10, 12, 24, 25,
 27, 29, 42, 58, 59, 60, 74, 83, 86, 95,
 99, 166, 168, 170, 190, 194, 195, 205,
 206, 207, 208, 213, 216, 217, 218, 220,
 221, 225, 235
Jozan, Édouard, 76
Judd, Donald, 127, 171
Juilliard School, 29, 54

Kafka, Franz, 213, 219
Kahn, Addie Wolff, 29
Kahnweiler, Daniel-Henry, 133, 176
Kandinsky, Wassily, 5, 24
Kazin, Alfred, 80, 231–32
Keats, John, 77, 88, 186, 200
Kelly, Ellsworth, 130, 171, 181
Kelly, Gene, 55
Kendall, Elizabeth, 42
Kern, Jerome, 19, 32, 52
Khokhlova, Olga, 29, 39, 178, 179, 180,
 181, 182, 183
Kisling, Moïse, 109
Kleiber, Carlos, 29
Klein, Yves, 171
Klemperer, Otto, 29
Kokoschka, Oskar, 62
Kolisch, Rudolf, 55
Koolhaas, Rem, 122
Krauss, Rosalind, 180–81
Krazy Kat (Carpenter), 31
Kreisler, Fritz, 54
Krenek, Ernest, 31, 33

Last Puritan, The (Santayana), 161
"Lady Be Good" (Gershwin), 54
Laforgue, Jules, 86, 97, 198, 205, 206
Lanvin, Jean, 46
Lardner, Ring, 56, 77
Larionov, Mikhail, 37, 59, 140, 142
Laurencin, Marie, 109
Laurens, Henri, 132

Lautrec, Henri de Toulouse, 174

Lawrence, D. H., 207, 225

Léger, Fernand, 5, 7, 8, 9, 10, 11, 12, 16,
 18, 23, 25, 46, 70, 73, 74, 90, 95, 105,
 111, 112, 114, 118, 120, 124, 125, 126, 127,
 128, 130, 132–39, 140, 142, 143, 144,
 145, 147, 148, 151, 153, 154, 155, 159,
 161, 165, 168, 169, 170, 171, 180, 187,
 194, 196, 228, 230, 235

Leininger, Theresa, 104

Lempicka, Tamara de, 1, 9, 73, 109

lens, the, 11–13, 112, 119, 125, 136, 143, 151,
 152, 153, 190

"Let's Do It" (Porter), 6

Le Vot, André, 71–72

Lewis, Wyndham, 25, 62, 65

L'Herbier, Marcel, 139

Lhote, André, 41, 105, 106

Lichtenstein, Roy, 130, 142, 143, 158

Lifar, Serge, 30, 42

Lindbergh, Charles, 2, 13

Lindsay, Vachel, 98

Lippmann, Walter, 211

Liszt, Franz, 32, 49, 117

Little Review, 218

Liveright, Horace, 91, 227

Living Well Is the Best Revenge
 (Tomkins), 158–59

Locke, Alain, 94

Loeb, Pierre, 226

Lohy, Jeanne-Augustine, 132

London Decca, 114

Long Island, 72, 74, 76, 77, 85, 167

Lost Generation, 1, 78, 167

"Love for Sale" (Porter), 6, 68

Luce, Henry, 194, 211

Luks, George, 103

Maar, Dora, 185

MacAgy, Douglas, 158

machine for living, 10, 121, 235

MacLeish, Ada, 59, 145, 184, 221

MacLeish, Archibald, x, xi, 2, 4, 8, 41,
 64, 67, 76, 84, 86, 91, 95, 96, 141, 145,
 153, 154, 156, 157, 158, 159, 165, 166,
 167, 168, 170, 184, 185, 194–212, 216,
 218, 219, 221, 222, 229, 231, 236

MacLeish, Kenneth, 170, 200, 202, 209

Magritte, René, 126

Maillol, Aristide, 9, 165, 183

Malevich, Kasimir, 171, 174,

Mallarmé, Stéphane, 4, 24, 97, 99, 112,
 117, 124, 127, 200, 202, 205, 206, 207,
 216

Mallet-Stevens, Robert, 139

Malraux, André, 139

Mandolin and Guitar (Picasso), 186,
 187, 188

Manhattan Transfer (Dos Passos), 12,
 47, 59, 60, 84, 90

Mann, Thomas, 12, 162

Maré, Rolfe de, 46

Mariés de la Tour Eiffel, Les (Cocteau),
 15

Mariinsky Theatre, 29, 36

Mark Cross, 141, 146, 147, 151, 156, 228

Markova, Alicia, 34

marriage of contours, 43, 126–27,
 129–30, 135, 148, 151,

Marsalis, Wynton, 55, 165

Massine, Leonid, 29, 30, 146, 177, 190

Matisse, Henri, 3, 9, 34, 37, 61, 100, 102,
 106, 109, 127, 129, 165, 176, 180, 181,
 198, 224

McAlmon, Robert, 66

McDonald, Maria, 213

McInerney, Jay, 75

McKay, Claude, 94, 98

McMillan, Dougald, 86

Meier-Graefe, Julius, 225

"Memorial Rain" (MacLeish), 200–205,
 209

"Memphis Blues" (Handy), 19

Metzinger, Jean, 133

Mies van der Rohe, Ludwig, 120, 121, 183

Milhaud, Darius, 10, 18, 20, 25, 33, 46, 47, 49, 52, 74, 95, 143

Millay, Edna St. Vincent, 62, 65

Mills, Eleanor, 167

Mills, Florence, 19–21

mimesis, 136, 166, 168, 170, 173, 189, 223, 230

minimalism, 10, 171, 174, 235

Mistinguett, 20

Modigliani, Amedeo, 9, 28, 109, 110, 132, 165, 198

Mondrian, Piet, ix, 5, 7, 9, 10, 124, 135, 139, 171, 174

Moned-Fontain, Isabelle, 180

Monet, Claude, 111, 118, 129

monotone, 11, 170–73, 189, 234

Monroe, Harriet, 73

Monte Carlo, 8, 34, 36, 66, 110, 178, 191, 193

Monteux, Pierre, 29, 114

Moody, David, 25

Moon Is a Gong, The (Dos Passos), 60

Moore, George, 67

Morgan, J. P., 83, 91

Mortimer, Harry, 92

Morton, Jelly Roll, 23

Motley, Archibald J., Jr., ix, 101, 103–5, 109

Moveable Feast, A (Hemingway), 11, 82, 196, 224, 226

Munch, Edvard, 59, 103

Murphy, Baoth, 81, 157

Murphy, Dudley, 26

Murphy, Esther, 5, 71

Murphy, Gerald, x, xi, xiii, 1, 4, 5, 10, 11, 12, 13, 18, 26, 29, 39, 46, 47, 60, 70, 71, 72, 73, 76, 81, 85, 90, 96, 112, 124, 126, 127, 128, 130, 134, 139, 140–60, 161, 167, 168, 177, 180, 184, 194, 195, 196, 197, 198, 221, 222, 226, 228, 229

Murphy, Patrick, 81, 141, 157, 159

Murphy, Patrick, Sr., 52, 147

Murphy, Sara, 1, 29, 39, 46, 54, 59, 72, 85, 178, 181, 182, 184, 186, 191, 194, 195, 196

Musée du Luxembourg, 105, 223

Museum of Modern Art, New York, xiii, 10, 128, 131, 148, 149, 171, 177, 180, 184

Mussorgsky, Modest, 32, 36, 50

Nabokov, Nicolas, 29, 33

Nabokov, Vladimir, 33, 166

Naked and the Dead, The (Walinska), 108

Negri, Pola, 62

Negro (Cunard), 63, 97, 99

neoclassicism, 6, 8, 11, 16, 29, 38, 41, 42, 44, 114, 115, 163, 167, 175, 177, 179, 180, 183, 189

neo-geo, 130, 171

Neruda, Pablo, 62

Newman, Barnett, 10, 130, 171, 174

Newman, Frances, 205

New Orleans, xi, 17, 19, 20, 22, 23, 32, 110

New York Public Library, xi, 91, 100, 198

New York Syncopated Orchestra, 118

"Night and Day" (Porter), 172–73

Night in the Forest (Cendrars), 12

Nijinsky, Vaslav, 34, 37, 41, 140

Nikitina, Alice, 42–43

Noailles, Comte de, 33

Noces, Les (Stravinsky), 15, 48, 5

Noone, Jimmie, 20

Nude Descending a Staircase (Duchamp), 73

Nugent, Bruce, 100
Nuttall, A. D., 168

Ober, Harold, 73
objective correlative (Eliot), 11, 148, 168, 202
objectivity, 138, 148, 168, 211
Ode (Nabokov), 29, 34
Oedipus (Stravinsky and Cocteau), 26, 29
Ogden, John, 71
Oja, Carol, 33
Okeh Records, 19
Old Dixieland Band, 21
Oliver, Joe "King," 19, 20
One Man's Initiation: 1917 (Dos Passos), 57, 58, 204
Orchestre de la Suisse Romande, 113
Orlova, Sophie, 42–43
Oud, Jacobus (J. P. P.), 135
Owen, Wilfred, 167
Ozenfant, Amédée, 27, 120, 124, 125, 126, 129, 130, 134, 143, 181

Page, Anita, 30
Pan, Yuliang, 108–10, 165
Parade (Picasso and Satie), 3, 18, 25, 35, 38–41, 45, 47, 114, 115, 123, 176, 189
Parade's End, 166
parallax (concept of), 67, 78, 203, 232, 233
Parallax (Cunard), x, xii, 64, 65, 67, 68, 69, 70, 77, 84, 91, 98, 202
Parker, Dorothy, 56, 59, 62, 81, 83, 156
Pavillon de l'Esprit Nouveau (Le Corbusier), 2, 139
Payne, Nina, 191
Pelléas et Mélisande (Debussy), 32, 50, 87, 117
Pennsylvania Academy of Fine Arts, 101, 106

Periscope (Johns), 90
Perkins, Maxwell, xii, 72, 75, 77, 221
Perret, Auguste, 119
Pfeiffer, Jinny, 221
Pfeiffer, Pauline, 154, 221, 234
Picabia, Francis, 25, 46, 118, 142
Picasso, Pablo, xi, 2, 3, 5, 6, 7, 8, 9, 11, 15, 16, 28, 29, 34, 38–44, 59, 61, 73, 98, 100, 103, 105, 106, 107, 108, 111, 112, 114, 115, 117, 118, 123, 124, 126, 127, 128, 129, 132, 133, 134, 136, 137, 140, 144, 145, 152, 154, 155, 157, 159, 161, 165, 168, 169, 170, 171, 174–93, 194, 196, 198, 199, 200, 218, 223, 224, 225, 226, 228, 230, 232, 234, 235, 236
Piston, Walter, 29
Planck, Max, 116
Plan Voisin (Le Corbusier), 120, 131
Plaza Hotel, xii, 5, 72, 85
Polignac, Princess de (Winaretta Singer), 33
Pollock, Jackson, 10
pop, 10, 11, 143, 148, 235
Porgy and Bess (Gershwin), 18, 31, 51, 55
Porter, Cole, ix, x, xi, 4, 6, 8, 10, 16, 28, 32, 33, 45–50, 51, 52, 55, 56, 59, 60, 68, 83, 96, 97, 110, 113, 143, 149, 170, 172, 173, 184, 191, 195, 198, 223, 234, 235
Porter, Linda Lee, 1, 5, 46, 48, 184, 198
postimpressionism, 10
postmodernism, 6, 13, 235
Poughon, Louis, 136
Poulenc, Francis, 10, 25, 33, 38
Pound, Dorothy Shakespear, 25
Pound, Ezra, x, xi, 5, 6, 8, 24–27, 59, 62, 64, 66, 67, 68, 70, 73, 86, 87, 95, 100, 134, 167, 168, 170, 194, 207, 217, 218, 221, 225, 226
Pound, Omar, 25
precisionists, 10, 112
pre-Raphaelites, 10, 102

Princeton University, 46, 72, 75, 77, 80, 158, 223

Prokofiev, Sergei, 5, 24, 29, 33, 37, 115, 191

Propher, Nancy Elizabeth, 101

Prose Trans-Sibérien (Cendrars), 65

Proust, Marcel, 1, 10, 59, 67, 147, 197, 199

Pulcinella (Stravinsky), 48

purism, 6, 9, 119, 120

Puvis de Chavannes, Pierre, 183

ragtime, 17, 19, 22, 48, 114

Rainey, Ma, 19

Rambert, Marie, 37

Rampersad, Arnold, 95

Rauschenberg, Robert, 158

Ravel, Maurice, x, 7, 10, 20, 23, 46, 54, 55, 139

Ray, Man, 26, 62, 63, 139

Razor (Murphy), 149, 151, 158

realism, 1, 6, 10, 36, 112, 114, 118, 153, 165–67, 169, 170, 174, 181, 228, 235

Redman, Don, 31

Reinhardt, Ad, 130, 174

Retablo (de Falla), 31

Revue des Ambassadeurs, La (Porter), 55

Revue Nègre, 23, 59, 97

Rhapsody in Blue (Gershwin), 2, 7, 31, 32, 49, 52, 53, 55, 91, 172

Richardson, John, 42, 177, 179, 181, 184–85, 186, 191

"Rich Boy, The" (Fitzgerald), 78

Rilke, Rainer Maria, 68

Rimbaud, Arthur, 24, 65, 97

Rime of the Ancient Mariner (Coleridge), 87

Ripolin, 10, 124

Rise and Fall of the City of Mahagonny (Weill), 31

Rodgers, Richard, 19, 32

romanticism, 26, 36, 167

Roosevelt, Franklin Delano, 194, 203, 210

Root, Waverley, 13

Rosenbach, Abraham, 208

Rosenberg, Léonce, 134, 137, 226

Rosenquist, James, 142, 143

Ross, Alex, 33

Rothko, Mark, 10, 174

Rothstein, Arnold, 166

Rousseau, Henri, 132, 230

Rubenstein, Ida, 34

Rubin, Rosina, 106

Rubin, William, 148, 181, 184–85

Rudge, Olga, 25, 26

Runyon, Damon, 56

Russell, Bertrand, 169, 171, 207

Russell, George William (A.E.), 206

"Russian Blues" (Coward), 19

Sacre du Printemps, Le (Stravinsky), 13, 15, 33, 36–37, 39, 40, 54, 114, 170–71

Salon d'Automne, 36, 100, 109, 226

Sandburg, Carl, 98

Santayana, George, 161, 225

Satie, Erik, 3, 10, 18, 24, 25, 26, 27, 29, 33, 38–41, 113, 170, 195

Savage, Augusta, 101

Savoye, Pierre, 121, 123

Schirmer, Mabel, 54–55

Schoenberg, Arnold, 20, 23, 26, 29, 48, 52, 55, 56, 165

Schola Cantorum (Paris), 28, 32

scissiparité (double consciousness), 78, 116, 117, 203, 232

Scott, William Edouard, 100, 101

Scribner's (publishing house), xi, xii, 75, 221

Seldes, Gilbert, 59

Shakespeare and Company, 15, 26, 207, 221, 225

Shead, Richard, 1

Sheeler, Charles, 228

Shipman, Evan, 227

Shuffle Along, xiii, 19–20

Silver, Kenneth, 10, 183

"Sketch for a Portrait of MME. G— M—, A" (MacLeish), 196–200

Smith, Ada "Bricktop," 21

Smith, Bessie, 7, 19, 23

Snows of Kilimanjaro, The (Hemingway), 9, 164

Southern Syncopated Orchestra, 21

Soutine, Chaim, 9, 103, 109, 132

Spengler, Oswald, 8, 9, 36, 75, 85, 111, 123, 161–64, 171, 210

"Stairway to Paradise" (Gershwin), 191

Stein, Gertrude, ix, 1, 3, 6, 8, 9, 10, 12, 31, 38, 64, 68, 69, 74, 78, 83, 86, 87, 98, 100, 101, 105, 123, 172, 173, 174, 175, 176, 183, 194, 195, 196, 202, 210, 215, 216, 217, 221, 223, 224, 225, 226, 229, 234

Stein, Leo, 3, 176, 225

Stein, Michael, 3, 42, 121, 123, 131, 175

Stein, Sarah, 3, 37, 42, 121, 123, 131, 174

Steiner, Wendy, 191–92

Stella, Frank, 10, 130, 154, 174, 181

Stella, Joseph, 87, 88

Stieglitz, Alfred, 83, 176, 228

Still Life (Le Corbusier), 127–28

"St. Louis Blues" (Handy), 19

St. Nicholas Hockey Club (St. Nick's), 79

Stoddard, Lothrop, 75

Stokowski, Leopold, 31, 54

Storr, Robert, 10, 180

Strauss, Richard, 29, 48

Stravinsky, Igor, ix, 3, 5, 6, 8, 10, 15, 16, 20, 23, 24, 29, 32, 33, 37, 38, 41, 42, 46, 47, 48, 49, 50, 54, 95, 98, 113, 114, 115, 118, 140, 159, 171, 177, 180, 191, 195

Streets in the Moon (MacLeish), 197, 200

"Summertime" (Gershwin), 51

Sun Also Rises, The (Hemingway), 62, 173, 231

suprematists, 135, 171

surrealism, 11, 33, 60, 73, 112, 118, 165, 176, 191, 216, 227, 228, 235

"Swanee" (Gershwin), 19, 51

symbolism, 36, 102

Symons, Arthur, 86, 99

Symphony of Psalms, 114

syncopation, 7, 16, 20, 31, 32, 49, 60, 114, 118, 235

synthetic cubism, 105, 133

tango, 33

Tanner, Henry Ossawa, 101–3

TanzSymphonie, 42

Tchelitchew, Pavel, 34

Tchernicheva, Lubov, 42–43

Tender Buttons (Stein), 12, 41, 64, 173, 217

Tender Is the Night (Fitzgerald), 157, 196, 199

Tériade (Stratis Eleftheriades), 7, 189

Terrasses, Les (Le Corbusier), 121

This Side of Paradise (Fitzgerald), 78

Thomson, Virgil, 29, 31, 100

Three Lives (Stein), 100

Threepenny Opera (Weill), 31

Three Soldiers (Dos Passos), 5, 57, 58, 166, 204

Thurber, James, 4

Tin Pan Alley, xi, 19, 32, 50, 114

Toklas, Alice B., 183

Tomkins, Calvin, 73, 145, 148, 158–59

Tractatus Logico-Philosophicus (Wittgenstein), 169

Transatlantic Review, 218, 226

transition, 86, 88, 213, 214, 218, 219

Trumbauer, Frank, 18
"truth in painting" (Clark), 11, 117, 165, 225
Tucker, Sophie, 19
Tulips and Chimneys (cummings), 61
Tumulte Noir (Colin), 22

Ulysses (Joyce), 3, 5, 15, 24, 25, 41, 42, 46, 58, 69, 95, 166, 173, 190, 206, 207, 208, 218, 235
U.S.A. (Dos Passos), 12, 60

Vaill, Amanda, 1, 47, 48, 143, 149, 183–84
Valentino, Rudolf, 48
Vanderlan, Robert, 211
Vaughan, David, 41
Veblen, Thorstein, 8, 9, 75, 229
Vechten, Carl van, 5, 20, 22, 70, 95, 97, 113, 172, 213, 215
Villa America, xii, 5, 48, 61, 71, 81, 145, 153, 157, 158, 196, 221, 222
Villa Stein (Le Corbusier), 42
Ville, La (Léger), 139, 147
virtuosos, 179, 192, 230
Vogue, 95, 221
Vortex, The (Coward), 6
Voyages (Crane), 84, 89

Wagner, Richard, 23, 24, 26, 32, 61, 64, 117, 142
Waiting for Godot (Beckett), 69
Walinska, Anna, 105–8
Wall Street, 2, 16, 125, 167
Ward, Geoffrey, 105
Waring, Fred, 45
Waring, Lara Wheeler, 101
Wasp and Pear (Murphy), 155
Waste Land (Eliot), 25, 41, 64, 65, 69, 70, 173, 218

Watch (Murphy), 146, 149, 151, 156, 158, 228
Waters, Ethel, 19
Wayne, Kenneth, 10
Weary Blues (Hughes), 93, 94, 95, 97
Weber, Nicholas Fox, 130
Webern, Anton, 20, 113, 168
Weill, Kurt, 31
Wells, H. G., 207
Wharton, Edith, 3, 95, 197
Whistler, James, 80, 103, 198
White, George, 51
Whiteman, Paul, 20, 23, 30, 31, 32, 51, 52
Whitney Museum, xi, xiii, 154
Wiborg, Hoytie, 48, 54, 186
Wilder, Thornton, 207
Williams, Clarence, 23
Williams, William Carlos, 25, 64, 65, 83, 85, 92, 195, 219
Wilson, Edmund, 46, 70, 213
Within the Quota (Porter and Murphy), 25, 45–50, 51, 55, 56, 59, 60, 72, 96, 139, 141, 143, 184, 191
Wittgenstein, Ludwig, 67, 168–70, 201, 208, 216
Wolfe, Tom, 73, 75
Woman in White (Picasso), 42, 73, 175, 177, 178, 181–86, 190, 194, 199
Woodruff, Hale, 100, 102
Woolf, Virginia, 64, 207
World War I, 2, 36, 57, 110, 111, 123, 132, 161, 162, 165, 200
World War II, 204, 220

Yale University, 45, 71, 75, 76, 141, 149, 154, 194, 197, 222
Yeats, William Butler, 25, 204, 207

Zeitoper, 31, 51, 165
Ziegfeld, Florenz, 20